Theatricality in Early Modern Art and Architecture

Art History **Book Series**

Series Editors
David Peters Corbett (University of East Anglia) and Christine Riding (Tate)

In this distinctive series, developed from special issues of *Art History*,
leading scholars are invited to publish new research on key ideas
and to reflect on contemporary concerns in the discipline. Each collection
of essays takes a particular theme and the scope is wide: from painting
and sculpture to photography and video, urban history and architecture,
collecting, and historiography.

Titles in the series include

Photography After Conceptual Art
Edited by Diarmuid Costello and Margaret Iversen

Art History: Contemporary Perspectives on Method
Edited by Dana Arnold

Art and Architecture in Naples, 1266–1713: New Approaches
Edited by Cordelia Warr and Janis Elliott

About Mieke Bal
Edited by Deborah Cherry

Spectacle and Display
Edited by Deborah Cherry and Fintan Cullen

Location
Edited by Deborah Cherry and Fintan Cullen

About Stephen Bann
Edited by Deborah Cherry

Between Luxury and the Everyday: Decorative Arts in Eighteenth-Century France
Edited by Katie Scott and Deborah Cherry

Art: History: Visual: Culture
Edited by Deborah Cherry

Difference and Excess in Contemporary Art: The Visibility of Women's Practice
Edited by Gill Perry

Tracing Architecture: The Aesthetics of Antiquarianism
Edited by Dana Arnold and Stephen Bending

Other Objects of Desire: Collectors and Collecting Queerly
Edited by Michael Camille and Adrian Rifkin

Fingering Ingres
Edited by Susan Siegfried and Adrian Rifkin

The Metropolis and its Image: Constructing Identities for London, c. 1750–1950
Edited by Dana Arnold

About Michael Baxandall
Edited by Adrian Rifkin

Image: Music: Text
Edited by Marcia Pointon, Simon Miller and Paul Binski

Theatricality in Early Modern Art and Architecture

Edited by Caroline van Eck and Stijn Bussels

A John Wiley & Sons, Ltd., Publication

Contents

Notes on Contributors

Marc Bayard is the Head of the Art History Department at the French Academy in Rome (Villa Medici) His publications include: *L'histoire de l'art et le comparatisme: Les horizons du détour, 2007; Rome-Paris, 1640: Transferts culturels et renaissance d'une école artistique,* (forthcoming).

Stijn Bussels is Assistant Professor in Theatre Studies at the University of Groningen. His monograph *The Antwerp Entry of 1549: Rhetoric, Performance and Power in the Early Modern Netherlands* will be published this year by Rodopi in the Ludus-series.

Maarten Delbeke teaches at Ghent University and the University of Leiden. With Evonne Levy and Steven Ostrow he edited *Bernini's Biographies: Critical Essays* (Penn State, 2006). This essay forms part of a book-length project titled *Sforza Pallavicino and Art Theory in Bernini's Rome.*

Caroline van Eck is Professor of Architectural History and Theory at Leiden University, where she directs a project on art, agency and living presence funded by the Dutch Foundation for Scientific Research. Recent publications include *Classical Rhetoric and the Arts in Early Modern Europe* (Cambridge, 2007).

Hanneke Grootenboer is a Lecturer in the History of Art at the University of Oxford. Author of *The Rhetoric of Perspective: Realism and Illusionism in Seventeenth-Century Dutch Still Life Painting* (Chicago, 2005), she is currently completing *Treasuring the Gaze: Intimacy and Extremity of Vision* on eighteenth-century eye miniature portraits.

Wendy Heller, Professor of Music at Princeton University and Director of the Program in Italian Studies, has published extensively on seventeenth- and eighteenth-century opera from interdisciplinary perspectives. She is completing a book on the reception of antiquities in baroque dramatic music.

Emmanuelle Hénin teaches art history and comparative literature at the University of Reims, France. Recent publications include Ut pictura theatrum. *Théâtre et peinture, de la Renaissance italienne au classicisme français* (Droz, 2003).

Lex Hermans holds a PhD in history and is research fellow in the Department of Art History at Leiden University. He has published studies of homosexuality in the Roman Empire and of Dutch neoclassical theories of architecture, and written a book on the rhetorical functions of images and architecture in Italian Renaissance theory (forthcoming).

Sigrid de Jong is a lecturer in architectural history at Leiden University. 'Staging Ruins: Paestum and Theatricality' will be part of her PhD thesis. Previously she was a curator at the Dutch Institute for Architecture.

Elsje van Kessel is a PhD candidate in the NWO-financed research programme 'Art, Agency, and Living Presence in Early Modern Italy' at Leiden University. She is currently preparing a dissertation on painting and audience response in sixteenth-century Venice.

Bram van Oostveldt is Assistant Professor of Theatre Studies at the University of Amsterdam and a member of the Amsterdam School for Cultural Analysis (ASCA). He is currently researching new visual technologies and the spectacularization of popular theatre and society in Paris, Brussels and Amsterdam between 1789 and 1830.

Kati Röttger is Professor and Head of the Department of Theatre Studies, University of Amsterdam. Her current projects are 'Spectacle and Society: Melodrama as a Mode of Modernity in the Netherlands, 1780–1914' and 'Transatlantic Image Streams: Towards a New Politics of the Image between Global Icons and Iconoclash'.

Laura Weigert is Associate Professor of Art History at Rutgers University. She is author of *Weaving Sacred Stories: Narratives of Saints and the Performance of Clerical Identity* (Cornell, 2004) and of articles in *The Oxford Art Journal*, *Gesta*, *Studies in Iconography*, and *The Art Bulletin*.

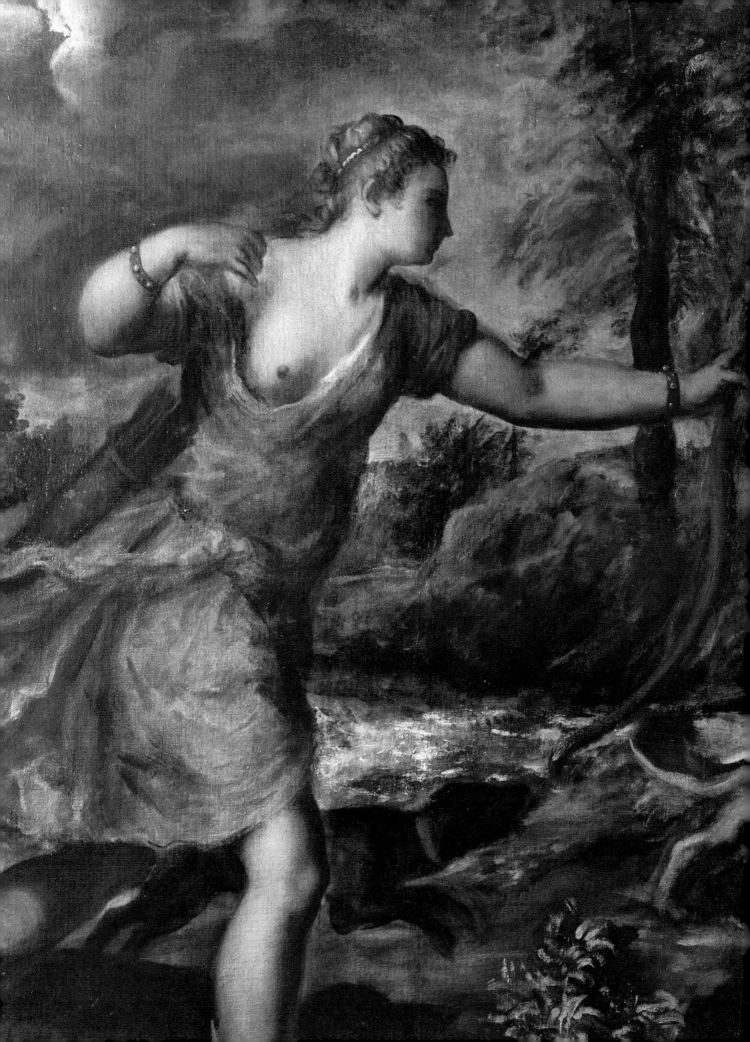

Chapter 1
The Visual Arts and the Theatre in Early Modern Europe
Caroline van Eck and Stijn Bussels

Detail from Titian, *Death of Actaeon*, 1562. (*plate 6*).

Theatricality in Early Modern Art and Architecture *Edited by Caroline van Eck and Stijn Bussels* © 2011 Association of Art Historians.

Art, Theatre and Theatricality

From its earliest beginnings, the theatre has borrowed elements from architecture, painting and other visual arts to stage and perform plays, ranging from the primitive wooden scaffoldings used in Athens in the fifth century BCE to perform Bacchic plays to the elaborate perspectival backdrops with their suggestion of infinite space developed in the eighteenth century by the Galli-Bibbiena family. Conversely, the arts have depicted theatrical actions such as the lifting of a curtain to stage what is represented in a painting, and imported gestures, costumes or entire stagings of a scene from the theatre. Venetian painting offers some of the best-known cases, for instance in Veronese's use of Palladian architectural backdrops for his large Biblical scenes. His *Feast in the House of Levi*, painted in 1573 (*plate 2*) was described by Carlo Ridolfi in the seventeenth century as a 'maestoso Teatro', and in the nineteenth century the painter was still praised as a superb stage manager; Ridolfi also described the action of Titian's *Crowning with Thorns* as taking place in a theatre.[1] But already in the sixteenth-century plays and joyous entries in Flanders drew on famous paintings such as Jan van Eyck's *Lamb of God* (1425–29) to provide a compositional framework for their staging of *tableaux vivants*. Such relatively straightforward cases of exchange and borrowing are well documented and the questions they have raised are mainly those of influence or adaptation of originals to new uses in a different medium.

But the inclusion of theatrical elements in a work of art is rarely simply a matter of borrowing a costume, gesture or compositional feature. Even in Veronese's *Feast in the House of Levi* the use of a stage, which at first sight seems to be a straightforward case of a painter employing a theatrical feature, fundamentally affects both the composition of the painting and the way it is viewed. The composition of Veronese's paintings depicting feasts, weddings or the Last Supper use architectonic backdrops that are very close to reconstructions by Serlio and Palladio of Roman theatrical backdrops as described by Vitruvius (*plate 2*).[2] These are not representations of actual buildings or urban spaces, because they cannot be reconstructed as such, but illusionist stage settings; they signal that the viewer is looking at the enactment of some drama.[3] At the same time they are not simply dramatic scenes represented as if on stage: Veronese handled the sacred and the secular, the elevated and the mundane, in a subtle way that could not have been achieved on a real stage. In the *Feast in the House of Levi* there is no central, unified linear perspective; instead each zone of the painting obeys a different visual order, probably because a unified perspectival system imposed on such a vast scene would look very unnatural. The receding orthogonals are broken,

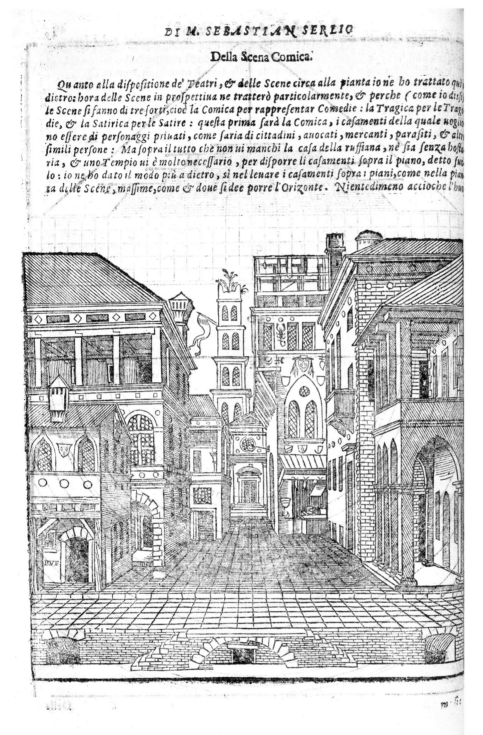

1 Sebastiano Serlio, *Design for the scenery of a comedy*, from Sebastiano Serlio, *Libro I-VI d'architettura*, Vicenza: Jac. de'Franceschi, 1584, f. 45v. Photo: Leiden University.

which prevents the composition from being taken in at one glance; only once all parts of the scene depicted have been absorbed can the spectator form an idea of the composition as a whole. Thus the spatial, two-dimensional, pictorial representation of an event is transformed into a narrative unfolding in the spectator's act of looking.

The Feast in the House of Levi thus points to one important implication of the use of theatrical elements in a work of art: the use of a stage signals to the viewer that he or she should look at what is represented as a viewer of a play, that is, as somebody who watches the unfolding of a play in the course of an evening. It does not show the events it depicts as static, frozen in the eternal present of *historia sacra* in the way many late medieval crucifixions, *pietàs* or annunciations do, but as a narrative. Depicting a situation or event as if it takes place on a stage also stages the way the viewer looks at it.

Introducing the visual arts in a theatrical performance is not a mere matter of mixing media or genres either. In the final scene of the opera *La Torilda*, first performed in Venice in 1648, the legendary musician Amphyon appears in a loggia near a marina, decorated with statues. He enters the stage riding a dolphin, singing praises to the goddess Venus and of love's power to set stones afire. The statues in the loggia are brought to life by Amphyon's song, and the work is concluded with a *ballo delle statue* – a dance of the statues. Thus, in an operatic realm in which everyday speech is elevated to song, statues express their inherent theatricality through the most sophisticated language of the body – dance. This example points to

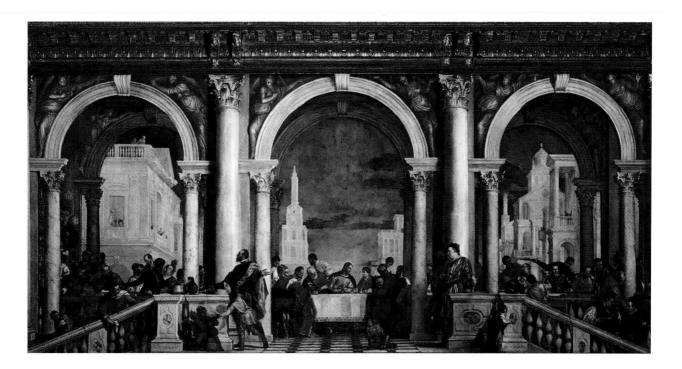

2 Paolo Veronese, *The Feast in the House of Levi*, 1573. Oil on canvas, 555 × 1280 cm. Venice: Gallerie dell'Accademia. Photo: CKD Nijmegen.

two recurring features of exchanges between the theatre and the arts: they undermine established distinctions between the arts, and they suggest transgressions of the boundaries between representation and presence. The inanimate statues in *La Torilda* become living beings, and their immobility is transformed into song.

In Venetian early modern opera statues could become living and moving actors on the stage; but in the courtly theatres built in Florence, Parma and Vicenza in the sixteenth century, statues of rulers were placed in the theatrical space to observe both the play and the audience. In the Farnese theatre in Parma an equestrian statue of the prince was installed in the theatre. In Sabbioneta a statue of the emperor Vespasian was positioned directly behind the seat of the Gonzaga ruler who shared his name with the emperor, as a visual reminder of the model the prince claimed – or was expected – to follow. But sometimes the prince himself became a theatre, a place to view the enactment of princely virtue, as the dedication of the treatise by the architect Giovanni Battista Aleotti bears out: 'As is well known, Your Highness is a living theatre', he wrote to his patron Ranuccio I of Parma, 'in whom all heroic virtues represent magnanimous and generous actions'.[4] For human beings, being theatrical in this context meant literally that they were a theatre, a place where their character was on display for all to see.

These examples all suggest that exchanges and borrowings between the visual arts and the theatre are not simply a matter of exchanges of media or genres. They affect the way a play, painting or statue is viewed, the relations between the media, genres and arts involved, and the characters on stage or represented in painting or sculpture. They raise questions about the ways genres are demarcated and defined, the relations between media, the way plays and art works are viewed, and ultimately the relation between representation and presence.

The relations between the theatre and the visual arts have been studied mainly in two ways, one concentrating on the actual relations between these arts, the other taking its departure in the concept of theatricality. Inspired by the topos of the *theatrum mundi* and the *paragone*, the first, more historically oriented approach, has rarely moved beyond documenting and studying individual cases of the use of theatrical elements

in the arts. Architectural history illustrates this well: whereas it is acknowedged that there exist unmistakable connections between the work of Veronese and Tintoretto and the architectural designs of Peruzzi, Serlio and Palladio; between French eighteenth-century public architecture and the theatre; or between the stage designs of the Galli-Bibbiena and the etchings of Piranesi, research has rarely moved beyond documenting these similarities.[5]

Theatricality is a concept with many meanings; ambiguity is a constant feature of its use. On one side of its semantic spectrum it simply refers to anything pertaining to the theatre, from the props to the script; at the other extreme it is a heavily laden ethical and political term. Prior to the second century AD, the Greek *thea* (derived from the verb *theaomai*, to gaze with admiration or bewilderment, or to contemplate) and its cognate *theatron* were used to identify the distinctive visual characteristics of the theatre. *Thea* refers to the act of seeing something, including the act of seeing involved in attending a spectacle or performance, but also to contemplation (hence our term 'theory').[6] The word was also used to name the actual spectacle or performance itself, whether staged in the theatre or elsewhere, and also the place from which a spectacle or performance is seen, such as a seat in the theatre or even the auditorium in general. From the second century AD, however, words derived from *thea* start to be used not only to point to the visual characteristics of the theatre, but also to refer to exaggeration, distortion and deceit. In his *Anthologies*, the Hellenistic astrologer Vettius Valens (*c.* 120–*c.* 175 AD) uses the term *theatrodes* pejoratively for persons of exaggerated behaviour (14.27).[7]

This negative understanding of the theatre has a long history. Ultimately it goes back to Plato's famous anti-theatrical, or rather, anti-mimetic, arguments in the tenth book of the *Republic*. Plato attacked what he saw as the theatre's distortion of reality. One of the greatest dangers of the theatre was that the audience might mistake the fictitious world of the tragedy for the truth. All artistic mimesis, but certainly the mimesis of tragedy, is for Plato, 'a corruption of the mind of all listeners who do not possess as antidote a knowledge of its real nature' (*Republic* 595B).[8] The excesses shown on stage habituate the audience to them, and therefore affect the norms and values of the polis. Moreover, the audience is not conscious that their understanding is distorted. Its modes of evaluation and analysis militate against genuine philosophical understanding.

The term theatricality is first documented in English in 1711, and in French somewhat later. From its introduction, it did not refer to such exchanges in a neutral way, but had clear moral connotations. In his instructions to the painter, published in 1711 in *Characteristicks of Men, Manners, Opinions, Times*, Shaftesbury prescribes that he should start from observations when the subject is behaving in a natural way and thus not playing a social role:

> Such study'd Action, and artificial Gesture, may be allow'd to the Actors and Actrices of the Stage. But the good Painter must come a little nearer to Truth, and take care that his Action be not theatrical.[9]

In French, the term *théâtral* was used in the early modern period to name situations or objects directly related to the theatre. At the end of the seventeenth century it came to be connected with the exaggeration and affectation attributed to the theatre, and used in the sense of 'amplifié, exagéré, comme ce qui se fait au théâtre', the opposite of natural social interaction.[10] Just as in the passage by Lord Shaftesbury quoted above, theatricality becomes associated with everything unreal and unnatural, with conscious deceit, not only of the audience in the theatre but of society at large,

and even with a loss of self. In his *Lettre à M. D'Alembert* of 1758, Rousseau made the influential argument that the middle classes and courtiers function as actors: they play a social role which they hope will promote their interests. However, these persons have to pay a very high price for such behaviour, since they tarnish their 'pure' and 'natural' self and ultimately risk isolation and mental derangement. They may lose not only their true self, but also all sense of true reality. The theatre, just as the visual arts, pretends to present something natural and therefore infects the true and natural by lies and deceit. This harms the psyche of both actors and audience.[11]

When German and Russian theatre historians introduced the term 'Theatralität/ teatral'nost', their approaches ranged from a narrow historical one to a wider, anthropological view. Two books published early in the twentieth century were fundamental for all subsequent analyses of theatricality. Georg Fuchs set out in *Die Revolution des Theaters* of 1909 to identify the elements that distinguish theatre from other art forms. Theatricality for him was the totality of material or sign systems used in a performance, apart from the text. But a year earlier Nikolai Evreinov had given a very influential definition of the other axis. In *Apology of Theatricality* he had developed a concept of theatricality as a pre-aesthetic instinct at work in all parts of society and culture. Whereas this definition is too wide to be useful, Evreinov was the first to think about ways in which the concept of the theatre can be defined and used as a cultural model. Concentrating on the work leads to a factual view along the lines of Fuchs, concentrating on the spectator to a wider, social or ethical notion of theatricality in the tradition of Shaftesbury or Evreinov.[12]

In art history the implications of thinking about a work of art in terms of a play performed in front of an audience have been the subject of many studies of theatricality over the past decades. Richard Wollheim for instance, in *Painting as an Art* (1987), offered theatrical concepts such as the external and internal spectator as ways of understanding what the viewer does. For him, theatricality functions as a heuristic device to help us understand the interaction between art and its viewers. Michael Fried's *Absorption and Theatricality* of 1980, on the other hand, took a critical view of the interdependence between a theatrically conceived work of art and its viewers. Within theatre studies many attempts have recently been made to define theatricality, both in technical and disciplinary ways that stay close to the theatre as a medium, and in ways that present the theatre as a metaphor through which to study society as a whole.[13]

The general impression created by recent studies on theatricality, however, is that of a dead end. Either the term has become so wide and all-embracing that it has become meaningless, or it is too narrowly based on a critique of the literally spectacular character of art works conceived in theatrical terms, and hence too much connected to late-modernist critiques of such theatricality, to be a useful instrument to study other varieties of the interaction between the arts and the theatre.[14] Depending on the meaning of the term one favours, even the theatre itself is not automatically theatrical, nor are works of art using elements taken from the theatre for that reason alone theatrical. As Josette Feral put it recently, to understand theatricality we need a double focus: the work on the stage and the spectator.[15]

In other words, a conceptual slippage tends to occur when a work of art is called 'theatrical': between its technical meaning as referring to all the elements that make up the theatre as a medium, and the wider social and moral phenomenon of theatricality as an awareness of acting a part or appearing in front of an audience, with all the connotations of unnaturalness, play-acting, lack of spontaneity, or artificiality this brings with it. This tends to affect current work, and in fact obscures much that distinguishes early modern uses of theatrical elements in the visual arts. But as the case

studies collected in this book show, such use in works of art or buildings predating the 1750s rarely raises the issue of theatricality in the moral sense that subsequently became so conspicuous. It would exceed the boundaries of this book to investigate in depth the reasons for this discomfort with falsity, but the chapters by Hermans and Delbeke do give some precise indications of the actual manner in which such ethical concerns became attached to the theatre: because of the presentation of public figures such as princes or popes as public stagings of virtue in a rather literal way.

Instead of taking a modern definition of theatricality as our point of departure we began here by studying the implications of the use of four elements that define early modern theatre: the scenario, the actor, the theatrical space, and the audience. The theatricality of art, we might say, resides in the implications of its use of theatrical elements. But unlike previous studies of such uses we did not stop by cataloguing and documenting them, but instead have taken them as the foundation for further inquiries. These include ontological issues of presence and representation; the poetics of pictorial narration; the boundaries between genres, media and arts; and virtually every use of theatrical elements presented here raises questions about the relations between works of art and their viewers, and about how the work of art stages the act of viewing.

The Use of Theatrical Elements in the Arts and their Implications

Theatrical Space

Exchanges between the theatre and the arts began at the very birth of Greek theatre, when architecture provided the scaffolding for the temporary stages on which comedies and tragedies were performed.[16] In the sixteenth century Peruzzi and Serlio designed urban and pastoral views to serve as the backdrop for plays, and conversely, fifteenth- and sixteenth-century paintings used such architectural stage sets as the backgrounds or settings of the *historia* they put before the viewer. Veronese's large Biblical scenes are probably the best-known instances of the use of architecture to provide a stage in this way. These paintings point to one important implication of the use of theatrical elements in a work of art: the use of a stage signals to the viewer that he or she should look at what is represented as a viewer of a play, that is, as somebody who watches the unfolding of a play.

In his contribution to this book, Marc Bayard argues against an approach to the exchanges between theatre and the arts in terms of influence, originality and imitation or appropriation. The implications of the use of elements which constitute a theatrical space, such as the stage, a backdrop or proscenium, are further articulated by introducing a distinction between referential and processional theatricality. In referential theatricality scenic elements in a painting, in particular perspectival architectural backdrops, clearly refer to stage sets that were in existence before the painting was made, or to general types of stage sets, such as the backdrops designed by Serlio in the 1550s, for tragic and comic scenes (*plate* 2). In the second variety the viewing process is structured by the painting's composition in a way that is similar to a theatrical *mise en scène*. The best-known and most evident instance of this is the figure of the witness or intermediary, a figure who looks out of the painting at the beholder, or points to what happens in the image. Alberti was the first Renaissance theorist to suggest in his *De Pictura* (1435/6) to include such a figure when depicting a *historia*, a story taken from the Bible, ancient history or classical mythology. In the near-contemporary *Trinità* by Masaccio in Santa Maria Novella in Florence (1425–28), Mary looks at the viewer

while at the same time pointing at her crucified son. Alberti's advice echoes the rhetorical doctrine that in the *actio*, the delivery of a speech, the orator should strive for maximum persuasiveness. *Enargeia*, vividness that makes what is represented in speech seem present before the eyes of the audience, could be achieved by words, but if the situation allowed, also by silent, visual, means such as gesture: 'In gesture, the body talks', as Cicero put it.[17]

At the same time, the use in paintings, buildings, or joyous entries of formal elements related to the theatre also suggests something further: that every space outside the theatre may be turned into a theatrical space. Already in ancient Greece, the architectural constructions on which the audience was seated were very similar to the scaffoldings for the participants in discussions concerning the *polis*. In late medieval and early modern Europe a parallel between the constructions of the theatre and public political discourse can be made too. No separate place was created as in ancient Greece, but during joyous entries where new political constellations were presented architectural constructions, such as triumphal arches, reshaped the city centre. This architectural framing of the city made clear that everyday reality was transcended and that a privileged locus of political negotiation had come into being. George Kernodle has suggested that the constructions for joyous entries heavily relied on architectural 'showpieces' such as funerary monuments. He puts the emphasis on a one-way communication from architecture to the theatre.[18] However, it is more appropriate to see these architectural constructions as part of a concerted, multi-media effort to achieve the most effective communication, which is discernibly at work in both funerary monuments and ephemeral constructions for joyous entries. To put it more generally, the question which medium has historical priority in the use of a certain element for the first time, is often hard to solve and just as often irrelevant.

Stijn Bussels' chapter on the communicative power of *tableaux vivants* in joyous entries from the southern Netherlands makes clear that it is hard to label the characteristics of these *tableaux* 'theatrical' or 'pictorial', since in the fifteenth and sixteenth centuries the theatre, painting and *tableaux vivants* used similar features and attempted in related ways to persuade their onlookers as effectively as possible. Laura Weigert's chapter raises a similar issue. She focuses on mystery plays and tapestries depicting the popular theme of the vengeance on Jerusalem for the crucifixion of Christ. Concentrating on both media, she does not identify influences and exchanges, but observes that they share a similar mode of representation. Weigert shows that the two media relied on a similar kind of participation by the beholder, and both called attention to their mimetic artifice.

Even when there is a received opinion about a theatrical element that painters took over, it is much more productive to trace the resulting transformations than to debate questions of priority. In Emmanuelle Hénin's chapter the pictorial use of the theatrical prop *par excellence*, the curtain, is reconstructed. She shows that the arts did not borrow the use of this prop from the theatre, but the other way around. From the 1550s, theatres took from painting the use of a painted curtain to unveil the space where the play was to be enacted. It served as a marker of fictional space. Sometimes, scenes within the play were unveiled to give particular emphasis to their fictional character, twice-removed from extratheatrical reality. Introducing painted curtains into a painting implies a certain auto-referentiality: the viewer is made doubly aware that what he or she is looking at is a representation re-represented. But also underlined is the spectacular nature shared by the theatre and the visual arts and their common task of presenting a scene to the viewer.

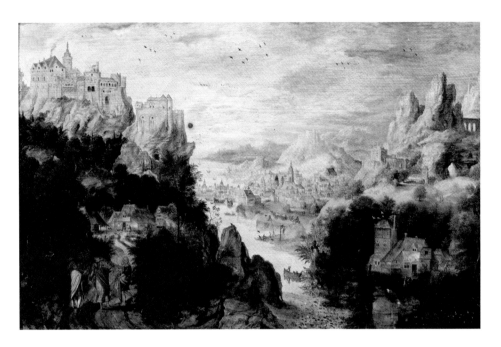

3 Herri met de Bles, *Landscape with the Journey to Emmaus*, c. 1550. Oil on wood, 34.1 × 50.5 cm. Antwerp: Museum Mayer van den Bergh. Photo: Beeldarchief Collectie Antwerpen.

The Scenario

If paintings can resemble the theatre in that they stage a play, or a scene from a *historia*, the similarity often goes much further than using the compositional device or *motif* of a stage curtain, or a stage on which actors enter, move, gesture and exit. Many early modern paintings also show clear similarities with theatrical scenarios in the way they build up a narrative. Traditionally, such pictorial use of narrative is discussed in terms of *ut pictura poesis* or the paragone, but the chapters by Kati Röttger and Bram Van Oostveldt addressing theatrical narrativity in the visual arts and gardening argue that this traditional contextualization should be reconsidered. In the 1750s and 1760s, the same period the term theatricality acquired a more or less stable ethical and moralistic meaning, the relation between painting and poetry was radically redefined. In his influential essay on the Laocoön of 1766, Lessing reacts against the doctrine of *ut pictura poesis* by focusing on the intrinsic differences between painting and poetry. He limits painting to spatial representations. Whereas poetry is an art unfolding in time – and as so often in comparisons of poetry and painting based on Horace, by poetry is meant above all dramatic poetry – a painting or sculpture can represent only one moment, and has to be comprehended in one glance. According to Lessing, choosing the 'most pregnant moment' is the only way to put a narrative before the viewer's eye. By depicting an event carefully, its past and future can be suggested. In her chapter in this book, Röttger goes deeper into the consequences of Lessing's thoughts. By focusing on his play *Emilia Galotti*, she shows how Lessing deals with the theatre and painting as rivals in performing and/or imagining Emilia.

However, before Lessing, many visual artists experimented with ways to overcome this opposition by attempting to convey the temporal aspects of the events or situations they represented. Sixteenth-century landscape painters from the Low Countries, for example, constructed their compositions in such a way that the beholder was obliged to build up his observations in a temporal sequence. In the generation of Pieter Brueghel the Elder (and also of Italian painters like Veronese and their experiments with interrupted perspectives), landscapes directed the beholder's gaze in time and led gradually to a final insight. Herri met de Bles' *Landscape with the Journey to Emmaus* (c. 1550), for instance, shows an impressive landscape in which the beholder gradually discerns the path to Emmaus. The biblical journey is depicted in such a way that it suggests spiritual enlightenment (*plate* 3).[19] In the same generation, graphic artists such as Maarten Van Heemskerck were inspired by the format of theatrical processions.[20] Just as on the floats, an allegorical Everyman was represented in successive prints

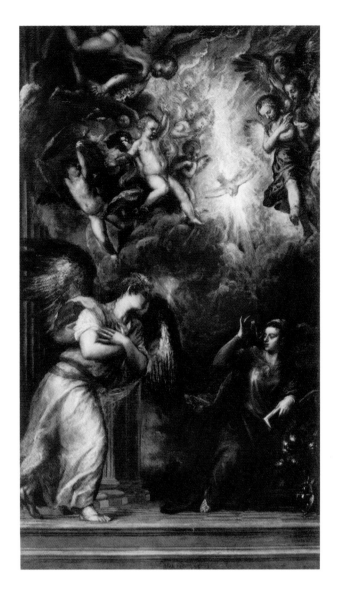

4 Titian, *Annunciation*, 1562–64.
Oil on canvas, 403 × 235 cm.
Venice: San Salvatore. Photo:
CKD Nijmegen.

showing the story's most decisive moments. In his series *The Miserable Fate of the Rich* (1563), for example, Heemskerck is inspired by the Antwerp procession, the *Ommegang*, and similarly shows by means of personifications the different ways a rich man can be tempted to abuse his richness.

Although Italian Renaissance painters rarely spoke of their work in theatrical or even poetical terms, the similarities between their work and the theatre were often noted. Titian's San Salvatore *Annunciation*, painted in 1562–64 (*plate 4*), for instance, breaks with the Renaissance tradition of representing this event as a private encounter between Mary and the Angel by giving it a dramatic staging that is very close to Aretino's description in his *Vita di Santa Maria*, a series of episodes from the life of Mary presented as *tableaux vivants*. There he wrote of the protagonists that they gesture as Titian would have painted them. In the *Humanità di Christo* (1539), a life of Christ in the form of a series of *tableaux vivants*, he even mentions a 'theatre of clouds'.[21] When discussing *ordine*, one of the main aspects of *disegno* or pictorial composition, the sixteenth-century Venetian art theorist Lodovico Dolce argued that painters should take care to observe chronological order in the *istoria* or narrative they depict. The classical authority quoted is Aristotle's *Poetics*.[22]

Such Aristotelian reactions were not exclusively Venetian. In *Il Figino* (1591), the art critic Gregorio Comanini argued, following Aristotle's *Poetics*, that both drama and painting should represent one single action or plot. The most highly regarded genres of painting (history and religious painting, not landscape, still-life or portraiture) resemble poetry because, like poetry, they represent plots or stories and offer visual narrative. As an example he took Raphaels fresco of the *Fire in the Borgo* in the Vatican (1514; *plate 5*), and argued that although Raphael included some details that recalled the fire of Troy, it did represent a unified narrative.[23]

In *The Death of Actaeon* (1562; *plate 6*), Titian did not depict separate scenes from the myth, but collapsed two successive moments into a single scene. On the left we see Diana shooting an arrow at Actaeon; her hand is still on the string of her bow but the arrow is already flying. In the centre, however, we see Actaeon already in the process of transformation: his head is changed into that of a stag, and Diana's hounds are tearing at his legs, which are turning into those of the animal he is becoming. This distillation of a well-known myth into the pivotal moment of its plot, or its most pregnant and meaningful point, engages the spectator's attention because it breaks with accustomed linear progress and thus becomes a rhetorically powerful means of visual persuasion. At the same time it helps the spectator to identify with what happens because Titian's conflation of Diana's shot and Actaeon's transformation force the viewer to re-enact in his or her mind the process which is so selectively represented. Thomas Puttfarken argued that Titian, in representing these *istorie*, selected precisely those moments from the story that are the crucial moments of the

plot, scenes of recognition and *periegesis*. Such selection of pivotal moments may be read as corresponding to Aristotle's analysis in the *Poetics* that Greek viewers of the tragedies were aware that they were looking at selected scenes from the myths on which they were based.[24]

Such use of narrative devices, combined with staging, was not limited to the visual arts. As Sigrid de Jong shows in her chapter, early visitors to the ancient Greek ruins in Paestum used theatrical techniques of representation to record the buildings. They were highly selective in what they depicted, suggested the passing of time and the unfolding of a narrative: that of initial expectations, deception and even terror when confronted with these uncouth heaps of stone, followed by attempts to assimilate Paestum into the canon of classical architecture, or acceptance that the ruins were simply remains from a past that was now lost. Here as well, the way the representation is staged directs the way the viewer should look at the records made of the temples, just as there was a conventional sequence of observation and affect that visitors to the site itself were obliged to feel they had undergone.

Sometimes, a painting could become part of an elaborate scenario that regulated the way it should be viewed. This scenario could become so detailed and rule-bound that it almost became a ritual, and the work of art could draw on already existing religious and political ritual practices. In the case of the portrait of the Venetian patrician Bianca Capello, which Elsje van Kessel discusses in her chapter, the owner of the painting Francesco Bembo developed an elaborate viewing scenario. It began with him gazing at the painting at set times; next he allowed his wife and relatives to view, touch, and kiss it; then it made an entry at his dinner table; finally, tours through the city were staged, ending with an official visit of the portrait to the Doge.

5 Raphael, *The Fire in the Borgo*, 1514. Fresco, width at base 670 cm. Rome: Vatican, Stanza dell'Incendio di Borgo. Photo: CKD Nijmegen.

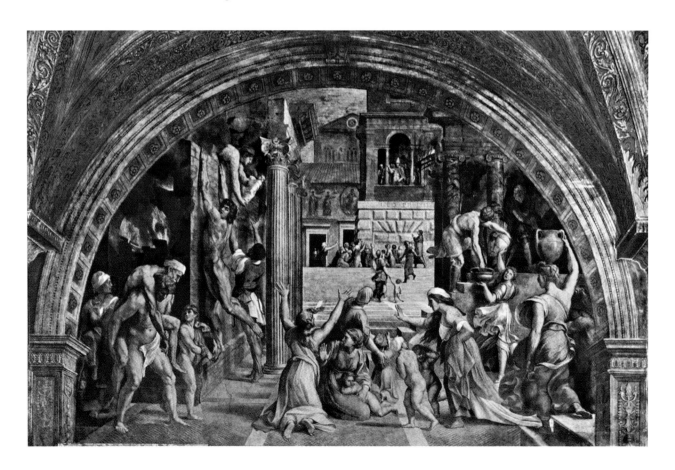

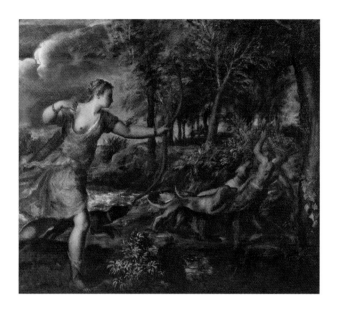

6 Titian, *Death of Actaeon*,
1562. Oil on canvas, 179 × 189
cm. London: National Gallery.
Photo: National Gallery.

The Actor

Staging the viewing of this painting, and creating
a scenario for the behaviour of the public, clearly
directed the way the viewers should behave in this
case. But it also points to another implication of
the use of theatrical elements in a painting, since in
painting, as in the theatre, the boundaries between
representation and presence are less clear-cut than
in ordinary life. Such ambiguity could be the result
of the use of theatrical gestures like the lifting of a
curtain to signal a new series within the action. This
action paradoxically suggests that the play in the play
thus indicated is somehow less real than the primary
theatrical performance of which it is part. But more
often the locus of this oscillation between presence
and representation is the body of the actor. Actors both
act their roles and in that sense offer a representation,
but at the same time are present on the stage in their own bodies. In many respects
Aby Warburg was the first art historian to consider interactions between the theatre
and the visual arts from an ontological perspective, but he did not follow up the
tantalizing remarks he made in his published works.[25]

The chapter by Lex Hermans reconstructs various degrees of ambiguity between
bodily presence and theatrical representation. In the courtly theatres built in Florence,
Parma and Vicenza in the sixteenth century, statues of rulers were placed in the
theatrical space to observe both the play and the audience. In the Farnese theatre in
Parma an equestrian statue of the prince was located in the theatre. In Sabbioneta a
statue of the emperor Vespasian was positioned directly behind the seat of the Gonzaga
ruler who shared his name with the emperor, as a visual reminder of the model the
prince claimed – or was expected – to follow. But sometimes, as we have seen, the
prince himself became a theatre, a place to view the enactment of princely virtue.

Wendy Heller, too, discusses the use of statues in the theatre. She concentrates on
performances with scenes, popular in seventeenth-century Venetian opera, in which
statues dance, and argues that these statues were put on stage in order to present a
repertory of mythological and historical personages, as well as to give the opera an
aura of antiquity. But these scenes featuring actors performing the role of inanimate
sculptures which come alive also inserted sculpture within discourses on the living
presence of art. So once again, a theatrical ambiguity of the bodily presence of actors
and the personages they perform was at stake.

Maarten Delbeke also deals with statues, although in urban space. He shows that
for Pope Alexander VII deciding whether to have a statue erected in his honour on the
Campidoglio, or deciding whether to live not only in the Vatican but also in a town
palace on the Quirinal, became primarily a matter of being seen to act in a certain
way. Ultimately the question of both the Pope's images and their physical presence
in Rome was judged in terms of the way he played his papal role. Whereas the
theatricality of Baroque Rome is usually conceived rather literally as a series of spaces
presented as stage sets, of which Giambattista Falda's *Il nuovo teatro delle fabriche, et edificii, in
prospettiva di Roma moderna* (1665–69) is a prime example, Delbeke shows in a more fine-
grained analysis how Rome, and in particular the Campidoglio and Quirinal, became
a silent actor in the performance of the Papal presence.

When public life is considered as acting and being seen to act, the role proper to one's station in life, having a portrait painted also becomes an intensely theatrical act. Like the urban spaces in which the pope performed his public roles, a portrait – as Hanneke Grootenboer puts it in her chapter – provides a space in which the sitter, placed in a *mise-en-scène* and surrounded by meaningful props, presents him or herself to the public as a subject, and a self that can be read. Hermans and Delbeke discuss cases of public role acting in the sixteenth and seventeenth centuries, where the focus is on the public persona, and a person's function or position – as prince, pope or condottiere – takes precedence over the individual, let alone the private, self. But in Grootenboer's analysis of seventeenth-century Dutch portraits the ultimate question is in what manner theatricality may help us to understand such presentation of the self as subject. Theatricality in her case refers to the performative character of self-presentation. Sitting for a portrait is a theatrical act in the original sense of the word *thea*, because one offers oneself to the gaze first of the painter and next of the viewer, but also in the sense that such sitting, like any act of theatrical representation, can be structured, ritualized and staged with varying degrees of consciousness and elaboration. The oscillation between presence and representation provides the conceptual space in which to elucidate how the self as the subject of a portrait is staged and understood.

The Audience

Performing one's social or political role and sitting for a portrait can be related to playing a role in drama, since they share its quality of unfolding over time and its fictional aspects. In all these cases the role-player takes on, selects, or constructs a role or public aspect that does not coincide entirely with what one might consider the core of one's being. Acting on stage, playing a role, character or public function in public or private life, all share a certain degree of fictionality, in the sense that something is shaped, presented or made that is not real. The Latin root of fiction, *fingere*, means to shape, form or fashion, but also, in its extended sense, to contrive, devise or invent. The fictional character of performances on the stage, in public and private life, or in the arts, is often signalled by the use of framing devices. De Jong's chapter on visual representations of Paestum using the conventions of theatre sets or landscape paintings documents a straightforward use of framing devices in the literal sense of selecting and fixating a viewpoint. Put in slightly different terms, if fiction is a way of organizing experience, theatricality may be said to be a way of organizing visual representation in relation to a viewer.[26]

But as the chapters by Röttger and Van Oostveldt show, from the 1760s onwards the fictional nature of theatrical performance became increasingly rejected as unnatural and therefore immoral. Another meaning of *fingere* can be invoked here: to pretend, to pose and to act insincerely. The overt organization of experience is evaluated as being 'pure fiction', too far removed from reality. Whereas for the Italian rulers and popes, or even the Dutch burghers of the sixteenth and seventeenth centuries, playing a role was part of being a public being, eighteenth-century German and French audiences began to see such contrivance or artificiality as immoral because flouting a stable self, and as the symptom of the ultimate modern sickness: alienation from oneself.

With regard to this issue, Denis Diderot strikes a completely different tone. By putting the emphasis on the active role of the audience, he moves the discussion from an ethical to an aesthetic context, most tellingly in the famous passage on Joseph Vernet's landscape paintings shown in the Salon of 1767 (*plate 7*).[27] Visitors to the popular biannual exhibition had to become absorbed in the works. They had to

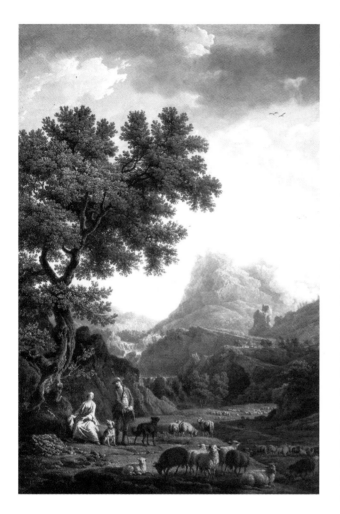

7 Joseph Vernet, *Shepherd in the Alps*, c. 1760. Oil on canvas, 78 × 112 cm. Tours: Musée des Beaux-Arts. Photo: Musée des Beaux-Arts, Tours.

abstract themselves from the overpopulated exhibition room, ignore the other paintings on the overloaded walls, and concentrate on a single one of the paintings by imagining that they were actually part of that painting. At that moment fictionalization comes in, for Diderot's readers are urged to follow the example of the author who imagines himself walking in the depicted landscapes with a local *abbé* and his pupils (figures not represented in Vernet's paintings). They might even try to enter into a fictive conversation with this interlocutor, which they often interrupt to admire the beautiful vistas. Diderot does not restrict himself to the two dimensions and the timelessness of painting. Instead, he becomes an actor who is looking and being looked at while walking in a natural setting. The fact that the philosopher chose landscape painting to explain this imaginary entrance into a landscape makes it part of the discussion, at the time, of landscapes and gardens in theatrical terms. Moreover, as Van Oostveldt makes clear, in real landscapes the onlookers are both actor and beholder, since they are both admiring their surroundings and at the same time aware of the gaze of others. This is also the case for the walkers in Diderot's fiction, since in the Vernet passage the *abbé* says he is not only an onlooker, but exclaims he is Adrienne Le Couvreur, one of the most famous actresses of that time.[28]

Conclusion

Understanding the theatricality of the arts in early modern Europe, we argue in this collection, is therefore not simply a matter of documenting exchanges between artistic and theatrical media and genres. In the preceding section we have traced some of the implications use of theatrical elements had for paintings, statues, buildings, gardens, and urban ensembles. When we try to summarize these implications, a few points stand out that may also serve to indicate new avenues of research. The concept of theatricality is fundamentally unstable, but in the definitions specifically addressing relations between the theatre and the arts developed from the early decades of the eighteenth century, one element remains constant: that of duplication and self-referentality, self-consciousness or even an infinite regress. Duplication occurs because works of art use elements from the theatre that are in themselves visual, such as stage sets, gestures, or framing devices. But the implication of the use of such elements is another, more abstract duplication: representational elements from the theatre are represented in works of art. The chapters by Hénin, Heller and Bayard illustrate the meta-representational implications, *mise-en-abyme* or infinite regress to which such use can lead. Ultimately, this can lead to the same kind of reflexivity the term theatricality itself has when used to define the theatre. But one of the major implications of the use of theatrical elements in the arts and the duplication or reflexivity it brings with it, is that several boundaries and distinctions that we tend to consider as essential to the arts are undermined: that between the genres to begin with, but also that between the work

of art and the public, between representation and presence, and between fiction and reality.

Looking more closely at the use of theatrical elements in the visual arts of early modern Europe therefore also leads to a revision of the significance of two concepts that have guided much research on early modern exchanges: *the paragone* and the *theatrum mundi* topos. Instead of reinforcing the similarity, or fundamental equivalence they both suggest between the theatre and the world outside it, the various contributions to this book point in another direction. They indicate that there is no equality or equal exchange between the two; rather the implication of the arguments offered here is that, at the moment theatrical elements are introduced into the arts, the ontological and generic status of the arts begins to slip. *Theatrum mundi* and the model of equal exchange associated with it therefore does not offer a sufficient guide for historical research into the use of theatrical elements in the arts and architecture. In a similar way, tracing the use of theatrical elements in the arts throws new light on the tradition of the *paragone*. Like the *theatrum mundi* topos, this presupposed a fundamental equivalence or similarity between the arts. In its formulations by Horace, and even more by Plutarch, the equation of poetry and painting rested on their equal power to achieve *enargeia*, lifelike, vivid representation. According to classical rhetoric this was one of the main instruments of persuasion.[29] This equivalence was challenged by Lessing who argued in the *Laocoön* that the pictorial and text-based arts differ fundamentally. But at the same time, he returned in his plays to the issue of the fraught relation between representation and presence, not to revive the rhetorical view that the dissolution of representation into what it represents is the supreme means of persuasion, but to redefine such vividness and its effect on the public as an epistemological and moral problem. The issues that arise when theatrical elements are used in the visual arts and architecture force us to rethink the relations between the theatre, the visual arts, and the ways in which they represent the worlds outside their artistic domains.

Notes

We are very grateful to David Peters Corbett for inviting us to edit a special issue of *Art History*, and to Sam Bibby for all his practical assistance and guidance. The Dutch Foundation for Scientific Research very generously funded the research on which the Introduction, and the chapters by Bussels, Hermans and Van Kessel are based. We are also much indebted to the translators of the chapters by Bayard, Hénin and Röttger.

1 Carlo Ridolfi, *Le Maraviglie dell'Arte* [1648], ed. Detlev von Hagen, Berlin, 1919–24, vol. 1, 315: 'Pregiatissimi pianti, pretiose perle, che liquefatte nel lambico del cuore al fuoco d'un ardente affetto haveste, virtù di lavar le macchie d'un inveterato errore. La mensa è situato nel seno di maestoso Teatro, nel cui circuito girano molte colonne ...'. Cf. Carlo Ridolfi, *The Life of Titian*, ed. Julia and Peter Bondanella, Peter Cole, and John. Shiffman, trans. Julia and Peter Bondanella, University Park, PA, 1996, 91.

2 David Rosand, *Painting in Cinquecento Venice: Titian, Veronese, Tintoretto*, New Haven and London, 1982, 150–82.

3 Rosand, *Painting in Cinquecento Venice*, 160.

4 Aleotti in the dedication of his design for the tragic scene in the Farnese theatre: 'ben si sà, ch'Ella è teatro vivo, in cui tutte le eroiche virtù rappresentano magnanime e generose azzioni' (quoted after Bruno Adorni, *L'architettura farnesiana a Parma, 1545–1630*, Parma, 1974, 73).

5 See David Rosand, *Painting in Cinquecento Venice*, 1982, 150–82; on Piranesi and the *Bibbiena* see A. Jarrard, 'Perspectives on Piranesi and theater', in Sarah Lawrence, ed., *Piranesi as Designer*, New York, 2007, 203–21; on

French eighteenth century and the theatre Germain Boffrand, *Book of Architecture*, ed. and introduced by Caroline van Eck, trans. David Britt, Aldershot, 2002, xviii–xix.

6 On the origins of *thea* and *theoria* see H. Rausch, *Theoria: Von ihrer sakralen zur philosophischen Bedeutung*, Munich, 1982, and D. Wachsmuth, chapter on *theoria* in A. F. von Pauly, K. Ziegler and W. Sontheimer, eds, *Der kleine Pauly: Lexikon der Antike*, Munich, 1975, vol. 5, 730–1.

7 Entry 'theatrodes' in Henry George Liddell and Robert Scott, eds, *A Greek-English Lexicon*, Oxford, 1968, 787.

8 Plato, *The Republic*, trans. Paul Shorey, Cambridge, MA, 1963. On the history of anti-theatrical attitudes see Jonas Barish, *The Anti-Theatrical Prejudice*, Berkeley, CA, 1981.

9 Lord Shaftesbury, *Characteristicks of Men, Manners, Opinions, Times*, ed. Douglas den Uyl, Indianapolis, IN, 2001, vol. 3, 7.

10 Entry 'theatrum' (II.1 and 2) in Walther von Wartburg, *Französisches Etymologisches Wörterbuch*, Basel, 1966, vol. 13, 300.

11 Günther Heeg, *Das Phantasma der natürlichen Gestalt. Körper, Sprache und Bild im Theater des 18. Jahrhnderts*, Frankfurt am Main and Basel, 2000, 13–22.

12 For an overview of definitions of theatricality within theatre studies see the special issue on theatricality of *Theatre Research International*, 20, 2, 1995, in particular Erika Fischer-Lichte, 'Introduction: Theatricality: a key concept in theatre and cultural studies', 85–9.

13 For a general and recent overview, see Thomas Postlewait and Tracy C. Davis, 'Theatricality: an introduction', in Thomas Postlewait and Tracy C. Davis, eds, *Theatricality*, Cambridge, 2003, 1–39.

14 For a recent survey of twentieth-century interactions between theatre and the arts and theatricality see Manuel Borja-Villel, ed., *A Theater without Theater*, exh. cat., Barcelona, 2007.

15 Josette Feral, 'Theatricality: the specificity of theatrical language', *SubStance*, 31: 2–3, 2002, 97.

16 On the origins of Greek theatre see most recently Eric Csapo and Margaret Miller, eds, *The Origins of Theater in Ancient Greece and Beyond*, Cambridge and New York, 2008. In his biography of Gottfried Semper, Harry Malgrave has argued that many of Nietzsche's ideas about the origins of Greek theatre were inspired by conversations with Semper, or by ideas first published Semper's *Der Stil* of 1863: the roots of architecture and theatre in ephemeral festivals in the sixth and fifth centuries BCE for instance, and the importance of Dionysian frenzy as the origin of new art forms. See Harry F. Mallgrave, *Gottfried Semper. Architect of the Nineteenth Century*, New Haven and London, 1996, 339-55. For the unique case of a playwright turned architect see Frank McCormick, *Sir John Vanbrugh: The Playwright as Architect*, University Park, PA, 1991; Timothy Mowl, 'Antiquaries, theatre and early medievalism', in Christopher Ridgway and Robert Williams, eds, *Sir John Vanbrugh and Landscape Architecture in Baroque England 1690–1740*, Thrupp, 2000, 71–93; and Vaughan Hart, *Sir John Vanbrugh. Storyteller in Stone*, New Haven and London, 2008, 27–45.

17 Alberti, *De Pictura* § 42; Cicero, *De Oratore* III.lvi.23.

18 George Kernodle, *From Art to Theatre: Form and Convention in the Renaissance*, Chicago, IL, 1943, 52–108.

19 Reindert Falkenburg, 'The Devil is in the detail: Ways of Seeing Joachim Patinir's "World Landscapes"', in A. Vergara, ed., *Patinir. Essays and Critical Catalogue*, exh. cat., Madrid, 2007, 61–81; 'Doorzien als esthetische ervaring bij Pieter Brueghel I en het vroeg-zestiende-eeuwse landschap', in Natasha Peters, ed., *De uitvinding van het landschap: Van Patinir tot Rubens 1520–1650*, Antwerpen, 2004, 53–65.

20 Ilja M. Veldman, 'Coornhert en de prentkunst', in H. Bonger, ed., *Dirck Volckertszoon Coornhert. Dwars maar recht*, Zutphen, 1989, 115–43 and Sheila Williams and Jean Jacquot, 'Ommegangs Anversois du temps de Bruegel et de Van Heemskerck', in Jean Jacquot, ed., *Les fêtes de la Renaissance: Fêtes et cérémonies au temps de Charles Quint*, Paris, 1960, vol. 2, 359–88.

21 Pietro Aretino, *La Vita di S. Maria Vergine, di Catarina Santa, & di Tomaso Aquinato Beato Venice*, 1539, 152 ff., and *I Quattro Libri de la Humanità di Christo*, Venice, 1539, 63–75; cf. Una Roman d'Elia, *The Poetics of Titian's Religious Paintings*, Cambridge and New York, 2005, 107.

22 Lodovico Dolce, *Dialogo della pittura di M. Lodovico Dolce, intitolato L'Aretino*, Venice, 1557, modern reprint in M.W. Roskill, *Dolce's 'Aretino' and Venetian Art Theory of the Cinquecento*, Toronto, 2000 [1968], 120–1.

23 G. Comanini, *Il Figino, ovvero del Fine della Pittura*, in Paola Barocchi, ed., *Trattati d'Arte del Cinquecento*, Bari, 1962, vol. 3, 345 and 347: 'Della favola, dice il vostro Aristotele che ella dee essere una e rappresentare una sola azzione d'un solo … . Corrisponde a questa unità di favola poetica l'unità dell'invenzione del buon pittore, il quale non dipinge dentro una tavola diversi azzioni, ma una sola. … E quantunque l'Incendio di Borgo, … abbia alcuni accidenti da me accennativi, co'quali par quasi che risomigli quello di Troia, … Quale adunque sia l'unità dell'invenzion del pittore, corrispondente a l'unità della favola del poeta.' Cf. Valeska von Rosen, 'Die Enargeia des Gemäldes: Zu einem vergessenen Inhalt des Ut-pictura-poesis und seiner Relevanz für das cinquecenteske Bildkonzept', *Marburger Jahrbuch für Kunstwissenschaft*, 27, 2000, 171–208. In 'Raphael's Incendio del Borgo', *Journal of the Warburg and Courtauld Institutes*, 22, 1959, 41–51. Kurt Badt has argued that Raphael was doubly dependent on classical sources: on Vitruvius and Aristotle's *Poetics*, and that the composition of the fresco closely follows Aristotle's precepts for successful dramatic plotting. See also *Il Figino*, 345 for a comparison between painting and dramatic poetry: '… il pittore non cede punto al poeta nell'arte dell'imitare, anzi, che col medesimo artificio, col quale il poeta imita, imita anch'egli e finge le cose. E perchè io non vi sembri parlare a caso, poichè la pittura più rassomiglia la poesia rappresentativa che la narrativa, e tra le poesie rappresentative principale sappiamo essere la tragedia; io voglio che consederiamo tutte le parti di questo poema, non le quanto, che sono il prologo, l'episodio, l'essodo e'l coro, ma le quali, che sono la favola, i costumi, il verso, la sentenza, l'apparato e la melodia …'

24 Cf. Thomas Puttfarken, *The Discovery of Pictorial Composition: Theories of Visual Order in Painting 1400–1800*, New Haven and London, 2000, in particular 94ff.; Puttfarken, 'Aristotle, Titian, and Tragic Painting', in Dana Arnold and Margaret Iversen, eds, *Art and Thought*, Oxford, 2003, 9–27; and *Titian & Tragic Painting. Aristotle's Poetics and the Rise of the Modern Artist*, New Haven and London, 2005, where he argues for a reading of Titian's late *poesie* in terms of Aristotle's *Poetics*.

25 In his doctoral thesis on Botticelli he quoted Burckhardt's remark that Italian festival art is the true transition from life into art: 'das Festwesen als wahren Übergang aus dem Leben in die Kunst' ('Sandro Botticellis "Geburt der Venus" und "Frühling"' [1893], in Horst Bredekamp and Michael Diers, eds, *Aby Warburg. Die Erneuerung der heidnischen Antike. Kulturwissenschaftliche Beiträge zur Geschichte der europäischen Renaissance*, Berlin, 1998, 37; cf. 'Sandro Botticelli', in Bredekamp and Michael Diers, *Aby Warburg*, 66: 'Nicht der Gipsabguß, wohl aber der festliche Aufzug, indem heidnische Lebensformen eine Freistätte volkstümlichen Fortlebens sich bewahrt hatte, war der Form, in der die Gestalten des Altertums in den bunten Pracht bewußten Lebens vor dem Augen der Italienischen Gesellschaft leibhaftig wiedererstanden'.

26 On fiction, but unfortunately with little attention to fictionality in the visual arts see David Davies, 'Fiction', in Berys Gaut and Dominic McIver Lopes, eds, *The Routledge Companion to Aesthetics*, London and New York, 2001, 263–75; and Peter Lamarque, *Truth, Fiction, and Literature*, Oxford, 1994.

27 Denis Diderot, 'Salon de 1767', in Diderot, *Œuvres Complètes*, ed. Laurent Versini, Paris, 1996, vol. 4, 595–635.

28 Diderot, 'Salon de 1767', 610.

29 On this issue in classical rhetoric see Caroline van Eck, *Classical Rhetoric and the Arts in Early Modern Europe*, Cambridge and New York, 2007, Introduction and Chapter III.

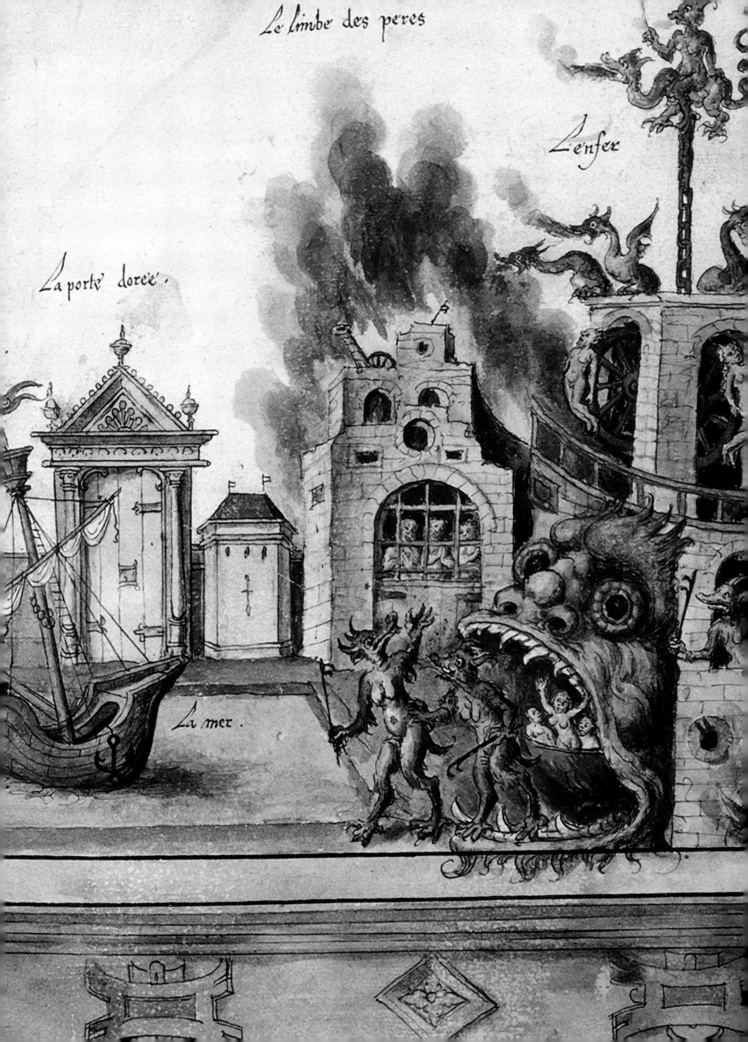

Chapter 2
'Theatricality' in Tapestries and Mystery Plays and its Afterlife in Painting
Laura Weigert

**Detail from Hubert Cailleau,
'Stage' for the 1547 Passion
play in Valencienne (*plate 1*).**

Theatricality in Early Modern Art
and Architecture *Edited by Caroline
van Eck and Stijn Bussels* © 2011
Association of Art Historians.

Here we see, according to the inscription, 'the theatre or stage as it was when the
Passion of our Lord was performed in 1547' (*plate 1*).[1] Indeed, Hubert Cailleau's
drawing offers a picture of the key sites included in contemporary Passion plays: God's
domain in heaven vies with limbo and an enormous hell mouth; the gates of Nazareth
and Jerusalem identify the major cities; structures designated as the Temple, Herod's
palace, and the Golden Gate further localize the setting. The drawing also shows how
geographically distant places appeared side-by-side and remained concurrently within
the spectators' visual field as the action moved from one location to the next. In these
respects it visualizes important components of mystery play performance in the
fifteenth and sixteenth centuries. As evidence for this distinct play-going experience,
however, the drawing is both misleading and incomplete. Its inscription evokes for
a modern reader an enclosed structure made to house plays and a performance area
elevated and separated from the one reserved for the audience. The image corroborates
these assumptions: the panorama of clearly identifiable buildings limits and
demarcates the field of action; the ornamented frieze creates a barrier between this
space and that of the audience. It was precisely the absence of such boundaries that
defined the performance of large-scale urban religious drama.

What type of image might actually provide evidence for the viewing experience
of a mystery play has not been the preoccupation of scholars concerned with
the relationship between the two forms of visual representation.[2] Reception has
been the focus of Pamela Sheingorn and Robert Clark's recent work in which they
characterize the reading experience of late medieval illuminated mystery play scripts
as 'performative'.[3] However, the majority of the scholarship on mystery plays and
visual representation has been interested primarily in their subject matter and
remains beholden to the methodological assumption of a causal connection between
the two media, even when this relationship is formulated as one of reciprocity.[4]
My goal here is to bring into focus a historical moment in which pictures and plays
shared a representational mode and engaged their audiences in a similar way.[5]
I suggest that the viewing experience of mystery plays was in many ways
homologous to that of contemporary tapestries and that isolating this similarity
allows us to establish and appreciate the specificity of both media and the theatrical
culture in which they participated.

Historians of medieval drama have recovered the term 'theatricality' to move
away from text-based analyses of plays to investigations of their performance and as a
means to describe the distinct characteristics of a variety of dramatic events.[6]

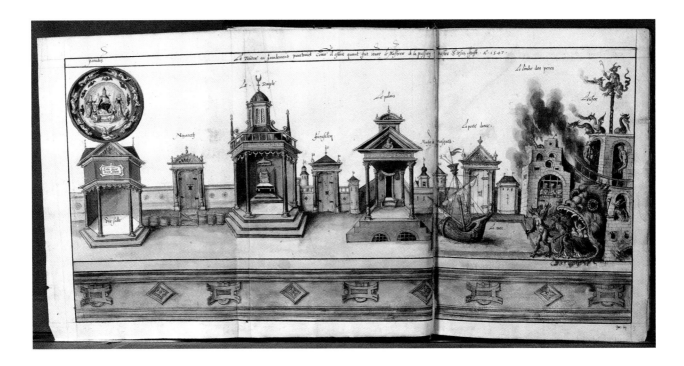

1 Hubert Cailleau, 'Stage' for the 1547 Passion play in Valencienne ('Le Mystère par personages de la vie, passion, mort, resurrection et ascension de Notre Seigneur Jésus-Christ en 25 journées'), 1577. Paris, Bibliothèque Nationale de France, MS Fr. Rothschild 3010 (I.7.3), frontispiece. Photo: BnF.

In so doing, they have embraced those features of the term that have been traditionally denigrated: namely, a reliance on spectatorial participation and a recognition and exaggeration of artifice.[7] Yet in most cases they have overlooked the evidence images provide for the nature of this form of dramatic artifice because they commonly attribute a documentary status to pictures.[8] Art historians, on the other hand, have been more interested in the transmission of a tradition of classical illusionism that links art and theatre in the early modern period. This is due, in part, to the continued emphasis in the discipline on painting, sculpture, and architecture. Tapestries present an alternative to the classical mimetic model. For historians of medieval theatre, they offer clues as to how plays might have been experienced; for art historians, they broaden the criteria with which images can be compared to drama beyond their purported 'lifelikeness'.

Of all the forms of visual representation, surviving or documented from the late medieval and early modern periods, tapestry exhibits the most numerous and striking similarities with mystery plays. Indeed, the two media were mutually dependent. For instance, the municipal authorities of the Burgundian city of Nevers paid two of its members to travel to nearby Moulins to study the tapestry of the Nine Worthies in the collection of the count of Bourbon. Upon their return, they organized a performance on the same theme.[9] Beyond instances of their direct exchange, the parallels between the two media can be seen more generally in the circumstances of their production and reception. The increase in quantity and scale of mystery plays within the realms of the French kings and Burgundian dukes from the fourteenth to the sixteenth century corresponded with the expansion of the tapestry industry.[10] The same noble patrons commissioned tapestries and subsidized plays.[11] Both media drew quite commonly on the same themes. Like a temporally defined performance, the display of a tapestry took place within, and was limited to, a particular ceremonial occasion, and the scale of its almost life-size figures resembled that of live actors. References to tapestries in inventory accounts can even be confused with documentation on the performance of a play or a script, since the language used for each is the same.[12]

My focus in this chapter is on the visual and affective resemblance between the two media, using as an example the French plays referred to in textual scripts and documents as the 'Vengeance of our Lord', the 'Vengeance of Jesus Christ', or simply the 'Vengeance', and tapestries depicting the same theme. The play was popular in France and the Burgundian Netherlands, with over fourteen recorded performances between the end of the fourteenth and the mid-sixteenth centuries.[13] At least six tapestry sets were produced at the height of the play's popularity in the fifteenth century.[14] A later set of paintings also survives, dating from the mid-sixteenth century, when royal and parliamentary legislation increasingly regulated the performance of mystery plays in Paris.[15] I will describe the structural, affective, and aesthetic characteristics one of the surviving tapestry sets shares with the 'Vengeance' play. I will then demonstrate that the paintings of the same theme depart significantly from the tapestries and plays and reevaluate their status as visual evidence for contemporary performance practices.

The earliest preserved French script of the 'Vengeance' play was composed before 1430 by Eustache Mercadé.[16] Loosely based on Flavius Josephus's version of events, it charts the episodes leading up to and surrounding the destruction of Jerusalem.[17] The play is distinguished from the more general narrative of the destruction of Jerusalem by its incorporation of three series of events: the destruction of Jerusalem by Titus and Vespasian, the arrest and death of Pontius Pilate, and the conversion of Vespasian upon perceiving Christ's face on Veronica's veil. A contemporary prose 'Vengeance' also includes this series of events.[18] However, the play differs from this version in terms of its sheer scale, number of characters, and its increased emphasis on Jewish depravity and guilt. The dominant theme of the play is the divine retribution for the death of Jesus, the responsibility for which, although Pilate's fate is described in detail, is placed squarely on the Jews. As the character of the preacher, who signals the start of the play puts it: 'We would like to play for you the vengeance of God to make known how the Jews were punished.'[19]

The episodes incorporated into the surviving tapestries of a set, currently distributed between New York and Tournai, parallel those in the French play and depart in the same ways from both Flavius Josephus's account and the prose version of the 'Vengeance'. In the left-hand section of one of the tapestries, now in New York, we witness Vespasian's cure and conversion.[20] The remaining tapestries of this set focus on events leading up to and including the siege and destruction of Jerusalem. Nero sends Vespasian and Titus to Judea in a fragment now in Tournai. Another fragment in the same museum depicts the assault on the city and the devastating impact of the siege on its citizens (*plate* 3). The New York tapestry incorporates the capture of the spoils and the murder and sale of the citizens of Jerusalem (*plate* 2). Stylistic criteria suggest that the set was produced in the Southern Netherlands in the 1460s.[21] References to 'Vengeance' tapestries appear in numerous royal and princely inventories, including those listing the possessions of Philip the Good (1420) and Charles VIII, king of France (1494).[22] Although any specific claims as to ownership and to the circumstances under which this particular set was displayed must remain hypothetical, it is clear that it was a product of the Franco-Flemish environment in which the urban performance of mystery plays flourished.

The distinctive feature of the 'alterity of medieval religious drama', to use Rainer Warning's term, is the lack of designated and fixed boundaries that have come to circumscribe the traditional modern theatre and the play-going experience it frames.[23] Taking place outside, in a central marketplace and in the streets, the performance space merged with the space of the city. The period of time in which the play took place,

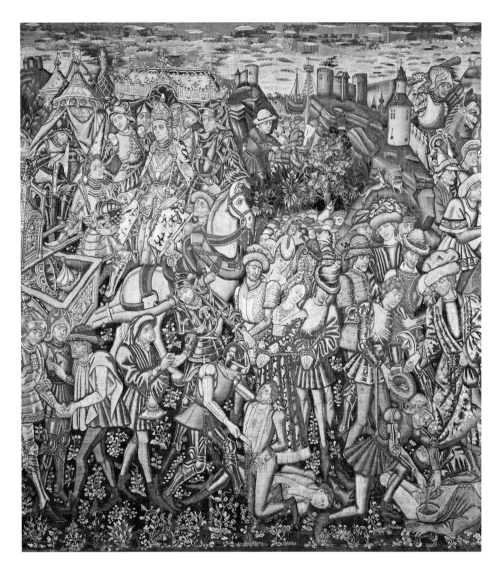

2 Detail showing episodes from *The Vengeance of Our Lord*, Southern Netherlands, 1460–70. Tapestry, 4.19 × 8.54 m. New York: Metropolitan Museum of Art. Photo: Metropolitan Museum of Art.

in its turn, overlapped with festive celebrations that accompanied the daily performances. Finally, the division between audience and actor often dissolved as actors moved into the locations occupied by spectators, who subsequently adopted roles as bystanders or as participants in the action of the play. Characteristics of these late medieval plays and how they were performed include excessive display, exaggeration, and the accumulation of a seemingly limitless quantity of disparate events, places, and characters.[24]

If the productions of the 'Vengeance' play exhibit anything, it is excessive display and exaggeration. A production was no small undertaking: it required a substantial investment of resources by an individual city and at least a year of planning. Documented performances lasted between two and four full days, involved over 100 speaking parts, costumes, and elaborate stage design.[25] The assault and conquest of Jerusalem in particular, to which at least a full day was often devoted, expanded the number of participants, incorporating horses and additional costumes.[26]

The 'Vengeance' play also demonstrates the principle of accumulation that structured the production of mystery plays, in which markers of location were added as needed over the course of an individual performance. The second day of the play, for instance, took place in Rome, Jerusalem, Heaven, Hell, Spain, Lyons, Hell, Armenia, and Jotapata, moving repeatedly back and forth between Jerusalem, Rome and Spain and then between Lyons and Rome.[27] As in other mystery plays, the locations were probably designated by wooden constructions or sets placed next to or across from each other.[28] Following such a 'Vengeance' performance required establishing the connection between events in different places as the action moved quickly from location to location, or transpired simultaneously. Stephen Wright uses the apt analogy of a three-ring circus to describe the highlighting of one location, while the place marks and actors remained in other locations elsewhere within the viewers' visual fields.[29] In turn, the audience had to gauge

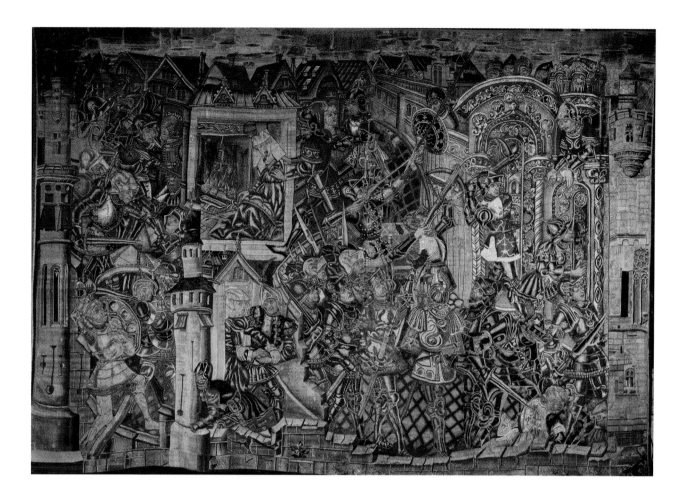

3 *The Siege of Jerusalem*,
Southern Netherlands,
1460–70. Tapestry, 3.70 × 5.40
m. Tournai: Musée d'Histoire et
d'Archéologie. Photo: IRPA.

the relationship between places, whose distance was conflated by the proximity of individual sets.

The multiplicity of events and the number and intertwining of figures in the 'Vengeance' tapestry create a similar sense of highly structured excess. Each panel provides visual cues that both differentiate and link episodes within the densely packed compositions. The assault on Jerusalem depicted in one of the Tournai fragments captures the movement and confusion of a battle through the profusion of overlapping figures and their exaggerated gestures (*plate* 3). At the same time, the city walls and streets serve to organize these figures into discrete, although related, groups. Particularly effective is the curve of the wall that encircles the group of archers directing their arrows at the Temple. A serpentine street of dark grey stones parallels the wall and winds from the top to the bottom of the composition beneath the Roman soldiers, unifying them as a group and defining their actions as one distinct event within the broader assault on the city.

The tapestry set as a whole would have presented viewers with an accumulation of episodes, rather than with a composition or series of compositions organized around a central event and characterized by structural balance or organic unity. Architectural structures or elements, like city walls, locate the events in specific places: they act as backdrops against which the figures are placed but which they do not inhabit. In turn, the placing of events along both vertical and horizontal axes denies the visual cues that might signal the temporal or geographic distance between events. We are often provided with multiple viewpoints onto a single place, as in the discrete events occurring simultaneously within the walls of Jerusalem (*plate* 3).

A 'Vengeance' performance in Mons, roughly contemporary to the tapestries in Tournai and New York, provides an example of the fluidity between the spaces of the actors and the spectators of the play.[30] Spectators gathered either on the ground, on raised scaffolds, or in the rooms of the houses with windows looking out onto the square, according to the entrance fee they had paid. The diversity of these viewing sites makes it difficult to designate a single space associated with the audience. Moreover, scenes like the battles that required more space and a greater number of actors, moved the action onto the square itself, effacing any clear distinction between individuals watching the play and those assuming the role of characters within it. In turn, the temporal limits of the performance were not strictly defined. Snacks and meals are included in the city's accounts of expenses; they were distributed to the intermingled actors and audience.

As in the plays, the boundaries between the space in which the woven action takes place and the one occupied by the viewer are permeable. The life-size figures often seem to spill over the edge of the fabric, unbounded by the barrier a border or frame would impose. Viewers of these pictures and plays were required to engage in interpretive work to situate events both temporally and spatially and to identify the relationships between what might appear initially to be a confusion of bodies. The scale of the tapestries and the urban performances, however, prevented the viewers from attaining a sufficient distance to allow them to obtain an overview of events or to perceive the story in its entirety.

This engagement in both the tapestries and the plays of spectators, as potential participants in the action and producers of narrative coherence, implicated them in the violence depicted. Indeed, the 'Vengeance' is considered the most violent of the late medieval mystery plays on account of the extent and variety of the acts of violence, which highlight the excess of the play.[31] Aside from Nero's order to cut into his mother's body, which is carried out live, the violence is focused in the final day or days of the performance and the battle in Jerusalem. This part of the play is filled with repeated and varied acts of violence performed on the Jews, described in detail by the characters enacting them.

The tapestries give visual form to these diverse punishments inflicted on the Jews. In addition to the general goriness of the battle scenes, they emphasize the atrocious acts meted out by the victors after the fall of the city. The fragment at the Metropolitan Museum captures the death of soldiers in battle, as swords puncture chests and blood sprays, drips, and oozes. A similar fate meets Jews after the destruction of Jerusalem: in the lower section of the same panel, at the viewers' eyelevel, blood streams from the wounds of men cut open to extract the gold they have swallowed in the hopes of preserving their wealth (*plate* 2).

Finally, both the tapestry set and the play focus on the gruesome incident of a Jewish mother who kills and eats her child. The description of this event is one of the significant ways in which the 'Vengeance' play departs from the prose version of the story. In the latter, the children of Christian women die of starvation in Jerusalem. An angel appears to them, saying it is God's will that the mothers nourish themselves on their children's bodies.[32] The surviving versions of the script follow Josephus's original text more closely and transform the story into one of infanticide in which the perpetrator is Jewish.[33] This atrocious act is given deliberate emphasis in the tapestry and in the script. The Tournai tapestry charts the episode in three stages: she eats a limb, while the body roasts on a skewer; a soldier accosts her; and she is dragged from her house (*plate* 3). The cluster of images devoted to her actions encourages the viewer to dedicate a prolonged look at this segment of the

4 First Cloth: *View of Jerusalem,*
c. 1500. Distemper on linen
cloth, 3 × 3 m. Reims: Musée
des Beaux-Arts. Photo: C.
Devleeschauwer, Musée des
Beaux-Arts de Reims.

tapestry. Similarly, the lengthy monologues by Josephus and the four women involved in the acts of infanticide and cannibalism in the script would have captured the audience's attention for the duration of the speeches.

The structural and affective qualities of this tapestry set, which I contend resemble the set performance of the 'Vengeance', recall numerous other contemporaneous tapestries, many of which also highlight battle scenes. We must recognize, however, the variety of tapestries produced during this period, including those which incorporate a floral pattern (millefleurs), are typologically organized, or which adopt a unified system of perspectival illusionism. Moreover, the 'Vengeance' tapestries, unlike other tapestries with similar compositional features, have a particular connection to contemporary drama in that the events they represent were also seen in actual performances. Viewing a tapestry set might have recalled the experience of watching a play. The reverse was also the case, as we learned in the city of Nevers, where tapestries of the Nine Worthies provided a model for a civic performance on the same theme.[34] Could it be that representatives from Mons, a city within the realm of Philip the Good, examined the tapestry listed in the 1420 inventory of the duke's possessions in order to imagine the impact on spectators of their own 'Vengeance' play?

In their attempt to recreate a 'Vengeance' performance, scholars have turned, instead, to a group of paintings in Reims. These seven water-based paintings on linen cloths, each one measuring approximately 3 by 3 metres, depict the key events in the 'Vengeance' story: Vespasian's conversion, Pilate's death, and the destruction of Jerusalem.[35] An inscription on the first cloth, stating that: 'Here follows the mystery of the Lord's Vengeance', has served as evidence for linking a performance of the play to the paintings, which were produced sometime in the first third of the sixteenth century. Conveniently, a nineteenth-century archivist discovered a reference to a performance in Reims in 1531; since then, scholarship on the paintings has assumed that they document this occasion.[36]

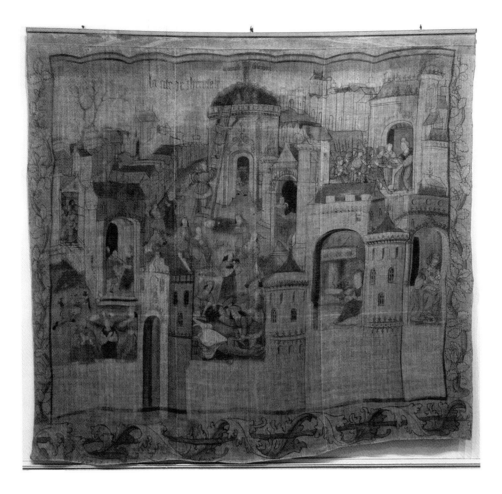

5 Fifth Cloth: *Scenes of Famine within the Walls of Jerusalem*, c.1500. Distemper on linen cloth, 3 × 3 m. Reims: Musée des Beaux-Arts. Photo: C. Devleeschauwer, Musée des Beaux-Arts de Reims.

I have argued elsewhere that this association between the paintings and an actual performance has been falsely established. Whereas scholars have assumed that the word 'mystère' in the inscription refers specifically to a mystery play, at the time it could have described a wide range of representations of sacred events.[37] Furthermore, despite the claims to the contrary, I have concluded that there is no evidence for a performance of the 'Vengeance' in Reims in 1531: the inclusion of the events from the play, and details such as inscriptions or gestures indicating a figure's speech, were a result of the artists' reliance on the printed script of the play, published in multiple editions between 1491 and 1539, rather than on its performance.[38] But more important to my point here than the concrete particulars of the surviving evidence, is the way in which these paintings depart from the structural, affective, and aesthetic qualities that characterize the 'Vengeance' tapestries and plays.

The Reims paintings do integrate key components of the staging of urban drama. The first cloth, which focuses on the Jews' denial of their guilt and blindness to their impending fate, recalls the fluidity between performance and civic spaces (*plate* 4). As a chariot and sword, omens portending the destruction of the city, appear in the sky, they feast, dance, and talk. This takes place in a central square, surrounded by town houses, from whose windows spectators observe the action. In front of the houses in the left corner, inhabitants of Jerusalem take part in a meal on long tables. Discrete architectural structures frame individual events within the composition. On the right-hand side, Pilate debates with his advisers who was responsible for Jesus's death. The different stages of infanticide during the siege of Jerusalem are contained within such structures (*plate* 5).

However, each composition isolates a fixed vantage point from which to observe the event it encompasses. The architectural structures incorporated into each composition provide a kaleidoscope of views, shifting the viewers' perspective to focus on the individual events that transpire within. The figures inhabit the structures, and are thereby both spatially and temporally differentiated from those around them. In the fifth painting, for instance, we move from an image of a woman holding her son with a knife held to his belly on the right, to his roasting on a spit, to her eating

the baby, and finally, to her sharing her food with soldiers (*plate 5*). The diminution in scale in the upper register of the composition signals both a geographic and temporal distance: the last event, in which a mother shares her child's body with the soldiers, appears in the top right corner of the image.

The viewers' experience of the 'Vengeance' story is thereby controlled. On the one hand, they are invited to identify the places in which the action unfolds as ones that they might conceivably occupy. Each painting offers privileged views into the individual houses in which the crime of infanticide occurs. The allusions to civic topography and festivities recall the viewers' own urban surroundings and civic theatre. On the other hand, however, the use of perspective determines the position from which the viewers perceive events. Moreover, the curious upward tilt of the centralized composition in the first cloth, or the bird's eye perspective in the fifth cloth, remove the depicted spaces of the city from that of the viewers. Finally, the ornamented borders that frame each painting, and which double in width at the bottom, closest to the viewer, define each painting as a discrete and self-sufficient representational field that viewers perceive only from a distance. The viewers' perception of the events as a whole is similarly guided and regulated. Each image focuses attention on an event or a series of events, which are, in turn, clearly isolated within the composition. Unlike the principle of accumulation that structured the events within mystery play performances, the series is organized with a clear beginning, the state of affairs in Jerusalem depicted in the first cloth, and a clear end, the sale and murder of its citizens, in the seventh. It offers a temporal, spatial, and thematic overview of the events of a 'Vengeance' play.

To the extent that the Reims paintings offer a vision of a 'Vengeance' play that would be impossible to obtain in an actual performance, they resemble Hubert Cailleau's drawing of the 1547 Passion play that took place in Valenciennes (*plate 1*). The drawing provides an overview of the sites at which the action occurred. Heaven and hell frame these locations and impose a boundary that adopts the compositional principle of Last Judgment scenes with heaven on the left, hell on the right. In both the Reims paintings and Cailleau's drawing, the image delimits the scope of the play and fixes the vantage point from which viewers perceive events. The space the viewers occupy is, in turn, clearly designated and distinct from the spaces in which the action transpires.

Moreover, the production of both the painted cloths and Cailleau's drawing relied on an experience of a play that differed significantly from that of a performance in the central square of a city. The cloths draw on the script of the 'Vengeance', widely distributed in print to be read, rather than to be performed on a large scale. The script codified the text of the play and could be perused within the privacy afforded by a domestic context.[39] Cailleau's drawing was made thirty years after the performance of the Passion play in Valenciennes, a performance that took place within the Hôtel de Croy, rather than on the public square previously used for mystery plays.[40] The architectural frame of this structure enforced a physical boundary between the site of the performance and the city of Valenciennes.

The theatrical activity that took place within an enclosed structure, as at the Hôtel de Croy, delimited the space and role of viewers in a way that the performances of mystery plays in city squares did not. Sixteenth-century legislation confirms that this type of limitation was not only common in the staging of religious drama but also intended and enforced. The Parliament of Paris's support and protection of the Confraternity of the Passion provided a way to control the performance of religious drama: it identified the actors permitted to perform

and restricted the locations in which their performances took place to a series of buildings the Confraternity rented.[41] The large-scale performance of mystery plays within public squares continued through the end of the sixteenth century outside Paris, coexisting and, in some cases, conflicting with other forms of theatrical activity. The Parisian legislation makes clear, however, that the civic authorities were concerned by instances in which plays were not effectively confined by their architectural settings, arguing that the spilling of religious drama into the city streets led to social disruption.[42]

The historical record has depended on images like the Reims cloths and Cailleau's depiction of the 'theatre' at Valenciennes to visualize the performance of mystery plays in the fifteenth and sixteenth centuries. Consequently, we have not been able to appreciate the open-ended nature of their narratives, the excess and accumulation they convey, and the permeable boundary between spectator and action that defined their performance. It is, rather, to the tapestries that we should return for a vestige of the visual experience of these plays. These tapestries suggest, in turn, that the distinctive characteristics of large-scale urban drama cannot be represented visually but can only be enacted through the viewer's participation.

Notes

Versions of this chapter, which draws on my larger study of the relationship between Franco-Flemish art and theatre in the fifteenth and sixteenth centuries, were presented at the Institute for Advanced Study (Princeton), Yale University (New Haven), Ruprecht Karls Universität (Heidelberg), Freie Universität (Berlin), and Fordham University (New York). I thank each audience for its input on these occasions. Reed College, the Institute for Advanced Study, the American Philosophical Society, and Rutgers University provided funding for my research. I am also grateful to Mario Longtin, Sarah McHam, Katherine Zieman, and the editors of the orignal journal, Stijn Bussels and Caroline van Eck, for their careful reading of the text.

1 'Le teatre ou hourdement pourtraict come il estoit quant fut jouer le Mystere de la passion nostre seigneur Jesus Christ anno 1547.' (Frontispiece of Paris, BnF, Ms. fr. Rothschild 3010 (I.7.3); Elie Konigson, *La Représentation d'un mystère de la Passion à Valenciennes en 1547*, Paris, 1969.) Many authors have expressed doubts as to its 'authenticity', but Henri Rey-Flaud most forcefully argues that Hubert Cailleau did not base his drawing on the Passion play that took place in Valenciennes (*Le Cercle magique. Essai sur le théâtre en rond à la fin du Moyen Age*, Paris, 1973, 209–18).

2 Since Emile Mâle's publications ('Le Renouvellement de l'art par les mystères', *Gazette des Beaux Arts*, 3rd series, 31:1–3, 1904, 89–106, 215–30, 283–301, 379–94), literature on the general topic has increased in sophistication and scope. It would be impossible to do justice here to the diversity of this scholarship.

3 Robert L. A. Clark and Pamela Sheingorn, 'Performative reading: the illustrated manuscripts of Arnoul Gréban's *Mystere de la Passion*', *European Medieval Drama*, 6, 2002, 129–54. Elina Gertsman adopts this model to describe the 'performative reading' experience to which late medieval dance of death paintings attest ('Pleyinge and peyntynge: performing the dance of death', *Studies in Iconography*, 27, 2006, 1–43).

4 For a study that emphasizes the reciprocity between art and drama, see Martin Stevens, 'The intertextuality of medieval art and drama', *New Literary History*, 22, 1991, 317–37.

5 In this respect my approach resembles that of Michael Fried (*Absorption and Theatricality. Painting and Beholder in the Age of Diderot*, Chicago, IL, 1980).

6 For instance, Helen Solterer, 'Performing the pasts: a dialogue with Paul Zumthor', *Journal of Medieval and Early Modern Studies*, 27: 3, 1997, 595–7, 622-5 'Theatre and theatricality' in Simon Gaunt and Sarah Kay, eds, *The Cambridge Companion to Medieval Literature*, Cambridge, 2008,

181-94; and and Meg Twycross, 'The theatricality of medieval English plays', in Richard Beadle and Alan J. Fletcher, eds, *The Cambridge Companion to Medieval English Theatre*, 2nd edn, Cambridge, 2008, 26–75.

7 For a summary of the negative associations of the term 'theatricality', see Tracy C. Davis and Thomas Postlewait eds, *Theatricality*, Cambridge, 2003, 4–5, 16–21.

8 For an exception to and clear articulation of this approach, see Gordon Kipling, 'Theatre as subject and object in Fouquet's "Martyrdom of St. Apollonia"', *Medieval English Theater*, 19, 1997, 26–80, 101–2 and 'Fouquet, St. Apollonia, and the motives of the miniaturist's art: a reply to Graham Runnalls', *Medieval English Theater*, 19, 1999, 101–20.

9 Nevers, Archives communales, Série CC (impôts et comptabilité): CC 55, 1457–58.

10 Jean Lestocquoy, *Deux siècles de l'histoire de la tapisserie (1300–1500): Paris, Arras, Lille, Tournai, Bruxelles*, Arras, 1978; Adolfo Cavallo, *Medieval Tapestries in the Metropolitan Museum of Art*, New York, 1993, 64–71; Thomas B. Campbell, *Tapestry in the Renaissance: Art and Magnificence*, New York, 2002, 29–40.

11 Marina Belozerskaya, *Rethinking the Renaissance: Burgundian Arts across Europe*, Cambridge, 2002, 104–16.

12 See, for instance, the references to tapestries cited in Daniel Mater, 'Les Anciennes Tapisseries de la Cathédrale de Bourges. Pierre de Crosses', *Mémoires de la Société des Antiquaires du Centre*, 27, 1903, 357–8.

13 Contemporary documents mention performances in: Nevers (1396 and 1432); Metz (1437); Amiens (1446); Bourg (1452); Mons (1457–58); Abbeville (1458, 1463); Aire-sur-la-Lys (1459); Lille (1484); Malines (1494); Lutry (1523); Troyes (1540); Plessis-Piquet (1541) (Louis Petit de Julleville, *Histoire du théâtre en France: les mystères*, Paris, 1880, vol. 2, 180–5; Gustave Cohen, *Le Théâtre français en Belgique au Moyen Age*, Brussels, 1952, 78; Stephen Wright, *The Vengeance of Our Lord: Medieval Dramatizations of the Destruction of Jerusalem*, Toronto, 1989, 110–12).

14 Fragments are preserved in Saumur, Lyons, Venice, Tournai, New York, Florence, Geneva, and Vienna. A 'Vengeance' tapestry appears first in the inventory of Louis d'Anjou (1364); the last reference is in the inventory of Francis I (1551) (Nello Forti Grazzini, *Gli arazzi della Fondazione Giorgio Cini*, Venice, 2003, 28–9).

15 Graham Runnalls, 'Mysteries' end in France: performances and texts', in Sydney Higgins and Fiorella Paina, eds, *European Medieval Drama 1998: Papers from the Third International Conference on Aspects of European Medieval Drama, Camerino, Jul 3–5, 1998*, Camerino, 1999, 175–86.

16 Two manuscripts preserve this script, entitled, 'La Vengance Jesucrist': Arras, Bibliothèque Municipale, Ms. 697 and Chatsworth, Library of the Duke of Devonshire, Ms. 48.B.

17 Flavius Josephus, *The Jewish War*, Book 3, trans. Geoffrey Arthur

Williamson, revised edition, Harmondsworth and New York, 1981. On the play, see Wright, *The Vengeance*, 147–60; Jean-Pierre Bordier, 'La composition de la *Vengeance de Notre Seigneur* (ms. Arras, Bibliothèque municipale, 697): un aspect de l'art dramatique d'Eustache Mercadé', in Denis Hüe, Mario Longtin and Lynette Muir, eds, *Mainte belle oeuvre faicte. Études sur le théâtre médiéval offertes à Graham A. Runnalls*, Orléans, 2006, 19–27.

18 Alvin E. Ford, *La Vengeance de Nostre-Seigneur. The Old and Middle French Prose Versions, the Version of Japheth*, Toronto, 1984.

19 'Mais volons juer la vengance
 De Dieu pour donner congnoissance
 Comment Juifz furent pugny.'
 Arras, B.M., Ms. 697, f. 310; Andrée Marcelle Fourcade Kail, ed., 'Edition de la *Vengance Jesucrist* d'Eustache Marcadé : Ière et IIIème journée', PhD. Dissertation, Tulane University, 1957, 4.

20 Forti Grazzini, *Gli arazzi*, 27–49; Cavallo, *Medieval Tapestries*, 198–209; Anna Rapp Buri and Monica Stucky-Schürer, *Burgundische Tapisserien*, 2001, 290–6; Anne Dudant, *Les tapisseries tournaisiennes au Musée d'Histoire et d'Archéologie de la ville de Tournai*, Tournai, 1985, 30–8. The tapestry in the Metropolitan Museum comprises three separate fragments, which have been sewn together (Cavallo, *Medieval Tapestries*, 198–201).

21 Cavallo, *Medieval Tapestries*, 205; Forti Grazzini, *Gli arazzi*, 30–1.

22 Nicole Reynaud, 'Un peintre français cartonnier de tapisseries au XVe siècle: Henri de Vulcop', *Revue de l'Art*, 22, 1973, 15–16; Forti Grazzini, *Gli arazzi*, 28–9; Cavallo, *Medieval Tapestries*, 205.

23 Although each play merits its own study, some generalizations are possible and have been made convincingly by, among many others: Martin Stevens, 'Illusion and reality in the medieval drama', *College English*, 32, 1971, 448–64; Rainer Warning, 'The alterity of medieval religious drama', *New Literary History*, 10, 1979, 278–85; and Jean-Pierre Bordier, *Le jeu de la Passion: le message chrétien et le théâtre français (XIIIe–XVIe s.)*, Paris, 1998, 16–20.

24 Bordier, *Le jeu*, 40–7.

25 The list of players at the end of Arras, B.M., Ms. 697 includes one hundred and eight (Arras, B.M., Ms. 697, f. 484v.–485v.; Kail, 'Edition', 427–31).

26 Petit de Julleville, *Histoire du Théâtre*, vol. 2, 180–5; Wright, *The Vengeance*, 110–12.

27 Arras B.M., Ms. 697, Adèle Cornay, ed., 'Edition of *La Vengance Jesucrist* by Eustache Marcadé (2nd journée)', PhD Dissertation, Tulane University, 1957.

28 On the difficulty of interpreting references to these constructions in contemporary documents, see Graham Runnalls, '"Mansion" and "Lieu": two technical terms in medieval French staging?', *French Studies*, 35: 4, 1981, 385–93.

29 Stephen Wright, *The Vengeance*, 133.

30 This performance took place in May 1458 (Gustave Cohen, *Le Livre de conduite du régisseur et le compte des dépenses pour le Mystère de la Passion joué à Mons en 1501*, Paris, 1925, xiv).

31 Grace Frank, *Medieval French Drama*, Oxford, 1954, 191–2; Gustave Cohen, *Histoire de la mise en scène dans le théâtre religieux français*, Paris, 1926, 151, 269.

32 Ford, *La Vengeance*, 32.

33 Arras, B.M., Ms. 697, f. 460v.–462, Kail, 'Edition', 340–6.

34 See note 9 above.

35 Charles Loriquet, *Catalogue historique et descriptif du Musée de Reims*, Reims, 1881; Louis Paris, *Toiles peintes et tapisseries de la ville de Reims ou la mise en scène du théâtre des confrères de la passion*, Paris, 1843; François Pomarède, 'Les "Toiles Peintes" du Musée de Reims', *Mémoires de la Société d'Agriculture, Commerce, Sciences et Arts du département de la Marne*, 41, 1976, 229–42; Jean-Louis Schefer, 'La vengeance de Notre Seigneur', *Dédale*, 3: 4, 1996, 317–48; Laura Weigert, 'The afterlife of spectacle: creating a performance of *The Vengeance of Our Lord* through paint', *Early Modern France*, 13, 2009, 65–87.

36 Paris, *Toiles peintes*, vol. 2, 61; Wright, *The Vengeance*, 133, 143; Loriquet, *Catalogue historique*, 233; Pomarède, '"Toiles Peintes"', 229, 238–9; Schefer, 'La vengeance', 317, 319.

37 Graham Runnalls, 'Mystère "représentation théâtrale": histoire d'un mot', *Revue de Linguistique Romane*, 64, July–December 2000, 321–45.

38 Weigert, 'The afterlife', 65–71.

39 Graham Runnalls, 'Religious drama and the printed book in France during the late fifteenth and sixteenth centuries', in Andrew Pettegree, Paul Nelles, and Philip Conner, eds, *The Sixteenth-Century French Religious Book*, Aldershot, 2001, 27–8.

40 Konigson, *La Représentation*, 21.

41 Petit de Julleville, *Les Mystères*, vol. 1, 412–39; Graham Runnalls, 'La Confrérie de la Passion et les mystères. Recueil de documents relatifs à l'histoire de la Confrérie de la Passion depuis la fin du XIVe jusqu'au milieu du XVIe siècle', *Romania*, 122, 2004, 135–201.

42 Runnalls, 'La Confrérie', 170, 171, 172, 176.

Chapter 3
Making the Most of Theatre and Painting:
The Power of *Tableaux Vivants* in Joyous Entries from the Southern Netherlands (1458–1635)
Stijn Bussels

In mid-fifteenth-and-sixteenth-century northern Europe, and certainly in the southern Netherlands, municipalities used *tableaux vivants* to welcome a prince during his Joyous Entry into their city. In these *tableaux* burghers performed carefully composed scenes with little or no movement or speech. By presenting historical, biblical, mythological and allegorical figures, the *tableaux vivants* told stories which expressed the municipality's views on the ideal symbiosis between the prince and the city. The municipality hoped that the prince would decode the stories carefully and find their message consistent with his own political agenda. The citizens attending the entries were also expected to take in the stories attentively. Not every bystander would have understood all the political references, certainly in the sixteenth century when the use of mythological and allegorical figures increased.[1] However, the large majority understood that the *tableaux* wanted to impress on them that they had to acclaim the prince's presence.

From the second half of the sixteenth century on, the *tableaux vivants* lost importance and heavily decorated triumphal arches came more and more to dominate entries. In this chapter, I will try to understand the success and subsequent decline of the *tableaux* by examining their success in transmitting a political message using means of persuasion they shared with theatre and painting. I will examine the *tableaux* to see if they may be called 'theatrical' and 'pictorial', in these adjectives' primary meaning as 'of or relating to the theatre/painting'. Therefore, I will refer to contemporary theatrical practices – the passion plays, the theatre of the chambers of *rederijkers* or rhetoricians (amateur groups of actors and dramatists)[2] and of the Jesuits – and also to painters, the brothers Van Eyck, Hugo van der Goes, Pieter Coecke van Aelst and Pieter Paul Rubens.

I will illustrate the success and decline of the *tableaux vivants* through the examination of three entries, spanning nearly 200 years, from the southern Netherlands: the entry into Ghent of Philip the Good in 1458, the entry into Antwerp of Charles V and his son Philip in 1549, and the entry, also into Antwerp, of don Ferdinand in 1635. Whereas in 1458 no less than nineteen *tableaux vivants* were used, and in 1549 thirteen, in 1635 only two were erected,[3] the notably small number of *tableaux* suggesting that they were merely there for tradition's sake. It is likely that the raising of the *tableaux* of 1635 was only possible thanks to the influence of the rhetoricians who erected them and who were in former times the chief organizers of the entries. Although they stood in the heart of the city, near the Town Hall, they were isolated. Formally they did not fit in with the larger part of the decorations. Moreover, the general organizers ignore the *tableaux* in the official festival album (see below).

Detail from Pieter Coecke van Aelst, Tableau vivant with the nine Joys and the six Miseries, (plate 2).

Theatricality in Early Modern Art and Architecture *Edited by Caroline van Eck and Stijn Bussels* © 2011 Association of Art Historians.

The decreasing importance of *tableaux vivants* in Joyous Entries is not unique, but points to a general evolution in northern Europe.[4] Most studies relate it to the growing absolutist aspirations of princes, since the political negotiations characteristic of earlier entries disappeared in favour of unanimous glorification. Roy Strong speaks of 'the transformation of the royal entry into an absolutist triumph'.[5] From this perspective, *tableaux vivants* can be understood as the ideal through which the 'pre-absolutist' period was able to negotiate power relations since burghers performed stories about ideal government in them. By contrast, triumphal arches were erected because they were the perfect means to glorify the prince in the seventeenth century. The imperial Roman past could be evoked without incurring any indebtedness to the city's burghers.[6]

This point of view needs modification, since it persists in recent authoritative research projects, notably *Europa triumphans* and *Triumphal Celebrations*.[7] It is barely acknowledged that at the beginning of the sixteenth century triumphal arches were already appearing next to *tableaux vivants*.[8] Both presented the municipality's political point of view and both referred to Roman emperors and heroes the entering prince could emulate. Moreover, in seventeenth-century entries the absolutist ambitions of the prince were not overpowering. As we will see presently, in the entry of 1635 the municipality was still able to present pressing requests, although this was not done by *tableaux vivants* but by triumphal arches.

The *tableaux vivants* of 1458 and 1549, as we will see, were very effective in their use of both theatrical and pictorial means to put across the political ideas of the citizenry. In 1635 the *tableaux* could no longer bring together the best of both and became isolated expressions of a dated tradition, since theatre and painting had changed drastically. By focusing on the *tableaux* and triumphal arches as media, I want to make clear that in the three cases all were employed to make the message come across in the clearest possible way. Between 1458 and 1635, the political situation changed considerably. Nevertheless, the three entries can be seen as major socio-political moments in which the municipalities tried to express their ideal view on society as convincingly as possible. With a comparison across time, I want to make clear that this could only succeed by reinventing the means of communication every time.

The Ghent Entry of 1458

From the mid-fifteenth century on, the Burgundian dukes increasingly tried to strengthen their hold on their territories. The revolt of the city of Ghent between 1447 and 1453 was a reaction to this, but did not end it, since Philip the Good violently brought Ghent back into line. This political situation was visualized in *tableaux vivants* performed for Philip's entry into the defeated city in 1458. The civic self-subjection drew on the Bible and antiquity. However, the organizers did not give in completely and used the same kind of references to express civic pride.

An extensive account of the Ghent entry can be found in the *Kronyk van Vlaenderen* (The Chronicle of Flanders).[9] There, *tableaux vivants* are called *stellagies*, 'stages on which one plays, gives theatre performances'.[10] The use of this term draws attention to the close relation between *tableaux vivants* and theatre practice, since theatre stages were also called *stellagies*.[11] The persons on stage are called *figure* or *figuere*.[12] The word can mean 'shape' and 'human form', but also 'image', 'sculpture' and 'depiction'. In the account of the Ghent entry, the terms *stellagie* and *figure* are used within the same context. This indicates the belief in the close bond between painting and theatre in the *tableaux vivants*. This bond can also be found in looking at the individual *tableaux vivants*. In 1458 they served as ideal means to experiment with the capacities of both media to present the political relation between Ghent and the duke of Burgundy.

At first sight, the restrictions in the use of sound and movement the *tableaux vivants* bring with them seem distinct from theatrical performance. However, the rhetoricians turned these restrictions to good use in their theatre performances.[13] At important moments in their morality plays, they often used a *tableau* to give the central personage (together with the audience) a moral insight.[14] Often at the end of the performance a scene was revealed for the central personage to observe in which frozen actors presented the theme of resistance to worldly temptation and to choose the road to God and heaven. The *tableaux* functioned in the same way in the entries. Using the silent and frozen personages of the *tableaux*, a concise message could be presented.

Nevertheless, in the *tableaux vivants* of 1458 movement and sound were not totally banned, but were used in a well-considered and sparing way. In one of the first *tableaux vivants* a young girl personified the city.[15] She was dressed like a bride (*ghelijc eenre bruyt*) and descended three stairs (*needere gecomen drye trappen*) to meet the prince. This must have seemed an ideal way to visualize a happy and profitable union between the city and Philip and a perfect starting point for the city to try to regain the prince's favour after the revolt. Sound was also used throughout the entry, but again more economically than in contemporaneous theatre. Trumpet players and singers stood at the gates, but sounds were also used in the *tableaux vivants*. In one *tableau* Mars took the stage next to a black lion. The account makes clear that the animal was played by a costumed man who roared like a real lion (*gemaect up eenen levenden man, roerende en briesschende ghelijc den leeu*). Mars and the lion are generally interpreted as Philip the Good and an allegory of Strength.[16] So the prince's power was not only visualized, it also resounded through the streets of Ghent.

Alongside movement and sound, stage machinery provided a third expressive resource for the producers of entries. Such machines were also in use in the theatre. In the passion plays, for example, God was shown in heaven and the devils in hell through the deployment of mechanical devices.[17] It is evident that much effort had been made in staging the Ghent entry to produce a particularly startling effect. Near one of the city's bridges a spectacle was organized on the water, exhorting the people of Ghent to trust their duke unconditionally. Actors were used in its staging, but additional use of mannequins is possible. A piece of scenery which had been hung over the water represented the sky. During the performance it opened and an angel appeared and lifted a large box that stood on a meadow placed on a raft in the water. Christ came into view. Not far from Him rode Saint John and Saint Peter. The latter set out to reach Christ, but sank, although miraculously only up to his shoulders.[18]

While drowning, Saint Peter unrolled a banderol: *Domine salvum me fac* ('Lord save me'; Matthew 14:30). Christ answered him with his own banderol: *Modicae fidei quare dubitasti* ('You of little faith, wherefore did you doubt?', 14:31). The figures in contemporary paintings were also frequently accompanied by banderols which clarified the action or identified the actors. One of the most theatrical events of the entry therefore used elements that also occur in contemporary paintings.

A famous example of banderols used in fifteenth-century painting is the reredos of the Ghent altarpiece of the brothers Van Eyck. There, the prophet Zaccariah and Micah and the Sibyll of Cumae and Eretria are depicted with sayings attributed to them on banderols which predicted to the birth of Chirst. The composition of the *tableaux vivants* of during the Ghent entry of 1458 can also be related to the Ghent altarpiece. The unfolded altarpiece was meticulously staged in this entry with only the panels of Adam and Eve omitted. As the altarpiece, the *tableau vivant* was separated in to different levels divided by planking. On the first level, the audience could admire God enthroned and accompanied by Mary, John the Baptist and angels singing and playing. On the second and third levels the Lamb of God held the central position.

1 Hugo van der Goes, *The Adoration of the Shepherds*, c. 1470. Oil on oak, 97 × 245 cm. Berlin: Gemäldegalerie, Bildarchiv Preussischer Kulturbesitz. Photo Jörg P. Anders.

It was approached from all directions by worshippers. In front of the stage water sprang from the Fountain of Life. All these elements were explained for the audience by the same Latin subscriptions featured in the original painting. By choosing to stage the altarpiece, the producers laid the accent on one of the city's most precious possessions, but at the same time on its humility. The burghers urged Philip the Good to forgive them, just as the Lamb bears the sins of the world.[19]

Conversely, there are also clear indications that *tableaux vivants* influenced painters. A concrete case can be found in Van der Goes' *Adoration of the Shepherds* which art historian Elisabeth Dhanens dates to his Ghent period (*c. 1470*) (*plate 1*).[20] There, close similarities with *tableaux vivants* can be discerned if we look at the two unidentified prophets in the foreground on both sides of the painting.[21] They draw back the curtains and reveal the adoration scene. One looks at the scene, the other at the viewer and makes a gesture inviting our attention. *Tableaux vivants* were similarly revealed by curtains at the moment the prince passed by. The account of 1458 mentions, for example, *voren ghesloten met witten gordinen* ('in the front closed with white curtains').[22] Moreover, prophets had an important role in the Ghent *tableaux* too. Just before the scene with the personification of the city, Isaiah and Ezekiel were represented in separate *stellagies* on both sides of the route. Like the prophets of Van der Goes, one prophet looked at the onlooker and the other at the city. Isaiah pointed at Philip and revealed the text, *Ecce nomen Domini venit de longinquo* ('Behold, the name of the Lord comes from far'; Isaiah 30:27). Ezekiel pointed at the city. His banderol read, *Canite tuba, praeparentur omnes* ('Blow the trumpet, let all be prepared'; Ezekiel 7:14). As the first set of *tableaux vivants* presented, they served as the intermediary between the onlooker and the rest of the representation. Isaiah told the burghers that the prince had reached the city. Ezekiel in turn showed the prince that the citizens had prepared his reception well. This intermediary function can also be found in the theatre of that time, where, in mystery plays, prophets often recited the prologue.[23]

The use of the prophets shows that it is hard to separate theatrical and pictorial elements from each other in the Ghent entry. Theatre, painting, and *tableaux vivants* used features which were so similar that it is impossible to tell to which medium they originally belonged. Since the *tableaux* had many means at their disposal to persuade, they were seen as an effective means to tell stories about ideal power relations and to propagate a new political understanding between the prince and the burghers. With the theatre they shared the marvel of machinery and the presence of living persons

capable of expressive movement and sound; with painting they had in common composition and the explicit presentation of significant sentences on banderols.

The Antwerp Entry of 1549

In 1548 preparations started for the succession of Charles V by his son Philip. However, the actual succession did not take place until 1555. By preparing it so long in advance, the emperor wanted to make the transfer as smooth as possible. The entries in the Low Countries were a key point in these preparations, and their importance can be gauged by the fact that Charles accompanied his son throughout the series. Moreover, the Habsburgs meticulously oversaw its organization.[24] The entry in Antwerp was one of the most important in the series.[25] The mighty dynasty met the rich city of commerce. Although the municipality did not fund all the festivities, it did aim at presenting one coherent message.[26] The emperor, his son and all the other onlookers had to be convinced that an increased collaboration between the Habsburg power and Antwerp wealth would benefit everyone.

Reading the festival album by the humanist town clerk and chief organizer of the entry Cornelius Grapheus, and looking at the accompanying illustrations designed by Pieter Coecke van Aelst,[27] we see that the *tableaux vivants* no longer used banderols, but painted inscriptions in Latin, in chiselled typefaces imitated from ancient memorials, and placed on the framing of the *tableaux vivants*, often triumphal arches. These references to Roman monuments were used to associate Charles with the Roman emperors, and Antwerp with Rome.

The illusion of spoken words created by the use of banderols disappeared, just as the stage machines did (although the second Antwerp *tableau vivant* is an exception; their heaven was sown with turning and twinkling stars). The typically theatrical and pictorial features in the *tableaux* of 1458 did not dominate in 1549, but it is interesting to consider the increasing importance of classical texts for painting and theatre in connection with the Antwerp *tableaux*. In the mid-sixteenth century, the handbooks of rhetoric were closely examined to learn how to use real or depicted bodies as means of clear and effective persuasion.[28] The Antwerp *tableaux vivants* can be seen as an early expression of this interest.

De Const van Rhetoriken (The Art of Rhetoric) of Matthijs de Castelein illustrates this.[29] De Castelein was a leading rhetorician in the Flemish city of Oudenaarde. Although his book was published six years after the Antwerp entry it is apposite to the discussion here, since it gives an insight into how actors in the period of the Antwerp entry were expected to perform. De Castelein used the handbooks of Quintilian and Cicero, as Leon Battista Alberti did in *De pictura*, a work that became influential north of the Alps after 1500.[30]

Both de Castelein's and Alberti's books emphasize the importance of a clear *sermo corporis*, a body language. Alberti refers to classical conventions of gesture, as recorded for instance by Quintilian who prescribed that every part of the body had to be able to express a certain emotion: 'Those who are angry have their eyes wide open and their faces are red, since their feelings are stirred up by anger. All the gestures of their bodily parts are violent and stormy due to fury.'[31] De Castelein in his turn wrote: 'Then there is the raising of the arm and, // Certainly by expressing indignation over someone, // The stamping of the feet, such as Tullius [Cicero] clearly wrote.'[32] This kind of clear and codified body language can also be found in Coecke's pictures of the Antwerp entry.[33] Although not straightforward representations of the performances, they can be used to explore the gestures on stage, for the pictures may be connected to the organizers of the performance.[34] Most scholars argue that Coecke was involved in the organization

of the entry.[35] Also, his illustrations are part of a detailed and exact account. Grapheus explicitly points, for example, to the use of scale to show the precise measures of the decorations.[36]

The frozen gestures on stage in the *tableau* of the nine Joys and the six Miseries show this *sermo corporis* (plate 2). The Miseries expressed their despair by bringing their arms to the head or breast, just as in the instructions of de Castelein. However, clear gesture is not the

2 Pieter Coecke van Aelst, *Tableau vivant* **with the nine Joys and the six Miseries, f.14 v. from Cornelius Grapheus,** *De seer wonderlijcke schoone Triumphelijcke Incompst, van den hooghmogenden Prince Philips* **...,Antwerp, 1550. Ghent: University Library. Photo: University of Ghent.**

only remarkable feature. The staging of the figures also reflects the notion that the human body is able to move the viewer strongly. The inscriptions made clear that the organizers wanted the onlookers to feel happy. A Latin inscription read: 'Oh let us be happy, let us again and again be happy: far, far from here all sorrow, all mourning: very beautiful happiness is brought to us by the pleasant presence of our Prince we so much desire.'[37] To achieve this, the nine Joys dominated the scene through their number, through the space they occupied and through their song. Moreover, they tried to make the onlookers happy by giving a good example. One Joy enthusiastically lifted her arms, others danced or rocked their hands to and fro to the music.

It is striking that prescriptions for actors and painters also focus on the emotional eloquence of the body. Alberti writes that a painting can only move the onlooker 'if the persons in the painting express their emotions as strongly as possible'.[38] In the *Art of Rhetoric*, de Castelein evidences a similar conviction when he refers to the Roman orator Gracchus, who is also mentioned in Cicero's *De oratore*. De Castelein writes:

The body has to be able to produce tears and moans ...

Therefore, every actor has his own style,
but Gracchus, who was unbeatable,
was perfect in all respects.
So fervently was he bound up in his role
that he could even move his enemies to tears.[39]

The Antwerp *tableaux vivants* are therefore both theatrical and pictorial. However, the intersection of the theatre and painting is different in 1549 to the Ghent entry of 1458. In Antwerp, it is not primarily a matter of sharing specific communicative means. Because they use similar rhetorical means to painting and theatre, the *tableaux* of 1549 show a close resemblance to experiments towards increasing persuasion in these media. There, a set of strict prescriptions was formulated to promote the

3 Pieter Coecke van Aelst,
The Spanish Arch, ff. F2 v. – F3
r. from **Cornelius Grapheus,**
*De seer wonderlijcke schoone
Triumphelijcke Incompst, van den
hooghmogenden* **Prince Philips
…, Antwerp, 1550. Ghent:
University Library. Photo:
University of Ghent.**

clarity and emotional expressiveness of the human body. The same agenda can be found in the Antwerp *tableaux vivants*. Movement, sound and machinery were reduced to the minimum. On its own, the silent and frozen human body had to put across the political message that everyone had to rejoice in the entry of the emperor and his son.

The theatrical or pictorial aspects of the *tableaux vivants* were also different from the pictorial and architectural character of their frames, triumphal arches or related structures. The relatively plain scenes that allowed the frozen bodies of the actors maximum space contrast sharply with the excess of decorations around the scenes. These included grotesques, animal masks, strapwork and human figures interlaced in architectural ornaments sporting fruit and vegetable garlands, and baskets.[40] The designer of the illustrations of the official account, Pieter Coecke van Aelst, is generally credited with spreading the grotesque style in the Low Countries and the decorations of 1549 are an early expression.[41]

Finally, the Antwerp constructions were also early examples of the use of the classical architectural orders. These were introduced by Coecke as well, specifically in his translation of Serlio's treatises, a translation which appeared in Dutch, German and French editions.[42] In 1553, the Dutch translations were posthumously collected by Coecke's widow as *Boecken van Architecturen Sebastiani Serlii* (Sebastiano Serlio's Books of Architecture).[43] The influence of the Serlian approach can clearly be seen in the Spanish arch of the Antwerp entry designed by the Spanish architect Francisco Montesa (*plate 3*).[44] The construction shows remarkable similarities with Serlio's *tempio sacro*, described and illustrated in Coecke's translation.[45]

The Antwerp Entry of 1635

After the experiments with the grotesque decoration in 1549, the relation between the central scenes of the ephemeral constructions and the surrounding decorations became far closer. This can be clearly seen in the Antwerp entry of 1635 organized to welcome Cardinal-Infante Ferdinand as new governor and designed by Peter Paul Rubens.[46] The festival album was written by the humanist and chief organizer Gevartius, and illustrated by Theodoor van Thulden. Both were involved in the organization of the entry.[47] Although there are other reports of the entry, I will use this one, since it can give us an insight into the intention and appreciation of the organizers and since it is abundantly illustrated.

It is telling that it was not the Spanish king, Philip IV, but his brother, the new governor, who made his entry. From the second half of the sixteenth century on, the

presence of the rulers decreased. Power became more centralized and the king less approachable. However, in spite of the lack of direct contact, the municipality did not restrict itself to veneration of the king and his governor alone. Rubens' *Temple of Janus*, for example, showed that the city expressed economic wishes that were all the more pressing given the city's deplorable state. Due to the Spanish war with the 'rebellious north', the mouth of the Scheldt, Antwerp's lifeline, had become closed.

The *Temple of Janus* (plate 4) shows clear similarities to the 1549 *Spanish Arch* (plate 3). Both edifices had a rectangular ground floor surmounted by an impressive dome. The two domes had a high drum with shell headed niches, and were topped by a large ball. However, there were also significant differences. The 1549 edifice expressed the *pax Augusta* by showing the Roman emperor on one side and Charles and Philip on the other. They announced peace by closing the temple doors. Whereas in 1549 a bright future had been promised, in 1635 the present was deplored, since in the *Temple of Janus* the open doors announced war, and the Furies were shown breaking out.[48] In order to increase the impact of this image, Rubens did not show the doors from the side, but frontally. He brought the central action to the lower storey where, to quote art historian John Martin, 'a stage [was] placed across the front on which painted figures enact[ed] a tableau of war and peace'.[49]

The ephemeral edifice of 1635 created the illusion of a *tableau vivant*, since there was a stage in front of the building on which people stood. However, no actors were used, but painted figures, which were often cut out to create the illusion of three dimensionality, such as the figures in the two porticos entitled *Tranquillity and Security* (on the right) and *The Ferocity of War* (on the left). In contrast to the figures in the *tableaux* of 1549, these painted figures were closely related to their surrounding architectural decorations, themselves far more abundant than was the case in the Spanish arch of 1549. As an ensemble they conveyed the message that war brings about misery. *The Ferocity of War*, with its cruel soldier and frightening skeleton, was flanked by the horrid caryatids of Discord and Strife. Above, on the second storey, figures of Poverty and Grief stood around the so-called base of Public Disaster. On the same storey, left from the base, a column was covered with spoils of war and two decapitated heads on spears.

Judging by their poses and the vigour of their actions, these painted figures would have looked much more lively than the static actors of 1549. The cruel soldier was shown pulling a woman violently by the hair; in the first storey at the centre of the stage a group of human and supernatural figures standing on the ground or flying through the air were depicted using all their strength to push and pull at a ponderous door. Such figures clearly corresponded to equivalents in the theatre of the time. There too violence and supernatural beings were common. Inspired by Seneca, the plays of the first half of the seventeenth century created an atmosphere of threat and strong pathos and invested much effort and ingenuity in impressive appearances of the Furies and fearsome ghosts.[50] Sometimes, the interaction between theatre and painting was remarkably close. During the festivities for the canonization of St Ignatius Loyola and St Francis Xavier in 1622, for example, a painting of Rubens

5 T. van Thulden, *Arbor Genealogiae Austriacae*, p. 143 from Jan Gaspard Gevartius, *Pompa introïtus honori serenissimi principis Ferdinandi Austriacis ...*, Antwerp, 1642. Ghent: University Library. Photo: University of Ghent.

was the starting point for the performance of an exorcism by Ignatius. As in the painting, the theatre production showed Ignatius in all serenity, but also in all perseverance curing a possessed woman.[51]

In seventeenth-century theatre special effects had reached unprecedented technical heights, beyond even those needed for the flying angel and drowning apostle staged in Ghent in 1458. Such technical wizardry required complex and large-scale apparatus which could not be used for *tableaux vivants* mounted in the narrow streets. As a result, the theatrical displays used in contemporary theatre and Rubens' decorations did not fit with the two *tableaux vivants* shown in the 1635 entry. Although both *tableaux* were situated in the heart of the city and illustrated in the official account, they are clearly presented as different from the other decorations. Exceptionally, one of the two – the stage of the rhetoricians of the *Goudbloem* – is not illustrated by Van Thulden, but by Schelte Bolswert. Only the other *tableau*, the Austrian Genealogical Tree, is described in the official account, albeit in a considerably shorter section of text than was given to the triumphal arches (*plate 5*). Moreover, Gevartius explicitly emphasizes that the Antwerp rhetoricians of the *Violieren*, not Rubens, were responsible.[52]

There are nevertheless correspondences with Rubens' designs, since the framing of the *tableau* is dominated by two paired caryatids. They represented Concord and resembled the left-hand pair of caryatids of the *Templum Iani*. However, the differences are more striking. Compared with the figures on the *Temple of Janus*, the actors on the *tableau* were presented in isolation from the architectural decorations. Moreover, although there were stairs which might have enabled closer contact between the actors and the architectural frame, no actor stood on them. Whereas Rubens' painted figures were placed close to the audience at the lower level just above the scaffold, the actors' positioning in the *tableau* created distance. The onlookers were confronted with a series of empty stairs surrounded by a dominating proscenium arch. On the right, Fortitude drove the figures of Paganism, Mohammedanism and Heresy to hell. On the left, Divine Providence presented to Belgica the shield of don Ferdinand. This twinned presentation did not have the same dynamic impact as Rubens' *Temple of Janus*. The figures on one side of the scene were not confronted by the others. Further on, the monstrous creatures of hell and the heavenly angels did not fly in the air, but were relegated to the corners at both sides of the stage.

The central figure, the allegory of the Holy Roman-Catholic Church, was put on a higher level in front of the painted Genealogical Tree. She was consequently even more removed from the audience than the other allegories. This central allegory is reminiscent of the *tableaux vivants* of 1549, since the figure sat enthroned and made a solemn impression, just like the allegories of Eternity, God's Mercy and Truth which were placed in a row directly behind her. All these allegories were staged with much restraint and with fixed attributes and gestures. Rubens' painted allegories on the Temple of Janus, in contrast, were strongly dynamic.

Conclusion

In the Ghent entry of 1458, the *tableaux vivants* deployed a rich variety of persuasive means which could also be found in contemporary theatre and painting. Both the theatre and the Ghent *tableaux* used machinery and living figures who made significant movement and sound. Painting and the *tableaux vivants* shared well-considered composition and the use of banderols. Thanks to this combination, the nineteen *tableaux vivants* were able to successfully tell a story that served as a vehicle for ideas on the restored relation between the subordinated city and the powerful duke.

The Antwerp entry of 1549 also shows painting and the theatre working together in the *tableaux vivants*. Both used strategies taken from the handbooks of classical rhetoric to communicate in a clear and emotionally strong way by means of gesture. The 1549 *tableaux vivants* can be seen as an early example of the attempt to utilize these characteristics in the *tableaux*. Whereas movement, sound and banderols are now banished, the Antwerp *tableaux*, like contemporary painting and theatre, try to express a message in a conventional *sermo corporis* and to move the onlooker by showing emotions with explicit gestures.

The 1635 *tableaux vivants* are still related to the experiments of 1549. However, they are now less conspicuous. Only two *tableaux* were performed, and they were disregarded in the festival album. The pictorial and architectural character of the framing of the *tableaux*, by contrast, had a different impact in 1635 and 1549, because the painted personages on the stage interacted with the decorations in the later examples. The framing, decoration and figures depicted on the stage worked together to create a powerfully affecting scene. In the two earliest entries discussed here, there had been crossovers between theatre and painting calculated to add extra force to the message the *tableaux vivants* had to convey, but the boundaries between the media had not been blurred. In his design for the 1635 entry, Rubens had achieved an interaction between the stage, the backdrop, the frame and the persons depicted that came so close to contemporary representations on the stage that the onlooker would have been engulfed by the metaphysical whirlwind of actions.

Notes

1 Lawrence M. Bryant, *The King and the City in the Parisian Royal Entry Ceremony: Politics, Ritual and Art in the Renaissance*, Genève, 1986, 61–6 and Jean Jacquot, 'Joyeuse et triomphante entrée', in Jean Jacquot, ed., *Les Fêtes de la Renaissance I*, Paris, 1973, 10–14. For the southern Netherlands, see Stijn Bussels and Bram Van Oostveldt, 'De traditie van de tableaux vivants bij de plechtige intochten in de Zuidelijke Nederlanden', *Tijdschrift voor Geschiedenis*, 115: 2, 2002, 151–68.

2 Elsa Strietman, 'The drama of the rhetoricians in the Low Countries', in John C. Coldewey, ed., *Medieval Drama: Other Vernacular European Drama: A Cultural and Critical Miscellany*, London and New York, 2007, vol. 4, 67–80.

3 Besides these two *tableaux vivants*, another theatrical display was organized at the start of the 1635 entry which the official festival album did not mention as a *tableau vivant*, but has similarities. Behind the *Keizerspoort*, the prince was greeted by Antverpia who descended from a gilt car and presented him with a laurel wreath. See John Rupert Martin, *The Decorations for the Pompa Introïtus Ferdinandi*, London and New York, 1972, 35.

4 For France, see Bryant, *The King and the City*, 207–24. For the southern Netherlands, see Hugo Soly, 'Plechtige intochten in de steden van de Zuidelijke Nederlanden tijdens de overgang van Middeleeuwen naar Nieuwe Tijd: communicatie, propaganda, spektakel', *Tijdschrift voor Geschiedenis*, 97: 3, 1984, 357–9.

5 Roy Strong, *Art and Power. Renaissance Festivals 1450–1650*, Woodbridge, 1984, 42.

6 Joël Blanchard, 'Le spectacle du rite: les entrées royales', *Revue historique*, 627, 2003, 495–8.

7 J. R. Mulryne and H. Watanabe-O'Kelly, eds, *Europa Triumphans: Court and Civic Festivals in Early Modern Europe*, Aldershot, 2004, vol. 1, 19–31 (France) and vol. 1, 466–71 (the Low Countries) and Barbara Wisch and Susan Scott Munshower, 'Introduction', in Barbara Wisch and Susan Scott Munshower, eds, 'All the World's a Stage': Art and Pageantry in the Renaissance and Baroque, Part 1: Triumphal Celebrations and the Rituals of Statecraft*, Pennsylvania, 1990, 1–22.

8 Sydney Anglo, 'Introduction', in Remy Dupuys, *La tryumphante entrée de Charles prince des Espagnes en Bruges 1515*, Amsterdam, 1973, 4–34.

9 Constant Philippe Serrure and Philip Marie Blommaert, eds, *Kronyk van Vlaenderen*, Ghent, 1839–1840, vol. 2, 212–57. Cf. Jeffrey Chipps Smith, 'Venit nobis pacificus dominus: Philip the Good's triumphal entry into Ghent in 1458', in Wisch and Munshower, *All the World's a Stage*, 258–90.

10 'Als toneel waar men op speelt, tooneelvertooningen geeft.' R. Van der Meulen, J. A. N. Knuttel and J. H. Van Lessen, eds, *Woordenboek der Nederlandsche taal*, 's-Gravenhage and Leiden, 1940, vol. 14, 1271.

11 W. M. H. Hummelen, 'Het tableau vivant, de "toog" in de toneelspelen van de rederijkers', *Tijdschrift voor Nederlandse taal- en letterkunde*, 108, 1992, 93–222 and Elsa Strietman and Lynette R. Muir, 'Play-texts and tableaux', in William Tydeman, ed., *The Medieval European Stage 500–1550*, Cambridge, 2001, 513–21.

12 Serrure and Blommaert, *Kronyk van Vlaenderen*, 219.

13 E.g. a play of Jan de Cuelenare, performed the day after the Ghent entry. It showed a *tableau* in which a scene from the life of Alexander the Great was shown. Samuel Mareel, 'In woord en beeld: Gesproken intredetoneel in de Zuidelijke Nederlanden op de overgang tussen

Middeleeuwen en moderne tijd', *Spiegel der Letteren*, 48: 6, 2005, 8.

14 Hummelen, 'Het tableau vivant', 93–222 and Strietman and Muir, 'Play-texts and tableaux', 513–21.

15 Serrure and Blommaert, *Kronyk van Vlaenderen*, 217.

16 Elisabeth Dhanens, 'De blijde inkomst van Filips de Goede', *Mededelingen van de Koninklijke Academie voor Wetenschappen, Letteren en Schone Kunsten*, 48, 1987, 55–89.

17 Véronique Plesch, 'Notes for the staging of a late medieval Passion Play', in Clifford Davidson, ed., *Material Culture & Medieval Drama*, Kalamazoo, 1999, 75–102.

18 Serrure and Blommaert, *Kronyk van Vlaenderen*, 226–7.

19 Paul Bergmans, 'Note sur la représentation du retable de l'agneau mystique des Van Eyck en tableau vivant, à Gand en 1458', *Annales de la Fédération archéologique et historique de Belgique*, 20, 1907, 530–7; Maximiliaan Martens, 'Art and politics: festive decorations for triumphant entries in the Burgundian Netherlands', in H.T. van Veen, V. Schmidt and J. Keizer, eds, *Polyptiek: Een veelluik van Groninger bijdragen aan de kunstgeschiedenis*, Zwolle, 2002, 27–34.

20 Elisabeth Dhanens, *Hugo van der Goes*, Antwerpen, 1998, 138–41.

21 Max Herrmann, *Forschungen zur Deutschen Theatergeschichte des Mittelalters und der Renaissance*, Berlin, 1914, 378.

22 Serrure and Blommaert, *Kronyk van Vlaenderen*, 223.

23 Dhanens, *Van der Goes*, 141. For a more general view, see Philip Butterworth, ed., *The Narrator, the Expositor, and the Prompter in European Medieval Theatre*, Turnhout, 2007, esp. 11–44.

24 E.g. the negotiations on the specific oaths publicly sworn, Jeanne Mennes, 'De Staten van Brabant en de Blijde Inkomst van kroonprins Filips in 1549', *Standen en Landen*, 18, 1959, 49–165.

25 For Joyous Entries into Antwerp in general, see Margit Thofner, 'Marrying the city, mothering the country: gender and visual conventions in Johannes Bochius's account of the joyous entry of the Archduke Albert and the Infanta Isabella into Antwerp', *Oxford Art Journal*, 22, 1999, 1–27, esp. 5–7.

26 E. J. Roobaert, 'De seer wonderlijcke schoone triumphelijcke incomst van den hooghmogenden Prince Philips ... in de stadt van Antwerpen ... anno 1549', *Bulletin van de Koninklijke Musea voor Schone Kunsten van België*, 9, 1960, 37–73.

27 The account appeared in three language, Dutch, French and Latin. I will use the first one: Cornelius Grapheus, *De seer wonderlijcke schoone Triumphelijcke Incompst, van den hooghmogenden Prince Philips (...)*, Antwerpen, 1550.

28 Jan Bremmer and Herman Roodenburg, eds, *A Cultural History of Gesture: From Antiquity to the Present Day*, Cambridge, 1991, 71–189.

29 Matthijs De Castelein, *De Const van Rhetoriken, Allen Ancommers ende Beminders der zelver, een zonderlijngh Exemplaer ende leerende Voorbeeld (...)*, Ghent, 1555.

30 Anthony Crafton, *Leon Battista Alberti: Master Builder of the Italian Renaissance*, Princeton, NJ, 2002, chapter 4 and N. E. Serebrennikov, '"Dwelck den Mensche, aldermeest tot Consten verweet": the artist's perspective', in Jelle Koopmans, ed., *Rhetoric-Rhétoriqueurs-Rederijkers*, Amsterdam, 1995, 222–7.

31 Alberti, *On Painting*, trans. Cecil Grayson, London, 1996, 41.

32 'Dan comtere des arems ophef en risijnghe, // Principalick op eenighs persoons versisijnghe: // Stamijnghe van voeten, zoo Tullius blye screef.' De Castelein, *Const van Rhetoriken*, strophe 177.

33 Stijn Bussels, 'Jaunty joys and sinuous sorrows: rhetoric and body language in a tableau vivant of the Antwerp entry of 1549', in Elodie Lecuppre-Desjardin and Anne-Laure Van Bruaene, eds, *Emotions in the Heart of the City (14th–16th century)*, Leuven, 2005, 257–69. See for a general view on the use of classical rhetoric in the 1549 entry, Mark Meadow, '"Met geschickter ordenen": the rhetoric of place in Philip II's 1549 Antwerp Blijde Incompst', *Journal of the Walters Art Gallery*, 57, 1999, 1–11.

34 Henri Zerner, 'Looking for the unknowable: the visual experience of Renaissance festivals', in Mulryne and Watanabe-O'Kelly, *Europa triumphans*, vol. 1, 75–98.

35 Georges Marlier, *La Renaissance flamande: Pierre Coeck d'Alost*, Bruxelles, 1966, 386.

36 Grapheus, *Triumphelijcke Incompst*, f° Aii v°.

37 'Och laet ons blijde sijn, laet ons wederom ende wederom blijde sijn: verre, verre van hier allen weedom, allen rouwe: seer schoone blijschapen heeft ons gebracht, de genouchelijcke tegewoirdichheyt van onsen so begeerden Prince.' Grapheus, *Triumphelijcke Incompst*, f° I v°. See Frank Zollner, 'Leon Battista Alberti's *De pictura*: Die kunsttheoretische und literarische Legitimierung von Affectubertragung und Kunstgenuss', *Georges Bloch Jahrbuch des Kunstgeschichtichen Seminars der Universität Zurich*, 4, 1997, 23–9.

38 Alberti, *On Painting*, 41.

39 'Veel behendicheits, moet den lichame dooghen // Met tranen, met suchten, (...) // Diveersche personagen maken diveersche actie: // In al dit hadde de vulle satisfactie // Gracchus, wien gheen speelders nooit verbeien coesten, // Zoo intentelick dede hy hem tot tspels redactie // Dat de vianden diett hoorden screien moesten.' De Castelein, *Const van Rhetoriken*, strophe 175.

40 Nicole Dacos, *La découverte de la Domus Aurea et la formation des grotesques à la Renaissance*, London and Leiden, 1969 and André Chastel, *La grottesque*, Paris, 1988.

41 H. De La Fontaine Verwey, *Humanisten, dwepers en rebellen in de zestiende eeuw*, Amsterdam, 1975 and Carl Van de Velde, 'Hans Vredeman de Vries en de Blijde Intreden te Antwerpen', in Heiner Borggrefe and Barbara Uppenkamp, eds, *Tussen stadspaleizen en luchtkastelen: Hans Vredeman de Vries en de Renaissance*, Ghent and Amsterdam, 2002, 81–90.

42 Rudi Rolf, *Pieter Coecke van Aelst en zijn architectuuruitgaves van 1539*, Amsterdam, 1978; Johannes Offerhaus, 'Pieter Coecke et l'introduction des traités d'architecture aux Pays-Bas', in Jean Guillaume, ed., *Les traités d'architecture de la Renaissance*, Paris, 1988, 443–52 and Krista de Jonge, '"Anticse wercken": la decouverte de l'architecture antique dans la pratique architecturale des anciens Pays-Bas: livres de modèles et traités: 1517–1599', in Michele-Caroline Heck, Frederique Lemerle and Yves Pauwels, eds, *Theorie des arts et création artistique dans l'Europe du nord du XVIe au début du XVIIIe siècle*, Villeneuve-d'Ascq, 2002, 57–74.

43 Pieter Coecke van Aelst, *Boecken van Architecturen Sebastiani Serlii*, Antwerpen, 1553.

44 This is mentioned in the Latin version of the account: Cornelius Grapheus, *Spectaculorum in Susceptione Phillipi Hisp. Divi Caroli. V. Caes. (...) F. An. M.D.XLIX. Antverpiae Aeditorum, Mirificus Apparatus*, Antwerpen, 1550, f° F4 r°.

45 W. Kuyper, *The Triumphant Entry of Renaissance Architecture into the Netherlands*, Alphen aan den Rijn, 1994, 44–9.

46 For the involvement of Cardinal-Infante Ferdinand in the conception of the entry, see David Howarth, 'Rubens and Philip IV: a reappraisal', in Hans Vlieghe and Katlijne van der Stighelen, eds, *Sponsors of the Past: Flemish Art and Patronage, 1550–1700*, Turnhout, 2005, 47–60.

47 Jan Gaspard Gevartius, *Pompa introïtus honori serenissimi principis Ferdinandi Austriacis (...)*, Antwerpen, 1642.

48 Gevartius, *Pompa introïtus*, 117–42. Cf. Elizabeth Mc Grath, 'Le déclin d'Anvers et l'entrée du prince Ferdinand', in Jean Jacquot and Elie Konigson, eds, *Les fêtes de la Renaissance III*, Paris, 1975, 173–86.

49 Martin, *The Decorations for the Pompa Introïtus*, 164.

50 Mieke B. Smits-Veldt, *Het Nederlandse Renaissancetoneel*, Utrecht, 1991, 34–9, 49–51, 63–4 and 83–4.

51 Karel Porteman and Mieke B. Smits-Veldt, *Een nieuw vaderland voor de muzen: Geschiedenis van de Nederlandse literatuur 1560–1700*, Amsterdam, 2008, 302.

52 Gevartius, *Pompa introïtus*, 145.

Chapter 4
Parrhasius and the Stage Curtain:
Theatre, Metapainting and the Idea of Representation in the Seventeenth Century

Emmanuelle Hénin

A fresco by Abraham Bosse representing a *Comédie donnée au château de Grosbois en 1644* (*plate 1*) and preserved *in situ*, is framed by two, apparently symmetrical, curtains. In reality, they are not on the same plane: the one on the right is a stage curtain, red throughout, while the one on the left is richly ornamented and ornamented with embroidery that recalls the wall covering of the principal room. The two curtains frame two levels of representation, to which two types of characters correspond: at ground level, gentlemen in Louis XIII dress, and, on the stage, actors wearing a richer version of the same costume with gilt decorations,[1] and a 'king of comedy' wearing an artificial crown. The painter has emphasized the mirror effect and continuity between the two spaces, which are both equally illuminated by the candlelight. Thus, between the representation on the stage and the representation in the room, there is a difference only of degree: the same compositional element, the curtain, is duplicated on the two levels in order to signify the fact of representation. Confronted with this duplicated image, the spectator adopts the same point of view towards the pictorial representation as the internal spectators do towards the theatrical representation; and the fresco reproduces the reflexive device of a theatre within a theatre, a device at its height in France in the 1640s. The way the representations have been combined completes this reflexive dimension, while emphasizing the parallelism between theatre and painting in the realization of the idea of representation, of which the curtain is one of the most emphatic signs.

This series of connections has a long lineage: the first presentation of a metapicture, the curtain of Parrhasius, certainly took place in a theatre, which is easy to forget because the translations of the anecdote nearly always obscure the fact that the competition between the artists took place in a theatre, a place of public competition, or that Parrhasius had painted a theatre curtain.[2]

[Parrhasius] entered into a competition with Zeuxis: the latter presented grapes so well described that the birds came fluttering close to them on the stage (*in scaenam*); but the former presented a curtain (*linteum*) painted with such perfection (*ita veritate repraesentata*) that Zeuxis, all swollen with pride because of the judgement of the birds, asked for the curtain to be lifted in order to show the painting beneath, and then, having understood his error, he gave in to his rival with sincere modesty, for, although he had tricked the birds, he said, Parrhasius, had tricked him, an artist.[3]

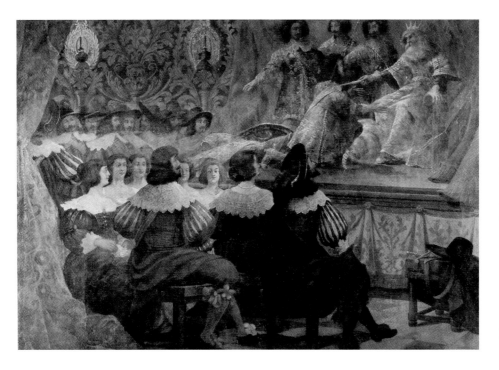

1 Abraham Bosse, *Une comédie au château de Grosbois*, 1644. Fresco. Boissy-Saint-Léger: Château de Grosbois. Photo: Hubert Josse.

The anecdote can be read on two levels: on the first, it is inserted in a series of illusionist anecdotes, and the deceiving of Parrhasius only differs in degree from that of the deception of Zeuxis' raisins (and it is in these terms that it has been understood throughout Western art theory): one tricks animals, stupid birds, the other tricks an *artifex*, an expert in the construction of fictions. Following the pattern of the biter bit, a trope in classical farce, Parrhasius takes Zeuxis for a ride. In fact, as a critic recently suggested,[4] the anecdote of Parrhasius is meta-illusionist: the curtain indicates the absence of representation, in the way in which Balzac's *Chef d'œuvre inconnu* (published in 1831 with substantial revisions in 1837 and 1845) reveals an empty canvas as the apogee of painting. According to Paolo Pino (1548), Parrhasius could have painted a white canvas, which would make it a sort of Malevitzian *White square on white background*, a true predecessor of postmodernism.[5] The curtain has nothing to reveal other than representation itself, it is a marker of representation, and not simply of theatricality. In passing from the grapes to the painted curtain, we pass from mimesis to metamimesis, from the subject of representation to representation as a subject, so that the paradigms of the theatre and of painting seem to pursue each other indefinitely. The curtain used on the first level of the paintings (as in the fresco by Bosse) indicates theatricality; and *a contrario* the stage curtain contributes to the transformation of the stage scene into a painting. Is this nothing more than an artistic version of the chicken and the egg? Fortunately not: when one tries to determine the order of the exchanges between the two arts, one can discern very clearly, behind the perfect reciprocity of the two paradigms on the theoretical level, a sequence of historical mobility. At least, this seems to be the case when we try to reassemble the pieces of the puzzle, and when we consult the numerous testimonies, textual and figural, of the early modern period.[6]

The motif of the curtain appears in art as early as 354, inspired by the court ceremony of the Roman emperors. It was Christianized in the iconography of the evangelists and then of the Virgin, under the influence of the biblical theme of the veil that covers the entrance of the sanctuary in the Old Testament, and that is opposed to the thematics of revelation in the New Testament. From the fifth to the fifteenth centuries the curtain was used in liturgy, notably to cover the altars, a fact which explains its acceptance in sacred iconography, but also its use in the *tableaux vivants* presented during royal entries, and the practice of deploying little curtains to hiding an interior scene in street and college theatre of the fifteenth to the seventeenth centuries. Finally, in the seventeenth century, this liturgical curtain became secularized

and passed from the churches to collections of painting. At the same time, the metacurtain represented on the first plane in the painting no longer serves to reveal divinity but to stage the desire of the spectator, as, in the same period the curtains used in plays employing theatrical machinery are meant to do. In this sequence of coming and going, the curtain is constantly in movement, not only between the theatre and painting, but also between political space (imperial ceremonies, royal entries) and sacred space (the liturgy, religious theatre), and between public (the theatre, the church, the street) and private space (private devotion, painting collections). However, there is a general tendency towards individualization and secularization of representation, in which the idea of unveiling attached to the curtain since its origin no longer leads to transcendence, but has resolved itself into the intimate pleasure of the spectator.

Painting in the Theatre

If the curtain of Parrhasius can be interpreted as a stage curtain, it is because the use of such curtains has been attested since the second century BCE. These curtains were struck at the beginning of the play, marking the beginning of the representation (*auleum mittitur*), and were raised at the end (*auleum tollitur*), a technique widely used until the seventeenth century, as we will shortly see.[7] Admittedly, Pliny does not use the term *auleum* specifically, but the word *linteum* (linen canvas), which is not restricted to either painting or the theatre but which can refer to both. Both arts are intimately linked not only in theatrical practice but also in the very concept of illusionism since Plato. His criticism of *skiagraphia*, the art of perspectives painted in *trompe-l'œil*, was aimed directly at stage sets, so much so that the tradition has assimilated *skiagraphia* and *scaenographia*.[8] According to Vitruvius the use of these painted perspectives on the scene goes back to Agatharcos (468 BCE), but Pliny records examples on the Roman stage closer to his own time, as an anecdote very similar to that of Parrhasius and Zeuxis confirms:

> There was also a stage set at the games offered by Claudius Pulcher [99 BCE], the paintings of which aroused great admiration: in particular, the crows, tricked by the illusions, tried to alight on the well-copied tiles.[9]

In Antiquity, painting and theatre are two equivalent paradigms of mimesis because both arts work to create illusion. In fact, theatre uses painting to achieve scenic illusions because not only has the decor been painted, but the curtain as well.

The practice of using painted curtains in Antiquity is documented in classical texts, and was well known to early modern scholars. In 1682, Ménestrier described the impact of the raising of a curtain at the end of a performance, gradually revealing the painted personages.

> [Virgil] tells us that the tapestries were folded at the lower edge, and that in raising them gently by pulling on the ropes attached to them, the characters represented on the tapestries seemed to raise themselves. Ovid says it more clearly: 'Thus, when in the theatre, on the rising curtain, the painted characters stand up, showing first their face, then little by little the rest and, unfolding suddenly with a slow and continuous movement, they appear completely and take their place at the edge of the stage.'[10]

Ovid compares this sudden appearance to that of the warriors born from dragon teeth who emerge out of the earth in front of Cadmos' eyes. This emphasizes the surprise and terror that such an appearance was bound to provoke. The surprise was accompanied by the bewilderment of seeing actors of flesh and blood replaced by their illusionary doubles as a result of a gradual shift in the level of representation.

It is precisely this confusion the 'decorators' of the Renaissance wished to provoke. The only surviving visible trace of this is the *bozzetto* carried out by Francesco Zuccari for the curtain of the *Cofanaria* of Francesco d'Ambra, performed in Florence in 1565, which is in the theatre created in Vasari's Uffizi. This marked the peak of illusionist theatre. The stage decor showed a perspective of streets, starting from piazza Santa Trinità, while the curtain represented a hunting scene with an idealized view of the surroundings of Florence.

> A large canvas representing different animals, hunted and captured in different ways, and supported by a large frame, hid the perspective behind it.[11]

> And, to prevent us from seeing it, the space in which the perspective of the play was placed was kept covered during several days by a canvas of 23 *braccio* long and 15 high [about 15 × 10m], on which a hunting scene had been painted, with numerous characters, both on horse back and on foot, with dogs and birds, hunting in a very large and very beautiful landscape.[12]

In the first years of the seventeenth century, under Italy's influence France adopted the painted curtain for the first, mainly ballet, performances to use stage sets and machinery adapted from Italian scenography. The curtains typically represented a city or landscape, or the interior of a sumptuous palace.[13] Just as in the Italian records, the accounts continually stressed the importance of hiding the scene decor in order to create the effect of surprise and to maintain the spectators 'in an impatient desire to see'.

> A large canvas on which Vaucluse was painted, and its fountain in the distance, stretched over the front from the cornice to the ground, for fear the spectators should see anything until the time decreed.[14]

> Because the things that surprise us touch our senses most powerfully, one has to be aware that to hide the façade of the theatre in such a way that one cannot see the scene before the beginning of the ballet from the parterre, nor from the amphitheatre, nor even from the galleries. To this end, there will be a large canvas stretched out in front, and, extending from the top of the floor to the ground, it will keep all the spectators in a state of impatient desire to see what it hides. Once the time has come to bring it down, it will disappear at once and unveil a quite comical scene.[15]

But the curtain could also represent an scene of action with characters, thus taking over the role of the stage to represent scenes that could not be staged. In this way, the ballet of *Tancrède en la forêt enchantée* (1619), inspired by Tasso's *Gerusalemme Liberata*, used an interlude to show the Siege of Jerusalem painted on a curtain.[16] In a more unusual case for city theatre, a play of 1662 written by the actor Rosidor, a canvas fell at the end of the fourth act showing 'a battling army is represented crossing a bridge', reminiscent of the *Battle of the Amazones* by Rubens of 1616.[17]

Yet, the painted curtain is best documented in Germany, both in texts and in surviving curtains which for the most part date to the eighteenth and nineteenth centuries.[18] Their introduction was due to Joseph Furttenbach (1591–1667), who visited Italy and its theatres and who built an ideal theatre in Ulm in 1641. Like the Italians and the Ancients, the architect installed a trapdoor between the playhouse and the stage to receive the curtain. In his *Architectura recreationis* (1640), Furttenbach proposed four types of painted curtains, adapted to different types of plot lines,[19] which the spectators would see immediately they entered the theatre.

> When the spectators enter the theatre and take their places, they simply notice the presence of the curtain, but do not know what is behind it and have to content themselves with imagining this marvel and being patient for a moment. This makes them even keener to keep their eyes fixed on it, especially when, in the interval, Mezzetino and Scapino, unseen, run after one another, their words and screams are heard, even sometimes a *canzonetta*, then the sound of the lute and the bass. Finally, there is a lot of movement and a lot of noise, as if all this wants to crash down on the spectator, quite apart from the kettledrums and trumpets, and precisely in the middle of this turmoil, the curtain suddenly falls and presents the heroic construction of the *scena di comedia*.[20]

The purpose of the painting was thus to keep the spectator frustrated and to sharpen his desire to see the representation. The play in fact starts behind the curtain, and the powerless public can do nothing but stare dispairingly at the image, while the sounds become more and more evident: dialogue, shouts, songs, trumpets, and, finally, a roar announcing the falling of the curtain that forms a first climax of the performance, even before its proper commencement. In presenting a substitute, splendid but inert and mimed, the director also created a gradation in his magnificent effects. Furttenbach's system spread over the German and Austrian courts, to Dresden, Munich, Innsbruck, Vienna. In each place, directors made use of the speed with which the painted image could reveal another, animated, image.[21]

The curtain of the *auleum* type, used in Italy since the beginning of the sixteenth century and in France since 1610,[22] transported the spectators into the fictive space in one single movement. It coexisted with another type of curtain that appeared around 1620 and was wound up on a cylinder situated in the stage frame. In his *Trattato per fabricar scene* (1628), which reviewed the inventions of the illusionist stage, Nicolo Sabbatini envisaged both techniques. He didn't conceal his preference for the second because it was able to avoid 'break[ing] the wonder that the unexpected and uniform fall of the curtain produces'.[23] In fact, a curtain managed by two persons risks not falling uniformly, or crashing down on the spectators, provoking confusion in the stalls – at least in the absence of a trapdoor sufficiently large to accommodate it, or when the spectators are seated on the stage as was the case in France.[24]

The curtain completes the assimilation of the stage into a painting. In closing the box of illusions it functions as a fourth wall, defined before Diderot by Leone de'Sommi of Ferrara around the middle of the sixteenth century.[25] While it forms a screen between the performance and the spectator, it is a provisory and unstable screen, a temporary separation rather than a breach. It is a curtain that exists to be raised, a curtain whose purpose is unveiling; it veils only to unveil, appears only to disappear, as the treatises and accounts of feasts show abundantly was the case in Italy as in France or Germany. In Italy and in France, the curtain does not serve to

mask the scene changes, which are produced 'in view' for the greater pleasure
of the spectator: a curtain was used for the first time to mark the entr'acte at the
Paris Opera in 1829. The lowering of the curtain is one of the prodigious effects
of the Baroque theatre, which were incessantly praised. When Corneille's *Andromède*
(1650) was staged by Torelli with six successive decorative schemes, as the second
grand production employing stage machinery after that of *Mirame* of 1641, the
gazetteer Théophraste Renaudot admired the speed with which it was done. The
stage used the cylinder system recommended by Sabattini to instantly unveil the
stage set:

> You will not find here the same artifice that Parrhasius used on his curtain to
> dupe his competitor in painting; for the curtain that presents itself first to the
> eyes of the spectators ought not to limit the view. That is why it is raised to
> mark the opening of the theatre, but so swiftly that, no matter how closely it
> watches, the subtlest eye cannot follow the speed with which it disappears, so
> well suited to its size are the counter-weights that raise it.[26]

Invoking the Greeks and the Romans and full of allusions to the canon of artistic
theory, Renaudot's account made Torelli, Zeuxis, the victorious rival of Parrhasius and
an *artifex* who made the greatest artifices. In fact, if Parrhasius produced the illusion of
an absent curtain, Torelli contrives the illusion that the curtain, although present, does
not exist. In the alchemy of representation that constantly covers over the tracks of
being and non-being, the Moderns prevail over the Ancients.

The curtain placed in front of the stage characterized with its magnificent
effects the illusionist theatre *à l'italienne*. In France, it was reserved for ballets and
plays using machinery during a large part of the seventeenth century. On the other
hand, the same effect of sudden unveiling was produced, though more modestly,
by the 'small curtain' that covered the compartments of the stage in one of the two
theatres in Paris.[27] The theatre of the Hôtel de Bourgogne, directed by the Confrères
de la Passion from the fifteenth to the seventeenth centuries, continued in fact to
use the compartments derived from mediaeval *mansions*, similar to those shown
in the frontispieces to the comedies of Terence produced for the humanist stage.
In the Trechsel edition, published in Lyon in 1493 for instance, every character
has a house in the form of a bath room covered by a curtain hanging from a small
rail which could open when necessary. However, in the Hôtel de Bourgogne these
compartments represented not houses, but a certain number of topical places
(forest, prison, room, palace). They were disposed on the stage in a symmetrical
manner, three, five or seven of them, and covered with a 'tapestry' until the moment
when they were brought into the action.

The curtain could have a purely functional role in revealing a new place, but, for
preferrence, it was opened onto a spectacular scene. In the *Illusion comique*, the final
raising of the curtain coincided with the *coup de théâtre*, since Pridamant notices that his
son is not 'really' dead and he has been playacting – revealing a third level of fiction:
'One draws a curtain and one sees all the actors who share their fee'.[28]

The curtain also often reveals a miraculous or bloody scene. In *Martyre de sainte
Catherine* by Puget de la Serre (1643), the emperor hears a noise of thunder and
then sees Catherine appear in a celestial apotheosis. The whole scene plays with the
ambiguity of the vocabulary of the 'marvellous' and 'belief', indicating the prodigies
both of the supernatural and of the theatrical machinery.

My eyes have to see it as well, I can hardly believe it: *the curtain is drawn*. What a strange spectacle, she leaves in triumph in the middle of the torments, as if her body were made of stone or bronze.

Yet, everything leads us to believe that the small curtain, hampered by its reduced dimensions and the poor visibility of the stage, produced a limited effect. To reduce its arbitrariness, the dramaturges made it similar to a curtain around a bed, following D'Aubignac's proposition all elements of the representation should have a precise motivation in the play's action, a position characterizing 'absolute mimesis' *à la française*. Several plays make use of this conceit of a bed equipped with opening curtains that permit the concealment and reappearance of a character, or even the representation of the moment of death.[29] The bed provides the pretext for the curtain, justifying its appearance in both the exterior and the interior of the representation; while existing in reality only for the spectator, it pretends that it exists for the characters of the fiction.

The use of the small curtain leads us to the heart of the exchanges between the theatre and painting. In fact, it comes directly from royal entries, where a partial curtain could unveil a painted canvas or a *tableau vivant*. In both cases, this unveiling was dramatized: entrusted to an actor, it was accompanied by music and commented on by a reciter. In this manner, street theatre imitated the custom of unveiling altars, paintings and relics in churches, to the accompaniment of music. It is a matter of the transposition of a sacred practice into the secular, like the Baroque vocabulary of the scenic 'miracle' directly derived from religious vocabulary. Thus, when the *Lamb of God* was performed in Ghent in 1458 in the form of a *tableau vivant*, the stage (which measured 38 × 50 *pieds*, approximately 30 centimetres) was covered by a black curtain, drawn to the side to reveal the picture exactly as the altarpiece was revealed by opening the shutters. The iconography of the royal entries, especially in the Low Countries, shows the size of the triumphal arches, the niches of which contained statues, paintings, and actors, as well as high galleries for the musicians, all successively intervening in the action according to an impeccable choreography. To give only one example, during the entry of James I into London in 1603, the arch of Flemish merchants showed the painting of a king on a throne as the king approached; then, at the sound of trumpets, a curtain in the central arch revealed a *tableau vivant* of seventeen young girls in Roman costumes, representing the seventeen provinces of the Low Countries. Behind them tapestries appeared, and on every side of this interior stage, niches with painted figures, both biblical and historical. After the young girls had saluted the king, a scholar read a compliment in Latin verse.

The importance of these interior scenes, whether they be theatres or paintings, is connected to the double images, which originated in the mid-sixteenth century in the atelier of Pieter Aertsen and marked the official advent of 'metapainting'[30] at the time when the 'metatheatre', or theatre within theatre, first saw the light on the Elizabethan stage. An engraving by Jacob Matham after Aertsen for instance represents a kitchen with a woman preparing fish. In the background, the scene of *Christ at Emmaüs* appears in a compartment, a small scenic box similar in detail to those street theatres that could be opened by drawing a curtain. This image shows the process of secularization of the interior image: the sacred image is relegated to the background and given a secular context. Although its unveiling recalls that of altar paintings, and its presence in the middle of the kitchen is supposed to project onto daily life the light of the beyond, the profane and the daily nonetheless invade the stage, and its symbolic connotations, such as the Christian symbolism of the fish, become less and less readily

2 Adrian van der Spelt, *Still Life with Flowers,* **1658. Oil on panel, 46.5 × 63.9 cm. Chicago: Art Institute (Wirt D. Walker Fund, 1949.585). Photo: Art Institute of Chicago.**

perceived by the audience. Moreover, the device of the double representation no longer serves to show the advent of the supernatural, but functions as a mere apology for the representation. The compartment with curtains, a device both liturgical and theatrical, is included in the painting as a mirror, a way to reflect its tools and its specific effects.

The Theatre in Painting
In describing the presentation of *Andromède*, Renaudot linked the story of Parrhasius to the theatre, and, at the same time, to the whole vocabulary of the illusion, of the *inganno*, common to both arts. In 1625, Piero Accolti gave the title *Lo Inganno degli occhi* to a treatise, recapitulating all the findings on pictorial and theatrical perspective since Serlio and Barbaro, while proposing original solutions, not only to match the stage paintings in *trompe-l'œil* with the inclined surface of the stage (chapter 31), but also to represent a painting in a painting – as Peter Aertsen did (chapter 34).[31] In the rewritings of the story of Parrhasius, the word *inganno* often reoccurs to translate the word 'error' in Pliny:[32] but the latter referred to the intellectual error of Zeuxis, whereas the term *inganno* refers to the creation of an illusion and has both an objective and a subjective meaning: the illusion contrived by the decor, and the illusion suffered by the spectator. In their translation and reading of Pliny, the theorists naturally inclined the text towards an illusionist meaning in accordance with dominant ideas of representation in the sixteenth century. Moralizing comments describing the deceit created by the 'as if' of representation multiply: 'as if it were a canvas covering the

painting' (Borghini[33]); the curtain was 'so similar to the natural' (Dolce); 'so natural' (Lomazzo); 'painted with such a relief' (Bocchi), that it provoked the *inganno*.
All these terms converge in a pean to illusionism, the lesson common to antique anecdotes and the old refrain of the art treatises, as Lomazzo suggested in a weary way:

> And everybody knows the story of Zeuxis, who painted the green grapes so naturally that birds flew onto the stage of the theatre in order to peck them; and he himself was then tricked by the veil that Parrhasius had painted over the grapes.[34]

Lomazzo understood that Parrhasius completed the painting of Zeuxis, and *really* painted his curtain *on top of* the grapes of his rival, but (and there the magic ends), unlike a real curtain, one could not raise it to reveal an image underneath.[35] The hypothesis is seductive, if one imagines that the curtain covered only half the grapes and let the viewer guess at what was beneath, so that the final image amounted to a *trompe-l'œil* painted by four hands. The success of the *trompe-l'œil* would therefore be due as much to Zeuxis as to Parrhasius, and would represent the curtain in the act of unveiling the fruits. It is precisely in this way that painters understood the anecdote, and it is with this double painting that they wanted to compete. In fact, if Cornelis Gijsbrechts perhaps painted the back of a painting (Copenhagen, Statens Museum for Kunst), not a single *trompe-l'œil* represents a *closed* curtain, but always a curtain *opening*. In the *Still life with flowers* by Adrian van der Spelt (1658, Art Institute of Chicago, *plate 2*), the curtain of blue brocade opens on an opulent still life of flowers: flowers and curtain are both equally sensually painted and full of texture, just as the curtain of Parrhasius was as well painted as the grapes of Zeuxis.

This *trompe-l'œil* curtain, hung on a fine brass rail and apparently covering the painting, corresponds to a fashion disseminated in Holland by Rembrandt and the Delft painters for a short period in the mid-seventeenth century. The first, and the most famous, example is the *Holy Family* by Rembrandt (Kassel, 1646, *plate 3*), where a red curtain unveils a family in a stable, represented in such a simple fashion that one is surprised to recognize the holy family in it – once again, the duplication of the representation is in step with the secularization of the imagery.[36]
In *The spy* by Nicolas Maes (1656, London, private collection)[37] an even more subtle device has been used, since, contrary to common use, the curtain is not drawn to the right side of the painting, but covers an intermediary zone, precisely where the characters observed by the spy are located,

3 Rembrandt, *Holy Family with Curtain*, 1646. Oil on panel, 45 × 67 cm. Kassel : Staatliche Museen, Gemäldegalerie. Photo: Staatliche Museen Kassel.

thus robbing the spectator of the principal scene and allowing him only the *parerga*, the indicators of the representation, in the feigned frame, curtain, and internal spectator.

It might seem that these curtains could easily be explained by the growing habit of collectors, on the recommendation of Giulio Mancini, of covering their paintings to protect them from the dust and light, as many Dutch paintings show.[38] But this sociological explanation will not suffice, for if those curtains reproduce in *trompe-l'œil* a conservation practice developed in the seventeenth century, how is it that it can be found already in the *Saint Augustine* by Botticelli (c. 1495, Uffizi), in the *Nativity* by Hugo van der Goes (c. 1470–80, Berlin; for an image see *plate 1* in the chapter by Stijn Bussels in this volume), in the *Annonciation* by Grünewald (Retable of Issenheim, Colmar, c. 1512–16), or also in the *Sixtine Madonna* by Raphaël (1513–14, Vatican)? In these works with a purely sacred purpose, revelation coexists with the *mise en abyme* of the representation, without the emphasis that this places on its autonomy harming the epiphany of the divine.[39] The curtain, suspended from a narrow rail, remains faithful to the one that can be observed on miniatures and bas-reliefs from late Antiquity and which became a *topos* of representations of Mary, and was determined as well by the liturgical practice associated with altar curtains. The curtain in *trompe-l'œil* of the seventeenth-century Dutch is therefore inspired by this liturgical use of altar curtains (which, as we have seen, had also inspired the scenography of royal entries), and also imitates a practice of collectors, itself transposed from the public and sacred space to the private and secular. Exhibition curtains appear at the very moment that liturgical curtains disappear.[40] Between the fifteenth and the seventeenth centuries, the in *trompe-l'œil* curtain gradually loses its sacred connotation, retaining only that of metapictoriality.

However, there is at least one exception to this rule. In the era of the complete secularization of the motif, a French painter of Flemish origin gave it back its original sacred connotation in an image that arouses confusion and ambiguity. In the *Sainte Face* by Philippe de Champaigne, the curtain opens on another paradigm of illusionism, the miraculous image of the real portrait of Christ, which is to Christian apologetics what the grapes of Zeuxis are to the artistic literature of Antiquity. The big difference is that the reality of representation (*ita veritate representata*, said Pliny) is guaranteed by the Reality of the Incarnation: this reality has a transcendent sense that redeems the painter's artifice. This is the argument invoked by Philippe de Champaigne for instigating a hyper-illusionism in the context of the aesthetics of Port-Royal, which were so hostile to images. The *artifex* has the power to unveil the invisible, and the illusionist artifice reveals the highest truth, according to a common dialectic in the religious theatre of the period, as we have seen in *Le Martyre de Sainte Catherine*.[41] Champaigne played with this ambiguity and seized on a fashionable motif to give it theological depth.

If the iconography of this *Holy Face* is exceptional, since it is the only one to connect the veil of Véronique with the artifice of the curtain, everything suggests that the religious connotation had not entirely disappeared. Paul Fréart de Chantelou provides a striking testimony of this. When he showed Bernini his collection of paintings in 1655, so he tells us, the display of the *Sept Sacrements* by Poussin was the object of a particular ritual. Chantelou arranged for the paintings to be uncovered one by one, while Bernini approached and knelt to observe them, comparing them finally to 'a beautiful sermon'.[42] The contamination of the respective registers of the visit and a devotional practice continued when Bernini went to visit the merchant Paul Serisier on leaving the church of Saint-Laurent. Theatrically unveiling the *Esther* by Poussin, the merchant affirmed in the tone of a revelation: 'It is by signor Poussin'.[43] Revealed truth

has been replaced by the authenticity of the work, and the sacredness of art is about to replace the sacred character of its subject.

Poussin himself approved of this habit of covering paintings with a curtain, which was also adopted by another of his devout clients, Séraphin de Mauroy.[44] He wrote to Chantelou on 22 June 1648:

> The intention of covering your paintings is excellent, and to make them visible one by one will mean we don't grow tired, for seeing them all at the same time fills the senses too much at once.

Just as the scenographers used a painted curtain to present their first spectacle to the audience and to emphasize the surprise of its unveiling, the collector transformed the decor of his gallery into a spectacle, not static anymore but dynamic, so that every raising of the curtain became a dramatic turn of events.

So, the exposition curtain had the same function as the theatre curtain: to unveil. Champaigne and Van der Spelt represented with hallucinatory effect the whole apparatus of hanging, with its rings of shiny brass, well designed to catch the spectator's gaze and to invite him or her to become aware of the representation. In including this system of hanging in their *trompe-l'œil*, the painters shift the limits of the image to the spectator's side and include a supplementary fragment of his reality. They thus blur the borders of representation, for, most often, the curtain is painted at the threshold of the picture, ambiguously in the exterior or the interior, insofar as it is possible to integrate it into the represented space at all. In this way the curtain in *trompe-l'œil* refers to two distinct realities, respectively extrinsic and intrinsic to the representation, and these two realities serve as a provocation for the metapainting and underline the representation.

Without a doubt the curtain is, even more than the frame, a motif that illustrates the importance of these concrete exchanges between theatre and painting, as I have tried to show by reconstructing a history of the successive migrations of the motif. In fact, the curtain is not a simple technique borrowed from the theatre, as a stage set, an emphatic gesture or a mask could all be borrowed. And we know how dangerous and futile it can be to label a painting with the term 'theatricality', either both arts derive from a common cultural background (for example the expression of the passions), or the painter voluntarily employs a theatrical technique to parody it, in which case the conclusion fails. Because of its reflexive dimension and its absolutely unique capacity to either unveil the representation, or, on the contrary, to hide it from the spectator's view, the curtain takes painting and the theatre back to their essence as representation. Since Plato, Aristotle and Pliny, both arts have constituted reciprocal paradigms of mimesis, which is defined as the art of deceiving the consenting spectator, and, by doing so, provoking his or her greatest pleasure. This is why, rather than speaking of 'pictorial theatricality', it seems to me better to talk of the reciprocity of two models, as one did not exist before the other and as this reciprocity stems from antique aesthetics. However, these two paradigms are not abstract, but are embodied in societies characterized by the wide presence of 'theatricality' in its broadest sense, early modern societies being societies of spectacle *avant la lettre*. Processions, *tableaux vivants*, royal entries, court ceremonies are all cultural realities that constantly influence and enrich the concrete practices of painting and the theatre. A mental immersion in this ancient culture is a first, indispensable, step for anyone who wants to understand its artistic expressions: the second step is to incessantly compare the sources, textual and visual, historical and practical, to allow the emergence of multiple connections

that will permit us to establish the relationships between painting and theatre. Such an approach, both historical and theoretical, presupposes the effort to rid ourselves of our modern and postmodern assumptions in order to perceive the strength and character of early modern aesthetics.

(Translated by Sigrid de Jong)

Notes

1 See A. Verdier, *Histoire et poétique de l'habit de théâtre en France au XVII^e siècle*, Paris, 2006.

2 With the notable exception of Lomazzo, *Trattato*, III, 1, cited below; the text is resumed as it is by F. Bisagno, *Trattato di pittura*, Venice, 1642, p. 227.

3 Pliny, *Natural History*, XXXV, 65.

4 See Stephen Bann, *The True Vine: On Visual Representation and the Western Tradition*, Cambridge, 1989; and Helen Morales, 'The torturer's apprentice: Parrhasius and the limits of art', in J. Eslner, *Art and Text in Roman Culture*, Cambridge, 1996, 182–209. Morales gives two possible interpretations: either a stage curtain, or a curtain covering a painting in the way of collectors.

5 The *White square on white background* by Malevitch dates from 1918. See P. Pino, *Dialogo di pittura* (1548), in P. Barocchi, ed., *Trattati d'arte del Cinquecento*, vol. I, Bari, 1960, 112.

6 For the history of the theatre curtain: G. Kernodle, *From Art to Theatre*, Chicago, 1944; G. Védier, *Origine et évolution de la dramaturgie néoclassique française*, Paris, 1955; and K. Bachler, *Gemalte Theatervorhänge in Deutschland und Österreich*, Munich, 1972. For the history of the curtain in painting: J-K. Eberlein, *Apparitio regis- revelatio veritatis. Studien zur Darstellung des Vorhangs in der bildenden Kunst von der Spätantike bis zum Ende des Mittelalters*, Wiesbaden, 1982; and for a typology of pictorial curtains: G. Banu, *Le Rideau ou la fêlure du monde*, Paris, 1997 (more interesting for the iconography than for the interpretation, that suffers from anachronism).

7 See Cicero, *Pro M. Caelio*, 65; Horace, *Epistles*, II.i, 189; *Phèdre*, V.7, 23.

8 See A. Rouveret, *Histoire et imaginaire de la peinture antique*, Rome, 1986.

9 Pliny, *Natural History*, XXXV, 23.

10 Ménestrier, *Des ballets*, 1682, 216. See Ovid, *Metamorphoses*, III, 112.

11 G.-B. Cini, *Descrizione dell'apparato fatto in Firenze per le nozze dell'Illustrissimo ed Eccellentissimo Don Francesco de'Medici*, in Vasari, *Opere*, Florence, 1906, vol. VIII, 572.

12 D. Mellini, *Descrizione de gl'interdmedii rappresentati con la commedia nelle nozze dell'Illustruissimo ed Excellentissimo Signor Principe di Firenze*, Florence, 1593.

13 *Ballet de la prospérité des armes de la France*, danced 7 February 1641 in the Cardinal's Palace, in P. Lacroix, *Ballets et mascarades de cour de Henri III à Louis XIV (1581–1652)*, Genève, 1898, vol. VI, 34: 'La grande toile qui cache le théâtre, représentant un beau palais, s'ouvre peu à peu, et découvre tout le théâtre.'

14 'Une grande toile où Vaucluse était peinte, et sa fontaine dans un éloignement, s'étendait sur le devant depuis la corniche jusqu'à terre, de peur que les spectateurs ne vissent rien jusqu'au temps ordonné.' *Ballet des divers entretiens de la Fontaine de Vaucluse*, danced in 1649 in Avignon, in the grand theatre of Roure, Lacroix, vol. VI, 195.

15 'D'autant que les choses qui surprennent touchent plus puissamment les sens, on s'est avisé de cacher la face du théâtre de telle façon, que ni du parterre, ni de l'amphithéâtre, ni même des galeries, on ne pourra voir la scène devant que de commencer le ballet. À cet effet, il y aura une grande toile qui s'étendra au-devant, et prenant depuis le haut du plancher jusques à terre, tiendra tous les assistants dans un impatient désir de voir ce qu'elle cachera. L'heure étant venue de l'abattre, elle disparaîtra incontinent et découvrira une scène tout à fait comique.' *Grand Ballet des effets de la Nature*, 1632, danced on 27 December 1632 in jeu de Paume du Petit Louvre, Lacroix, vol. IV, 194.

16 *Grand Ballet du roi sur l'aventure de Tancrède en la forêt enchantée*, danced in the Louvre on 12 February 1619, Lacroix, vol. II, 168c: A large canvas was extended in the front, that measured from the stage until the ground a length of five *toises*, and that had been painted with the siege of Jerusalem, and a forest on the side. As the canvas breaks down, a grand and thick forest in flat painting appears in the background and to the sides.

17 'On fait tomber une toile, où est représentée une armée en bataille qui passe sur un pont.' Rosidor (Jean Guillemay du Chesnay), *La mort du grand Cyrus*, Paris, 1662. The Rubens was painted for Philip IV in 1616, and is now in the Alte Pinacothek in Munich.

18 See K. Bachler, *Gemalte Theatervorhänge*.

19 They respectively represent a street perspective with simple houses, another one with noble houses, following the example of the comic and tragic scenes of Serlio; a garden and the Palio square in Sienna.

20 Furttenbach, *Architectura recreationis*, Augsbourg, 1640, 60.

21 See Georg Philipp Harsdörffers, *Frawen-Zimmer Gespräch-Spiel*, 1649.

22 The first curtain of the forestage was designed for the ballet of the duke of Vendôme in the Louvre, in 1610; see Lacroix, vol. I, 241: 'There was a great silence everywhere, when the curtain that covered the forest fell to the ground, and this forest became visible.'

23 'Rompre l'émerveillement que produit, en un tel instant, la chute inattendue et uniforme du rideau.' Sabattini, *Prattica per fabricar scene ne'teatri*, Ravenna, 1638; trans. L. Jouvet, Paris, 1947, ch. 37. 'Comment et de quelles façons enlever le rideau qui cache la scène' (59).

24 Sabattini, *Prattica per fabricar scene ne'teatri*, 60: 'The second way, if it necessitates more costs and work, would on the other hand be better. It would create its effect with a greater velocity and not rouse any confusion, which is the case when the curtain falls partly on the spectator causing noise and disorder.'

25 For this book, I refer to my book, *Ut pictura theatrum*, Genève, 2003.

26 'Vous ne trouverez pas ici même artifice que Parrhaze employa dans son rideau pour tromper son compétiteur dans la peinture; car celui qui se présente le premier aux yeux des spectateurs ne doit pas borner la vue. C'est pourquoi s'il se lève pour faire l'ouverture du théâtre, mais avec une telle vitesse que l'œil le plus subtil, quelque attachement qu'il y apporte, ne peut suivre la promptitude avec laquelle il disparaît, tant les contre-poids qui l'élèvent sont industrieusement proportionnés à sa grande étendue.' *La Gazette*, 18 février 1650, in Corneille, *Andromède* (1650), ed. C. Delmas, Paris, 1974, 158.

27 The date of the appearance of the forestage curtain is a source of debate; in the Hôtel de Bourgogne, the documents only give prove of its use from 1647 onwards, and before that its use is rather exceptional.

28 'On tire un rideau et on voit tous les comédiens qui partagent leur argent.' Corneille, *L'Illusion comique*, 1635, last scene.

29 For example *Agésilan de Colchos, Crisante et Les deux pucelles et L'Heureux naufrage* de Rotrou, *Les Galanteries du duc d'Ossonne* de Mairet. See M. Vuillermoz, *Le Système des objets dans le théâtre français des années 1625–1650*, Genève, 2000, 259.

30 See V. Stoichita, *L'Instauration du tableau. Métapeinture à l'aube des temps modernes*, Genève, 1999.

31 Pietro Accolti, *Lo inganno degli occhi, prospettiva prattica*, Florence, 1625.

32 The word 'inganno' is notably found in Lomazzo, Bisagno (loc.cit.) and Borghini (*Il Riposo*, 1584, 270); and the participle 'ingannato' at Dolce, *Dialogo di pittura*, in P. Barocchi, *Trattati*, vol. I, 182–3, Bocchi (*Eccellenza del San Giorgio*, ibid., vol. III, 163–4).

33 (Or, according to Dolce, 'a part of a canvas that seemed to hide a painting,' (*pareva che occultasse una pittura*).

34 Lomazzo, *Trattato dell'arte della pittura*, Milan, 1585, III, 1: 'Et è istoria nota a ciascuno di Zeusi che dipinse verti grappi d'uva tanto naturali, che nella piazza del teatro vi volarono gli uccelli per beccargli; è ch'egli medesimo restò poi ingannato del velo, che sopra que'grappi havea dipinto Parrhasio.'

35 The same G.-B. Adriani imagines that Parrhasius has placed a veil painted on a canvas on top of the painting of Zeuxis. (Letter to Vasari, 8 September 1567, in Vasari, *Vite* (1568), Florence, 1906, vol. I, 27.)

36 On the painting, see W. Kemp, *La Sainte Famille de Rembrandt ou l'art de lever un rideau* (1986), Paris, 1989.

37 Painting studied by V. Stoichita, *L'Instauration du tableau*.

38 G. Mancini, *Considerazioni sulla pittura* (v. 1620), ed. A. Marucchi, Rome, 1956, volume I, 143: 'Without a doubt, the curtains help to keep the works in good condition. The ideal would be to have a curtain that we can raise and lower, instead of open it to the side, which harms a good exhibition of the painting.' The learned collector advises a green or red taffeta (in fact, the colours we find in the painting). This protective curtain is seen in the cabinets of Flemish amateurs, notably the ones of W. Van der Haecht, *La collection de Cornelius van der Geest*, 1628, Anvers, Maison de Rubens; or Adriaen van Stalbemt, *Cabinet d'amateur*, Baltimore, Walters Art Gallery, but also in the scenes of the Dutch genre such as the *Lady reading a letter* by Metsu (about 1664, Dublin).

39 As D. Arasse has shown in *Les Visions de Raphaël*, Paris, 2003, in regard to the Sistine Madonna, following J.-K. Eberlein, 'The Curtain in Raphael's Sistine *Madonna*', *Art Bulletin*, 1983, 61–77.

40 See J. Braun, *Der Christliche Altar*, Munich, 1924.

41 We can name an example resembling the sacred remotivation of the curtain, although that one covers a crucifix and not a painting: in the *Saint Bonaventure* de Zurbarán (1629, Berlin, Gemäldegalerie), the Franciscan saint opens a curtain covering a crucifix placed in a niche in his library, to show it to the Dominican monks.

42 P. Fréart de Chantelou, *Journal de voyage du cavalier Bernin en France*, 1655, ed. M. Stanic, 88.

43 Chantelou, *Journal de voyage du cavalier Bernin en France*, 112.

44 See R. Beresford, 'Séraphin de Mauroy. Un commanditaire dévot', *Nicolas Poussin* colloque, 1996, vol. II, 721–45. The three paintings by Poussin, with a religious topic, were covered by a curtain of red taffeta, mentioned in the inventory: 'Item un tableau de la Nativité de Poussin avec sa bordure de bois doré un rideau de taffetas rouge' (736).

Chapter 5
In Front of the Work of Art:
The Question of Pictorial Theatricality in Italian Art, 1400–1700

Marc Bayard

The relationship between theatre and the visual arts, especially painting, has long been examined with a certain degree of ambivalence, generally being studied through the lens of a logic of influence that perceives the sources of one art form as archetypes for the other. At the beginning of the examination of the link between pictorial and theatrical arts, two publications laid down the methodological foundations of the comparative method. As early as 1908, Émile Mâle saw in medieval sacred theatre the source of a great many iconographical motifs.[1] In contrast, George Kernodle suggested that pictorial solutions (most notably in the use of linear perspective) enabled the development of theatre and opened it up to more 'realist', secular performances, which placed greater emphasis on being 'true to life'.[2]

From a bibliographical point of view, Ernst Gombrich adopted a semiological approach in order to study the viewer's gaze, and focused on the psychological component of perception, a subjective way for the viewer to embrace visual forms throughout the history of art.[3] In the context of an early archaeology of the gaze, the work of Michael Baxandall – especially on the issue of the relativity of perception and on linear perspective in the Quattrocento – was fundamental for the understanding that every epoch developed its own 'period eye' based on economic, political and, at least in the Renaissance, especially theological assumptions.[4] For his part, John Shearman discerningly recognized the importance of the place of the viewer, his geographical position and ideal spatial placement in grasping the meaning of the work of art, especially in the case of altarpieces.[5] However, he drew no conclusions for an interpretation of works of art as an archaeological study that would elucidate the historical circumstances of the gaze. Nevertheless, Shearman remains one of the few scholars to emphasize the importance of the link between a primary viewing point and the composition of works of art. Generally speaking, and without getting into bibliographical details, studies on this topic have most often portrayed the relationship between painting and theatre as an issue of influence of forms and craft, with the notable exceptions of André Chastel and Daniel Arasse who both proved that the aim of pictorial space went well beyond the simple issue of intra-artistic influences.[6] Emmanuelle Hénin, for her part, has effectively deciphered the constitution of a *paragone*, of an *Ut pictura theatrum*, in theoretical texts.[7] Most recently, Philippe Morel has put forward a semantic approach to the great secular decors of the Renaissance: between illusionistic transitivity and decorative reflexivity, these ensembles developed an internal logic that engaged with the beholder on different levels.[8] Finally, in the wake of Gombrich, other authors have chosen to focus on the

Domenico Beccafumi,
Reconciliation of Marcus Emilius Lepidus and Fulvius Flaccus,
1529–35, (plate 1).

Theatricality in Early Modern Art and Architecture *Edited by Caroline van Eck and Stijn Bussels* © 2011 Association of Art Historians.

viewer in painting and his status as painting's objective: the focus of the gaze and the subject of the visual process understood as a viewing experience.[9]

In this context, it is judicious to examine the relationship between the arts from a visual and historical perspective, and in particular within the framework of an archaeology of the gaze, focusing on Italy from the fifteenth to the seventeenth centuries. This reassessment is less a study of socio-economic conditions as recommended by Baxandall than a physiological configuration related to the circumstances surrounding the viewing conditions of a work of art. How did observers from different time periods position themselves in relation to the image, both on a physical level and on an interpretative level; or, at the very least, how can one infer this through historical context?

The comparative study of two art forms, and especially the analysis of possible ties between theatre and painting, cannot be consigned to the issue of influence. It must take shape in a more circumstantial manner; in particular, through the establishment of categories that enable the application of an interpretative framework for works of art. To do so, it is essential to make a shift from the pursuit of direct analogies (the transfer of motifs from one art form to the other) in order to concentrate on other aspects, that is to say not to focus on the disparities between various analogies but to try to grasp the structure of the viewer's gaze in front of the work of art. How might observers from any given period, with its own aesthetic and religious categories, apprehend a painting? Beyond a history of reception,[10] it is less its dissemination and audience awareness that is of interest here than the attempt to understand how artistic representations triggered in the viewer a chain of reactions that can only be understood in relation to his cognitive environment. Put concisely, I want to ask if the viewing process is a historical subject within the context of the art of painting and its relationship to the theatre. I call 'viewing process' a series of several movements of observation that the viewer is compelled to undertake due to the particular character of a work of art, including its location within a physical space. This series of movements can have a physiological source (the movement of the gaze or of the body) or an intellectual one (in the form of an analogical recognition, a historical evocation or a spiritual quest). Pictorial theatricality is less the study of two artistic practices than a means of understanding works of art in their viewing processes at a specific historical moment.

To do so, I draw on examples from Italian art, which was widely viewed across Europe, over an extended period of time (fifteenth–seventeenth centuries). The birth and development of linear perspective, like the emergence and growth of stagecraft, led to a wealth of technical developments: as a result, we find a multiplicity of viewing experiences that presuppose an equal abundance of historical subjects. Thus, in order to define the intellectual and physical relationship between the beholder and a work of art, I identify three categories whose connection to stagecraft has often been noted.

A Painting of Reference and Memory: Referential Theatricality

The widespread establishment in the fifteenth century of the technique of perspective lines converging towards a single vanishing point was rapidly adopted by painters as a means of constructing unified architectural ensembles. From it emerges an urban centre, echoing Brunelleschi's early experiments with linear perspective in front of the Baptistery in Florence. While, on the one hand, this technique seeks to represent what cannot be represented, as Daniel Arasse has shown;[11] it also aims to present the city as a unified scheme while keeping open the possibility of varying the representation of the different buildings with in it. Thus, the marquetry on church

stalls,[12] a few decorative cycles in palaces[13] and *cassoni* decorations[14] depict urban views that combine a single viewpoint with a variety of architectural sites. Only from the late fifteenth century onward were perspectival constructions of urban settings used in theatrical scenery and, concurrently, in painting, sometimes to conjure up the idea of a theatre set. Thus, from Peruzzi to Raphael (*Fire in the Borgo*, Vatican, 1514), Veronese (*The Wedding at Cana*, Louvre, 1571–72) and Nicolas Poussin (*The Plague at Ashdod* of 1630, for example), painters used architectural decoration to frame narrative scenes. The verb 'to frame' is in fact more accurate than the verb 'to decorate', as the latter is nowadays imbued with a secondary connotation that relegates the decor to the background of the main action.[15] At the same time, some set designers, including Peruzzi, devised open expanses in which actors could move around a *proscenium* bordered by a city view in the background. One must therefore note the coexistence of visual models, rather than a simple pattern of reuse or influence:[16] architects and painters contemporaneously experimented with the use of linear perspective – with its strong points and limitations – to evoke the third dimension.

In all likelihood, the model established in the mid-sixteenth century by Sebastiano Serlio's prints – following a decorative model greatly influenced by Peruzzi and referring back to antiquity – only confirmed the appeal of contemporary and Vitruvian models. The inspiration drawn from the impact of antique rhetorical structures became one of the keynotes of referential theatricality. Indeed, expanding on the work of Vitruvius, Serlio illustrated the three types of sets that corresponded to the typology of theatrical genres inherited from antique poetry, in particular from Aristotle. The set design for tragedy consisted of a view of official-looking urban buildings: facades of princely palaces, religious and *all'antica* buildings (obelisks, triumphal arches, ruins). The set design for comedy displayed facades of houses with porches and terraces. The pastoral genre was illustrated by a natural setting with trees, rocks and the occasional rustic dwelling. The humanist stage set in the late fifteenth and early sixteenth centuries was therefore a specific type of space, divided into two very distinct areas. On the one hand, there was the space where the actors performed, an area close to the spectators and devoid of any scenery, and where the plot unfolded (the *proscenium*). On the other, sprawling in the back of the stage was a rigid structure, inaccessible to the actors and displaying clear visual typologies (the *frons scenae*).

The technical novelty of late fifteenth-century stagecraft, which is too seldom noted, was to do away with these two hitherto distinct areas and merge the action unfolding in all directions (with the use of stage machinery) on the one hand, and, on the other, the 'naturalism' of three-dimensionality. Only at that period was the temporality of the action integrated into a space constructed with a one-point perspective: the action was no longer set in front of an infinite expanse but rather merged with this boundless space. To put it more succinctly, *historia* was integrated into the *locus*, the body integrated the space; this can all be related to the sixteenth-century rediscovery of the physics and poetics of Aristotle.[17]

Thus, for a large part of the sixteenth century – up until the invention around 1580 of sliding side wings that rendered the set truly three-dimensional – the main area of the action was located in front of the scenery, and the two areas of the action and the image were irremediably segregated. This scenographic construction, in which the *proscenium* took pride of place, stemmed from a difficulty on the part of the architect-set designers in physically mastering the third dimension of perspective,[18] and can be linked to the frieze-like compositions found in antique low-reliefs. It made a clear distinction between the time of the action and the space of the image

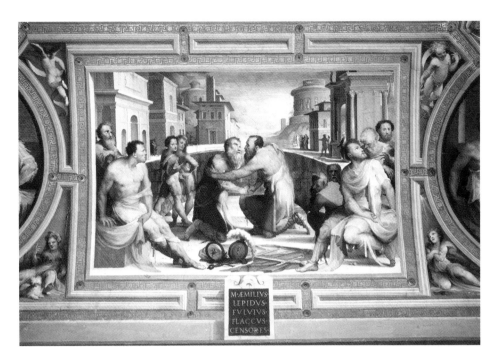

1 Domenico Beccafumi,
*Reconciliation of Marcus Emilius
Lepidus and Fulvius Flaccus,*
1529–35. Fresco, 134 × 85 cm.
Siena: Palazzo Pubblico, Sala
del Consistorio. Photo: © Foto
Lensini Siena.

that metaphorically underlined the typology of the action, whether tragic, comic or pastoral.

Far from being a straightforward analogy, the recurring use of this scenographic scheme of the city view in perspective reveals a specific rhetorical purpose. While I am not suggesting that this was an invariable rule, it is nevertheless possible to demonstrate that we are dealing here with a reference to the dramatic arts that stemmed from antique poetry: for the solemn performance, the set displayed public urban buildings; for the lighter theme, or if the artist wished to characterize the scene as such, the set displayed examples of private urban architecture. The point of reference was less the subject matter, derived from such and such an artist, than the mood of the set designs (tragic or comic). The following two examples will allow us to understand better the iconological issues of referential theatricality.

In the Sala del Consistorio in the Palazzo Pubblico in Siena is an episode from the cycle of Good Government painted by Domenico Beccafumi between 1529 and 1535. It depicts the *Reconciliation of Marcus Emilius Lepidus and Fulvius Flaccus* (plate 1), which took place during the Roman Republic, in the third century BCE. In this scene *Concordia* – the main virtue needed for good government, and one whose political implications were not lost on contemporary viewers[19] – is represented in the embrace of the two protagonists flanked by accompanying figures placed very close to the viewer. Of particular note is the decoration in the background where public buildings are depicted clearly: triumphal arches, the communal palace with its tower, a round religious building, among others. In order to emphasize the virtuousness of reconciliation in the name of the public good and at the expense of personal interests, the painter placed the episode in a typical urban setting. He did not imply that the scene was unfolding on a stage, but framed the virtue of Concord within a visual typology that emphasizes the *decorum* of the meeting. The point of reference is not the scenery but the visual structure that highlights the public and virtuous character of the event.

Markedly different is another gathering, this time bearing a religious connotation. In Perino del Vaga's *Visitation* in the Pucci chapel in the church of the Trinità dei Monti (Rome, 1526), the artist, inspired by Raphael's frescoes, placed the encounter between Elizabeth and Mary on a few steps, between the *proscenium* and a backdrop representing an architectural perspective described by Vasari as 'casamenti' (plate 2). It is interesting to note in passing that Vasari stressed the fitting correspondence between the architectural framework and the figures' attitudes ('oltra che i casamenti e l'altre figure hanno del buono e del bello in ogni loro atto'). Vasari thereby expressed his appreciation for the

painter's use of *decorum*. If one compares this Visitation scene with the one painted by Francesco Salviati in the oratory of San Giovanni Decollato (*plate* 3), it becomes clear that, despite its expressive and lively tone with bustling figures in the foreground, Perino's representation possesses a less formal character than Salviati's. Perino's architectural framework is sealed by a perspectival decoration that mainly evokes the facades of private buildings, while the more sweeping architectural framework of Salviati's fresco clearly shows a disparate group of public buildings that allude to a Vitruvian and Serlian civic ambiance.

These perspectival views of fictive cities should not necessarily be associated with the reuse of motifs from theatrical scenery. The term employed by Vasari ('*i casamenti*') points to the fact that, in the sixteenth century, an architectural ensemble was not automatically associated with a Serlian stage set. It does not point to 'decoration' in the modern sense of the word (something secondary, that embellishes) but rather to a 'décor' in the sense of *decorum*. Indeed, the setting of the scene framed the *historia* and bestowed on it the appropriate tone and reference: to the grandiose architectural site corresponded a solemn discourse geared towards the public sphere, while a plainer architecture indicated greater levity, more closely associated with the private sphere. The medieval concept of 'modus' was applied here; it adopted the Aristotelian categories of *heroic* verse and *iambic* verse, the *modus gravis* (the solemn mode) and *modus levis* (the light mode) inherent to poetic creation.[20] It thus constituted an early theory of modes, which Poussin later applied in a more theoretical manner, dubbing 'Doric mode' all things constant, serious and solemn, while pleasing and joyous things belonged to the 'Phrygian mode'.[21]

The question of the reference of the discursive tone thus seems particularly suited to elucidate the iconological issues surrounding these images, while, in my view, the issue of influence between theatre and painting diminishes their elaboration. Referential pictorial theatricality draws the viewer into an investigation of the iconographical constituents of an image and its deeper meanings. A number of paintings exhibit an iconographical structure that probably alludes to contemporary developments in scenic decoration, such as Peruzzi's sets and Serlio's engravings. However, such references do not entail a plain or direct correlation between a theatrical logic and painting. This referential theatricality is not one of repetition and simple variation but rather a means of bestowing meaning on an investigation of the main scene. This convention (*topos*) is not the replication of a common source but an adaptation to the requirements of the story. The allusion to a shared memory,

2 Perino del Vaga, *Visitation*, 1526. Fresco, 380 × 300 cm. Rome: SS. Trinità dei Monti, Pucci Chapel. Photo: © Bibliotheca Hertziana.

3 Francesco Salviati, *Visitation*, 1546? Fresco, 104 × 68.4 cm. Rome: Oratory of San Giovanni Decollato. Photo: © Marc Bayard.

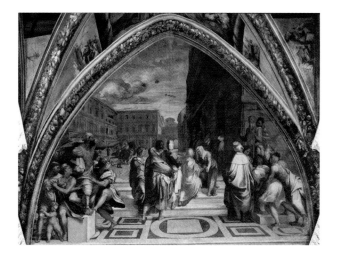

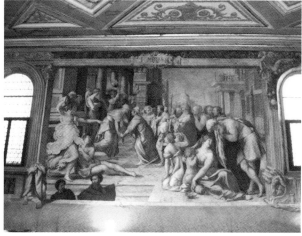

the city view in perspective, is not solely one of direct citation or replication; rather, it participates in the construction of the image, steering the viewer through the decipherment and understanding of the episode depicted. The nature of this allusion, then, is not one of a stylistic ornamentation of the visual discourse, but belongs squarely within the discourse itself, always unique and idiosyncratic.

A Painting of *Pathos*: The Breadth of Emotions

Some pictorial works depict stories imbued with particular pathos (as in the case of Guercino, *The Death of Didone* of 1630 in Galleria Spada in Rome or Pietro da Cortona, *Rape of the Sabine Women* of 1629, now in Pinacoteca Capitolina in Rome). The passions, most often tragic, need a setting, a *decorum* in keeping with their depiction. It is well known – though perhaps not superfluous to recall – that, from the first theoretical treatises of the fifteenth and sixteenth centuries, one of the aims of painting was to rival poetry, in an attempt to prove that painting, the silent art, can both narrate a story and express the internal passions. The issues concerning the theory of the representation of the passions in painting, a vast and much-studied topic, is outside the scope of this study.[22] It simply seeks to point out that scholars are often too ready to invoke the concept of the theatre and dramatic arts to describe painted works. Reliance on this convenient terminology can hinder proper appreciation of the painting and its composition. The representation of emotions, through the positioning of bodies and expressions, does not necessarily allude to theatrical performance, but corresponds to a greater extent to one of the major aspirations of painting, that is to depict through visual means the inner torments of the passions. This is a rhetorical ambition rather than the result of a simple play of influence between the arts. Expressiveness, anatomical constitutions, costumes and their folds, backdrops all represent a challenge for the painter who, by mastering these various elements, proves that he is equal to poets, and not to stage directors. This change of perspective allows us to reconsider the aims of painting, which are not to replicate another art form, but rather to master all the characteristics of its own medium. To rival but not to copy slavishly: this principle of emulation, well studied by scholars,[23] was often at the heart of the creative process in the Renaissance.

Alberti's remarks, even if they are well known, bear recollection:

> A *historia* will move spectators when the men painted in the picture outwardly demonstrate their own feelings as clearly as possible. Nature provides – and there is nothing to be found more rapacious of her like than she – that we mourn with the mourners, laugh with those who laugh, and grieve with the grief-stricken. Yet these feelings are known from movements of the body …The painter, therefore, must know all about the movements of the body, which I believe he must take from Nature with great skill.[24]

Alberti establishes a direct link between the rendering of physical appearance and internal emotion. The body's movements convey internal turmoil, the outer image expresses inner nature, and the painter must be able to visually transcribe these things by drawing on examples taken from nature. The movements of the body and the movements of the soul are correlated; they act in unison to display, transcribe, and expose the inner torments of the heroes of painted stories. Their bodies must render their invisible turmoil: 'finally, each person's bodily movements, in keeping with dignity, should be related to the emotions you wish to express.'[25]

In the mid-sixteenth century, Lodovico Dolce expressed the same idea: although the painter's is a silent art his great strength lies in the fact that he can depict 'the thoughts and affections of the soul'. The artist must be able to render by pictorial means the passions that agitate the figures depicted in order to express them correctly. He must accurately relate the rendering of the passions to the painting's overall theme.[26] Numerous treatises reminded their readers of the need for artists to learn how to depict the passions in order to make a silent art speak. It is thus not always valid to assume that certain paintings are literal transcriptions of a theatrical performance; rather, they echo pictorial concerns, that is to say that the painter must engage in a visual process that allows the viewer to grasp the dramatic implications of a painted scene.

Ultimately, we are concerned here with a logic of compunction, so dear to the theologians of the Middle Ages, in which the image serves as an aid to the faithful.[27] This type of image is not itself the object of adoration but arouses emotions to assist worship. It compels the faithful to suffer with Christ, to feel for him, so that the faithful can be guided to devotion and redemption. Gregory the Great associated compunction with prayers for closeness with God: 'in order that, upon seeing the story (*rei gestae*), they [the faithful] experience the ardour of compunction and humbly prostrate themselves in adoration of the only Holy Trinity'.[28] The image acts as a vector for the passions. It accompanies the viewer throughout his discovery of the invisible, whether on the level of the sacred or through the breadth of a story.

Naturally, this effusive expression of the passions could be found on stage; this is what most closely connects pictorial works to the 'theatrical' nature of performative art. But the use of the word 'theatrical' to describe a pictorial scene whose purpose is first and foremost to depict a story and the inner conflicts of its protagonists is too equivocal. The issue of pathos in theatrical performances is therefore not really a separate category in the framework of the relationship between theatre and painting. We are not dealing with a clearly defined type, as is the case with the referential theatricality I discussed earlier and with the processional theatricality I discuss below. The demonstrative nature of the passions, whether depicted in two or three dimensions, ultimately bridges both art forms. However, each has its own artistic practices. The simplistic tendency always to explain them by reference to a play of influence must be extensively revised and nuanced.

Painting the Process and the Gap: Processional Theatricality

I would now like to turn to another type of pictorial theatricality that engages the viewer in a process that could be considered akin to theatre. The spatial construction of painting, the place of the viewer, his physical and mental progression inside the work of art, all pave the way for the assimilation of painting to a scenic space. The pictorial work unfolds in a physical space and, like a theatrical production, plays on this space to unlock a multiplicity of meanings. Processional theatricality of this kind is mainly visible in great church altarpieces, these 'machines' as the Président de Brosses dubbed Veronese's *Wedding at Cana* (1571–72), which he saw at San Giorgio Maggiore in Venice around 1740.[29] The main characteristic of these religious decorations lies in the fact that, from the late fifteenth century onward, they were most often integrated within defined architectural decors (at the top of a set of steps, in front of an altar, sometimes surrounded by ostentatious decoration), resulting, in the seventeenth century, in the Berninian 'bel composto' (stucco, wood-panelling, marble). These decorative ensembles (altars, chapels) set or place the worshipper in an idiosyncratic relationship to the surrounding space: he finds himself in a relationship with the work of art that I have described elsewhere as 'an

inclusive distanciation'.[30] Let us consider for example the *San Zaccaria Altarpiece*, executed by Giovanni Bellini in 1505 for the church of San Zaccaria in Venice (*plate* 4). The horizontality created by the frieze-like disposition of the four saints (Saint Peter and Saint Catherine on the left; Saint Jerome and Saint Lucy on the right) draws attention to the depiction of the enthroned Virgin. The feigned architectural scheme gives rhythm to the composition by playing on the spatial continuity with the existing architecture of the church. The two pilasters on either side and the rounded arch create an aperture towards the half-cupola of the niche in which the Virgin is set. The pavement, composed of pink and white squares, continues the pavement in the nave of the church and is located at eye level. The viewer's gaze thus starts at this visual continuum and moves upward to meet the gaze of the angel, who acts as Albertian admonisher, but above all as visual intermediary and intercessor, an issue that will be explored below. The visual process is a gradual and upward progression, from the bottom of the work to the top. The beholder is located beneath the image, facing the scene with the Presentation of Christ by the Virgin. He is integrated into a relatively continuous space, but is at the same time detached from it, set apart from the sacred scene depicted. He is embedded within the realm of the sacred but not fully integrated within it. He is included but kept at bay. Thus, there is both a visual inclusion (through the admonisher and some of the painted objects) and a physical exclusion (through the distance involved, height, and separating architectural elements). The inclusive distanciation plays on the relationship between fiction (the painting) and reality (the viewer's space). This process, found in a great many altarpieces from the late fifteenth century all the way to the eighteenth century – with varying degrees of inclusion and exclusion – offers not only a rhetorical discourse but also a theology of images that Jérôme Baschet has perfectly outlined in his comments on the medieval image-object: 'the theology of images, which intensifies in the twelfth century, has at its core the notion of *transitus*, the process by which one is able, through visible objects, to reach the contemplation of the invisible.'[31]

Indeed, the majority of these visual 'machines' have common characteristics: fictive architecture, painted flights of stairs and balustrades (both real and trompe-l'œil), but, most especially, human admonishers that look out at the spectator or point to him. All these visual elements are included to draw the beholder in but also keep him at a distance: the deictic function creates a three-way circularity, which, while appearing to establish a certain intimacy, amounts in fact to a disconnection because the direct, one-to-one relationship no longer exists. The presence of a third party introduces mediation, wedging a gap between the two interlocutors. This process of creating a distance while not excluding any figure within the representational orbit is thus amplified by the presence of intermediaries, of visual elements located between the sacred figure and the faithful. In my view they were not introduced for purely rhetorical reasons (as a way to draw the viewer in more effectively, the Albertian *admoneat*);[32] they are important figures interposed between the heart of the sacred representation and the worshipper. As Alberti reminds us, their purpose is to reinforce the message, to help the viewer grasp the meaning of the story. They act as intermediaries in understanding: 'everything the people in the painting do among themselves, or perform in relation to the spectators, must fit together to represent and explain the *historia*.'[33]

I have shown that a number of intermediary figures, the admonishers in religious paintings, could take the form of theological figures: they reaffirm the logic of the intercessory nature found, in particular, in the careful rereading in the Renaissance of the writings of the Pseudo-Dionysius, with their description of the celestial hierarchy

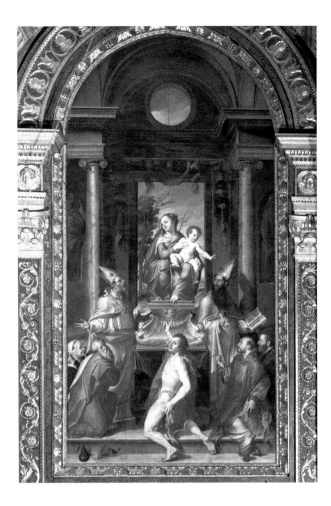

of angels, as well as in iconographical representations of altarpieces in Catholic churches[34] (*plate* 5). As most Renaissance scholars – and Umberto Eco first and foremost – claim, this period sparked in the whole of Europe a new idea of Man as mediator between God and the world.[35] However, one could argue that not only did sacred Catholic art bring about a proliferation of representations of these visual intermediaries, each one a pivotal figure from a rhetorical standpoint (as admonisher), but that they also draw the beholder into a viewing process that emphasizes the importance of the concept of a theological intermediary.

Examples can be found in numerous devotional paintings on display in churches. In some cases, these figures are donors and patrons.[36] However, visual means are used to suggest that this level of reality does not fully intersect with the realm of sacred depicted in the painting: shadows behind the figures, profile views with sharply delineated contours, isolating backdrops, architectonic elements that divide the space (balustrades, sets of steps), among them. All these elements create a gap between the various intermediaries. However, the majority of intermediaries who either look at or point to the viewer are saints or important ecclesiastical figures (popes, cardinals, bishops or high-ranking political figures), and are integrated in a visual continuity with the sacred representation at the heart of the painting (the Virgin or Christ).

In the wake of a reaffirmation that was especially pronounced from the late Middle Ages onwards but which would later prove controversial, direct access to God was not part of the Eucharistic celebration during mass. Rather, it was through private devotion and contemplation of *devotio moderna*, introduced by the Rhineland mystics in the late Middle Ages, that direct access to God was made possible. In contrast, public church celebrations reaffirmed the intercessory role of the Catholic Church and the importance of the saints. The teachings not only of the Pseudo-Dionysius[37] but also of Saint Thomas, Saint Augustine and Roman Catholicism in the fifteenth and sixteenth centuries were continuously evoked to impress upon the faithful the importance of the Church of Rome as intercessor.[38] In the case of altarpieces, the idea was not to establish a dialogue between Man and God but to determine everyone's place in the *infra* and the *supra*. We are not dealing here with the union of the divine and human spheres, not even with the contact between these two realms, rather, with a focus on the juxtaposition of these two clearly distinct but intricately linked entities, the sacred and the profane.

In his definition of a 'Mediator' (or in French '*office du milieu*'),[39] Saint Augustine specified that the intermediary must be 'united to us here below by the mortality of His body [and] should at the same time be able to afford us truly divine help in cleansing and liberating us by means of the immortal righteousness of His spirit, whereby he remained heavenly even while here upon earth'.[40] This mortal body and immortal soul, represented by the figure of Christ or by the saints, acting as intermediary between the *infra* and the *supra*, played on the notion of location, of the in-between, of the right distance.

The Correct Distance and the Area of Interiority: *Humilitas*

Processional theatricality raises two questions that will be broached here only succinctly. The first difficulty is the issue of the correct distance that must be maintained to examine and ascertain the religious meaning of a work of art such as a large altarpiece. Too close, and one sees only the details; too far away, and one gets lost in the whole. Thus, in this viewing space, situated between the beholder and what is beheld two issues emerge: on the one hand, the issue of symmetry and proportion, and on the other the issue of the inner speculation that arises in the beholder's attitude to distance and the work. As a result, two aspects must be briefly examined: the physical entity of the viewing space and the inner dimension of the viewer.[41]

At the heart of treatises on the construction of perspective was the issue of the position of the viewer, and in particular his viewpoint, the direct counterpart to the vanishing point.[42] In Book I, Alberti mentions the mathematical knowledge required to be a good painter. He not only advocates a correct distance from which to perceive things,[43] but also elaborates a perspective technique that follows this pattern of correct perception.[44] From this he concludes that 'the function of the painter is to draw with lines and paint with colours on a surface any given bodies in such a way that, at a fixed distance and with a certain, determined position of the centric ray, what you see represented appears to be in relief and just like those bodies.'[45] Alberti thus primed the observation of a painting at a 'fixed distance' and paved the way not only for a spatiality of viewing (the viewpoint) but also for the issue of the correct distance. This notion was also outlined by Filarete in his *Treatise on Architecture* (1460–64): 'Now you must consider at what distance you wish to view your work of art, taking into account the fact that, from close up, things will look larger and from further away, they will seem smaller; therefore, place yourself not too close but not too far.'[46] For his part, Serlio noted in the art of perspective, the need for a means to assess the correct viewing distance between the depicted object and the place of observation.[47] Finally, in the North, Dürer, influenced by Italian theorists on perspective, was also interested in the appropriate space that must be left between the eye and the object that is seen.[48]

In theatrical performances, as in painting – and in particular, in the great decorative ensembles of the pictorial 'machines' of church altarpieces – to see correctly is a means to place oneself correctly. Sight is shaped by an arrangement that is both physical and, more generally, social.[49] The geography of sight serves as a guarantee in the process of comprehension: to follow the logic of the composition also involves an internal process. As is well known, the issue of correct placement was raised by Horace in his *Ars Poetica*: the Roman theorist shaped the analogy between poetry and painting in terms of the location of the gaze. Some paintings, like some poems, require close viewing while others demand to be seen from a distance.

Poetry is like painting. There might be a painting that will hold your attention more if you stand close to it and another if you stand at a distance. This painting loves a dark corner, while that one wants to be seen in the light, since it does not fear the penetrating judgment of the critic. This painting brought pleasure only once, while another will still please if you look at it ten times over.[50]

The issues of correct distance on the one hand and of harmony and beauty on the other are linked to a geography; a place, to use a Renaissance term. The properties of symmetry (*simmetria* and *euritmia*) thus produce inner feelings, most notably the feeling of Beauty. Umberto Eco rightly observed that these issues already appear in medieval debates on aesthetics: for authors like Saint Bonaventure, 'sense knowledge is governed by a rule of proportion … and pleasure arises when the object is a pleasurable one':

6 Pierre Mignard, *San Carlo Borromeo Contemplates the Holy Trinity with Saints John of Matha and Felix of Valois*, 1645–46. Oil on canvas, 400 × 300 cm. Rome: San Carlino alle Quattro Fontane. Photo: © Marc Bayard.

'for delectation results in a conjunction of the delectable and a person who takes delight in it'.[51] From the proportionality of the contours (the beauty of regular forms) and the appropriate physical relationship between the beholder and the beheld emerges a dialogic bond, 'an affection of love' (in the words of Saint Bonaventure and William of Auvergne) that invites contemplation.[52] From correct distance stems the appropriate relationship between prepositions: rhythm and placement shape Beauty; symmetry paves the way towards contemplation. The practice of combining spiritual progression and physical location already existed in the Middle Ages. As Jérôme Baschet rightly stressed, the quest for salvation in medieval religious structures was a combination of the *locus* (the place) and the *iter* (the path, or progression). The sacral unity of sacred architecture, a church or chapel for the Renaissance, constitutes a dynamic process that produces thresholds that the faithful must cross as proofs of faith.[53]

One can therefore ask what is the meaning of this 'correct distance', in particular in the case of religious paintings, not only as an aesthetic evaluation of the placement of the viewpoint, but more importantly as the inner experience of the faithful in front of a work of art representing an episode of sacred history (*plate* 6). Naturally, one cannot overlook the pragmatic aspects of distance for the quality of the gaze: a viewer who is correctly placed in front of the work admires its details all the more. However, beyond the issue of comfort, one can also wonder if this spatial organization of the gaze is not also tied to theological concepts. Indeed, the relentless opposition of parts of the Catholic Church to the use of images in devotional practices from the Middle Ages to well into the early modern era is well known. The work of art must never be an object of veneration on its own account, a precept vigorously reiterated during the Council of Trent. Thus, the viewing conditions imposed by processional theatricality might indicate the reaffirmation of the concept of *humilitas*, the humbleness of the worshipper before the image, through which he cannot appropriate the deity it depicts. Standing at an appropriate distance, the faithful adopts a position of humility, which, it is important to remember, is one of the fundamental Christian virtues.[54] Located below the image, in a position of inferiority and detachment, in an inclusive distanciation, the kneeling worshipper finds himself in a position of humility in front of the re-presentation of the sacred. The notion of humility could thus explain the spatial organization that is also found in the theatre, at least in the case of spectators seated in the stalls.

Thus, in processional theatricality, the place of the viewer has a special importance, even more so considering that, thanks to visual intermediaries, the work of art creates a space that is both fictive (painted perspective) and real (the play on spaces with the beholder). It is possible to regard it as a straightforward effect of visual rhetoric or as a semantic game. However, it is equally possible to detect within it a set of wider concerns in which the notion of distance is not restricted to a mere reflection on spatial relationships: it can also perhaps constitute a theological

insight into a progression in which otherness and the path of faith are highlighted to accompany the faithful in his spiritual quest.

Matter and Essence: The Issue of Visual Registers

The second issue raised by processional theatricality is the relationship between the identity of visual forms, which alludes both to material realities and sacred entities. The immanent nature of the Virgin, Christ and the saints is an integral part of Catholic beliefs and religious paintings are there to demonstrate their presence (*plates* 5 and 6). However, painters – with, in the background, their patrons and the religious authorities – judiciously stratified the space into different levels of corporeality. Starting from the bottom, the worshipper's gaze follows an upward trajectory. In this progression, painters generally depicted the most sacred realm (that of God, his Son and the Virgin) either bathed in light, amidst the clouds (the angels dissolving into the light, in a play on the change of register) or at the apex of a particularly subtle perspective. This upper register presents 'an iconic spatial mode – vertical, frontal and centralized', as defined by David Rosand.[55] One can therefore conclude that this construction, which tends towards an 'abstraction' of forms, constitutes a stratification of sacredness. This ascendant pyramid-like structure of religious images displays a superimposition of temporalities, realities and substantialities. To the figure of the saint (and/or donors/admonishers) corresponds an immediate reality, a tangible, substantive and singular form; whereas to the representation of the divine corresponds a corporeality more akin to pure concept and to the universal.[56]

The tiered structure present in religious paintings for churches raises the issue of temporal and atemporal registers, of the finite and infinite, of the particular and the universal, the Absolute and the Real, all themes that were passionately and persistently debated during the Middle Ages and the Renaissance.[57] The atemporality of the sacred, as potentiality, is thus made possible only if there is a temporal moment to highlight it.[58] In this Aristotelian vision, expounded in the *Metaphysics*, mediation is thus a precondition in the connection between the universal and the individual, between the transcending realm of the divine and the immanent level of the human. In other words, placed within the context of theological thought, the only requirement of the sacred is to appear mediated by matter, a temporal reality close to, or concomitant with, the worshipper. The visual intermediary, the intercessor between the universal and the individual, thus constitutes a source of knowledge and of revelation. He acts as a mediator between the mobile and the immobile, between the defined and the undefined. This public sacrality is thus defined in a relation of alterity, or extension between one realm and the next, between the human and the divine.

It therefore appears that religious painting from the fifteenth to the seventeenth centuries, and altarpieces in particular, developed a two-tiered presentation, linked by an aesthetics of mediation. These works, whose compositions were especially repetitive throughout the sixteenth, seventeenth and eighteenth centuries, may thus be explained by a theological approach. The repetition of the models in this type of work does not necessarily entail a logic of influence between the arts but is more persuasively viewed as the result of liturgical and theological structure.

In conclusion, what remains of the notion of pictorial theatricality in the sense of a visual analogy in Italian art, sustained from the fifteenth to the seventeenth centuries? In truth, not much. Indeed, following the argument presented here of the three kinds of relationship between the viewer and a work of art, it is hard to

defend the notion that theatre exerted a real influence on pictorial arts throughout this period. Indeed, prior to the seventeenth century, theatre was a rather nebulous social event. It remained an exceptional, festive occurrence, which took place only at specific times of the year. It belonged to the culture of the courts, and until the late sixteenth century was little disseminated. The invention of stage machinery only became significant in the 1610s in Italy and after 1650 in France. Only when scenic decorations became particularly innovative and grandiose in their spatiality, when theatre and especially opera became real social phenomena (around the mid-seventeenth century and especially in the course of the eighteenth century), was a visual correlation conceivable.

Notes

I would like to express my gratitude to Caroline van Eck, Paméla Grimaud, Philippe Morel, Genevieve Warwick, Angela Stahl, and to Karen Serres for her translation.

1 Émile Mâle, *L'Art religieux de la fin du Moyen Âge en France. Étude sur l'iconographie du Moyen Âge*, Paris, 1908.

2 George Kernodle, *From Art to Theatre: Form and Convention in the Renaissance*, Chicago, IL, 1944.

3 Ernst H. Gombrich, *Art and Illusion: A Study in the Psychology of Pictorial Representation*, New York, 1960.

4 Michael Baxandall, *Painting and Experience in Fifteenth-century Italy: A Primer in the Social History of Pictorial Style*, Oxford, 1988.

5 John Shearman, *Only Connect: Art and the Spectator in the Italian Renaissance*, Princeton, NJ, 1992, especially chapter 2.

6 Marc Bayard, 'La théâtralité picturale dans l'art italien de la Renaissance', *Studiolo*, 3, 2005, 40–2; Daniel Arasse, 'Espace pictural, espace théâtral au Quattrocento. Remarques sur un rapprochement', in *L'Ecrit-voir. Revue collectif pour l'histoire de l'art*, Paris, 1982; André Chastel, 'Vues urbaines peintes et théâtre', in *Fables, formes, figures*, Paris, 1978, volume I, pp. 317–22.

7 Emmanuelle Hénin, *Ut pictura theatrum. Théâtre et peinture de la Renaissance italienne au classicisme français*, Geneva, 2003.

8 Philippe Morel, 'Fonction des systèmes décoratifs et de l'ornement dans l'invenzione maniériste: réflexions autour de Francesco Salviati', *Programme et invention dans l'art de la Renaissance*, Michel Hochmann, Julian Kliemann, Jérémie Koering and Philippe Morel, eds, Symposium papers, Rome-Paris, 2008, 286. Illusionistic transitivity 'deals with the relationship of the décor to its exteriority' (to the storia or the beholder) while decorative reflexivity deals with the relationship of the décor to itself, part of its opacity and self-existence'.

9 Daniel Arasse, *Le détail: pour une histoire rapprochée de la peinture*, Paris, 1992; Michael Fried, *Absorption and Theatricality: Painting and Beholder in the Age of Diderot*, Los Angeles, CA, 1980; Richard Wollheim, *Painting as an Art*, The A. W. Mellon Lectures in the Fine Arts (1984) Bollingen Series XXXV, 33, Princeton, NJ, 1987.

10 As defined by Hans Robert Jauss, *Pour une esthétique de la réception*, translated from the German by Claude Maillard, preface by Jean Starobinski, Paris, 1978.

11 Daniel Arasse, *L'annonciation italienne, une histoire de perspective*, Paris, 1999.

12 For example, the wooden choir stalls in the Basilica dei Frari in Venice (in 1468, Marco Cozzi executed part of this marquetry work).

13 Domenico Rosselli, door with a marquetry decoration after drawings by Botticelli, Urbino, Palazzo Ducale, room 8. See André Chastel, 'Marqueterie et perspective au XVe siècle', in *Fables, formes, figures*, Paris, 1978, vol. 1, 317–32.

14 For example, the famous panels: *La Città ideale* (known as 'the Urbino panel', Galleria Nazionale delle Marche), *Architectural Perspective* (known as 'the Baltimore panel', Walters Art Museum) and another *Architectural Perspective* (known as 'the Berlin panel', Staatliche Museum). For the examination of these panels, see André Chastel, 'ìVues urbaines et peintesî et théâtre', in *Fables, formes, figures*, Paris, 1978, vol. 1, 497–503, as well as Hubert Damisch, *L'origine de la perspective*, Paris, 1987.

15 In the Renaissance and still in the seventeenth century, the decor was part of the *decoro* or *decorum* (the elements around a *historia*) and must set, characterize and specify the poetic and rhetorical meaning of the main scene.

16 André Chastel had already noted that there is no objective link between painting and theatre. He perceived in it 'only proof that spaces constructed according to linear perspective – depicted and therefore imaginary spaces – exert such fascination on the mind that they become intensely meaningful and are instinctively albeit erroneously related to the empty and monumentalized space of theatre.' André Chastel, 'Les Apories de la perspective au Quattrocento', in Marisa Dalai Emiliani, ed., *La Prospettiva rinascimentale. Codificazioni e trasgressioni*, Florence, 1980, 60.

17 Victor Goldschmidt, 'La théorie aristotélicienne du lieu', in *Mélanges de philosophie grecque offerts à Mgr Diès*, Paris, 1956; Charles Schmitt, *Aristotle and the Renaissance*, Cambridge, 1983.

18 It is important to remember that the actor cannot get too close to the vanishing point without revealing the acute distortion between physical reality and the perspective lines.

19 Antonio Pinelli, 'Intenzione, invenzione, artifizio. Spunti per una teoria della ricezione dei cicli figurativi di età rinascimentale', *Programme et invention dans l'art de la Renaissance*, Michel Hochmann, Julian Kliemann, Jérémie Koering and Philippe Morel, eds, Symposium papers, Rome-Paris, 2008, 58.

20 Avigdor Arikha, 'Réflexions sur Poussin', in *Nicolas Poussin. Lettres et propos sur l'art*, Paris, 1989, 229.

21 Letter from Poussin to Chantelou dated 24 November 1647, in *Nicolas Poussin. Lettres*, 136.

22 See in particular James H. Marrow, *Passion Iconography in Northern European Art of the Late Middle Ages and Early Renaissance: A Study of the Transformation of Sacred Metaphor in Descriptive Narrative*, Courtrai, 1979; Marc Fumaroli, *L'âge de l'éloquence*, Geneva-Paris, 1980; 2nd edn Paris, 1984; Thomas Kirchner, *L'expression des passions. Ausdruck als Darstellungsproblem in der französichen Kunst und Kunsttheorie des 17. und 18. Jahrhunderts*, Mainz, 1991; Mosche Barasch, 'Le spectateur et l'éloquence de la peinture à la Renaissance', in *Peinture et rhétorique*, Symposium papers (French Academy in Rome, June 1993), Olivier Bonfait, ed., Paris, 1994, 21–42; Jennifer Montagu, *The Expression of the Passions: The Origin and Influence of Charles Le Brun's Conférence sur l'expression générale et particulière*, New Haven and London, 1994; Erich Auerbach, *Le culte des passions: essais sur le XVIIe siècle français*, Paris, 1998; Sophie Hache, *La Langue du ciel. Le sublime en France au XVIIe siècle*, Paris, 2000; Caroline van Eck, *Classical Rhetoric and the Visual Arts in Early Modern Europe*, Cambridge, 2007. Website with a bibliography on the issue of the representation of the passions in the arts (painting, theatre, opera): http://mediatheque.cite-musique.fr/MediaComposite/CMDE/CMDE000000400/08.htm

23 Rona Goffen, *Renaissance Rivals: Michelangelo, Leonardo, Raphael, Titian*, New Haven, 2002.

24 Leon Battista Alberti, *De pictura* (1435), trans. Cecil Grayson, London 1991, 76–7.

25 Alberti, *De pictura*, 80.

26 Lodovico Dolce, *Dialogo della pittura*, presentation and notes by Lauriane Fallay d'Esta, Paris, 1996, 56.

27 Olivier Boulnois, *Au-delà de l'image. Une archéologie du visuel au Moyen Âge (Ve–XVIe siècle)*, Paris, 2008, 92.

28 Gregory the Great, *Registrum Epistularum XI, Epistula* 10 (CCL 140 A, 875), quoted by Olivier Boulnois, *Au-delà de l'image.*

29 Charles de Brosses, *Lettres d'Italie du Président de Brosses*, Letter 17, Paris, 1986, vol. 1, 267.

30 Bayard, 'La théâtralité picturale', 52–6.

31 Jérôme Baschet, *L'iconographie médiévale*, Paris, 2008, 30.

32 Alberti, *De pictura*, 77.

33 Alberti, *De pictura*, 78.

34 Marc Bayard, 'Intermédiaires et admoniteurs dans l'art théâtral et pictural. Pour une approche comparée des arts', *L'histoire de l'art et le comparatisme. Les horizons du détour*, Marc Bayard, ed., Symposium papers, Rome-Paris, 2007, 57–66.

35 See for example Umberto Eco, *Art and Beauty in the Middle Ages*, New Haven and London, 1986, 240.

36 For example, Masaccio, *Holy Trinity*, Florence, Santa Maria Novella, or Titian, *Pesaro Altarpiece*, Venice, Santa Maria Gloriosa dei Frari.

37 R. Roques, 'La notion de hiérarchie selon le Pseudo-Denys', *Archives d'histoire doctrinale et littéraire du Moyen-Âge*, XVII, 1949, 199.

38 See in particular Jean-Marie Moeglin, *L'intercession du Moyen Âge à l'époque moderne. Autour d'une pratique sociale*, Geneva, 2004; Daniel Ménager, *Diplomatie et théologie à la Renaissance*, Paris, 2001.

39 Saint Augustine, *The City of God*, Book IX, chapter 15.

40 Saint Augustine, *The City of God*, Book IX, chapter 17.

41 I would like to thank Philippe Morel for suggesting this distinction.

42 Ferruccio Marotti, *Storia documentaria del teatro I, La Spettacolo dall'Umanesimo al Manierismo. Teoria e tecnica*, Milan, 1974, 169–89. For the technique of perspective in general and the issue of the viewpoint in particular, see Pierre Hamon, *La vision perspective (1435–1740)*, Paris, 1995, 15.

43 Alberti, *De pictura*, 42.

44 Alberti, *De pictura*, 53ff. He even specifies, 'besides, no learned person will deny that no objects in a painting can appear like real objects, unless they stand to each other in a determined relationship' (56).

45 Alberti, *De pictura*, 87.

46 Filarete, quoted by Hamon, *La vision perspective*, 91.

47 Sebastiano Serlio, *Secondo libro d'architettura* (1545), quoted by Hamon, *La vision perspective*, 179.

48 Albrecht Dürer, *Instruction sur la manière de mesurer avec la règle et le compas* (1525–1538), quoted by Hamon, *La vision perspective*, 138.

49 Dorothée Marciak, *La Place du prince. Perspective et pouvoir dans le théâtre de cour des Médicis, Florence (1539–1600)*, Paris, 2005.

50 'Ut pictura poesis. Erit quae, si propius stes, / Te capiat magis, et quaedam, si longius abstes; / Haec amat obscurum, volet haec sub luce videri, / Iudicis argentum quae nin formidat acumen; / Haec placuit semel, haec deciens repetita placebit.' Horace, *Ars Poetica*, v. 361–365, in Rensselaer W. Lee, *Ut Pictura Poesis: The Humanistic Theory of Painting*, New York, 1967, 5, note 15.

51 Eco, *Art and Beauty*, 67.

52 Eco, *Art and Beauty*, 67.

53 Baschet, *L'iconographie*, 78.

54 Alain de Libera, *Penser au Moyen Âge*, Paris, 1991, 317.

55 '... the altarpiece in its purest form represents what we might call an iconic spatial mode – vertical, frontal, and centralized.' David Rosand, *Painting in Cinquecento Venice: Titian, Veronese, Tintoretto*, New Haven and London, 1982, chapter 1, 39ff.

56 I am well aware that this differentiation of registers echoes one of the great dichotomies of Western philosophy, between Matter and Substance, already present in the works of Plato and Aristotle.

57 Eco, *Art and Beauty*, chapter on 'The Aesthetics of the Organism', 74ff.

58 This reading of mediatic thought, based on Aristotle, as the link between the universal and the individual was put forward by Theodor W. Adorno, *Métaphysique. Concepts et problèmes*, Paris, 2006, especially in Lesson 7, 85.

Chapter 6
Staging Bianca Capello:
Painting and Theatricality in Sixteenth-Century Venice
Elsje van Kessel

The painting reproduced in *plate 1* shows the head and bust of an elaborately dressed woman. Regally, calmly, but at the same time attentively, she looks towards the viewer. At first sight, an apparently simple painted portrait such as this does not readily make one think of the theatre. Yet, when the painting's first owner expressed his admiration for it, he did just that. In a letter to the portrayed lady, the late sixteenth-century grand duchess of Tuscany, Bianca Capello (1548–87), the portrait's owner wrote how, after having contemplated the painting for more than two hours after it was delivered to his house, he took the painting upstairs to the women. I quote from his letter:

> [A]fter having held [the women] back a bit, I lifted up the cloth with which I had it covered. And as if the curtain of a scene was dropped, the people were full of admiration. When the cloth fell, these Women were left stupefied and completely and totally satisfied.[1]

When the cloth that had hidden the portrait from view was removed, the admiration of the spectators was such that they seemed to be watching the unveiling of a scene in the theatre. Apparently aware of the theatrical connotations of his act, the owner turned the painting's revelation into a real spectacle. And this was only the beginning: the painting was soon to become the object of an amalgam of ritual and theatrical behaviour, both public and private, both longstanding and newly invented, which ultimately resulted in an *azione teatrale* – a theatrical action – of unexpected proportions.

Among specialists of Venetian sixteenth-century painting it has become commonplace to characterize the paintings they study as 'theatrical', especially those of the second half of the century.[2] Theatricality here, one often finds, is a quality of the paintings themselves; the visual elements in the paintings proper are said to have much in common with the visual aspects of contemporary theatre. Architectural backgrounds, the clothes figures are wearing, the compositions, all have been shown to have parallels in contemporary theatre.[3] Although this approach certainly has its merits, art-historical understanding of the 'theatricality' of Venetian painting has been rather one-sided. A central element of theatre, namely audience involvement, has only been sketched in in the most general manner.

This is surprising, for the audience for these paintings was certainly familiar with the theatre. Indeed, the society in which both paintings and public were embedded can itself be called theatrical.[4] What is meant by this term 'theatricality' here? Venetian life was thoroughly immersed in all sorts of ritual. Many of these Venetian

Detail from Scipione Pulzone,
Portrait of Bianca Capello, 1585,
(plate 1).

Theatricality in Early Modern Art
and Architecture *Edited by Caroline
van Eck and Stijn Bussels* © 2011
Association of Art Historians.

rituals were overtly visual in character and were meant to be enacted in full public view. When Richard Schechner discusses the interrelatedness of theatre and ritual in his *Performance Theory* (1977; rev. edn 2003), he points to several characteristics of theatre that can be discerned in Venetian ritual as well, for instance the performers' awareness of what they enact, and the role of the audience, not so much as participants but rather as passive, if appreciative, onlookers.[5] Interestingly, Schechner quotes Honorius of Autun who, as early as the twelfth century, compared the most widespread ritual of all, the Mass, to theatrical performance:

> It is known that those who recited tragedies in theaters presented the actions
> of opponents by gestures before the people. In the same way our tragic author
> ... represents by his gestures in the theater of the Church before the Christian
> people the struggle of Christ and teaches to them the victory of redemption.[6]

Part of what makes the Mass a theatre for Honorius is its visuality: by means of gestures, the celebrant shows the Passion to the assembled crowd, that is supposed to learn from what it sees. In the same manner, visuality is a major component of the theatricality of Venetian society and of Venetian ritual.

Another component, which is already mentioned above, is audience involvement. Throughout the early modern period, the idea that public life was theatrical in character was expressed in the concept of the *theatrum mundi*. People were thought of as actors on the stage of the world, the cosmos as its surrounding theatre. In antiquity, the onlookers had been the Olympic deities, in later times they were replaced by the Christian God.[7] In the early modern period, however, this began to change, and people started thinking of a new audience for their ups and downs on the world stage – their fellow human beings. This development meant that the role of man as a viewer became much more important: people were no longer only actors on a stage, but were now also each other's audience. A parallel with this change in thinking about the *theatrum mundi* can be found in early modern Venetian monumental painting. From Giovanni and Gentile Bellini's paintings for the Scuola Grande di San Marco to the late sixteenth-century decorations of the Sala del Maggior Consiglio in the Ducal Palace by Tintoretto, Veronese and their workshops, the main actors in these paintings are surrounded by groups of onlookers, all watching the spectacle taking place before their eyes. And some painters even went further: certain figures from Veronese's famous fresco decorations of the Villa Barbaro in Maser, for example, seem to suggest that the most important spectacle is not the painting, but the viewer, standing in the room, for all to see. The painting itself has turned into the audience.

As I have indicated above, I will approach the theatricality of Venetian painting, not primarily as a quality of the paintings themselves, but as connected to the theatrical character of Venetian society and of Venetian ritual in which these paintings were embedded. Taking the portrait of Bianca Capello as a case study, I hope to show that portraits in sixteenth-century Venice had indeed a very particular part to play.

From October 1585 to the summer of 1586, the portrait of Bianca Capello was the subject of a lively correspondence between the portrayed lady herself and her Venetian admirer Francesco Bembo (d. 1599), the patron and owner of the portrait. At that time, Bianca Capello had been grand duchess of Tuscany for six years. Already in Bianca's own time, the story of her life assumed mythic proportions. Originating from a wealthy, powerful, and ancient patrician Venetian family, at the age of fifteen she ran away with the young accountant Pietro Bonaventuri to his hometown of Florence against her father's will. The latter must have been relieved when his daughter married

the young man and even more so when he heard that Francesco de' Medici, heir to the grand ducal throne, took Bianca under his wing. What her father could hardly have foreseen was that the Medici prince was rather charmed by Bianca himself, and that his daughter and Francesco would start a love affair. In 1578, soon after the death of Francesco's first wife, and six years after Bianca's husband was killed, presumably with the knowledge of the grand duke, the couple married secretly.[8] A year later, they remarried in public, and from that moment onwards Bianca was able to officially call herself the grand duchess of Tuscany. It was probably around the same time that Bianca started a correspondence with her Venetian friend, Francesco Bembo, which would continue until her untimely death in 1587.[9]

Bianca Capello managed to obtain a special position within the Venetian Republic. Having fallen from grace when she ran away with her Florentine lover, she was received with open arms again the moment the news reached Venice that she had married Tuscany's grand duke.[10] Immediately, all sorts of festivities and ceremonies were organized: Bianca's father and brother were invited into the Ducal Palace and knighted by the Doge; the Florentine community held a great banquet in honour of their ambassador; and the Venetian nobility arranged a regatta.[11] It was in this way that her diplomatic value was generously acknowledged by her native city. Most importantly perhaps, Bianca Capello was declared 'daughter of the Republic', an honour bestowed before only on Caterina Cornaro, queen of Cyprus.[12] In this way, an explicit connection between Bianca and this prototype of female Venetian virtue was established which did not go unnoticed.[13] In 1489, Caterina, a member of the patrician Cornaro family who ruled the isle of Cyprus, was forced by the Venetian government to give up her kingdom and retreat to the village of Asolo, which had been given to her in exchange. For the Venetian republic, 'Caterina Cornaro' came to embody everything praiseworthy in a Venetian woman: chastity, modesty, and self-sacrifice in favour of the State. By bestowing on Bianca Capello an honour that had only previously been associated with the former queen of Cyprus, the republican government fully recognized the possibilities of 'Bianca Capello' as a cultural construct.

Just like Bianca, Francesco Bembo was a member of an ancient Venetian patrician family; the same family, in fact, that had produced the famous poet Cardinal Pietro Bembo (1470–1547).[14] As was quite usual with male members of the Venetian nobility, Bembo filled a variety of posts for the Republican government.[15] In one of these capacities he travelled as an envoy to Florence and Rome in the autumn of 1585. At the Medici court, he met Bianca in person, and also saw a painted portrait of her executed by the Roman master Scipione Pulzone. Impressed by both this portrait and its prototype, he decided to order a copy from the master himself as soon as he arrived in Rome. The appearance of the copy was somewhat delayed, but on 8 March 1586 the painting was finally delivered at Bembo's house. From that day onwards, people started to perform acts that can only be called rituals around the painting. The manner in which Bembo described these rituals in his letters to Bianca was openly theatrical.

The portrait as described by Francesco Bembo can almost certainly be identified with Scipione Pulzone's *Portrait of Bianca Capello* now in Schloss Ambras, Innsbruck (*plate* 1).[16] The painting is characterized both by its apparent absence of idealization and by its considerable detail, especially in the execution of clothes and jewels. It is 57 by 47 centimetres in size, and shows only the lady's head and bust. We see Bianca in a life-size, three-quarter view, with her head slightly turned towards the viewers, suggesting a movement which is emphasized by the folds on the left side of her neck; meanwhile she is looking in our direction. She is wearing a rich blue dress lavishly embroidered with threads of silver and gold and under the dress is a collar decorated with lace.

The grand duchess is further adorned with four pearl necklaces, pearl earrings, and in her reddish hair, which is also decorated with a delicate veil, another ornament made of pearls. In her décolletage she carries a red carnation.

Writing about the Venetian painters that tried to copy Bianca's portrait, Francesco Bembo remarked: 'Many want a copy, and few, or rather none, of these painters will make it. Tintoretto has started one, but it turns out to be very dissimilar, for [the original] looks more like a living person than a painted one, and its diligence misleads all.'[17] The Venetian painters with their large and spontaneous brushstrokes were apparently unable to imitate Pulzone's prototype, or so Bembo thought. The detailed character of Pulzone's painting, recognized by the Venetians, makes it very apt to be studied from nearby. It invites the viewer to approach and see what the painter has been doing, especially since the portrait is relatively small. Giorgio Vasari underlines this idea in his analysis of Titian's later style:

1 Scipione Pulzone, *Portrait of Bianca Capello*, 1585. Oil on canvas, 57 × 47 cm. Innsbruck: Schloss Ambras. Photo:© Kunsthistorisches Museum, Vienna.

> It is true that his way of working in his last pictures is very different from that of his youth. For his first works were finished with a certain delicacy and incredible diligence, and might be looked at near or far, but the last are worked at one go, with [the paint] sloshed thickly [on the canvas] and in stains, so that they cannot be seen near, but at a distance they look perfect.[18]

Titian was certainly not the only Venetian painter to use large brushes. With Pulzone's portrait of Bianca, however, it was exactly the opposite; his painting almost forces the viewer to come close, even to grab it with his or her hands. In this way, a very intimate connection between painting and viewer is established.

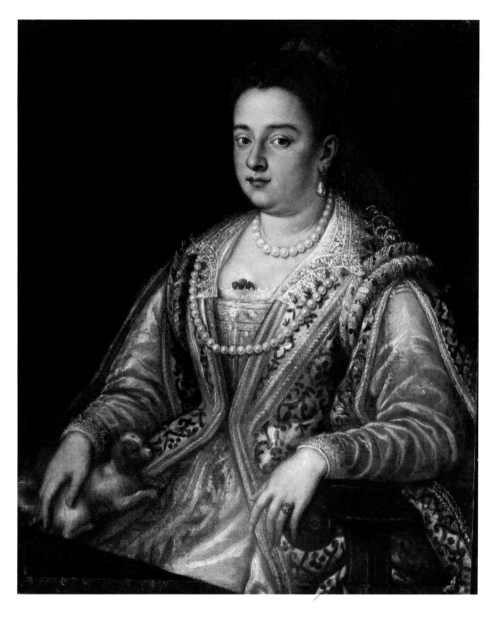

As mentioned above, verisimilitude is another remarkable characteristic of the painting. It has all the qualities of a trustworthy impression and is rather similar to other portraits known to represent Bianca, as we shall see. What is more, her brother Vittore remarked that it was very lifelike (‘*s’assomiglia assai al vivo*’).[19] This is not to say that the portrait is ‘realistic’: after all, it will always be uncertain what Bianca Capello looked like and we will never be able to compare the portrait to the ‘real’ Bianca – a fact equally true for most of the contemporary Venetian spectators of the portrait. We may rather conclude that the portrait is rhetorically convincing as the depiction of a living person. With the dark, heavy eyebrows, the somewhat pronounced and fleshy nose, and the short, plump neck with its three chins,

2 Scipione Pulzone (?), *Portrait of Bianca Capello*, c. 1585–87. Oil on canvas, 97 × 79.5 cm. Bologna: Musei Civici d’Arte Antica. Photo: Courtesy of the Musei Civici d’Arte Antica, Bologna.

the portrait hardly qualifies as an idealization.[20] In accordance with his reputation, Scipione Pulzone does not seem to have embellished Bianca much.[21] Rather, he has depicted her convincingly as a real and living woman including a number of flaws to achieve a certain reality effect.[22]

Yet, the individualized facial features are just one aspect of the painting; the clothes and jewels solicit the viewer’s attention as well. Their importance only becomes more apparent when Bembo’s portrait is compared to others of the same type. His painting belongs to a series of portraits that seems to have been established by Alessandro Allori, court painter of the Medici family, in the period of Bianca’s marriage to the grand duke.[23] This particular series of portraits of Bianca all show exactly the same face (for example, *plate* 2).[24] The dresses and some of the jewels, on the contrary, are different each time and remarkable for their meticulous detail. This can be understood as part of a larger tendency in early modern Italian portraiture to focus more on clothes and ornaments than on the body per se. Sometimes the hands were even painted after those of a studio model.[25]

3 'Young married woman of the Venetian nobility', from Cesare Vecellio, *Degli habiti antichi, e moderni di diverse parti del mondo libri due [...]*, 1590. Woodcut, 15.2 × 9.5 cm. Venice: Damian Zenaro. Photo:© Leiden University Library, 1366 G 1, 97v.

Judging from examples in Cesare Vecellio's *Degli habiti antichi e moderni* (1590), Bianca's dress as it is depicted in Pulzone's portrait is quite similar in its shape and ornamentation to those worn by Venetian noblewomen at public celebrations – compare for instance the large lace collars – and, with her hair symmetrically divided in two more or less vertical shapes, the dressing of her hair is characteristically Venetian as well (*plate* 3). The pearls and the flower refer on the other hand to marriage and fertility. As is shown by Vecellio and other costume books, Venetian women of the time had different dress for every age, for marital status, for each season, and according to social class and occasion.[26] The point is that the clothes in this portrait of Bianca are not just clothes; they have a message to convey; they perform.[27] Thus, every element in Bianca's outfit tells a part of a story; her body is like a mannequin on which she displays her precise position in Venetian society.[28] Pulzone's portrait is an official portrait, showing not only a person of flesh and blood but also her function in society. At the same time, it is intimate in character and invites the viewer to come close. As we will see, it is, all in all, well equipped to function in the way that it would.

What did actually happen to the portrait of Bianca Capello? In his letters to Bianca, Francesco Bembo recorded how hundreds of people came to his house to see the portrait, month after month. By the end of May – he had received the painting on 8 March – allegedly as many as 700 visitors had dropped by, a number that certainly exceeds a normal amount of guests in a period of less than three months. According to Bembo, every single one of these visits proceeded according to a more or less fixed scheme. People entered the house, were taken to the portrait, expressed their admiration, and left again. Apart from that, people performed acts in front of the painting that we may qualify as theatrical because they clearly referred to religious rituals, and openly displayed people's devotion to the lady. On the day that Bembo received the painting, for example, he wrote that his wife tried to kiss it – and that he had to stop her, afraid that her kiss would damage the paint.[29] And when in the month of May the news reached Venice that Bianca had fallen ill, many people came to her portrait to pray in front of it.[30]

That at least some of these events actually took place and are not solely products of Bembo's imagination is confirmed by the fact that other Venetian people also mention the portrait in their letters to Bianca Capello, exactly matching the dates given by Bembo. To give one example, when Bembo writes on 20 April that he had taken the painting to the Capello family's house the previous week, there is a letter from Vittore Capello, Bianca's brother, dated 12 April and sent to his sister, that corroborates his account. 'Bembo brought here a portrait of Your Highness by the hand of Scipione, very diligent and rich.'[31]

All these people who came to visit the portrait did not come independently, but were part of clear and distinct social groups – or so Bembo liked to present it.

The first group to see the painting in his account were the women living in his house, among whom were his wife and some servants. Other groups were artists, friends of Bembo's, *avvocati*, but also people from other cities such as the *vicentini* (from Vicenza) and the *bresciani* (from Brescia).

Even the Venetian Doge and his entourage saw the portrait, although this time roles were reversed and Bembo had to take it personally to the Ducal Palace, as we shall see. 'The magnificent portrait of Your Highness', wrote Bembo to Bianca, 'is praised more every day, by anyone who sees it, and by every sort of person; besides the painters, sculptors, and miniaturists, and people of similar professions, there have been many judicious persons, such as the brightest advocates, and others.'[32] As is suggested in Bembo's letters and also in those written by others, these different social groups neatly followed each other. It is noteworthy that the complete succession of visitors shows a gradual shift from those people very close to Francesco, such as his wife and the maids, or close to Bianca, such as her brother, towards those people that both of them had probably never heard of before, anonymous visitors from Venice's mainland possessions.

Bembo's presentation of this hierarchically structured succession of people shows an interesting parallel with the ducal and other processions held so often in Venice during the sixteenth century (*plate* 4). As Edward Muir has shown, these heavily formalized and institutionalized events not only illustrated Venice's constitution and hierarchic social structure but in fact helped to create that ideology anew every time.[33]

4 Detail of Anonymous, *The Procession of the Doge on Palm Sunday*, 1556–59. Engraving, 38 × 414.5 cm. Amsterdam: Rijksmuseum. Photo:© Rijksmuseum, Amsterdam.

In the sixteenth century, the organization of these ducal processions had become fully professionalized and the exact position of every officer was securely laid down in special legislation. Bembo's description of the process of people visiting his portrait of Bianca Capello is remarkable not so much because of its hierarchic structure as such; it is much more significant that he relied on patterns he knew from Venetian civic ceremonies to interpret what he saw. With no legislation available, no rules, nor an official master of ceremonies, people encountering an unknown situation such as this portrait of a beloved lady, 'daughter of the Republic', grand duchess of Tuscany, had recourse to familiar habits and well-known rituals. That the focus of attention was this time not the person of the Doge but the painted portrait of a lady apparently did not matter.

There are other parallels between the newly invented ritual behaviour around Bianca's portrait and already existing rituals in late sixteenth-century Venice. In Bembo's mind, the painting was not only the centre of a procession, waiting passively, so to speak, for the people to pass by; he also took it on several trips through the city. The first trip occurred very soon after the portrait's arrival, to, as he says, a good friend of his, the art connoisseur Jacopo Contarini, who was ill at the time and could not come to Bembo's house by himself.[34] The second was a few weeks later, when Bembo brought the portrait to the Capello family, that is, to the family of the portrayed lady.[35] It should be noted that the portrait had been without a proper frame all this time; when the painting's frame was finally finished and attached, this was the occasion for Francesco to take his precious image on a third journey, destined to bring it to the very centre of Venice's government and society: the Ducal Palace. In the middle of June, Bembo visited the Doge who, as one of the last people of importance yet to see it, was finally shown Bianca's portrait. Before we proceed, it is worth stressing the significance of the fact that Bianca came to the Doge and not vice versa: the person with the lower rank was the one who took the initiative and approached her superior, just as was usual in contemporary etiquette.

It is particularly in this trip to the Doge, elaborately described both by Bembo and another visitor to the Ducal Palace on that day,[36] that we find a reminiscence of a Venetian civic ritual, namely the so-called coronation of the Dogaressa, during which the wife of the newly elected Doge officially entered the Ducal Palace. Although, owing to various circumstances, the Venetians performed this ritual only twice in the whole sixteenth century, a particularly sumptuous ceremony was celebrated not long after the events discussed here, when Marino Grimani was elected Doge and Morosina Morosini – who, incidentally, belonged to the same family as Bianca Capello's mother – became Dogaressa.[37] Morosina was accompanied from her private palace to the Grand Canal on a boat trip ending at the Piazzetta S. Marco. The boat in which the Dogaressa was rowed was designed by the architect Vincenzo Scamozzi, and its decoration contained diverse allegorical elements, showing that the Doge and Dogaressa were personally elected by Saint Mark to rule both land and sea. Having arrived at the *Piazzetta*, Morosina passed through a triumphal arch, which showed even more explicitly the power and nobility of the Grimani and Morosini families.

Now, both Scamozzi's boat and the triumphal arch quite literally 'framed' the Dogaressa by referring directly to her putative character, virtues and power. In this sense, they remind one of the frame that Francesco Bembo designed himself for Bianca Capello's portrait. It was, as Bembo explains in his letters, executed in ebony, at the time a very valuable type of wood, and inlayed with various semi-precious stones. These pieces of stone were in turn adorned with four painted figures, personifications of four of Bianca's many supposed virtues: Innocence, Prudence,

Constancy, and Mercy.[38] Through this ornamentation, Bembo managed to establish a relation between the frame and the depicted person within.

The final stage of the Dogaressa's coronation meant that Morosina Morosini entered the Ducal Palace and took visual possession of it by sitting on the Doge's throne in the Senate Hall. When the portrait of Bianca Capello entered the palace, the Doge, very delighted by it, as Bembo recounts, took it to his private quarters and placed it on a little table, where he usually only kept a crucifix and the *corno*, his ceremonial hat.[39] The visit culminated in the arrangements made by Bembo and the Doge for the painting's stay in the palace overnight. The portrait of Bianca Capello, presented to the Doge as the 'daughter of the Venetian Republic', was allowed to enter the very heart of that republic. Again, ways to deal with the portrait were provided for by already existing types of ritual behaviour.

There are, however, still other frames of reference with which to interpret the veneration of Bianca's portrait. These may be found in the more private relationship that Francesco Bembo developed with Bianca through their correspondence. As I described above, Bembo wrote to the portrayed lady almost weekly, recording the responses of people to her painted portrait in great detail. Almost every week, he sat down in his study – which was, not unimportantly, the place where he usually kept Bianca's portrait so that he could look at it while working – and wrote her a letter two or three pages long. Time and again, he ended his letters with his praise, both for the portrait and for the portrayed person, never forgetting to stress that the real lady was the more beautiful of the two.

As was mentioned earlier, Francesco Bembo belonged to the same family as the renowned poet Cardinal Pietro Bembo, active in the first half of the sixteenth century.[40] Pietro Bembo is known for his *Prose della volgar lingua* (Prose of the Vernacular Language; 1525), a book on style in which he proposed the language of the fourteenth-century poet and humanist Francesco Petrarca as the model for contemporary vernacular poetry. There are, however, a number of clues that Pietro Bembo also used Petrarch's work, in particular his *Canzoniere*, as a model for amorous behaviour.[41] For example: Pietro received some portraits of his mistress, Maria Savorgnan, as presents from the lady herself, and, inspired by the fourteenth-century poet, he wrote: 'I have kissed her a thousand times instead of you, and I pray her for that which I would like to pray for to you.'[42] Pietro used petrarchan thought to frame the enactment of his own love story.[43]

Is it likely that Pietro's relative Francesco was aware of at least some of this? Like all Venetian patricians Francesco would have been very much aware of his family ties, especially with so illustrious a kinsman. In addition, and perhaps more importantly, Francesco was active as a poet himself, publishing poems on his own and in collections with fellow poets.[44] He exchanged sonnets with the poet Celio Magno (1536–1602) about a portrait painted of the latter by Domenico Tintoretto and also sent at least one sonnet to Bianca in praise of hers.[45]

Just as Pietro had done, and possibly through Pietro's poems and other writings, Francesco Bembo took Petrarch's *Canzoniere* as a model with which to give a visible and public shape to his own relation to a lady. This is particularly clear in the way he treated his painted portrait, which he in some way preferred to the original, just as his relative had done. More than a real woman, a portrait was amenable to all kinds of projections, could be appropriated, and thus fully serve one's own desires:

As far as that's concerned, your style is less cruel than hers / And you do not throw my hope away: / For at least when I look for you, you do not hide.[46]

Bianca Capello for her part contributed to Francesco's 'scenario', not only by donating her painted portrait to him, but also by enacting the role of the unwilling and inaccessible beloved. Answering Bembo's letters, but not too frequently, and refraining from visiting Venice in person, she must have provided him with infinite petrarchan inspiration: 'Not to see Your Highness – indeed, it has been almost two years since we last met – and not to have as many of your letters as would be possible: that is dying twice. And if dying only once will take one's life, what is one to believe that dying twice can do?'[47] Thus, through the painted portrait and the correspondence the two were able to act out a script that already existed.

By means of this theatrical behaviour, Bianca's painted portrait sometimes even came to function as Bianca herself. Through this series of acts, Bianca was made present. Such a process of making present by means of ritual and other conventional actions appealing to the eye, certainly not without parallels in the Christian tradition,[48] is made explicit in a letter by Francesco Bembo to Bianca of 22 November 1586, in which he wrote about a dinner party at his house:

> ... talking about you, it seemed to me as if I could see you and hear you, being present here; the same happened to my wife ... Your Highness was brought to the table with our desire and our imagination, and everyone made you a toast, and even did we speak with you, with much gentleness, as if you had truly been there. But when everyone became aware of their mistake and of their detriment, we tried to correct it, and to partially undo it, by beholding, and again beholding your most beautiful painted image, which seems to speak, and which welcomes anyone who looks at it.[49]

The company at the dinner table imagined the grand duchess being present, but upon realizing that they were wrong, that they were deceiving themselves, that she was not there, they took the lady's portrait to compensate for their mistake. At first, Bianca's presence was only imagined, but when the painted portrait became involved, her presence became real, or so the letter wants to suggest.

Yet, the end of the passage also suggests that there are limits to the analogy between Bianca and her portrait. Would the real Bianca tolerate the gazes that scrutinize her features without restraint, let alone invite them? Would she, for that matter, allow Francesco Bembo's wife to kiss her? In this period, such behaviour only befitted a very specific class of women to which Bianca most likely would not have wanted to belong.[50] This shows us again that painted portraits did have certain characteristics that, under specific circumstances, gave them certain advantages over real people. In this way, paintings came to possess an agency of their own.

Taking into account Bianca Capello's special position in Venetian society, it is not hard to understand why her portrait evoked such strong reactions. In fact, it is tempting to interpret all the events and correspondence purely in the light of the social relationships between Bianca Capello and members of Venetian civic society. We have so much historical knowledge of these relationships, after all, that we can easily forget that all these rituals were not centred around a human being but focused on her representation. One should not, therefore, overlook the materiality of the painting that was at the centre of all of this. As a commonplace of the art theory of the time had it, it is an art to hide art, and Pulzone's painting certainly succeeds as an artwork in this sense.[51]

To conclude: the way in which Francesco Bembo openly exhibited the ritual that had developed around his painting – most importantly, in fact, to Bianca Capello herself

by means of his letters – makes it thoroughly theatrical in character. This suggests that the theatricality of Venetian sixteenth-century painting lies not only in the paintings themselves, but certainly as much in the theatrical nature of the rituals in which these paintings were involved. The theatricality that guided the way people treated paintings could take many forms: from the modelling of Venetian constitution and citizenship to a petrarchan relation between a woman and a man. All in all, the similarities between the way people treated paintings on the one hand, and ritual behaviour in Venetian society on the other are striking; indeed, paintings could be as much part of Venetian society as any human being.

One wonders, however, how visual elements in paintings influenced theatrical behaviour and vice versa. I have suggested that the detail and relative unusualness of Pulzone's painting triggered a certain response in the Venetian audience and that the depiction of Bianca not only as a woman of flesh and blood but also as the cultural construct 'Bianca' further worked upon people's theatrical, and even exhibitionistic inclinations. It remains open, however, how this may have functioned in the case of more complex, multi-figure paintings.

Talking about the changing role of women in Venetian public ceremonies during the fifteenth and sixteenth centuries, Edward Muir revealed that their positions became more and more marginal.[52] On those rare occasions that women were still involved, they were elevated to an ideal status and became the passive subjects of chivalric fantasy. In part, this happened to Bianca Capello as well: although she was actively feeding her presence in Venice by means of her painted portrait, the letters she sent to Venetian inhabitants, and the Venetian palaces she bought, at the same time her memory became the plaything of her Venetian admirers, for whom, from the spring of 1586 onwards, her painted portrait was the main focal point. For in the theatrical society that was Venice the paintings themselves were actors on a stage.

Notes

I would like to thank my colleagues from the NWO programme 'Art, Agency and Living Presence in Early Modern Italy' at Leiden University for their comments and suggestions, and Caroline van Eck and Stijn Bussels in particular for giving me the opportunity to participate in this volume. The Dutch Foundation for Scientific Research (NWO) generously funded the research on which this chapter is based. I am also thankful for the repeated hospitality of the Dutch University Institute for Art History in Florence and for the exchange of ideas with members of staff and other fellows. Furthermore, this chapter has profited a great deal from the comments of the anonymous reviewer of *Art History*. Finally, a special word of thanks to Joris van Gastel, who has read versions of this chapter many times and supplied me with ideas throughout the whole process of writing.

1 '[E]t dapoi l'haverle trattenute un pezzo, levo il panò, [con] che lo havevo coperto. et se al cader delle telle d'una scena, le persone restano amiratrice; queste Donne al levar di questa, restarono stupefatte, e appagate in tutto, e per tutto.' Archivio di Stato di Firenze, *Mediceo del Principato*, 5938, 707v. The letter is dated 8 March 1586.

2 See, to name just a few examples regarding the art of Jacopo Tintoretto, Lora Anne Paladino, *Pietro Aretino: Orator and Art Theorist*, New Haven, 1981; Roland Krischel, *Jacopo Tintoretto's 'Sklavenwunder'*, Munich, 1991; Tom Nichols, 'Tintoretto, *Prestezza* and the *Poligrafi*: a study in literary and visual culture of Cinquecento Venice', *Renaissance Studies*, 10:1, 1996, 72–100; Wolfgang Brassat, *Das Historienbild im Zeitalter der Eloquenz: Von Raffael bis Le Brun*, Berlin, 2003.

3 The most important studies in this field are Michelangelo Muraro, 'Vittore Carpaccio o il teatro in pittura', Maria Teresa Muraro, ed., *Studi sul teatro veneto fra rinascimento e età barocca*, Florence, 1971, 7–19; David Rosand, 'Theater and structure in the art of Paolo Veronese', *Art Bulletin*, 55, 1973, 217–39; also Rosand's *Painting in Cinquecento Venice: Titian, Veronese, Tintoretto*, New Haven and London, 1982, later revised as *Painting in Sixteenth-Century Venice: Titian, Veronese, Tintoretto*, Cambridge, 1997; see also, more recently, Marc Bayard, 'La théatralité picturale dans l'art italien de la Renaissance', *Studiolo*, 3, 2005, 39–57; and also by Bayard 'Intermédiaires et admoniteurs dans l'art théatral et pictural', in his *L'histoire de l'art et le comparatisme: Les horizons du détour*, Rome, 2007, 53–69. For more information on the treatment of the concept of theatricality in art history in general see Michael Quinn, 'Concepts of theatricality in contemporary art history', *Theatre Research International*, 20:2, 1994, 106–13.

4 The rituality and theatricality of Venetian public life come to the fore in studies such as Edward Muir, *Civic Ritual in Renaissance Venice*, Princeton, NJ, 1981, and Iain Fenlon, *The Ceremonial City: History, Memory and Myth in Renaissance Venice*, New Haven and London, 2007.

5 Richard Schechner, 'From ritual to theater and back: the efficacy-entertainment braid', *Performance Theory*, London, 2003, 112–69.

6 Schechner, 'From ritual to theater', 136.

7 See Richard Sennett, *The Fall of Public Man*, New York, 1977, 34.

8 Francesco I had first been married to Giovanna of Austria (1547–78), but took Bianca Capello as his wife two months after Giovanna's death. See Emanuele Antonio Cicogna, *Delle inscrizioni veneziane*, Venice, 1842, vol. 5, 563–5, and Alberto Maria Ghisalberti, ed., *Dizionario biografico degli italiani*, vol. 10, 15–16 (Bianca Capello). See also Jacqueline Marie Musacchio's recent chapter, 'Objects and Identity: Antonio de' Medici and the Casino at San Marco in Florence,' in John Jeffery Martin, ed., *The Renaissance World*, New York and London, 2007, 481-500.

9 How and when the two met each other is unclear, but it seems probable that their friendship had its origin in their youth. The house where

Bianca spent her childhood, near the church of San Polo, is not far from one of the palaces of the Bembo family on the Grand Canal near the Rialto Bridge; it might be that the two met in the neighbourhood, just as happened to Bianca in the case of her first Florentine husband.

10 *Dizionario biografico degli italiani*, vol. 10, 15.

11 Cicogna, *Delle inscrizioni veneziane*, vol. 5, 559 and further.

12 Cicogna, *Inscrizioni*, 559.

13 *Venetia città nobilissima et singolare descritta in XIII libri da M. Francesco Sansovino*, Venice, 1581, 285r–v.

14 In fact, the two men belonged to separate branches, both with their origins in the fourteenth century, of one of the oldest families in town. See Archivio di Stato di Venezia, Marco Barbaro, *Arbori de' patritii veneti*, vol. 1, 319, 325 (Bernardo Bembo), and 331 (Lorenzo Bembo).

15 It is almost certain that he was the same Francesco Bembo who, in 1599, having been appointed as a magistrate with access to the senate and its state secrets, was convicted for diverting confidential information to 'un Principe d'Italia' or, more precisely, to the 'Gran duca di Toscana', as Marco Barbaro put it. See Biblioteca Nazionale Marciana, Venice, ms It. VII 176 (8619), 248v–249r; Barbaro, *Arbori*, 331; Cicogna, *Inscrizioni*, 563.

16 Alexandra Dern, *Scipione Pulzone (ca. 1546–1598)*, Weimar, 2003, 60–1. The provenance of the painting can be traced to the Venetian collection of Bartolomeo della Nave, sold in 1638. The size of this canvas and that of the painting in Ambras are nearly equal. See further on this painting Ernst Diez, 'Der Hofmaler Bartholomäus Spranger', *Jahrbuch der Kunsthistorischen Sammlungen des Allerhöchsten Kaiserhauses*, 28, 1909/1910, 93–151; Loredana, *Bianca Cappello: Patrizia Veneta, Granduchessa di Toscana*, Rome, 1936; Ellis Kirkham Waterhouse, 'Paintings from Venice for seventeenth-century England: some records of a forgotten transaction', *Italian Studies*, 7, 1952, 1–23; Federico Zeri, *Pittura e Controriforma: L'arte senza tempo di Scipione da Gaeta*, Turin, 1957; Günther Heinz, 'Studien zur Porträtmalerei an den Höfen der Österreichischen Erblande', *Jahrbuch der Kunsthistorischen Sammlungen in Wien*, 59, 1963, 99–224; Karla Langedijk, *Portretten van de Medici omstreeks 1600*, Assen, 1968; Günther Heinz and Karl Schütz, eds, *Porträtgalerie zur Geschichte Österreichs von 1400 bis 1800: Katalog der Gemäldegalerie*, Vienna, 1976, 269–70; for 1585 as date see Karla Langedijk, *The Portraits of the Medici: 15t–18th Centuries*, Florence, 1981, vol. 1, 320–1.

17 'Molti voriano copia; et pochi, anzi nissuno di questi pittori la farà. il Tentoretto l'hà principiato, ma disugualis.o riesce in fatti. perche questa ha più del vivo, che del dipinto, et la dilig.za che è in essa, smarrisce ogni uno.' A.S.F., *Mediceo del Principato*, 5942, 352v.

18 'Ma è ben vero che il modo di fare che tenne in queste ultime è assai differente dal fare suo da giovane: con ciò sia che le prime son condotte con una certa finezza e diligenza incredibile, e da esser vedute da presso e da lontano, e queste ultime, condotte di colpi, tirate via di grosso e con macchie, di maniera che da presso non si possono vedere e di lontano appariscono perfette.' Giorgio Vasari, *Le vite de' piu eccellenti pittori, scultori et architetti nelle redazioni del 1550 e 1568*, eds Rosanna Bettarini and Paola Barocchi, Florence, 1966–1987, vol. 4, 166.

19 A.S.F., *Mediceo del Principato*, 5942, 44r.

20 Important studies on the contemporary ideal of feminine beauty have been written by Elizabeth Cropper. See her 'On beautiful women, Parmigianino, petrarchismo and the vernacular style', *Art Bulletin*, 58, 1976, 374–94 and 'The beauty of women: problems in the rhetoric of Renaissance portraiture', in Margaret W. Ferguson, ed., *Rewriting the Renaissance: The Discourses of Sexual Difference in Early Modern Europe*, Chicago, IL and London, 1986, 175–90. This is not to say that Bembo did not constantly praise Bianca's beauty. He was probably not the only one, for Michel de Montaigne wrote after having visited the Medici court: 'Cette duchesse est belle à l'opinion Italienne, un visage agréable et impérieux, le corsage gros, et de tétins á leur souhait.' Michel de Montaigne, *Journal de voyage*, ed. François Rigolot, Paris, 1992, 82.

21 Giovanni Baglione called Pulzone 'accurate' and also Raffaello Borghini praised Pulzone's 'ritratti di naturale ... che paion vivi'. Dern, *Scipione Pulzone*, 21 and 42.

22 For the 'reality effect', see Roland Barthes, *The Rustle of Language*, Berkeley and Los Angeles, CA, 1989, 141–8. For the problem of verisimilitude and idealization in early modern female portraiture, see also Joanna Woodall, 'An exemplary consort: Antonis Mor's portrait of Mary Tudor', *Art History*, 14: 2, 1991, 207 and further.

23 For a catalogue of the portraits of Bianca Capello, see Karla Langedijk, *The Portraits of the Medici*, vol. 1, 314–27. Langedijk argues that Pulzone's portrait of Bianca in Florence was knee-length and that it was a pendant of a portrait of the same size of Francesco I de' Medici. For Bianca's Florentine portrait, see vol. 1, 126, and for Francesco's portrait, vol. 2, 866–7.

24 See Langedijk, *The Portraits of the Medici*, I, 314–27.

25 Ann Rosalind Jones and Peter Stallybrass, *Renaissance Clothing and the Materials of Memory*, Cambridge, 2000, 34.

26 *De gli habiti antichi, et moderni di diuerse parti del mondo libri due, fatti da Cesare Vecellio, & con discorsi da lui dichiarati*, Venice, 1590.

27 On clothes in the early modern period, see, among others, Carole Collier Frick, *Dressing Renaissance Florence: Families, Fortunes, and Fine Clothing*, Baltimore, MD, 2002, and Jones and Stallybrass, *Renaissance Clothing*.

28 See Sennett, *The Fall of Public Man*, 65–72.

29 '[Q]ueste Donne al levar di questa [tela], restarono stupefatte, e appagate in tutto, e per tutto. et mia moglie si grettò per basciarlo, quando la tenni per tema, che non le facesse qualche nocume[n]to.' A.S.F., *Mediceo del Principato*, 5938, 707v. Later on, however, he did allow one of Bianca's younger relatives to kiss the painting. See A.S.F., *Mediceo del Principato*, 5942, 99r.

30 A.S.F., *Mediceo del Principato*, 5942, 243v.

31 'Il Bembo portò qui un ritratto di V.A. di man di Scipione molto diligente et fornito ... ' A.S.F., *Mediceo del Principato*, 5942, 44r. There are more letters that confirm Bembo's account: see the letter by Cillenia Bembo, A.S.F., *Mediceo del Principato*, 5938, 661r; another one by Vittore Capello, A.S.F., *Mediceo del Principato*, 5942, 139r–v; and by Mazzino Ebreo, A.S.F., *Mediceo del Principato*, 5942, 663r–v.

32 'Il bell.mo ritratto di V.A. è ogni dì più commendato da ogni uno, che lo vede, et da ogni qualità di persona oltra li pittori, et scultori, miniatori, et simili intendenti, vi sono state molte persone giuditiose; come Avocati, clar.mi et altri.' A.S.F., *Mediceo del Principato*, 5942, 352v.

33 Muir, *Civic Ritual*, 189 and further.

34 A.S.F., *Mediceo del Principato*, 5938, 690r. For Jacopo Contarini and his rich collections, see Michel Hochmann, 'La collection de Giacomo Contarini', *Mélanges de l'École française de Rome: Moyen Age, Temps Modernes*, 99, 1987, 447–89, who also offers a good bibliography. See also Manfredo Tafuri, *Venezia e il Rinascimento: religione, scienza, architettura*, Turin, 1985, 197.

35 A.S.F., *Mediceo del Principato*, 5942, 99r.

36 For the letter by Bembo see A.S.F., *Mediceo del Principato*, 5942, 649r–650r; for the letter by Mazzino Hebreo, who was also present, see 663r–v.

37 Muir, *Civic Ritual*, 293 and further.

38 A.S.F., *Mediceo del Principato*, 5942, 639v.

39 A.S.F., *Mediceo del Principato*, 5942, 649r–650r; see also 663r–v.

40 See note 14.

41 Gordon Braden, *Petrarchan Love and the Continental Renaissance*, New Haven and London, 1999, 92 and further. See also Gorden Braden, 'Applied petrarchism: the loves of Pietro Bembo', *Modern Language Quarterly*, 57, 1996, 397–423. For another family member singing the praises of a beloved lady and her portrait, see Jennifer Fletcher, 'Bernardo Bembo and Leonardo's portrait of Ginevra de' Benci', *Burlington Magazine*, 131, 1989, 811–16.

42 See Lina Bolzoni, *Poesia e ritratto nel Rinascimento*, Rome and Bari, 2008, 24. Bolzoni quotes from Maria Savorgnan and Pietro Bembo, *Carteggio d'Amore (1500–1501)*, ed. Carlo Dionisotti, Florence, 1950, 52, n. 54.

43 See also Bolzoni, *Poesia e ritratto*, 23–4.

44 Cicogna, *Inscrizioni*, vol. 5, 563.

45 Bembo's sonnet and accompanying letter to Magno are in the Biblioteca Nazionale Marciana, Venice, MS It. IX 172 (6093), 142r. The sonnet was later published in a joint publication of poems by Celio Magno and Orsatto Giustiniani and, more recently, in Barbara Mazza Boccazzi, 'Ut pictura poesis: Domenico Tintoretto per Celio Magno', *Venezia Cinquecento*, 11, 2001, 167–75. For a reference to a sonnet about Bianca's portrait, see A.S.F., *Mediceo del Principato*, 5942, 352v. The sonnet seems not to have survived.

46 'In questo hai tu di lei men fero stile | Né spargi sì le mie speranze al vento | Ch'almen, quand'io ti cerco, non t'ascondi.' Quoted after Bolzoni, *Poesia e ritratto*, 88.

47 'Non veder V.A., et di già siamo vicini alli due anni; et non haver q[ua]nto è possibile sue lettere; è doppia morte. et se una sola, leva di vita, che si può credere, che facciano due?' A.S.F., *Mediceo del Principato*,

5944, 248r.

48 See especially Muir, *Ritual in Early Modern Europe*.

49 '... ragionando di lei, mi pareva vederla, et udirla qui p[rese]nte; il med.mo è intervenuto à mia moglie ...; et V.A. fu portata à tavola con il desiderio, et con l'imaginatione; et ogni uno le fece [brindisi]; et non meno ragionavamo con lei, e con molta dolcezza; come s'ella vi fosse ver.te stata. Ma poi che del suo errore ogni uno si accorse, e del suo danno; cercassimo di emendarlo, et di rifarsi in parte, con mirare, e rimirare la sua bellissima imagine dipinta; la quale par, che parli, et faccia accoglienza à chi la mira.' A.S.F., *Mediceo del Principato*, 5943, 771–2.

50 For sexual morals in Venice in this period see Daniela Hacke, *Women, Sex and Marriage in Early Modern Venice*, Aldershot, 2004.

51 For this *topos* see Valeska von Rosen, 'Celare artem: die Ästhetisierung eines rhetorischen Topos in der Malerei mit sichtbarer Pinselschrift' in Ulrich Pfisterer and Max Seidel, eds, *Visuelle Topoi: Erfindung und tradiertes Wissen in den Künsten der italienischen Renaissance*, Munich, 2003, 323–50, in particular 325–8.

52 Muir, *Civic Ritual*, 303–4.

Chapter 7
The Performing Venue:
The Visual Play of Italian Courtly Theatres in the Sixteenth Century

Lex Hermans

The protagonists of this chapter have to be considered as performers – actors, one might say – but they are not living beings. Its subject is the sixteenth-century Italian courtly theatres of Rome, Florence, Sabbioneta, and Parma, together with the visual effect their often very elaborate decoration schemes have on their viewers. It is about the agency of things, not persons. The performances that took place in these venues, though important, are left out.

Origins, Size, and Audiences

Italian society of the sixteenth century has often been called 'theatrical'; the historian of mentalities Peter Burke dubbed it a *società spettacolo*.[1] Religious and civic rituals, acts of government, and even the presentation of self were conceived as performances. Since the middle ages, theatre, in its narrowest sense of plays performed on a stage, had been linked with significant dates in the Christian calendar such as Christmas, Epiphany, and Easter. Traditionally, Carnival, the boisterous popular festival prior to the beginning of Lent, had also been an occasion to stage elaborate shows. Typically, ruling families such as the Este of Ferrara in the decades around 1500 and the Medici of Florence in the second half of the sixteenth century tied occasions such as the celebration of princely weddings into this festive tradition.

Until the third quarter of the fifteenth century, the theatre had been largely religious in character. The timing of performances was dictated by the church, as was subject matter. By the 1470s, however, the spread of humanism had gained such momentum that a revival of ancient Roman theatrical traditions became feasible. By performing the 'rediscovered' comedies of Plautus and Terence on stage the humanists brought about the emancipation of theatre from religion. Moreover, they promoted the theatre as an institution that would help to impress civic and moral values upon its audiences.[2]

Humanists wanted the theatre to be a public building, open to everybody. In 1486 Giovanni Sulpizio praised cardinal Raffaele Riario for having been the first to offer performances of classical theatre to the citizens of Rome, and expressed the hope that he would build a permanent stage for the city.[3] As late as 1560, Alvise Cornaro proposed to the council of Venice the ambitious though unrealistic project of building an amphitheatre in the very centre of the city that would be open to all and in which everyone would have a place according to the rank God had given him.[4] The rulers of the time were not inclined to follow these 'democratic' ideas. Much as

Detail from Giorgio Vasari, Theatre in the Salone dei Cinquecento, Palazzo Vecchio, Florence, 1565, (plate 2).

Theatricality in Early Modern Art and Architecture *Edited by Caroline van Eck and Stijn Bussels* © 2011 Association of Art Historians.

they had sought to usurp the carnival for their own ends they tried to monopolise the humanist theatre, presumably because the intellectual and cultural prestige it conferred would reflect well on their courts. It was the ruling families and the aristocracy who, from the 1480s onward, claimed the humanist stage and housed it within their own premises.[5] Halls constructed to house stages in existing palaces and a number of sixteenth-century plans for new ones that include an indoor theatre illustrate this trend.[6]

Once established, the bond between aristocratic celebrations and theatrical productions was never severed. Although the planning of a theatre as an integral part of a palace would seem to suggest that patrons wanted a permanent stage at their disposal from sheer enthusiasm for watching plays or to promote their status, most stage halls were built for a special event. Of the five courtly theatres considered here, an identifiable event is lacking only for that in Sabbioneta commissioned in 1588. In 1513 a temporary theatre was built on the Campidoglio in Rome to host the celebrations around the conferment of Roman citizenship and peerage on Giuliano and Lorenzo de' Medici, relatives of Pope Leo X. In Florence, the Medici created a semi-permanent theatre in the Palazzo Vecchio for the wedding festivities of the future grand duke Francesco I and Joan of Austria in 1565, and later expressly constructed a more permanent one in the Uffizi for those of Virginia de' Medici and Cesare d'Este

1 Vincenzo Scamozzi, *Teatro all'antica* in Sabbioneta, 1588–90. Interior, from the stage towards the bleachers and the ducal 'box'. Photo: Václav Sédy.

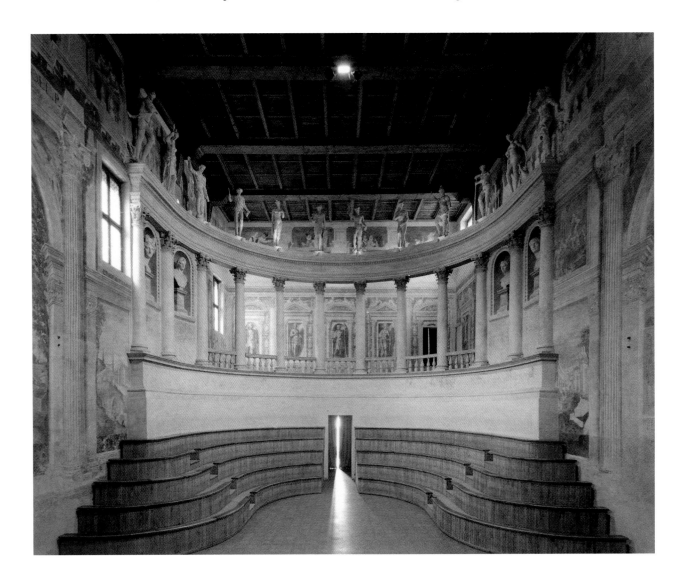

in 1586. And the Farnese theatre in Parma owes its existence to a planned state visit to duke Ranuccio Farnese of Parma and Piacenza by grand duke Cosimo II of Tuscany in 1618–19 that never took place.[7]

These courtly theatres were never intended for the exclusive performance of plays. On the contrary, almost all of them were built as multi-purpose halls, with sufficient capacity to accommodate state banquets, nuptial balls, ceremonies, and even – as in Parma – indoor tournaments.[8] Some of these halls, such as the one in the *salone dei Cinquecento* in Florence or the *Teatro Farnese* in Parma, could accommodate around a thousand people although the majority were built for far less; the ducal theatre in Sabbioneta cannot hold more than a hundred spectators.[9]

Although entrance was free, as the carnival shows had always been, the princes paying for them out of their own pocket, theatre-owning aristocrats clearly wanted to control who was to be admitted.[10] We have a number of accounts by eyewitnesses, typically envoys reporting to their masters or local authors whom the organizing court had commissioned to produce detailed descriptions in print of the festivities as a record of their sumptuousness and to perpetuate the renown of their owners. These occasionally refer to the *popolo* as spectators. Yet, their writings bear out my view that the audience of the courtly theatres usually consisted of the princely family and their relatives, courtiers, the local elite, and intellectuals. At weddings, their number was increased with the foreign guests and their retinue. Even when a prince was very liberal with his invitations, like Cosimo I in 1569, it turns out that the individuals admitted were 'gentlemen and favoured persons'.[11] One can tentatively conclude that these halls were used to assemble those members of society who played a part in the upkeep of the state and the support of princely rule.

Elements of Decoration

In many respects these theatres resembled festive *apparati*, the ephemeral but expensive and often exuberant decorations that were put up for events such as visits by foreign rulers, princely weddings, or state funerals. The décor was an integral and indispensable part of the festivity, celebration or event, as it was of theatrical performances in the narrow sense. The late sixteenth-century director Angelo Ingegneri defined an *apparato* as the entirety of set, house, and actors.[12]

What were the salient elements of the *apparati*? Why were they put up? And – perhaps most important – how were they intended to affect an audience? In the following discussion, I shall review four key elements of the *apparati* in order to provide answers to these questions: statues and paintings representing gods, emperors, heroes, and virtues; history paintings; the stage set; and the architectural design of the house itself.

The statues and paintings of gods, heroes, emperors, and other virtuous men and women found in virtually all courtly theatres tied into the tradition of the *viri illustri*.[13] The custom was thought to originate with the ancients, who according to Giorgio Vasari, 'set up images of their great men in public places, with honourable inscriptions', in order 'to turn the minds of their successors towards excellence and glory'.[14] These divine and imperial presences, whose conspicuous display can still be admired on the colonnade and on the inner walls of the ducal loge in the theatre in Sabbioneta (*plate* 1), were examples for individuals, models with whom the observer could become familiar, and even identify himself, as Francesco Patrizi of Cherso (1529–97) claimed.[15] According to this philosopher and rhetorician, identification was made the easier because of the human tendency to imitate one's fellow human beings.[16] Patrizi's remark is a reiteration of the idea that an object can only occasion

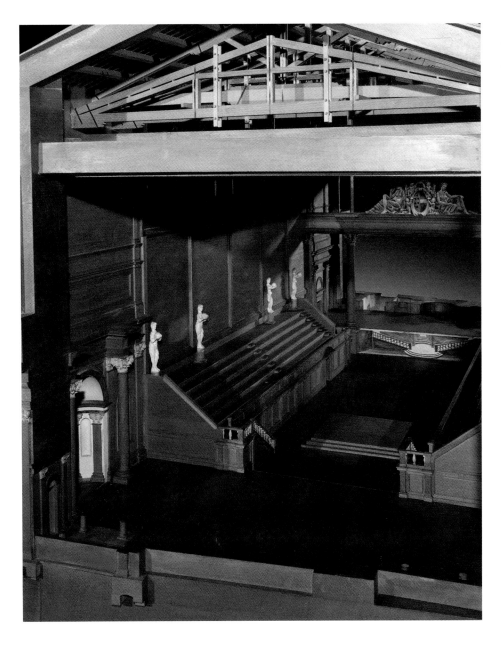

2 Giorgio Vasari, Theatre in the Salone dei Cinquecento, Palazzo Vecchio, Florence, 1565. Reconstruction model (scale 1:25) by Cesare Lisi, 1975. Wood, 252 × 117 × 124 cm. Florence: Palazzo Medici Riccardi. Photo: Courtesy of the Provincia di Firenze.

effects similar to itself. The principle *omne agens agit simile sibi*, developed and accepted by the formost representatives of scholasticism, was taught until the end of the sixteenth century. Thomas Aquinas had on several occasions explained its functioning: every *agens* or cause (*causa*) generates an effect that in form and movement is similar to it, but always less perfect than the cause itself. The principle is valid only for first or primary causes, not for secondary or derivative ones. For example: the effect of a painting will be similar to the effect of the painter, not to that of his brush.[17]

The agency of man and its impact on his fellows was considered in visual terms: seeing a persuasive model stimulates a man to imitation. Models could be ancient heroes, long dead emperors, and even gods. Notwithstanding the fact that they were pagans, the euhemeristic tradition made the ancient gods worthy of imitation. The ancient Greek author Euhemeros, whose doctrine was revived in the sixteenth century, had taught that gods were originally humans who did so well on earth that they were deified. As Cicero remarked, Hercules would never have been received among the gods if he had lacked in praiseworthy actions as a human being.[18]

Living persons could also be models for behaviour. Seeing them caused inspiration, as a letter of dedication by the architect Giovanni Battista Aleotti bears out. 'As is well known, Your Highness is living theatre', he wrote to his patron Ranuccio I, 'in whom all heroic virtues represent magnanimous and generous actions.'[19] And he goes on to assure the duke that if Ranuccio will continue to employ and protect him, he will be inspired by the devotion he feels towards his employer to create more arches and colossal statues for him than 'Rome, that most fertile mother of superb structures, erected for her victorious heroes, the equals of Your Highness'.[20] Of course this is self-interested flattery, yet it shows the decidedly

theatrical character which great examples had in the eyes of the viewers, and the sort of effect these lifelike visual models might work in their minds. It also shows that the models served as yardsticks against which to measure living rulers. Were they less or more in comparison to the ancients? Tellingly, in his loge Vespasiano Gonzaga was surrounded by frescoes of seven Roman emperors, but the one directly behind his seat, on the longitudinal line of the theatre, was Vespasian – the duke's namesake, and no mean emperor. The first Vespasian was a victorious general and astute financier, who had restructured Rome and its tax system, and had given the city one of its most iconic buildings, the *amphitheatrum flavium* or Coliseum. Vespasiano – a successful military man himself – did the same for Sabbioneta, even if on a smaller scale.[21]

Much like the images of *viri illustri*, history paintings had to serve as models, though the chain of influence was thought to pass from collectivity to collectivity rather than from person to person. The mural paintings in the interior of the *teatro capitolino* showed a variety of true or imagined instances of Roman-Tuscan friendship and cultural exchange, stressing – and this is typical of the Medici point of view – how much the ancient Romans owed to the Etruscans, who had been, after all, true, indigenous, Italians.[22] Paolo Palliolo of Fano, a junior magistrate in the service of the Roman *comune*, who described the theatre and the events there in detail in a letter to the Bolognese wife of a Roman senator,[23] concludes that in these painted scenes the Romans of his day were depicting how their forebears had taken many of their rites, literature, regalia, and religious practices from the Etruscans, and moreover expressing the 'enormous joy and pleasure they feel now that they see the same repeated and happening in our own time'.[24] Of Giorgio Vasari's paintings in the *salone dei Cinquecento*, which was turned into a theatre hall in 1565 (*plate 2*), no such pertinent contemporary interpretation has come down to us.[25] Yet beyond doubt the allegory of Cosimo I in the middle roundel of the coffered ceiling, which shows the grand duke as a vigorous lion (reminiscent of Florence's *Marzocco*) between two languid military men in Roman dress, and the series of images of submitted cities on the long walls, were meant to impress on the observers the extent of Medici rule and the military power of the grand duke. At the same time they reminded onlookers of the recent history of Florentine expansion.

Italians of the sixteenth century regarded history as a long chain of edifying examples, fitted to impart to the reader or hearer models he or his society ought to imitate. Francesco Patrizi stated that man has 'in history, almost as in a complete theatre, every kind of example'.[26] In his view examples should be instructive and elevated and help cities and states reach a superior level of civilization and power. Therefore, insignificant actions were useless as models; only what was really important could be of help.[27] As a good rhetorician, Patrizi also held that history had to be visualized – put before the eyes, as the ancient orators called it (*pro ommatōn tithemenon* in Greek; *ante oculos ponenda* in Latin)[28] – in words, but also in images. Because history was made up of human actions, he called the men making history actors and suggested that such acting was something that could be made visible.[29] Hence Patrizi's claim that 'one can make history of all things one can see, in writing or in painting. For history is not only written, but also sculpted, and painted, and the last ones are with more justification called *showpieces*, because they are objects of the view'.[30] History was something of a theatre, then, a spectacle to watch, and watch closely at that. Very likely, Pope Leo X and grand duke Cosimo I saw the history paintings in the *teatro capitolino* and the *salone dei Cinquecento* in this light. In all probability, the honoured guests at their festivities did the same.

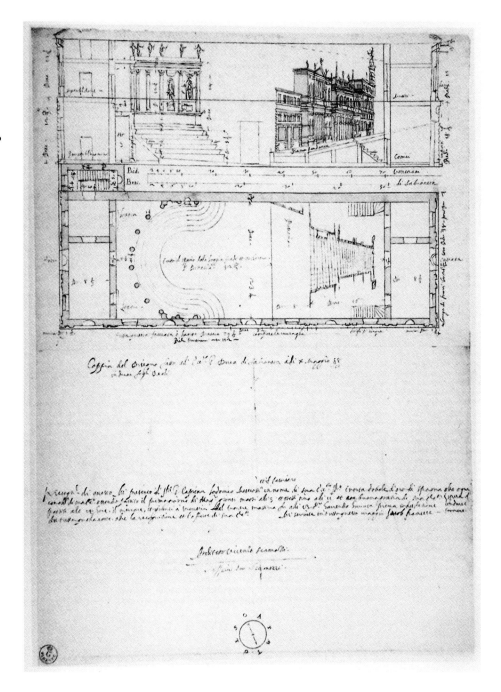

The frescoes in Sabbioneta's theatre hall are of a different category, and easier
to understand when compared with the decoration of the backdrop of a stage. They
show ideal views of Rome, the Castel Sant'Angelo featuring prominently among
them. But they are not 'true' cityscapes, certainly not highly realistic images of the
Eternal City. They are capriccios, made up of various iconic Roman buildings in order
to convey the ideal of unalloyed *Romanitas*. They provide the view of Rome as it had
been, if one accepted the testimony of its ruins. 'How great Rome once was is taught
by her very ruins': not for nothing did Vespasiano's theatre have this text inscribed
on both its interior and exterior walls.[31] These views of Rome were meant to impart
on the observers the idea of an ideal city, as was the three-dimensional cityscape the
architect Vincenzo Scamozzi had erected as a fixed stage set.

In the design of the stage set Scamozzi had summarily followed the recommendations on designing for the tragic scene in the second book of Sebastiano Serlio's multi-volume architectural treatise (1545). There are no 'low' buildings to be seen in Scamozzi's design; the whole cityscape is full of noble houses and round-arched arcades (*plate* 3). In many respects this stage architecture resembled the painted backdrops used in many plays in Rome and Florence from the 1520s onward. Architectural theory of the fifteenth and especially the sixteenth centuries postulated a close relationship between the style of a building and the character of its owner. Although the first explicit formalization of the concept is due to Serlio in the 1530s, a looser system was in vogue from the middle of the fifteenth century. Typically, the higher levels of society were expected to build in an elevated, classicist style, in imitation, so it was thought, of the ancients. Hence, if one saw a scene with only noble, or palatial houses, temple-like churches, obelisks, and triumphal arches, it was almost self-evident to the educated, period observer that the cityscape on view represented a noble, indeed ideal, city. Moreover, the stern central perspective would remind the spectator of Cicero's *dictum* that visible order suggests there must be someone who has established and maintains that order.[32] The conclusion for visitors to the courtly theatres would be that it was the prince who provided the *ratio*, *modus*, and *disciplina* of this ideal cityscape. So the visible order came to be a celebration of the power and virtues of the ruler – and by extension, or substitution, of the well-placed, and probably carefully selected, visitors themselves. By the same token, such a well-ordered city might seem to be a 'new Rome', a community that could stand comparison with the capital of the ancient empire in administration, wealth, power, and civilization, though not, of course, size. And, just as the cityscapes represented both Rome and its modern imitations and emulators, the observers of such stage sets could consider themselves as 'new' Romans. In view of this it comes as no surprise that Palliolo concluded of the *teatro capitolino* that everyone who observed it well would think the felicitous times of ancient Rome had returned. Its execution was so well done that the shape and quality of the building evoked the glories of antiquity (*plate* 4).[33]

In princely theatres the tragic scene *à la Serlio* was at the same time a representation of the glory of the ancients and the achievements of modern rulers. In the letter to Ranuccio I of February 1618 cited above, Aleotti wrote that he wanted his design for the tragic scene in the *Teatro degl'Intrepidi* in Ferrara – the only type of scene he considered fit for a huge building like the *Teatro Farnese* – to 'appear in this Theatre of the World' under Ranuccio's 'most glorious name'.[34] While calling the daily life-world a theatre – a common metaphor of the time – the

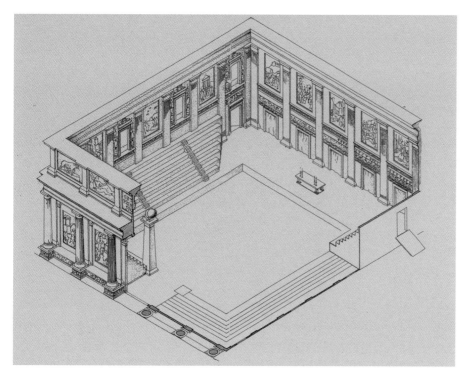

4 Theatre on the Campidoglio, Rome, 1513. Reconstruction designed by Arnaldo Bruschi. Plate 3 from Fabrizio Cruciani, *Il teatro del Campidoglio e le feste romane del 1513, con la ricostruzione architettonica del teatro di Arnaldo Bruschi*, Milan: Il Polifilo, 1969.

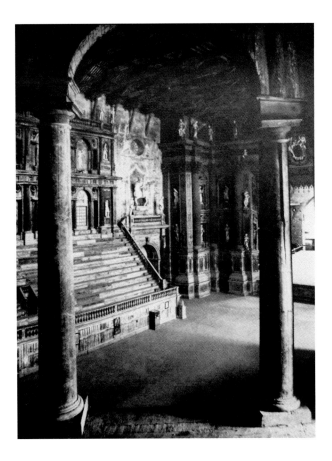

5 Giovanni Battista Aleotti,
Theatre in the Farnese Palace,
Parma, 1518–28. Interior
(destroyed in 1944; rebuilt
without its original statues
and paintings, 1950–62).
Anonymous photograph c.
1920, courtesy of Paolo Sanvito,
Berlin.

architect consciously saw to it that the stage set for the ducal theatre matched both the status of its patron and the notions of sublimity associated with 'noble' buildings and their architectural display.[35]

This brings my discussion to the final element under review: the architectural design of the house. Most had semicircular or rectangular rows of seats around an orchestra and in front of the stage. The walls featured suggestions of ancient architecture, in the Uffizi theatre and in Parma even a reminiscence of the Coliseum (plate 5). The architect Bernardo Buontalenti played on this theme when he made the scene for the plays staged in Florence in 1589 completely match the architecture of the house, so that when the curtain rose the audience saw a copy of their own seats, people sitting on them like themselves![36] The implication of this arrangement was that the theatre was an amphitheatre – and fifteenth- and sixteenth-century theory had it that amphitheatres had originally served as places for civic rituals and political assembly.[37] In a wider sense, the amphitheatre was both a symbol of the city as a built entity and of its inhabitants as a responsible citizenry.[38] Thus the architectural form of the hall was itself highly meaningful.

A similar link was thought to exist between the theatre and the basilica, the parliament of the Roman senators and magistrates. For the *teatro capitolino*, the place where modern Roman senators conferred the Roman peerage on Leo's relatives, the idea of conflating the building – described by Palliolo as 'the very image of the ancient palaces for emperors and first citizens' – with the conference hall of the antique Roman senators was a natural one.[39] Contemporary descriptions of the Sabbioneta theatre do not survive, yet we know it possessed a basilica- or palace-like exterior with its semi-rusticated base and elegant Doric first floor (plate 6); interior decoration with emperors and scenes representing Rome in a happy, healthy state; and gods on the cornice of the loggia, perhaps implying the presence of the tutelary deities of the house. It is therefore probable that one of its intended symbolic meanings referred to the *curia*, the place where the prince and his advisers and administrators gathered to discuss affairs of state.[40] At the same time, the façade was probably intended to convey some of the complexity of its patron's character. For according to Serlio, '[i]f a building (public or private) is intended for men of arms and robust characters, whether of high, middle or low rank, this Doric work is suitable – the more robust the character, the more appropriate is work of greater solidity. If, on the other hand, this man, however warlike, also has a delicate side to him, then the work could be carved with some delicacy.'[41]

Agency

The courtly venues of the sixteenth century were not just built to host stage plays and other functions, but were meant to perform through and by themselves. Their performance had to be a combination of celebration of the rulers (a self-celebration of course), a mirror that reflected the power and authority of princes and magistrates, a model comparison with the world of the ancients, and a call for good government

ROMA QVANTA FVIT IPSA RVINA DOCET

6 Vincenzo Scamozzi, *Teatro all'antica* in Sabbioneta, 1588–90. Exterior, original entrance to the ducal loggia. Photo: Václav äédy.

so that society would prosper. No doubt this performance was in the first place perceived as an intellectual event. Well-educated visitors were used to looking for allegorical images and hidden meanings. Nonetheless, there are some indications that visitors also reacted more viscerally to the sumptuous *apparati*.

In 1513 Palliolo, whose manuscript report is very factual and detailed, wrote about the paintings on the front of the *teatro capitolino* that the figures, though bigger than life, were so well proportioned that they seemed alive.[42] This may have been the main reason why people who came to see the structure – men, women, and even old people who only ever went out to visit church – were so impressed by it. 'All honestly confessed they had never seen such a thing before.'[43] More than a century later Marcello Buttigli wrote in his printed account of the inauguration of the Farnese theatre, that the judicious visitor entering the hall could not go far before he would feel arrested by the surroundings: 'The majesty of the proscenium catches the eye, and the beauty of the architecture, the allure of the painting, the liveliness of the sculpture so completely feeds the mind, that both [eye and mind] cannot be tired by it or get enough of it.'[44] Perhaps this is a hired writer's hyperbole, but undeniably the architecture, scenography, perspective painting, and sculpture in the Farnese theatre amounted to a grand, all-consuming spectacle staged in a self-consciously artificial space, where the distinction between life and theatre was collapsed even as the architecture and decoration continually referred outwards to the realities of power, authority, and image.[45] As a performing venue, the *teatro Farnese* came as the high point – and at the same time the end – of a sixteenth-century courtly tradition.

Notes

I want to thank NWO (Netherlands Organization for Scientific Research) for its grant that allowed me to work on this subject.

1 Peter Burke, *The Historical Anthropology of Early Modern Italy: Essays on Perception and Communication*, Cambridge, 1987, 10 and 167.

2 See Marzia Pieri, *La nascita del teatro moderno in Italia tra XV e XVI secolo*, Turin, 1989, 59 and 62.

3 Giovanni Sulpizio of Veroli in the preface to his Vitruvius-edition of 1486; text in Fabrizio Cruciani, *Teatro nel Rinascimento: Roma 1450–1550*, Rome, 1983, 224.

4 Proposal by Alvise Cornaro for the restructuring of the San Marco basin, Venice State Archive, *Savi ed Esecutori alle Acque*, busta 986, filza 4, cc. 23–25, transcribed in Manfredo Tafuri, *Venezia e il Rinascimento: Religione, scienza, architettura*, Turin, 1985, 242.

5 See Pieri, *La nascita del teatro moderno*, 28; cf. Manfredo Tafuri, 'Il luogo teatrale', in Fabrizio Cruciani and Daniele Seragnoli, eds, *Il teatro italiano nel Rinascimento*, Bologna, 1987, 54–5.

6 Examples are Raphael's plans for Villa Madama near Rome (c. 1517), see Margherita Azzi Visentini, *La villa in Italia: Quattrocento e Cinquecento*, Milan, 1995, 95–112; and Jacopo Barozzi of Vignola's projects for the Farnese palace in Piacenza, see Christoph Luitpold Frommel, 'Vignola e il Palazzo Farnese a Piacenza', in Christoph Luitpold Frommel, Maurizio Ricci and Richard J. Tuttle, eds, *Vignola e i Farnese*, Milan, 2003, 221–47.

7 Rome: see Fabrizio Cruciani, *Il teatro del Campidoglio e le feste romane del 1513*, Milan, 1969, xxxiv–xxxvii; Florence (1565): Licisco Magagnato, *Teatri italiani del Cinquecento*, Venice, 1954, 45; Florence (1586): Ludovico Zorzi, *Il teatro e la città: Saggi su la scena italiana*, 2nd edn, Turin, 1977, 112 and 116–31; Sabbioneta: see Stefano Mazzoni and Ovidio Guaita, *Il teatro di Sabbioneta*, Florence, 1985, 51–2; Parma: Roberto Ciancarelli, *Il progetto di una festa barocca: Alle origini del teatro Farnese di Parma (1618–1629)*, Rome, 1987, 23–5.

8 See Licisco Magagnato, *Teatri italiani del Cinquecento*, Venice, 1954, 81; see also Adriano Cavicchi, 'Il teatro Farnese di Parma', *Bolletino CISA*, 16, 1974, 339.

9 Arnaldo Bruschi, 'Il teatro capitolino del 1513', *Bolletino CISA*, 16, 1974, 195 estimates the *teatro capitolino* could house from 1,500 up to 1,800 persons, although sources speak of 20,000 spectators (thus Francesco Chierigati in his report of 1513, quoted in Cruciani, *Il teatro del Campidoglio*, 416–17; cf. Vettor Lippomanno, the Venetian ambassador, who mentions 10,000 spectators: Cruciani, *Il teatro del Campidoglio*, 419). Heinz Kindermann, *Das Theaterpublikum der Renaissance*, Salzburg, 1984–86, vol. 1, 207 relates – on the authority of Domenico Mellini, *Descrizione della Entrata della serenissima Regina Giovanna d'Austria et dell'Apparato in Firenze*, Florence, 1566 – that the galleries in the *salone dei Cinquecento* offered seats for c. 360 ladies, apart from the benches for the men in the orchestra; Kindermann, *Das Theaterpublikum*, 217 refers to sources estimating the capacity of the Uffizi theatre between 800 and 2,000 persons. Zorzi, *Il teatro e la città*, 118 reckons that some 1,000 spectators was the maximum capacity of courtly theatres and dismisses higher figures as period hyperbole. For the estimated capacity of the theatre in Sabbioneta, see Stefano Mazzoni, 'Temi aulici e motivi comici nel teatro di Sabbioneta', *Bolletino CISA*, 24, 1982–87, 116–7.

10 Nino Borsellino, 'La letteratura teatrale del Rinascimento', *Bolletino CISA*, 16, 1974, 407–8.

11 '[G]entilhuomini e persone favorite' according to Filippo Giunti's description of the festivity (quoted in Zorzi, *Il teatro e la città*, 106, n.134). According to Francesco Chierigati watchmen stood at the entrance of the *teatro capitolino* and stopped 'unworthy' people from entering; the invited guests were the high nobility, the aristocracy, city magistrates, ambassadors, and cardinals (in Cruciani, *Teatro nel Rinascimento*, respectively 418 and 416–7). Nonetheless, people managed to sneak in, as testified by the fact that on 16 February 1586 Francesco I and his nobles had to throw out of the Uffizi theatre a group of people who had blended into the crowd of guests (Zorzi, *Il teatro e la città*, 116–17).

12 Angelo Ingegneri, 'Della poesia rappresentativa e del modo di rappresentare le favole sceniche [1598]', in Ferruccio Marotti, ed., *Storia documentaria del teatro italiano: Lo spettacolo dall'Umanesimo al Manierismo: Teoria e tecnica*, Milan, 1974, 298. Cf. Leone de' Sommi, who about

an *apparato* that served as a backdrop for tournaments at a Gonzaga wedding in Mantua in 1561 wrote that it 'sarebbe però stato mirabile da rappresentarvi et comedie et tragedie'. (Quoted in Magagnato, *Teatri italiani*, 68, n.1.) Richard Bernheimer, 'Theatrum mundi', *Art Bulletin*, 38, 1956, 237, n.72 remarks that the word *apparato* 'can also refer to the architecture of the auditorium or to any other architectural decoration, provided it be three-dimensional'.

13 For this tradition, see Martina Hansmann, *Andrea del Castagnos Zyklus der ,'Uomini famosi' und ,'Donne famose': Geschichtsverstandnis und Tugendideal im florentinischen Frühhumanismus*, Munster, 1993.

14 Giorgio Vasari, *Le opere*, ed. Gaetano Milanesi, Florence, 1906, vol. 3, 169: 'Et a che altro fine … ponevano gli antichi le imagini de gli huomini grandi ne' luoghi publici con onorate iscrizioni, che per accender l'animo di coloro che venivano, alla virtù et alla gloria?'

15 Francesco Patrizi, *Della historia diece dialoghi*, Venice, 1560, 46v: 'Hora recando le cose dette in una somma, io dico che per lo fine giouar altrui con altrui essempio, si dee scriuere historia di uita di quegli huomini, i quali furono, con le maniere della loro uita, alla lor' patria gioueuoli, o dannosi in eccellenza. Et di quelli che eccellenti guerrieri furono. … Con la qual historia l'huomo si fa coloro hospiti suoi, & famigliari; & quasi riceuuti nelle proprie case, ragionando con loro & conuersando, scopre le maniere degli animi loro, & de' corpi; per mezo lequali; & de la fortuna essi hebbero operato opre eccellenti. Le qualità, & la grandezza delle quali contemplando noi, ci accendiamo per uirtu nascosta in loro, & in noi diffusa occultamente, di desiderio di seguitare o l'une, o l'altre, o di fuggirle, si che ci rechino, o per la buona, o per la mala, à nominanza & à grandezza.'

16 Patrizi, *Della historia*, 49r: 'Voi sapete, che gli huomini tutti portano seco dal nascimento loro, lo studio della imitatione. … Et tanto ci ha la natura fatto piacere la nostra simiglia, & delle nostre cose che e' si sono trouati de gli huomini sopra humani, i quali tutto il loro sapere hanno dispeso à porre in alcune statue lo spirito, & la uita: & l'hanno fatto.'

17 See Battista Mondin, 'Il principio ìomne agens agit simile sibiî e l'analogia dei nomi divini', *Divus Thomas* 63, 1960, 336–41 for a survey with examples of Thomas's reasoning. Interesting as to the agency of artists and works of art is Thomas's argumentation *Summa Theologica* 2–2.123: 'Finis autem proximus uniuscujusque agentis est ut similitudinem suae formae in alterum inducat; sicut finis ignis calefacientis est ut inducat similitudinem sui caloris in patiente; et finis aedificatoris est ut inducat similitudinem suae artis in materia.'

18 Cicero, *Tusculanae disputationes* 1.32; see also Cicero, *Tusculanae disputationes*, 1.25 and *De natura deorum* 2.24. For the allegorical reading of representations of the ancient gods, see Jean Seznec, *La survivance des dieux antiques: Essai sur le rôle de la tradition mythologique dans l'Humanisme et dans l'art de la Renaissance*, London, 1940, esp. 236–8.

19 Aleotti in the dedication of his design for the tragic scene in the Farnese theatre: 'ben si sà, ch'Ella è teatro vivo, in cui tutte le eroiche virtù rappresentano magnanime e generose azioni' (quoted after Bruno Adorni, *L'architettura farnesiana a Parma 1545-1630*, Parma 1974, 73).

20 Aleotti in the continuation of the dedication quoted above: 'rendendosi ben certa, che se in me il poter dell'Architettura pareggiasse le forze della divozione nell'animo, più archi e più Colossi à V.A. da me si drizzarebbono, che già à vittoriosi Eroi pari di V.A. non eresse Roma fecondissima madre di superbe moli' (quoted after Adorni, *L'architettura farnesiana*, 73).

21 A short biographical sketch of Vespasiano Gonzaga is given by Judith Stallmann, *Sabbioneta: Die Wiederentdeckung einer inszenierten Stadt*, Munich, 1997, 19–29.

22 For a list of subjects, see Chierigati in Cruciani, *Il teatro del Campidoglio*, LXIV, n.16, and Palliolo, *Narratione*, in Cruciani, *Il teatro del Campidoglio*, 27–32.

23 On Palliolo, see Cruciani, *Il teatro del Campidoglio*, XXXVII–XXXVIII; on the manuscript of his text and its copies, Cruciani, *Il teatro del Campidoglio*, 131–6.

24 Palliolo, *Narratione* in Cruciani, *Il teatro del Campidoglio*, 32: 'Se desiderasti sapere el significato delle historie qua coacervate, dico che Romani per esse dimostrano il commertio et amicitia sua, al presente rinovata et più che mai stabilita con Thoscani, havere antiquissima origine et da loro altre volte haver presi non solo molti costumi, la litteratura, gli citadini, le insegne de l'Imperio et esso Re, ma anchora lo augurare, lo auspicare, el sacrificare, gli sacerdoti et essi Dei. Così vengono ad exprimere lo

immenso gaudio et piacere che senteno vedendo il medesmo sucedere et rinovarse a' nostri giorni.'

25 For a description of the theatre which the artist passed as his own but that was actually written by Giovan Battista Cini, see Vasari, *Le opere*, vol. 8, 517; cf. Mario Fabbri, Elvira Garbero Zorzi and Anna Maria Petrioli Tofani, *Il luogo teatrale a Firenze: Brunelleschi, Vasari, Buontalenti, Parigi*, Milan, 1975, 96.

26 Patrizi, *Della historia*, 23r: 'uoi hauete nell'historia, quasi in un pieno teatro ogni maniera d'essempio.'

27 Patrizi, *Della historia*, 32v.

28 For the Greek: Aristotle, *Poetica*, 17, 1455a. For the Latin: *Rhetorica ad Herennium*, 4.34.45 and 4.55.68; cf. Cicero, *De oratore* 3.53.202 and *Orator* 40.139.

29 Patrizi, *Della historia*, 38r. Patrizi here uses the word *attore* in the meaning of 'agent', much like Cicero, *De oratore* 3.56.214, who contrasts the 'oratores, qui sunt veritatis actores' with the 'histriones' who were merely 'imitatores autem veritatis'. In any case it is probable that both ancient and early modern society thought of people in the double sense of 'agent' and 'actor' when they performed an action, because of the visibility of their actions.

30 Patrizi, *Della historia*, 14r: 'Et si puo fare historia ... di tutte quelle cose, che si ueggono ... una scrittura [o] ... una dipintura. ... Non solamente ... l'historia si scriue, ma & si scolpisce ella, & si dipinge, & saranno queste piu propriamente Isorie, per essere elleno oggetti della vista.' For the etymology of the word *isoria* (meaning 'visualized history'), see Patrizi, *Della historia*, 8r, where he erroneously derives the word *historia* (from *historeō*, 'to research', 'to recount') from an etymologically different verb (*horaō* with prefix *is-* 'to see', 'to watch'). Outside Italy, Patrizi's contemporaries such as Jean Bodin or François Baudouin adhered essentially to the same view: see Anthony Grafton, *What Was History?* Cambridge, 2007, 76–7 and 181.

31 'Roma quanta fuit ipsa ruina docet.'

32 Cicero, *De natura deorum* 2.15; cf. Leone de' Sommi, *Dialoghi in materia di rappresentazioni sceniche* [1556], in Marotti, *Storia documentaria del teatro italiano*, 243: theatre plays – both tragedy and comedy – are (because of their ordered forms) exemplary of well-ordered cities (*ben regolate città*).

33 Palliolo in Cruciani, *Il teatro del Campidoglio*, 33: 'Et per certo a qualunque bene lo contempla, et considera parimente la forma de la machina et qualitate de le depinture, li pare vedere renovati quelli felici tempi quando Roma più beata in la celebritate de' maggiori triomphi se ritrovava.'

34 Aleotti to Ranuccio I, February 1618: 'Dovendo però uscire alle stampe per comandamento di chi può, il disegno della Scena Tragica, che quello è, che sola in così vasta mole ha l'ultima mano, ho' rissoluto, che sotto all'ombra del Gloriosissimo nome di V.A. Ser.ma egli compaia nel Theatro di questo Mondo' (quoted in Bruno Adorni, *L'architettura a Parma sotto i primi Farnese, 1545–1630*, Reggio Emilia, 2008, 101).

35 For the *theatrum mundi* metaphor, see Bernheimer, 'Theatrum mundi'; also: Paula Findlen, *Possessing Nature: Museums, Collecting, and Scientific Culture in Early Modern Italy*, Berkeley, CA, 1994, 17–47, and Ann Blair, *The Theater of Nature: Jean Bodin and Renaissance Science*, Princeton, NJ, 1997, 153–78.

36 See Bastiano de' Rossi, *Descrizione dell'apparato e degl'intermedii fatti per la commedia rappresentata in Firenze nelle nozze de' Serenissimi Don Ferdinando de' Medici e Madama Cristina di Loreno, Gran Duchi di Toscana*, Florence, 1589, 16: 'quel paramento incarnato fatto sparire, che le bellezze dell'Apparato, e della Prospettiva ascondea ... s'appresentò agli occhi di giascheduno tutta la sala uno amfiteatro perfetto (perciochè la Prospettiva che era in faccia con la sua architettura Corintia si congiungeva con l'apparato).'

37 See e.g. Flavio Biondo, *Romae instauratae libri tres* [1444–46], 2.103, in *Opera*, Basilea, 1531, 257; Leon Battista Alberti, *De re aedificatoria* 8.7; Pellegrino Prisciani, 'Spectacula', in Marotti, *Storia documentaria del teatro italiano*, 53–4; Daniele Barbaro in the commentary to the second edition (first edition 1556) of his own translation of Vitruvius: *I dieci libri dell'architettura di M. Vitruvio*, Venice, 1567, 223–4.

38 See Gerd Blum, 'Palladio's *Villa Rotonda* und die Tradition des "idealen Ortes": Literarische Topoi und die landschaftliche Topographie von Villen der italienischen Renaissance', *Zeitschrift für Kunstgeschichte*, 70, 2007, 169–71; cf. Lina Padoan Urban, 'Teatri e "teatri del mondo" nella Venezia del Cinquecento', *Arte veneta*, 20, 1966, 143–4. See also Michela Di Macco, *Il Colosseo: funzione simbolica, storica, urbana*, Rome, 1971.

39 Palliolo in Cruciani, *Il teatro del Campidoglio*, 27: 'Così sta la fronte di questo theatro, la quale tanto superba et magnifica a quelli che al Campidoglio ascendono se mostra, che representa il vero simulacro de gli antiqui palazzi che per gl'Imperatori et primati di Roma, quando era più florida, con molta arte et inestimabile spesa furono edificati'. – Bruschi, 'Il teatro capitolino', 201 suggests the link theatre – curia on the basis of Leon Battista Alberti, *De re aedificatoria*, ed. Giovanni Orlandi and Paolo Portoghesi, Milan, 1966, vol. 2, 762–3.

40 It is interesting to note the various signs by which a citizen could recognize good government in his city. As described in 1493 by Giovanni Pietro Cagnola, who was speaking of Lodovico il Moro's projects in the main cities of the duchy of Milan, these were: orderliness, accessibility, beauty of streets, monumental squares, ornamented façades: see Manfredo Tafuri, *Interpreting the Renaissance: Princes, Cities, Architects*, trans. Daniel Sherer, New Haven and London, 2006, 94. In duke Vespasiano of Sabbioneta's times criteria had not changed much: see e.g. Vincenzo Scamozzi, *L'idea della architettura universale*, Venice, 1615, vol. 1, 45.

41 Sebastiano Serlio, *Regole generali di architettura sopra le cinque maniere de gli edifici*, Venice, 1537, XIXr: 'ma se ad armigeri, & robusti, o gran personaggi, o mediocri, o bassi, si farà edificio alcuno cosi publico, come priuato, si conuien questa opera Dorica, & quanto il personaggio sarà piu robusto tanta se gli conuien opera piu soda, & se anchora l'huomo, quantunque armigero, participerà del dilicato, cosi le opere si potranno far con qualche dilicatezza' (*L'architettura*, book 4, ch. 6; trans.: Vaughan Hart and Peter Hicks, *Sebastiano Serlio on Architecture*, New Haven and London, 1996, vol. 1, 281).

42 Palliolo in Cruciani, *Il teatro del Campidoglio*, 27: 'sonno di grandezza sopra naturale et excessiva assai del iusto, ma bene proportionate per modo tale che pareno vive'.

43 Palliolo in Cruciani, *Il teatro del Campidoglio*, 33: 'ingenuamente confessano mai non havere veduta cosa simile.'

44 Marcello Buttigli, *Descrittione dell'apparato, fatto, per honorare la prima, e solenne entrata in Parma della Serenissima Principessa, Margherita di Toscana, Duchessa di Parma, Piacenza &c*, Parma, 1629, 252: 'entrandovi per testa del Théatro nel Salone, non può giudicioso spettatore avanzarsi molti passi, che non arresti il piede. La maestà del Proscenio rapisce l'occhio, la bellezza dell'Architettura, la vaghezza della Pittura, la vivezza della Scoltura pasce si fattamente l'animo, che ambidue non possono, ne stancarsi, ne satiarsi'.

45 Thus Adorni, *L'architettura farnesiana*, 77.

Neue und Curieuse
THEATRIALISCHE
TANTZ-SCHUL

DELICIÆ THEATRALES

NÜRNBERG
verlegts
Johan Jacob Wolrab

Chapter 8
Dancing Statues and the Myth of Venice: Ancient Sculpture on the Opera Stage

Wendy Heller

Among the many artworks immortalized by the poems in Giambattista Marino's *La galeria* (1620) is one describing a statue of the famed Theban musician Amphyon who built the walls of Thebes merely by animating stones with his lyre.

> *Amphyon in Marble*
> That Theban Musician
> whose sweet song
> gave life to stones,
> Now I am an image carved in stone.
> But even though stone, I live, I breathe,
> and from time to time
> thus, I sing silently.
> Now hand must surrender praise to your hand,
> illustrious maker and ruler,
> because, your scalpel [chisel] knows better
> than my lyre how to animate stone.[1]

Although Amphyon was able to build an entire city with his lyre, his gifts as a statue are equally if not more impressive. Endowed by the poet Marino with a remarkable self-awareness, the statue of Amphyon acknowledges the fact that the sculptor who created him had a greater power to animate with his chisel than he once had had with his lyre. In this elegant evocation of the *paragone* of the arts, we find the most masterful musician championing the superiority of sculpture over his own medium. Nevertheless, the poet does not deem Amphyon entirely bereft of musical talent. By imagining that his statue has the power to sing – albeit silently – Marino acknowledges the latent performative potential of the mythic musician locked inside marble.[2] In fact, Marino seems to suggest that were the sculpted Amphyon to come to life, he would express himself not in ordinary speech, but rather in a manner appropriate to a heightened theatrical universe, one in which even the effigies of musicians retain all their abilities.[3]

A similar notion about the inner life of statues may well have inspired a slightly different intersection between singing and the plastic arts. The final scene in Bissari's libretto for Francesco Cavalli's opera *La Torilda* (Venice, 1648) features another legendary musician, Arion, whose singing summoned forth a mythical dolphin to

Detail from Title page, engraving by Johann Georg Puschner, from Gregorio Lambranzi, *The New and Curious School of Theatrical Dancing*, Book II, Nuremberg: Johann Jacob Wolrab, 1716 (reprinted 1928), (plate 3).

Theatricality in Early Modern Art and Architecture *Edited by Caroline van Eck and Stijn Bussels* © 2011 Association of Art Historians.

save him from drowning.[4] The scene is set in a *loggia* near a marina, and one decorated with statues. Arion appears riding the dolphin, singing praises to the goddess Venus, and of love's power to set stones afire. Whereas Marino's Amphyon had readily acknowledged the sculptor's superior generative power, in the opera *La Torilda* it is the singer who performs the magic: the statues in the *loggia* are brought to life by Arion's song, and the work concludes with a *ballo delle statue* – a dance or ballet of the statues. Thus, in an operatic realm in which everyday speech is elevated to song, statues do not demonstrate their lifelike tendencies merely by coming to life; they express their inherent theatricality through the most sophisticated language of the body – dance.

The use of dancing statues in *La Torilda* was by no means unique. In fact, the seemingly illogical affinities between theatre, music, and the plastic arts celebrated in Marino's poem became an integral part of the aesthetic framework of Baroque opera and were particularly relevant in seventeenth-century Italy, when sung drama became one of the most eloquent means of giving voice to the heroes and heroines of ancient myth and history.[5] This fanciful notion about the potential life of statues so firmly captured the imaginations of librettists and choreographers that the *ballo*

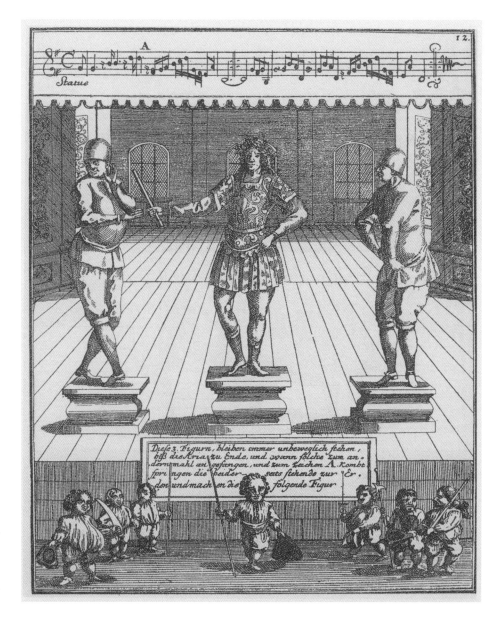

1 'Dance of the Statues', engraving by Johann Georg Puschner, plate 12 from Gregorio Lambranzi, *The New and Curious School of Theatrical Dancing*, Book II, Nuremberg: Johann Jacob Wolrab, 1716 (reprinted 1928). London: Imperial Society of Teachers of Dancing. Photo: Courtesy of Rare Books Division, Department of Rare Books and Special Collections, Princeton University Library.

delle statue would become a standard trope in Venetian opera. Between the opening of the first public opera theatre in Venice in 1637 and the end of the Republic in the late eighteenth century, over twenty operas featured dancing statues, sculptors, or antiquities.[6] This convention travelled to France where it was fully exploited, most memorably in Jean Philippe Rameau's opera *Pigmalion* (1748).[7] Perhaps the most compelling evidence of the popularity of the *ballo delle statue* comes from the text that codified the Italian tradition of theatrical dance *Nuova e curiosa scuola de' balli theatrali* by the Venetian Gregorio Lambranzi.[8] Published in Nuremberg in 1716, Lambranzi's treatise included an elaborate dance for statues, to which he devotes no fewer than six plates (*plate 1*).[9] In addition, he described and illustrated another ballet which features dancers sculpting a statue, and in which statues also appear as part of the stage set (*plate 2*).[10] The kinesthetic potential of sculpture is prominently displayed on the

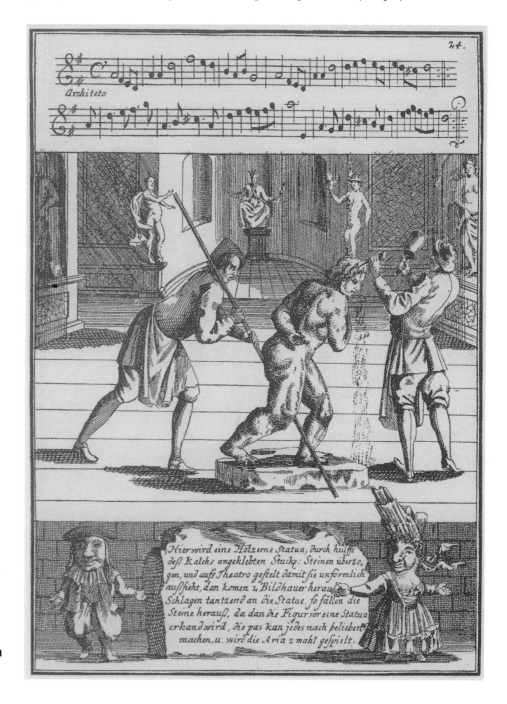

2 'Dance of the Sculptors', engraving by Johann Georg Puschner, plate 24 from Gregorio Lambranzi, *The New and Curious School of Theatrical Dancing*, Book II, Nuremberg: Johann Jacob Wolrab, 1716 (reprinted 1928). London: Imperial Society of Teachers of Dancing. Photo: Courtesy of Rare Books Division, Department of Rare Books and Special Collections, Princeton University Library.

3 Title page, engraving by Johann Georg Puschner, from Gregorio Lambranzi, *The New and Curious School of Theatrical Dancing*, Book II, Nuremberg: Johann Jacob Wolrab, 1716 (reprinted 1928). London: Imperial Society of Teachers of Dancing. Photo: Courtesy of Rare Books Division, Department of Rare Books and Special Collections, Princeton University Library.

volume's title page, which features Mercury and Minerva hovering at Lambranzi's side: Minerva holds a page of Beauchamps-Feuillet notation and the mischievous Scaramouche dances beneath them, flanked by a chorus of provocatively clad statues that seem poised to descend from their pedestals and commence a *ballo* (*plate* 3).[11] The engraving thus acknowledges the debt of modern theatrical dance to the humanist tradition: for if the pagan gods might applaud the tools of the contemporary choreographer, then the dances of the ancients – represented by the moving statues – must truly live again on the stage.[12]

In the remainder of this chapter, I explore the dancing statues of Venetian public opera in the context of another uniquely Venetian phenomenon: the collection of antique statues given to the city of Venice by the Grimani family, usually referred to as the *Statuario Pubblico* or the Public Statuary. The use of the word 'public' to describe both enterprises is by no means accidental. Both commercial opera and the Public Statuary transformed cultural events that had so often been confined to noble households or royal courts and systematically made them accessible to a wider population.[13] Both were sought after and described by Venetian tourists in the seventeenth and eighteenth centuries; both opera and the Public Statuary used myth and history as a vehicle for self-expression; and both earned prestige for the patrician families whose generous support of the arts expressed patriotic devotion to the Republic. Indeed, it is not coincidental that the Grimani family, which had donated a substantial portion of their massive

collection of antiquities to the city of Venice in the late sixteenth century, would play a fundamental role in the Venetian opera industry throughout the seventeenth and early eighteenth centuries. In a city in which art collecting went hand in hand with the patronage of opera, both private and public collections were part of the *theatrum mundi*, providing creative stimulus for this new dramatic genre that so skilfully represented Venice to the world.

Numerous stories might be told about the close relationship between opera and art collecting in the seventeenth century. I will focus on several different ways in which the Venetian Public Statuary could have inspired the operatic imagination: first, as a repertory of historical and mythological characters; second, as an integral element of stage design and essential props which created the aura of the antique; finally, as latent dancers with the unexpected power to come to life and dance the myth of Venice.

Venice's Public Statuary and the Grimani Family

For patrician families in early modern Venice, collecting antiquities was an essential means of demonstrating social status and erudition, as well as providing an appropriate conduit for artistic self-expression.[14] However, the idea that a collection might do more than provide fulfilment for individual collectors or glorify the name of a single family was exploited to the fullest by the Grimani.[15] The story of the gathering and donation of their collection to the Venetian Republic is now well known, but worth recounting in brief.[16] When the Patriarch of Acquilea, Cardinal Domenico Grimani (1461–1523) discovered a number of valuable artefacts during the construction of his palace on the Quirinale in Rome in the early sixteenth century, he found a hobby that quickly turned into a second career as a collector of rare books, gems, and statues. Grimani seems to have come to the conclusion that art was a commodity which should be supported by the nobility but shared with the state. The Cardinal therefore left all his statues and paintings to the Venetian Republic in his will with the proviso that they be prominently displayed in the Ducal Palace. That the Republic chose only to keep the statues indicates the value it placed on them as living symbols of Venice's mythic past.[17]

This tradition of viewing art collecting as a service to the state was carried on by Domenico's nephews, in particular Cardinal Giovanni Grimani (1506–93), who was also Patriarch of Aquilea. Cardinal Giovanni inherited his uncle's interest in, and knowledge about antiquities, acquiring his own impressive collection through his extensive travels and prestigious political connections. As a result of his efforts, the Grimani collection became so large that Domenico's nephews were obliged to renovate the family Palazzo at Santa Maria Formosa to house them all, enhancing the building with classicizing decorations designed to show the collection to its best advantage.[18] In 1586, towards the end of his long life, Giovanni Grimani offered to donate his entire collection to the *Serenissima*. This, however, was dependent on the condition that the Republic designate an appropriate public space in which to exhibit both his own collection and the one previously donated by his uncle. The Senate accepted Grimani's offer and chose the Antisala of the Biblioteca Marciana, originally designed by Jacopo Sansovino (1486–1570), as an appropriate venue because it would allow the Grimani antiquities to share the spotlight with the Republic's treasured collection of books and manuscripts. The project to modify Sansovino's library to house this vast collection was undertaken by Vincenzo Scamozzi (1548–1616), who as a theatre designer, certainly knew best how to exhibit the collection.[19] The remodelling was not finished until 1596, three years after Grimani's death, when the major pieces of the collection were moved from the Grimani Palazzo at Santa

Maria Formosa to the
Biblioteca Marciana.
The Public Statuary
remained on exhibition
until the end of the
Republic, and today
forms part of the
Museo Archeologico.

Much of what we
know about the condition
and arrangement
of this collection in
the seventeenth and
eighteenth centuries
is the result not only
of travellers' reports,
but also of surviving
contemporary catalogues.
Of particular value is the
visual inventory begun
under the supervision
of the *Bibliotecario*
Lorenzo Tiepolo in
1736 and carried out
by the library's *Custode*
Antonio Maria Zanetti
in collaboration with
his younger brother
Girolamo Zanetti and
an older cousin of
the same name.[20] In
addition, Antonio and
his cousin produced an
elaborate publication, a
set of two folio volumes
of exceptionally high
quality that included full-
page engravings of the
statues, carefully ordered
by subject, identified
by name, with each one

SILENO.

4 'Sileno', plate 79 from Antonio Maria Zanetti, *Ancient Statues, Greek and Roman: Designed from the Celebrated originals in St. Mark's, and other public collections in Venice*, London: M. Ritchie, Lackington, Allen, and Co., 1800. Photo: Courtesy of Marquand Library of Art and Archaeology, Princeton University Library.

dedicated to one or another important individual.[21] While this was the first systematic attempt to reproduce and circulate the images from the Venetian Public Statuary, the practice of doing so was by no means new. Perhaps the most notable example was the set of engravings commissioned in the seventeenth century by the Roman collector Vincenzo Giustiniani to make a record of his own elaborate collection of statuary, not to mention the famous drawings of sculpture included in his contemporary Cassiano dal Pozzo's 'Paper Museum'.[22] The engravings for the Giustiniani collection have been singled out by Elizabeth Cropper as examples of what she describes as the 'Pygmalion effect': the statues seem literally to be animated through the power of the engraving.[23]

Notably, many of the drawings and engravings of the Public Statuary completed by the Zanetti also show a tendency to heighten the dramatic personalities of the sculptures, magnifying those details (props, headdresses, or costumes) that identify the statue, and posing them in lifelike positions – perhaps an expression of the family's considerable experience of Venetian opera production.[24] Their engraving of the satyr Silenus (*plate* 4) shows the arms and legs in a balletic pose that seems antithetical to the marble statue that it presumably represents.

From the outset, the display of ancient artefacts in an official public space perfectly captured the character of Venetian sensibility. As Marilyn Perry says: 'All of the circumstances surrounding the establishment of the museum were uniquely or essentially Venetian – the love of public display, the enthusiasm to glorify the state, the patrician involvement in political life, and of course the underlying but crucial expectation of stability.'[25] That antiquities would serve this purpose so well is by no means surprising. As Patricia Fortini Brown has emphasized, an important element in Venice's self-representation was the desire to stress the Republic's links to great civilizations of antiquity – in particular to the splendours of Ancient Rome – as a way of compensating for the inelegant facts surrounding the city's own birth on sand pilings in the Adriatic. This goal was well served by adopting and displaying historical narratives and objects from past civilizations.[26] Venice was particularly adept at exploiting every available artefact and symbol – Eastern and Western, Pagan and Christian – to create what we have come to call the myth of Venice.[27] Debra Pincus uses the word 'stage manage' to describe Venice's presentation of herself to the world, and indeed the Public Statuary became a kind of theatre, presenting a dynamic, expansive ancient universe in which Roman and Greek villains and heroes, pagan gods, gladiators, satyrs, and other enticing figures from the past lived together in apparent harmony.

The Museum as Theatre

There can be little question that the problem of managing the collection on stage was of utmost concern to Vincenzo Scamozzi, who devoted considerable attention to finding the best way to display so large a number of antiquities in a limited amount of space. This may well have come naturally to an architect so experienced in stage design; Scamozzi seems to have worked assiduously to create a classicizing framework that would transport the viewer back to the appropriate moment in the past. Marilyn Perry describes in detail the classical precedents that Scamozzi used to create the desired effect:

> Scamozzi's solution for converting the Antisala into a Statuario was to adopt a simple classical formula and then adapt it for the maximum display of the ancient marbles. On the end walls, on either side of the doors, he constructed niches to accommodate four of the larger statues; these niches were enclosed in tabernacles formed by engaged ionic columns supporting triangular pediments, and further bracketed by Corinthian pilasters, which rose to the ceiling. Similar ionic tabernacles, alternating triangular and segmental pediments, framed each of the windows, and were separated in turn by Corinthian pilasters. The bases of the pilasters were extended into the room to serve as appropriate bases for small statues, and two moldings – one at the level of the tabernacles and a second at the height of the doors – were added as suitable sites for statuettes and smaller busts.[28]

The care with which Scamozzi used classical elements in housing these objects also tells us something about their special importance in expressing Venice's unique brand of humanism.[29] The numerous classical texts made accessible by the busy Venetian printing presses may have provided one path to the ancient world, yet they did not supply the visual stimuli so necessary to the theatrical imagination. As Paula Findlen has noted 'humanism was structured around the objects that served as the basis for most intellectual and cultural activities', which actually had a more immediate, visceral, impact on viewers and owners than classical texts.[30] With their associated narratives, moral virtues and failings, the statuary was thus at the centre of the same eclectic humanistic urge that underlies so much of seventeenth-century opera. While a private collection could serve variously as a 'theatre of the mind' or demonstrate the erudition and taste of individual patrons, the Grimani collection in its new home assumed an unprecedented public role as a collection of antiquities intended for the benefit and pleasure of Venetians and visitors. The Public Statuary became a museum in the original sense of the word, a space consecrated to the muses. The theatrical potential of the collection was recognized soon after it was established; the 1601 dedication of Pietro Maria Contarini's *Compendio Universale di Republica* repeatedly refers to the statuary as a *teatro* that renders the Republic more celebrated and glorious.[31] Carefully placed in niches and arranged into logical groupings, the statues thus provided more than a hint of the sensory stimulus that would become the norm in the Venetian opera house.

The sense of theatre is also evident in contemporary descriptions of the Statuary, such as the one provided in the early seventeenth century by the English traveller Thomas Coryate. Recounting his experience in the Marciana, Coryate names the statues of over a dozen heroes and villains of Ancient Rome, noting their missing limbs and torsos and occasionally mentioning salient details about their histories. Thus, we have 'Julius Caesar in alabaster, but little more than his head' while Cleopatra, also in alabaster is included twice – one with 'onely her head with a black vaile around it', while a second Cleopatra has 'stumpes without any hands and serpent by her, and which she stung her selfe to death'. Coryate also describes the pagan gods and goddesses with their appropriate props and attributes: the naked Venus, a winged Cupid with a dolphin, Bacchus with grapes, a Jupiter with an eagle, and another Jupiter 'in the forme of a swanne, wantonly conversing and dallying with Leda'.[32]

Particularly interesting is the way Coryate combines his descriptions of the physical appearance of the statues with details of their histories, personalities, and accomplishments, calling forth dynamic and coherent dramatic narratives for each figure. Coryate is scarcely concerned about the fragmentary nature of the artefacts. By reminding the reader of the narratives with which they are associated and making the reader aware of the contrast between the surviving bits and the parts that are missing, Coryate actually initiates the process of bringing the sculpture to life. This is precisely the phenomenon that Leonard Barkan has observed in the Renaissance recovery of antiquities.[33] Barkan also astutely notes that the logical next step in restoring life to ancient sculpture is to give them voice. 'In an effort both to make these enigmatic works live and to fix a particular identity upon them, Renaissance viewers responded not only by describing the works in their own voices, but also by giving the objects voices of their own.'[34] Opera, arguably, was the ideal medium to accomplish this task.

The Grimani and their Statues on the Operatic Stage

Some forty years after the installation of the Grimani's gift at the Biblioteca San Marco, the next generation of the Grimani family found themselves deeply involved in the business of opera.[35] Over the course of the seventeenth and eighteenth centuries, they came to own five different theatres. The younger Giovanni Grimani (1603–63) and his brother Antonio Grimani (1605–59) became first the proprietors of SS. Giovanni e Paolo, in 1639, followed by the Teatro S. Samuele in 1655. Antonio's sons, Giovanni Carlo (1648–1714) and Vincenzo (1652–1710) took over the opera business in 1668, and in 1678 would go on to establish the Teatro S. Giovanni Grisostomo, Venice's most luxurious opera house. After the death of Giovanni Carlo, his son Michele (1696–1775) carried on the family business, opening up the Teatro S. Benedetto in 1755.

The importance of the Grimani's participation in the Venetian commercial opera cannot be overestimated. Indeed, they were not passive owners of their theatres, but became deeply involved in many aspects of opera production – choosing singers, librettists, and composers, and certainly approving the subjects for libretti – even during the period in which they employed the impresario Marco Faustini as manager.[36] The Grimani association with opera was in many respects analogous to their commitment to collecting art and antiquities. Theirs was an activity inspired by a deep passion for the arts, family pride, and a desire to serve the Republic. Opera may have been a commercial business in Venice – a veritable industry, as it is frequently called – but it was perpetually unprofitable, earning the family far more in prestige than in wealth.[37]

Opera also allowed the Grimani brothers to create a theatrical universe that – perhaps naturally – reflected the family's obsession with antiquities and the past. Giovanni and Antonio Grimani, it must be recalled, grew up among the splendours of the family Palazzo at Santa Maria Formosa, which even after the establishment of the Public Statuary still housed a substantial number of antiquities.[38] As Irene Favaretto observes, the collection reflected a 'love of antiquities and art not only of a single individual, but of an entire family, a love that developed in time over generations'.[39] In fact, much of the fame that the family would achieve in the seventeenth and eighteenth centuries came from their association with opera, and is reflected in the numerous printed libretti that prominently featured the Grimani name.

On the surface, the relationship between the Public Statuary and the opera industry is apparent first of all in the shared repertory of characters drawn from myth and history. Not surprisingly, the majority of the famous Romans and pagan gods included in the collection and named by Coryate appeared at one or another time on the Venetian operatic stage. Figures such as Cupid, Hercules, and Venus (an important symbol of Venice) had played a vital role in opera since its inception in the Northern Italian courts. But it was not until the opening of the Venetian public theatres that the epics of Virgil and Homer and pivotal events from Roman history were creatively adapted by librettists and composers. Beginning with Nero in Monteverdi's *L'incoronazione di Poppea* (1643), Venetian opera would feature a veritable parade of famous and infamous Romans who had flourished between the early years of the Republic and the fall of the Empire.[40] The glories of the Roman Republic and the dangers of the Empire provided an infinitely flexible set of narratives with which to portray Venice's unique political wisdom: the heroes of Republican Rome were worthy role models, while the less-than-flattering portrayals of the Julio-Claudian emperors, for example, could demonstrate not only Venice's equality but even superiority to its ancient rival.[41] The Grimani family was certainly well aware of the power of these figures to engage Venice's political ideology. While the repertory is littered with operas based on Roman topics, the first few seasons of the luxurious Teatro S. Giovanni Grisostomo highlighted the careers of several figures

5 Marco Boschini, engraving of
Giacomo Torelli's Elysian Fields
set for *Venere gelosa*, from
*Apparati scenici per il Teatro
Novissimo di Venetia nell'anno
1644 d'inventione e cura di
Iacomo Torelli da Fano*, Venice,
1644. Photo: Courtesy of
University of Michigan Library
Special Collections.

well known from the Statuary: *Il Nerone* (1679) and *Il Vespasiano* (1680), both with librettos by Giulio Cesare Corradi and music by Carlo Pallavicino; and *Massimo Puppieno* (1685) with libretto by Aurelio Aureli and music by Carlo Pallavicino.[42]

But the point is not merely that statuary and opera shared a repertory of emblematic heroes and heroines. The surviving engravings of the sets designed by the incomparable Giacomo Torelli demonstrate the vital role that statuary played in the Venetian theatrical imagination in the earliest decades of Venetian opera.[43] Torelli, who also drew up the plans for the Teatro Novissimo, worked on several productions at the teatro SS. Giovanni e Paolo before leaving for Paris in 1645, and was particularly renowned for his remarkable stage machinery and scenic effects, which set the standard for operatic spectacle in the seventeenth century. Statues, in fact, feature prominently in Torelli's designs as well as those by many subsequent Italian stage designers. It is as if the ancient world could not be staged without also presenting the ruins and artefacts of antiquity. Since, like the Grimani the most erudite and sophisticated nobles packed their houses with ancient statues and relics, such props were likewise deemed necessary to decorate the palaces occupied by the monarchs and nobles who populated the operatic stage.

What is particularly notable, however, is the extent to which the 'Pgymalion effect' enlivens the statues depicted in the engravings of stage designs by Torelli and his colleagues.[44] The statues of the gods shown in the niches in the representation of the Elysian Fields in the opera *Venere Gelosa* (1642), for example, are nearly as lifelike as the singers shown at centre stage: with their elaborate arm gestures, bent knees, and varied positioning of the feet they seem about to jump off their pedestals and begin to dance (*plate* 5).[45] A similar effect can be seen in the figures decorating the upper reaches of the Temple of Jove in Marco Boschini's engraving of the opera *Bellerofonte* (1642).[46] Indeed, the engraver seems to have gone to considerable lengths to present the statues in the most diverse possible poses – altering the positions of arms and legs so that they appear to be already dancing (*plate* 6).

As we noted at the outset, however, sculpture was not merely used to provide props. Recalling Lambranzi (*plate* 2), we can observe that the very process of creating a statue could be conceived of in choreographic terms. A review published in the *Mercure Galant* by Saint-Didier in August of 1677 provides a vivid description of a *ballo* featuring stonecutters sculpting a statue of Nicomedes in *Il Nicomede in Bitinia* (Venice, 1677).

The first act finished with a ballet of stonecutters. They each held their hammers and chisels, and made their movements in rhythm around a statue of Nicomede, which they seemed to complete while dancing; but all of this in a manner so well planned that one could see nothing more precise.[47]

The opera *Venceslao* (Venice, 1703) features a dance with Polish sculptors building a tomb,[48] while the operatic treatment of Ovid's tale of Iphis' metamorphosis from female to male, *Iphide Greca* (Venice, 1671), includes a dance for sculptors, painters, and courtiers.[49] In this case, Iphis' acquisition of male attributes seems to have been associated with increased artistic potency.

The choreographer's vision of a statue that comes to life is perhaps the ultimate realization of the lifelike tendencies that we have observed in the engravings. In the artists' rendering they seem full of life, ready to breathe and move, testifying to the temptation for librettists, composers, and choreographers to challenge the strictures of verisimilitude and bring these inert figures to life. While the entire genre of opera may be inherently unrealistic, the dances in Venetian opera, usually placed at the ends of Acts I and II, tended to push beyond the imaginative plane of the drama, and thus were endowed with a licence to transcend the special reality of the sung drama in suggestive ways.[50] Indeed, the exotic (foreigners Turks, Armenians, or Moors) or creatures (satyrs, animals, infernal spirits) that danced outside the plot between the acts arguably stretched the viewer's sense of reality far more than a singing protagonist.

But the animated statues played a special role in Venetian opera. As relics of the ancient world and simulacra of dead heroes or gods, they could invoke the supernatural, or even the presence of those who had died. For example, the final scene of Act I from the 1670 revival of Pietro Andrea Ziani's *Antigona delusa di Alceste*, an opera based loosely on Euripides *Alcestis*, is set in a forest where some statues are placed around the ruins of an ancient castle. During the *ballo*, satyrs appear and lure

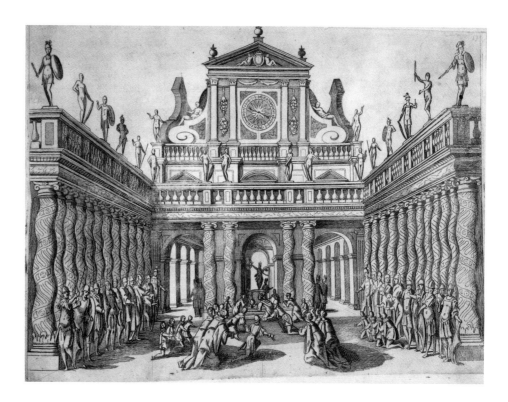

6 Marco Boschini, engraving of Giacomo Torelli's Temple of Jupiter set for *Bellerofonte*, from *Apparati scenici per il Teatro Novissimo di Venetia nell'anno 1644 d'inventione e cura di Iacomo Torelli da Fano*, 1644, Venice. Photo: Courtesy of the University of Michigan Library Special Collections.

7 Pietro Andrea Ziani,
L'Antigona delusa d'Alcesta,
1670. Conclusion of Act I:
I-Vnm, Cod. It IV 388 (=9912),
32r.

the statues from their pedestals to join in the dance.[51] The statues apparently had no difficulty performing the lively movements that one might associate with their satyr companions. The bass line that survives from the opera, in the 12/8 metre typical of a gigue, suggests that this was in fact a quite lively and energetic dance (*plate 7*).[52] But while the *ballo* functioned primarily as an interlude between the acts, it also provided a subtle comment on the principal plot of the opera. Admeto (Admetus), doomed to death, is saved by his wife Alceste (Alcestis) who dies in his place and is brought back from the underworld by Ercole (Heracles). The first act features the singing statue of Apollo, while virtually all of the characters fall in love with portraits of absent lovers at some point in the opera. The dance featuring the remnants of antiquity that come to life amid the ruins and dance playfully with the satyrs may not be essential to the progress of the main drama, but can nonetheless be understood to reflect the opera's central preoccupation with the notion of resurrection, perhaps symbolizing as well the living spirit of Greek tragedy in Venetian opera.

But it was in those works that brought history to life on the operatic stage that we find some of the most striking intersections between the Public Statuary and the dancing statues. While the Statuary may have provided opportunities for Venetians and visitors to gaze upon the great heroes of Greece and Rome, condemn their vices and applaud their acts of bravery, opera was seen as the most expedient means of making the past live anew and speak to the present in previously unimagined ways. The fact that opera was regarded as an important medium for recounting history is more than apparent in the care with which numerous printed librettos recount the distance between historical fact and operatic fancy.[53]

In Francesco Cavalli's *Mutio Scevola* (1665), with libretto by Nicolò Minato, the dancing statues are in fact linked to a particularly expressive kind of musical language: the prophetic voice. The *ballo delle statue* in this work is part of an elaborate scene that takes place in the temple of Jano (Janus) at the conclusion of Act I.[54] The Roman consul Publicola and his captain Melvio enter the temple to ask the god whether they will be victorious in the battle with Tarquinio Superbo (Tarquinian the Proud). This provides an opportunity for a remarkable series of special effects: a sudden, flashing, light illuminates a vision of a battle which is being fought inside a cloud of fire. Publicola and Melvio take this as a sign of impending doom, and run from the temple in fear. The final scene of the act features a ponderous recitative sung by

Jano

E dan-do mo-to a i de-lu-so-ri sas-si scio - glie-te, scio - glie-te, scio - glie - te, scio - glie-te, a

liet - te dan-ze a lie - te dan-ze i dur - i, i du - ri pas - si.

Ballo di statue

8 Francesco Cavalli, *Mutio Scevola,* **1665. Conclusion of Act I: I-Vnm, Cod. It IV 364 (=9888), 54r-54v.**

the statue of Jano, who scolds the Romans for giving credence to false gods such as himself. While no music survives for the actual *ballo*, the last phrase of Jano's recitative provides a hint of the music that would have followed. Jano shifts unexpectedly to a jovial triple meter as he compels the evil spirits to confer motion on the stones and allow their 'hard steps' to melt into a happy dance (see *plate 8*). The statues step down from their niches, dance around Jano, and then return to their places as if had nothing had happened. The god Jano, who takes on the role of the prophet, possessed the power not only to predict the future but also to make the past live again.

The dancing statues of Venice provide a glimpse into the provocative association between sculpture and opera during an arguably critical moment in the development of both media. In the age of Bernini, when sculpture had acquired a newly lifelike quality, when the display of art collections acquired a theatrical meaning and antiquities provided a vital link to the past, opera must certainly have seemed the most expressive way to make past glories live once again, inspiring awe and wonder in the viewer. Opera not only endowed statues with voices, as Barkan suggests, but also challenged notions of verisimilitude by imagining them as if they possessed the grace and agility of dancers – an art form whose roots in ancient practice were no less noble. We cannot know, of course, whether the audiences would have associated the dancing statues or any recreation of antiquity on the stage with the Public Statuary, Venice's other public display of ancient myth and history. But like Amphyon whose lyre playing caused the walls of Thebes to magically build themselves, the Grimani family and other nobles who sponsored opera in Venice used music not only to bring statues to life but to create a vision of Venice's imaginary mythic past, one that was calculated to ensure her continued glory.

Notes

An earlier version of this chapter was presented at the 2008 Annual Meeting of the Renaissance Society of America in Chicago. I would like to thank all those whose comments improved this chapter, and extend my special gratitude to Estelle Lingo and Barbara Sparti for their comments on early drafts.

1 'Quel musico Tebano / Lo cui soave canto / A le pietre diè vita, / Hor son di pietro imagine scolpito. / Ma benche pietra, io vivo, io spiro, e 'n tanto / Così tacendo io canto, / Hor ceda ogni altra il progiò a la tua mano / Fabro illustro, e sovrano / Poich'animar la pietre / Sù meglio il tuo scarpel che la mia cetra.' 'Anfione in Marmo', in Giambattista Marino, *La galeria del Cav. Marino distinta in pitture e sculture*, Venice, 1620, 286. Translations mine unless otherwise indicated.

2 See Linda Nemerow-Ulman, 'Narrative unities in Marino's *La Galeria*', *Italica*, 64: 1, Spring 1987, 76–86; Gerald Ackerman, 'Gian Battista Marino's contribution to seicento art theory', *The Art Bulletin*, 43: 4, 1961, 326–36.

3 Marino seems to have imagined that the reader would experience the poems in his collections much as a viewer walking through a picture gallery. The theatrical implications of this are apparent, particularly in so far as 'Marino deliberately extends the pictorial moment beyond the temporal limits of the depiction with his original interpretations of the narrative', Nemerow-Ulman, 'Narrative unities', 76. Moreover, when he endows his images with the powers of expression, this allows 'the poet to enter into the time frame of the narrative' (79) – in short the poet and (hence the reader) becomes involved in the ongoing drama – that is to say they not only see the image in their minds eye but also listen to its inner voice.

4 Pietro Paolo Bissari, *La Torilda*, Venice, 1648, 127. The music, likely by Francesco Cavalli, is lost.

5 On opera's use of emblematic women, see Wendy Heller, *Emblems of Eloquence: Opera and Women's Voices in Seventeenth-century Venice*, Berkeley and Los Angeles, CA, 2003.

6 For an index of the balli in the operas, see Irene Alm, *Catalog of Venetian Opera librettos at the University of California at Los Angeles*, Berkeley and Los Angeles, CA, 1992. On dance in Venetian opera, see Irene Alm, 'Winged feet and mute eloquence: dance in seventeenth-century Venetian opera', *Cambridge Opera Journal*, ed. Wendy Heller and Rebecca Harris-Warrick, 15, 2003, 216–80.

7 J. L. Carr, 'Pygmalion and the Philosophes: the animated statue in eighteenth-century France', *Journal of the Warburg and Courtauld Institutes*, 23, 1960, 239–55. Certainly some of the interest in statuary on the opera stage spread from Venice to France through the efforts of Giacomo Torelli (1608–78), who installed staged machinery for the Hôtel du Petit Bourbon and the Palais Royal. See Francesco Milesin, ed., *Giacomo Torelli: l'invenzione scenica nell'Europa barocca*, Fano, 2000. On the trope of the dancing statue, see Kenneth Gross, *The Dream of the Moving Statue*, University Park, PA, 1992.

8 Gregorio Lambranzi, *Nuova curiosa scuola de' balli theatrali*, Nuremberg, 1716. The preface and descriptions of the dances is in Italian, but the plates by Johann Georg Puschner contain descriptions of the dances in German. The work was reprinted in facsimile as *New and Curious School of Theatrical Dancing*, trans. Derra de Moroda, London, 1928; repr. New York, 2002. See also, Daniel Heartz, 'A Venetian dancing master teaches the Forlana: Lambranzi's balli teatrali', *Journal of Musicology*, 17, 1999, 136–51.

9 Plate 1 features only the first stage of the dance of the statues; the caption reads as follows: 'These three persons remain motionless until the air has been played once. When it is repeated and the sign "A" is reached, those at each side jump to the ground and assume another pose as shown in the next plate.' In the subsequent stages of the dance, the statue in the centre remains motionless throughout, while the two on the side engage first in a battle and are joined by two others for a sword dance before they return to their pedestals. See *New and Curious School of Theatrical Dancing*, Book II, plates 12–17, 98–105.

10 The caption for the dance of the sculptors reads as follows: 'Here is a wooden statue which has been covered with pieces of stone, made to adhere by means of plaster, so that it appears shapeless. It is set up on the stage. Then enter two sculptors who chisel the statue as they dance, so that the pieces of stone fall off and the mass is transformed into a statue.

The *pas* can be arranged at pleasure. The air is played twice.' See *New and Curious School of Theatrical Dancing*, Book II, plates 24, 110.

11 A system of notating dance choreographies devised in the 1680s by Pierre Beauchamps and published in 1700 by Raul-Auger Feuillet.

12 Irene Alm, 'Humanism and theatrical dance in early opera', *Musica Disciplina*, 49, 1995, 79–93.

13 There is an extensive bibliography on Venetian opera. See the classic text by Ellen Rosand, *Opera in Seventeenth-Century Venice: The Creation of a Genre*, Berkeley and Los Angeles, CA, 1991; see also Beth Lise Glixon and Jonathan Emmanuel Glixon, *Inventing the Business of Opera: The Impresario and his World in Seventeenth-century Venice*, Oxford and New York, 2006.

14 Irene Favaretto, *Arte antica e cultura antiquaria nelle collezioni venete al tempo della Serenissima*, Roma, 1990; Krzysztof Pomian, *Collectors and Curiosities: Paris and Venice 1500–1800*, Cambridge, UK and Cambridge, MA, 1990. Marino Zorzi, ed., *Collezioni di antichità a Venezia: nei secoli della Repubblica*, Rome, 1988.

15 Michel Hochmann, *Peintres et commandataires à Venise (1540–1628)*, Rome, 1992, 234–9.

16 The summary below is indebted to the work of Marilyn Perry, 'The Statuario Publico of the Venetian Republic', *Saggi e Memorie di Storia dell'Arte*, 8, 77–253; and 'Cardinal Domenico Grimani's legacy of ancient art to Venice', *Journal of the Warburg and Courtauld Institutes*, 41, 1978, 215–44. See also, Irene Favaretto and Giovanni Luisa Ravagnan, eds, *Lo statuario pubblico della serenissima: due secoli di collezionismo di antichità 1596–1797*, Padua, 1997.

17 Patricia Fortini Brown, *Venice and Antiquity: The Venetian Sense of the Past*, New Haven, 1996.

18 Patricia Fortini Brown, *Private lives in Renaissance Venice: Art, Architecture, and the Family*, New Haven, 2004, 229–35.

19 Vincenzo Scamozzi (1548–1616) completed the perspective sets for the Teatro Olimpico after the death of Andrea Palladio in 1580, and also went on to design the Teatro Ducale at Sabbioneta which, unlike the Teatro Olimpico, was conceived as a modern theatrical space. See Stefano Mazzoni and Ovidio Guaita, *Il teatro di Sabbioneta*, Florence, 1985; Franco Barbieri and Guido Beltramini, eds, *Vincenzo Scamozzi, 1548–1616*, Venice, 2003. See also, Eugene J. Johnson, 'Jacopo Sansovino, Giacomo Torelli, and the theatricality of the Piazzetta in Venice', *The Journal of the Society of Architectural Historians*, 59: 4, 2000, 436–53.

20 *Delle antiche statue greche e romane* (1740–1753) published also as *Ancient Statues, Greek and Roman: Designed from the Celebrated originals in St. Mark's, and other public collections in Venice*, London, 1800. On Zanetti see Perry, 'Statuario Publico', 86–95. As Perry notes, there has been considerable confusion between the younger Anton Maria [Alessandro] Zanetti (1706–78) and his older cousin Antonio Maria [Girolamo] Zanetti (1680–1757), who was known as a printmaker, draughtsman and collector. Both cousins contributed to the collection of engravings, though Zanetti *il giovane* was responsible for the inventory.

21 Reproductions of the Zanetti drawings for the inventory preserved at the Biblioteca Marciana (I-Vnm Cod. It. IV, 123 [10040] and I-Vnm Cod. It. IV, 65 [6058]) are included in Irene Favaretto and Giovanni Luisa Ravagnan, eds, *Lo statuario pubblico della serenissima: due secoli di collezionismo di antichità 1596–1797*, Padua, 1997, 140–227. These differ from the set of engravings published by the Zanetti in *Delle antiche statue greche e romane che nell'Antisala della Libreria di S. Marco e in altri luoghi pubblici di Venezia si trovano*, Venice, 1740–3. For more details on the publication, see Perry, 'The Statuary Publico', 114–16.

22 See Elizabeth and Dempsey Cropper, *Charles Nicholas Poussin: Friendship and the Love of Painting*, Princeton, NJ, 1996; *Cassiano dal Pozzo's Paper Museum*, Milan, 1992.

23 Cropper describes '... a grace and liveliness that transcended the limits of stone that gave the statues facial expressions, softness, and a kind of vitality to their skin, as if indeed they were alive' (108). Elizabeth Cropper, 'Vincenzo Giustiniani's Galleria: the Pygmalion effect', in Ian Jenkins, ed., *Cassiano dal Pozzo's Paper Museum*, Milan, 1992, 101–26.

24 The young Anton Maria Zanetti and his brother Girolamo revised several librettos for operas presented at the Grimani family theater, the S. Giovanni Grisostomo. These include the revision of Apostolo Zeno's *Ambleto* (Venice, 1742); the addition of several arias for Matteo Noris' *Tito Manlio*, revised by Jacopo Sanvitale, the composition of the entire libretto of *Sofonisba* (1746), and the revision of Silvio Stampiglia's *Camilla Regina de' Volsci* (Venice, 1749). The elder Zanetti, famed for his caricatures of friends and colleagues, became particularly renowned for his humorous drawing of the castrato Farinelli. See Daniel Heartz,

'Farinelli revisited,' *Early Music*, 18: 3, 1990, 431. See also *Caricature di Anton Maria Zanetti. Catalogo della mostra*, ed. Alessandro Bettagno, Venice, 1969.

25 Perry, 'Grimani's legacy', 231.

26 Brown, *Venice and Antiquity*.

27 Debra Pincus, 'Venice and the two Romes: Byzantium and Rome as a double heritage in Venetian cultural politics', *Artibus et Historiae*, 26: 13, 1992, 101–14. There is an extensive bibliography on the myth of Venice. See the classic essay by Gino Fasoli, 'Nascita di un mito', in *Scritti storici in onore di Gioacchino Volpe*, Florence, 1958, 445–79; J .S. Grubb, 'When myths lose power: four decades of Venetian historiography', *Journal of Modern History*, 58, 1986, 43–94. On the role of the myth of Venice in opera, see Ellen Rosand, *Opera in Seventeenth-Century Venice* and *Monteverdi's Last Operas: A Venetian Trilogy*, Berkeley and Los Angeles, CA, 2007. On Venetian opera and Roman history, see also Wendy Heller, 'Tacitus incognito: opera as history in L'incoronazione di Poppea', *Journal of the American Musicological Society*, 52, 1999, 39–56.

28 Perry, 'Statuario Publico', 80–1.

29 The classic study of the Venetian approach to humanism remains Margaret L. King, *Venetian Humanism in the Age of Patrician Dominance*, Princeton, NJ, 1986.

30 Paula Findlen, 'The museum: its classical etymology and renaissance genealogy', *Journal of the History of Collections*, 1, 1989, 61.

31 On Contarini's *Compendio*, see Perry, 'Statuary Publico', 129. Perry's appendix includes the transcription of notes by the Marciana librarian Jacopo Morelli, presumably from the dedication of the first edition of Pier Contarini's *Compendio universale di Republica* (1601) to Federico Contarini, the *Procuratore*. Notably this dedication does not appear in the later extant edition. As Perry notes, Contarini 'praises in particular and at length the Procuratore's efforts in establishing the new Statuario Pubblico, described as "un bellisimo Teatro"'. The word 'teatro appears no fewer than four times in Morelli's transcription of the dedication.

32 Coryate, *Crudities*, 180.

33 Leonard Barkan, *Unearthing the Past: Archaeology and Aesthetics in the Making of Renaissance Culture*, New Haven, 1999, xxiv.

34 Barkan, *Unearthing the Past*, xxiv.

35 On the Venetian opera theaters, see Rosand, *Opera in Seventeenth-Century Venice*; Glixon and Glixon, *Inventing the Business of Opera*. Vincenzo Grimani, who became a cardinal in 1697, also wrote a number of libretti, likely penning the libretto for Handel's *Agrippina* (1709).

36 On the activities of the impresario Marco Faustini, see Glixon and Glixon, *Inventing the Business of Opera*.

37 Glixon and Glixon, *Inventing the Business of Opera*.

38 On Grimani palace, see Brown, *Private Lives*, 217-18 Annalisa Bristot and Mario Piana, 'Il Palazzo dei Grimani a Santa Maria Formosa', in *Il statuario pubblico*, 45–52.

39 Favaretto, *Arte antica e cultura* (84): 'La collezione era dovuta infatti all'amore per le antichità e le cose d'arte non un singolo individuo, ma di una intera famiglia, amore che che involse nel tempo più generazioni.'

40 Wendy Heller, 'Venice's mythic empires: truth and verisimilitude in Venetian opera', in Victoria Johnson, Jane F. Fulcher, and Thomas Ertman, eds, *Opera and Society in Italy and France from Monteverdi to Bourdieu*, Cambridge, 2007, 34–53. On the relationship between opera and Roman history, see Heller, 'Tacitus incognito', 39–96.

41 Heller, 'Tacitus incognito'; William Bouwsma, 'Venice and the Political Education of Europe', in *A Usable Past*, Berkeley, CA, 1990, 266–91.

42 Harris Saunders, Jr, 'The Repertoire of a Venetian Opera House (1671–1714): The Teatro Grimani di San Giovanni Gristostomo', PhD Dissertation, Harvard University, 1985.

43 See Milesi, *Giacomo Torelli*.

44 Cropper, 'Vincenzo Giustiniani's Galleria'.

45 Vincenzo Nolfi, *Il Bellerofonte*, Venice, 1642. On the ways in which the sets for *Il Bellerofonte* invoked Sansovino's designs for the Piazzetta, see Johnson, 'Jacopo Sansovino, Giacomo Torelli'.

46 As the author of several important books on contemporary Venetian art, including *La carte del navegar pitoresco* (1660), Marco Boschini was an important link between the worlds of art and opera.

47 Cited by Alm, 'Winged feet', 236.

48 Apostolo Zeno, *Venceslao*, Venice, 1703. As Marilyn Perry notes, the antiquarian and librettist Zeno was also involved in Zanetti's project to publish engravings of the statuary. See Perry, 'Statuario Publico', 116–19.

49 Nicolò Minato, *Iphide Greca*, Venice, 1671.

50 Since the invention of opera, composers and librettists had grappled with the genre's inherent lack of verisimilitude; by the middle of the seventeenth century they had arrived at a fairly consistent set of criteria of what was plausible within the inherently unrealistic world of opera, a boundary that was frequently transgressed in the dances. See Wendy Heller, 'Truth and verisimilitude' and 'Dancing the myth of Venice'. Alm, 'Winged feet' (241) notes as follows: 'The extraordinary variety of subjects and characters in the *balli* was in large part a result of librettists' efforts to link the *balli* to the plot or subject of the opera, even though they did not necessarily play a critical role in advancing the action.' Thus, to cite one example, in Cavalli and Faustini's opera *La Calisto*, the heroine's transformation into a bear (a patently unrealistic moment) is acknowledged by a *ballo* featuring dancing bears. Although no less verisimilar, the bears have no place in the opera's plot.

51 Aurelio Aureli, *L'Antigona delusa d'Alceste*, Venice, 1670. Act I *ballo*: 'Ballo di Satiri tramezato con alcune Statue'.

52 Wendy Heller, 'The beloved's image: Handel's Admeto and the Statue of Alcestis', *Journal of the American Musicological Society*, 58, 2005, 559–638.

53 Heller, 'Truth and verisimilitude'.

54 Nicolò Minato, *Mutio Scevola*, Venice, 1665. Act I *ballo*: 'Ballo di Otto Statue che mosse da Spiriti partono dal site dove circondavono la Statua di Iano per ornamento, e doppo il Ballo ritornano al loro luoco.'

Chapter 9
How to Become a Picture:
Theatricality as Strategy in Seventeenth-Century Dutch Portraits

Hanneke Grootenboer

In 1656 Michael Sweerts painted a portrait of an unknown man, leaning over a writing table, his head resting on his right hand (*plate 1*).[1] Piled around him on his desk are papers and books, as well as various coins, probably removed from the blue silk purse on the left. Perhaps he had been writing before pausing to replace the quill in the inkpot. Looking out as if he has just posed a request relating to the document he holds, he seems to be waiting for some kind of response. 'Well?' he seems to say. His face shows traces of exhaustion, raising the question of what kind of letter he has been composing. Does the man intend to disclose something about himself? Does the document perhaps contain a message that he needs to communicate? It is not entirely clear whether he intends to present the document to us. A slight effect of hesitation, noticeable in the gesture of his hand, suggests that he may not yet be prepared to submit the paper; that he is holding back, waiting.

Sweerts' painting represents what John Pope-Hennessy would have called, in the context of Renaissance painting, an 'augmented portrait' that includes clues such as emblems, objects, or mottos appearing on scrolls or ledges that reveal something of the sitter's character.[2] Upon closer inspection we see that the pewter ink set placed on the table's rim draws attention to a small *cartollino*. Attached with two pins to the tablecloth in *trompe l'oeil* fashion, it bears the Latin motto *Ratio Quique Reddenda*, the date 1656, and, in tiny letters in the bottom left-hand corner, the name of the artist ('Michael Sweerts F').[3] For a while this painting was known as 'the bankrupt banker'. The inscription, which translates as 'each man must give an account [of himself]' can be considered as a typical *vanitas* message, reminding the viewer that on the day of judgment, we all must render an account of our deeds and misdeeds. However, in strong contrast to the universal *vanitas* message the picture as a whole is supposed to convey, the man's relaxed pose creates a pronounced sense of intimacy. He does not address a general audience but seems to turn to a particular 'you'.

The man's relaxed, expectant pose, taken together with the suggestion that he is soliciting a particular kind of response through a rather obscure demand, can be considered an instance of seventeenth-century 'theatricalized' beholding. In *Absorption and Theatricality: Painting and Beholder in the Age of Diderot* (1980), Michael Fried explains how for Diderot the object–beholder relationship is essentially theatrical because the theatre is a medium of dislocation and estrangement rather than absorption.[4] For Diderot, the success of painting and drama depends on the degree to which painters and dramatists are capable of undoing this situation, to 'de-theatricalize' beholding. The anti-dualistic implications of his project are not applicable to Sweerts'

Detail from Michael Sweerts,
Portrait of a Young Man, 1656,
(plate 1).

Theatricality in Early Modern Art
and Architecture *Edited by Caroline
van Eck and Stijn Bussels* © 2011
Association of Art Historians.

composition, which, as I will demonstrate, fully exploits the dualism of the subject in portraiture. The man's pensive posture possesses a relatively high degree of demonstrativeness, revealing his awareness that he is being watched. His anticipation, in fact, presupposes a mode of perception brought about by the separation between him and us, 'out there' as viewers. His entire posture addresses the invisible place from which we see, a separation that has traditionally been called theatrical. In her book on *Theatricality* (1972), Elizabeth Burns linked theatricality to perception when she explained that theatricality occurs when behaviour is constructed according to a kind of grammar of rhetorical and authenticating conventions rather than being spontaneous. Theatricality can thus be understood as

1 Michael Sweerts, *Portrait of a Young Man*, 1656. Oil on canvas, 114 × 92 cm. St Petersburg: The State Hermitage Museum. Photo: © The State Hermitage Museum.

calculated, affected, or studied social behaviour, as well as the place from which one sees, as designated by the Greek word *theatron*. The term denotes a form of social role-playing in order to achieve a particular effect on a viewer. Recently, Marvin Carlson has presented Burns's theory as anticipating Judith Butler's notion of subjectivity as a construct that is itself a performative process.[5] For Butler, the role of the self is performed not self-consciously in order to achieve a certain effect, but the 'you' to whom the performance is addressed is essential for the subject to recognize him or her *as self*. Toward the end of this chapter, I will say more about the way in which, for Sweerts, Descartes and Butler, the self exists (only) by virtue of a 'you'.

However, much as Sweert's painting attempts through its structure of address to designate the place from which one is able to see, as the word *theatron* suggests, there is no audience visible. And yet, Sweerts' young man addresses us as if he wants to disclose something. His relaxed posture, however, does not give the impression that we are being invited to share a secret. It is not, I would say, that we are merely kept in suspense, but rather that we get a sense of withdrawal on the man's part. If he is

indeed giving an account of himself here, the last word has not yet been said.
To a certain extent, any portrait can be considered a fragment of biography. 'To sit for one's Picture, is to have an Abstract of one's Life written, and published', Jonathan Richardson famously wrote in *An Essay on the Theory of Painting* (1715).[6] Harry Berger Jr could not have agreed more. In his *Fictions of the Pose: Rembrandt against the Italian Renaissance* (2000), Berger argues that augmented portraits rhetorically employ the notion of anecdote in the original meaning of 'things not given out' (from the Greek *anecdota*), that is in the sense of unpublished, secret, or private narratives.[7] In line with Berger, we can define portraiture as providing a space in which the sitter's body, as the object of the painting, becomes legible as a subject when placed in a particular mise-en-scene surrounded by meaningful props. Are we invited to 'read' Sweerts' painting as a narrative of this transformation from object to subject of the painting? If we do, we have to admit that the hesitant gesture of the hand and the sitter's slight withdrawal give this work an unfinished quality. Does Sweerts' young man make a rather theatrical gesture, in fact, by waiting for us as viewers to take the next step?

In this chapter I explore how theatricality in portraiture allows a particular exposition of the sitter through which a sense of self is constructed. I am particularly interested in the extent to which the absent 'you' conditions the mode of display. In his essay 'The Look of the Portrait,' Jean-Luc Nancy states that portraiture revolves around the figure of the subject, but that any sense of unveiling of (part of) the self can only take place on condition of its exposition, that is, the exposure or display of the self, in a sense an explanation or expounding of it, that takes place via an account of its exterior appearance.[8] Following Nancy to this extent, I am interested in exploring two meanings of the word exposition: as the positioning of the subject's exteriority in front of an audience; and, in an extension and reversal of the idea, as its dislocation, its ex-position. In using these concepts in what follows, I do not intend to merely make a historical argument about early modern portraits. Instead, I want to make a theoretical argument as to how theatricality as an analytical tool can help us unpack subjectivity as performance in portrait paintings, and assist in investigating this pictorial space in which the self is constituted.[9]

I start from an understanding of theatricality that transcends the notion of the theatre as such.[10] In his book *Theatricality as Medium* (2004), Samuel Weber starts from the question how theatre has been conceptualized in the West. He notes that in writings of nineteenth- and twentieth-century theatrical thinkers, theatre and theatricality emerge as alternatives to relatively worn-out terms of identity, reflexivity and subjectivity. Posing the ancient question of the theatre as medium, Weber argues that in various instances, the history of the theatre reveals a shift from theatre as a fixed location where a performance takes place to theatricality as ongoing happenings. Such happenings, Weber writes in the Introduction, are not tied up with the place of the performance, but they cannot be separated from it either. They 'come to pass'; they take place and 'pass away', not to vanish but to happen somewhere else. In fact, such events never take place only once but are ongoing or open-ended and potential. 'Theatricality demonstrates its subversive power when it forsakes the confines of the *theatron* and begins to wander.'[11] The shift Weber observes in definition from theatre to theatricality, from a 'placing before' to exposition, he sees reflected in theoretical and philosophical writings of the past two centuries. As we have seen, Nancy implies a similar shift from representation to exposition, which he connects to subjectivity by discussing his idea of the subject's dislocation or ex-position to portraiture. Joseph Litvak believes that 'theatricality' owes its value as a critical term to its open-endedness, and argues that, unlike 'theatre', the word does not denote a fixed

2 Gerard ter Borch, *Portrait of a Man*, c. 1640. Oil on copper, 50.8 × 37.8 cm. Richmond: Virginia Museum of Fine Arts (The Adolph D. and Wilkins C. Williams Fund). Photo: Katherine Wetzel ©Virginia Museum of Fine Arts.

place but rather resists circumscription.[12] Following Litvak, I am interested in the extent to which theatricality's open-endedness ultimately allows for the duality of the exposition of the subject of portraiture as both an expounding and a dislocation. As we will see, the open-endedness of Sweerts' painting plays a fundamental role in the young man's desire to give an account of himself.

To fully understand the sophistication of the structure of address in Sweerts' painting, I would like to compare this work to the remarkably austere portraits of Gerard ter Borch. In contrast to the relaxed yet studied attitude of Sweerts' young man, ter Borch's sitters do the exact opposite. Visibly uncomfortable in striking a pose, ter Borch's clients, members of the political elite in Deventer, are shown full length against uniformly dull and empty backgrounds. These small-scale portraits

3 Gerard ter Borch, *Portrait of a Woman*, c. 1640. Oil on copper, 50.8 × 37.8 cm. Richmond: Virginia Museum of Fine Arts (The Adolph D. and Wilkins C. Williams Fund).

never measure more than seventy centimetres in height and are set in elaborate frames. This format proved highly successful for ter Borch, but remained an anomaly in the Netherlands.[13] For instance, if we look at a set of pendants painted about 1640 we see a couple standing in a shallow, neutral space (*plates* 2 and 3).[14] The spare room contributes to the artless postures of the sitters. The faint floor line linking the two panels fails to overcome the sense of isolation and loneliness around each figure. Even the conventional trope of the gloves, meant to emphasize the marriage bond between the figures, has little impact here. Ter Borch's characteristically dull backgrounds, as here, have been said to be reminiscent of Diego Velázquez's portraits. It is possible that during his travels, ter Borch became familiar with Velázquez's work; however, his dejected-looking figures lack the strong sense of self-possession

and performance of Velázquez. As if to make up for his closely circumscribed vacuums, ter Borch occasionally offers his sitters pieces of furniture for company. The same chair-and-table set, clad in red velvet and trimmed with golden frills, appears in several of his portraits as a prop for his sitters to hold on to. However, the pieces of furniture give the impression of being more attached to one another than to any of the figures, as we see in the portraits of Jan van Duren and his wife Marghareta van Haexbergen of about 1666 (*plates* 4 and 5).[15] Their figures remain stiff and ill at ease, or indeed like puppets, as Gerard de Lairesse would have it. Though he is referring to the work of ter Borch's pupil Caspar Netscher, de Lairesse's critique of his small scale portraits for their unnatural representation of figures is equally applicable to the older artist: 'So is it with a portrait in little, which has nothing of nature but the features and looks like a puppet; whereas there are well-known methods to make it appear as big as the life; nay, to move and speak, as I say; but being slighted, the figure seems immovable, dumb and little, and therefore unnatural.'[16] Though the gazes of Jan van Duren and Marghareta van Haexbergen betray their awareness of being watched, they are prepared to reveal no more of themselves than what is expressed by their modest yet expensive dress. Their body language may be stately and distinguished – neither affected nor actor-like, just as the contemporaneous art theorist Petrus Francius had it – but such poise comes at the expense of a performance of a self or interiority.[17] Nothing whatsoever is disclosed about these puppet-like figures except for the mere facts of their exteriority.

Comparing ter Borch's portraits to his genre pieces, what appears to be lacking is not just skill or invention. In his genre scenes, he is always successful in orchestrating a moment of suspense through the interaction of his figures, whose stolen glances or faint gestures brim with meaning. In his compelling *tableaux vivants*, stitched together

5 Gerard ter Borch, *Margaretha van Haexbergen, Wife of Jan van Duren*, 1666–67. Oil on canvas, 81.3 × 65.1 cm. New York: The Metropolitan Museum of Art (Robert Lehman Collection). Photo: © 2007, The Metroploitan Museum of Art/ Art Resource/Scala, Florence.

by plots that are present but never disclosed, the figures always seem to strike the exactly appropriate pose for the scene in which they are placed. A lifted hand is positioned with absolute precision; a slightly tilted head, a shy upward glance, a faint suggestion of a body turning are always exactly apt. Judging by this, he could easily have transformed his portraits into engaging pictures but instead deliberately chose to render his clients affect-less. In strong contrast with the mildly provocative yet silent request that is posed by Sweerts' young man's eyes and hesitating hand, and which somehow seems to breathe through his features, it is as if ter Borch's clients simply wait for the sitting to end. Apparently not used to being in a painting, they seem awkward striking a pose. Neither ter Borch's flattering brush nor his well-to-do sitters' sense of propriety were able to conceal the weariness on some of these faces nor hide a clear sense of boredom, which may be the natural result of posing. In this sense, these pictures are not unnatural, as de Lairesse thought, but rather too natural.

In his 2003 book, *The Education of the Eye*, Peter de Bolla describes how artists' studios in eighteenth-century Britain became spaces of entertainment where spectators would come to watch the making of the portrait, often distracting the sitter. Portraits were often put on display in the studio and the presentation of a portrait by a famous figure drew large crowds. De Bolla observes a parallel between the rise of such studios and the changes in the degree of comfort communicated by the postures of sitters. Roughly around the same time that the provision of large mirrors to enable sitters to observe their likenesses coming into being began to prevent them from being bored by long sessions, a development in portraiture emerged in which formerly static and stiff figures began to yield to pictures in which sitters pose more naturally.[18] Whereas the figures in earlier pieces had rarely engaged with the viewer,

hiding behind stiff postures and forced grins, sitters in the mid- to late-eighteenth century appear to be comfortably installed and at ease about meeting the viewer's gaze, and seem to feel no disjunction between an internal, imagined, self-image and its representation. This development leads De Bolla to conclude that by the end of the century, both sitters and viewers had solved the problem of how to appear in public, how to imagine oneself as 'a subject-in-the-picture'. The culture had matured, De Bolla argues, and had 'grown to accept the public face of self-image, [had] become comfortable with the seductions of visuality and the pleasures of narcissism' (60).

Though he is discussing eighteenth-century British portraiture, some of De Bolla's ideas on the transformation of a sitter to a subject-in-the-picture can be helpful in analysing the exposition of interiority and exteriority in seventeenth-century Dutch portraits. In her essay 'Sovereign Bodies: The Reality of Status in Seventeenth-century Dutch Portraiture,' Joanna Woodall describes a process comparable to the one observed by De Bolla. She argues that Dutch citizens grew increasingly comfortable with adapting the received conceptions and conventions of aristocratic forms and values to their modes of self-representation and self-promotion as a new elite.[19] Leading Amsterdam citizens used portraiture to claim positions equal to, yet distinct from, the hereditary nobility as well as to define their status in relation to each other (96). Woodall argues that a changing conception of nobility lay at the roots of this development in the Dutch portrait, a revolution that ultimately aimed at justifying its sitters' exercise of authority despite their lack of noble blood. Portraits of the newly established elite, presenting the recently fashioned identity of a class of burghers not yet grown into a full-blown bourgeoisie, were meant to make up for the lack of aristocratic heredity by acknowledging virtues linked not to the noble body but to the subject's interiority, such as intelligence or genius.[20] Nobility became a broadly defined concept, encompassing more than high birth. Valorized as well was the virtue of those who served the state, or the skill of men of letters. Thus, portrait conventions typical of sovereignty, ranging from a full length, life-size, format to the bearing of arms, the holding of canes or fans, or the trope of the hand resting on the hip, ultimately produced a distinction between the respectable Amsterdam citizen identifying with his/her interior virtues, and the expenditure and irresponsibility associated with the court in The Hague.[21] This was particularly important as in the first half of the century, as the political rivalry between the stadholder and his court in The Hague on the one hand, and the burgher elite on the other hand, was played out in Amsterdam.[22]

Fundamental to the interior qualities and virtues promoted in this new bourgeois portraiture is the dualist subject whose material body is understood as separate from his identity. From this separation is born the very notion of subjectivity. It is precisely this dualism, constructive of the class of portraits described by Woodall, that is not so much emphasized or thematized but *staged* in Sweerts' portrait of the young man. In their quest to distinguish themselves from less mature fellow citizens as well as from the court in The Hague, these proud and self-aware Amsterdam burghers must have striven to recognize themselves in this type of being-in-the-picture. Nancy has said that the portrait does not look at or for an object but rather looks out *for itself*. The exclusive concern of the portrait, according to Nancy, is a self in and for itself.[23] The rise of portraiture in the Netherlands can said to be an effect of the self-consciousness of a newly affluent merchant class who considered pictures as mirrors in which their riches and prosperity were reflected in images of themselves. However, Woodall has demonstrated, the Amsterdam burgher elite insisted on seeing themselves as much as on *showing* themselves before an audience

6 Hendrick Golzius, *Portrait of Jan van der Aar*, 1603. Oil on canvas, 108 × 83 cm. Rotterdam: Museum Boijmans van Beuningen (Loan from Stichting P. en N. de Boer). Photo: © Museum Boijmans van Beuningen, Rotterdam.

of peers. They, as well as their portraitists, developed highly sophisticated ways of articulating the exposition of the bodily self as a way of constituting the sitter's singularity.[24] Indeed, we may say that recognition of the self can occur only through a mediation that takes place exterior to the self, a mediation that happens in painting and which is profoundly theatrical. In the light of Nancy's explorations, I would like to take a closer look at a portrait of Jan van der Aar by Hendrick Goltzius of 1603 (*plate* 6) to see how this mediation occurs.[25] The Haarlem shell collector is seated at a table, on which is displayed an impressive and valuable collection of shells from the East and West Indies of the sort that were regarded as prestigious investments.[26] Van der Aar had himself shown displaying what is probably the most precious item in his shell collection, a very expensive, stripped and polished *turbo marmoratus* from the Indian archipelago. Posing as the proud owner of this great treasure, he holds it up in one hand for the viewer's perusal. This painting's structure of address invites its audience to compare van der Aar to the turbo as a way to contemplate interiority versus exteriority, outside versus inside, and surface versus depth. The opening of the shell is turned slightly toward the viewer so as to rhyme visually with the sitter's collar which has casually fallen open, leaving part of van der Aar's chest exposed. Though it would go too far to say that van der Aar intends to reveal a deeper self, his exposure of his bare chest and rhyme with the stripped turbo suggests a high degree of self-awareness about the discrepancies between one's outer appearance and sense of inner self.

This strategy of exposition is emphasized by the materiality of the painting. Goltzius has taken great pains to establish a subtle connection between the shell's

surface and his sitter's face, rendering the curves of the shell in such a way that they suggest a correspondence with the dignified curls of the man's hair. The shell's mother-of-pearl lustre appears to be reflected in the sheen of the sitter's grey locks. These formal connections make the turbo appear as if it were an 'extension' of the sitter, whereby lustre and sheen become surface qualites of both the shell and the subject. The nature of the role played by the turbo may be further clarified if we look at a didactic poem by Philibert van Borsselen, entitled 'Beaches, or Poem on Shells, in Praise of the Creator of All Things' and published in 1611. Considering the *turbo marmoratus*, Van Borsselen wrote:

> Just as this shell receives its beautiful luster from Heaven's greatest Light and reflects it back on man's face and cheers his spirit, thus man whose heart has been gladdened further the honor of God and edify his fellow men. And man should not delve into his unfathomable heart, the treasure which God has given him, but lend it out everywhere as a pawn, and it will bring profit.[27]

In light of this poem, we might choose to read the turbo as van der Aar's treasure, compared to his heart as God's treasure, which ultimately reveals a part of his inner self that is offered here to the viewer.

In addition, if we continue to read van Borsselen's poem we see that Goltzius may have entertained a rivalry with the turbo: 'Oh sensuous Painter, although your hand be highly praised, here it falls short, neither your paint nor brush can do justice to this beautiful luster.'[28] The artist alludes to various aspects of mimesis: on the one hand, a likeness as the exact copy of nature, in the sense of a perceived visual resemblance between image and model; and, on the other, a likeness as a way of portraying someone's inner self but doing so *through* an emphasis on physical exteriority. In deploying the turbo as a means to mount an exposition of his sitter through surface qualities, Goltzius' picture makes full use of oil painting as a mode of reflection and narcissism.

To what extent should we interpret the pose and structure of address in Sweerts' painting of a young man in terms of self-reflection or narcissism? De Bolla endorses the idea of eighteenth-century portraits as mirrors of the self in a culture that allowed itself to indulge in narcissism. In contrast, Woodall's more subtle argument refrains from considering the development in portraiture as a merely self-reflective mode. Although there are certainly traces of self-congratulation in Sweerts' painting, I believe that the young man's mode of recognition of the self is still more complicated than the mode of self-fashioning Woodall and De Bolla propose. We may be better able to examine the exposition of the self in Sweerts' picture if we read a famous passage at the beginning of Descartes' *Discourse on Method* (1637). Asserting that the power of judging well is given equally to all of us, and that diversity among us results from the various pathways taken by the mind and the different things we take into consideration, the philosopher explains that he does not want to impose a method for reasoning well for everyone to follow. Rather, he wishes to demonstrate how he has conducted his own thinking. His essay thus intends to give an account of his life:

> I know how much we are prone to err in which affects us, and also how much the judgments made by our friends should be distrusted when these judgments are in our favor. But I will be very happy to show in this discourse what paths I have followed and to represent my life in it *as if in a picture*, so that everyone may judge it for himself, and thus, that, learning from the

common response the opinions one will have of it, this may be a new means of teaching myself, which I shall add to those that I am accustomed to using.[29] (my italics)

Descartes wishes to describe his life *as if in a picture*, drawing it out as if it were a story or a fable. By representing himself in a way that is open to the judgment of others he wants to demonstrate his method, but he also seeks to discover a new way of teaching himself about himself. Describing his life 'as if in a picture' would allow him to re-present it, in the literal sense of having his life 'stand before' him and the others whose opinion he seeks. Implicit in this discourse on method is that, in wanting to be taught about himself by others, Descartes believes that he can recognize his life-as-if-in-a-picture through the opinion of his judges more accurately than he otherwise could. We might say that, ultimately, recognition of the self according to the picture of one's life is in fact an encounter not merely with the self, but also with the opinions of others. Indeed, recognition of the self only occurs through the necessity of exposing one's life, as a fable, as an image, to others; with the result that the account of one's life is always disoriented or interrupted by the gaze of others, who in responding slightly change the course of the story.

It would be going too far to state that Sweerts translated Descartes' passage into pictorial terms, yet juxtaposing text and image may assist us in discovering why the young man seems to address a particular 'you' and anticipate his/her response. Like Descartes recounting the paths of his life in order to elicit other people's views of it, this young man cannot look out for himself literally and figuratively speaking without there being a gaze to look back at him. His own gaze, resting quietly upon us as viewers, may be an attempt to look out for himself, an attempt born from the desire to recognize himself and all the while be recognized *as* himself. Viewing Sweerts' painting in the light of Descartes' passage (which might similarly be considered a biographical fragment), and assuming for the moment that the figure at the table like the philosopher is representing his life to us (this time literally as a picture), we may be able to articulate precisely why there is a slight hesitation in the hand holding the piece of paper. If this man is indeed giving an account of himself in the manner of Descartes, it follows that the paper cannot possibly contain the full account. Indeed, as Descartes' method explains, part of the account depends upon a judging other from whom we expect a response, that is, an addition. Though holding up the paper as if wishing to say 'here it is', the young man is obviously aware that he can never *give* the account, in the sense of handing it over, because it is not entirely his own. In the light of Descartes's text, we may reason that the painting's anticipatory posture I discussed earlier can now be explained as awaiting the completion of the account by the judgment of others who may see it, and without whose responses it can never be wholly drawn out.

Read as two variations of a similar attempt to narrate the self, Sweerts' painting demonstrates that through its theatricality, this pictorial account adds a profound sense of duality to the spectrum of self-recognition set out by *Discourse on Method*. While, in the confined time and space of the theatre, spectacle and spectator need to be in each other's vicinity in order for the theatrical event to take place, the pictorial scene of the painting does not require its audience to be present. In Weber's words, we may say that theatricality has started to wander. The fundamental disjunction of theatrical painting, or rather its paradox, is played out by Sweerts in masterly fashion through the *exposition* of the dualism of the subject that portraiture encompasses.[30] The young man cannot do otherwise but count on the presence of a spectator to judge the account that he is

giving. But here the paradox dramatically reveals itself. The 'you' he addresses is never there, and yet the completion of his account depends on this 'you'. The disclosure is never going to occur, for there is no option for us to record our response. The young man will always continue to give an account of himself in the continuing present tense of the painting, and as a consequence, the future moment it alludes to will never *take place*, but is ongoing. It is in that sense that the young man is ex-posed, in the sense of dislocation. The open-endedness of Sweerts' portrait yields a philosophical dimension. The closure whose lack is shown by the painting is constitutive of the notion of subjectivity as Descartes describes it. The part of the account that is not 'his' as it is altered by our judgment will never be filled in, but will remain for ever pending. Disorientation and dislocation will thus be a constant in the painting whenever it is viewed. If, as Litvak observed, theatricality owes its value as a critical term to its open-endedness, we could say that this painting's theatricality lies precisely in its provision of clues and its failure to come to a denouement. Whatever need there may be for Sweerts' young man to have a 'you' in order to expound himself as a subject, is dramatically undermined by the medium of painting as such that anticipates yet never requires the audience to be present for the performance of the self to take place.

At the beginning of this chapter I referred to Weber's argument that theatricality occurs at the moment a spectacle is inscribed in a different scene. If theatricality demonstrates its subversive power at the moment it separates itself from theatre and begins to wander, we may say that in Sweerts' painting we can almost see how a kind of theatricality that has started to wander may have come to a temporary halt when it starts to align account and judgment, subject and other, interiority and exteriority, body and mind, and, finally, position and exposition. As such, Sweerts' painting nicely illustrates my argument that theatricality brings out a profound dualism in the body by playing with inside and outside, presence and absence, interior and exterior, and position and exposition. In her essay, 'Giving an Account of Oneself', Judith Butler discusses the irreducibility of exposing one's body in relation to the difference between giving an account of oneself and of giving an account for another. Butler's conclusions are illuminating in the context of the problem of the subject in the picture that we have been discussing here. She claims that the exposure to the irreducible corporeality of the subject structures any account one may give of oneself, but that it cannot itself be given an account of because it is inherently not narratable.[31] I hope to have demonstrated that in order for the sitter's body to be exposed, a portrait relies on means that remain unaccountable and unnarratable in this sense, non-textual elements that ultimately we can call theatrical. Having offered an exposition of the young man's pose in terms that the portrait itself has suggested to us, we may be left wondering if it is Sweerts' sitter who is out of place (ex-posed) or whether it is us, as viewers, who have ultimately been dislocated in our essential inability to accommodate the painting's theatrical request for closure.

Notes

1 The information in this section is based on Guido Jansen and Peter C. Sutton, *Michael Sweerts (1618–1664)*, Zwolle, 2002, especially cat. no. xx, 136–8, and Rolf Kultzen, *Michael Sweerts: Brussels 1618–Goa 1664*, Doornspijk, 1996.
2 John Pope-Hennessy, *The Portrait in the Renaissance*, London, 1966, 208.
3 Jansen and Sutton, *Michael Sweerts*, 136–8.
4 Michael Fried, *Absorption and Theatricality: Painting and Beholder in the Age of Diderot*, Chicago, IL, 1988.
5 Elizabeth Burns, *Theatricality: A Study of Convention in the Theater and in Social Life*, New York, 1972; Judith Butler, *Bodies that Matter*, New York, 1993, and more recently, *Giving an Account of Oneself*, New York, 2005. See, Marvin Carlson, 'The resistance to theatricality', *Substance*, 31:2/3, 2002, 238–50.
6 Jonathan Richardson, *An Essay on the Theory of Painting*, London, 1715, 14.
7 Harry Berger, Jr, *Fictions of the Pose: Rembrandt Against the Italian Renaissance*, Stanford, CA, 2000, 226.
8 Jean-Luc Nancy, 'The look of the portrait', in Simon Sparks, ed., *Multiple Arts: The Muses II*, Stanford, CA, 2006, 220–41.
9 Evidently, using the term subjectivity in a discussion of early modern portraiture is strictly speaking an anachronism. Rooted partly in the Hegelian master–slave dialectic, the terms subject and subjectivity have been further developed in the twentieth century, mainly in psychoanalytical and existentialist discourses. This chapter does not attempt to historicize a notion of the self in portraiture, but to lay bare the theatrical strategies with which a sense of self is performed in pictorial space through a framework of twentieth- and twenty-first-century theory. Therefore, the term subjectivity cannot be avoided. Some (Lacanian) scholars have argued that our notions of subject and subjectivity are intricately tied up with portraiture's history, and that the birth of the subject occurred in tandem with the birth of perspectival oil painting (*tableau*). See for instance Gérard Wajcman, *Fenêtre: Croniques du regard et de l'intime*, Paris, 2004. For a genealogy of the subject in the modern portrait, see Catherine Soussloff, *The Subject in Art: Portraiture and the Birth of the Modern*, Durham, NC and London, 2006, 5–24. For dualism and portraiture, see Joanna Woodall, 'Introduction', in *Portraiture: Facing the Subject*, Manchester, 1997, 1–28. When this article was already in print Ann Jensen Adams' important book came out on *Public Faces and Private Identities in Seventeenth-Century Holland*, Cambridge, 2009, which offers an in-depth analysis of subjectivity on formations of identity in the seventeenth century in the Netherlands.
10 For a substantial discussion of the term theatricality, see Josette Féral, 'Foreword', *Substance*, 31:2/3, 2002, 3–13.
11 Samuel Weber, *Theatricality as Medium*, New York, 2004, 37.
12 Joseph Litvak, *Caught in the Act: Theatricality in the Nineteenth-Century English Novel*, Berkeley, CA, 1992, xii.
13 Alison McNeil Kettering, 'Gerard ter Borch's Portraits for the Deventer Elite', *Simiolus: Netherlands Quarterly for the History of Art*, 27: 1/2, 1999, 46–53.
14 For more details on Ter Borch's paintings, see Arthur K. Wheelock, Jr, *Gerard Ter Borch 1617–1681*, Washington, DC and New Haven, 2004, especially cat. no. 5, 6, 42, 43.
15 Equally strong examples are *Portrait of a Young Man* (1663, London, National Gallery) and *Portrait of a Young Woman* (c. 1663, Cleveland, the Cleveland Museum of Art, The Elisabeth Severance Prentiss Collection), in which the elaborate and luxurious dress of the sitters contrasts with their rather depressed figures lost amidst the chair-and-table set.
16 Gerard de Lairesse, *The Art of Painting*, trans. J. F. Fritsch, London 1778, 278, and quoted in McNeil Kettering, 'Gerard ter Borch', 54. Though the phrase 'portraits in little' usually refers to portrait miniatures, the context of the quotation indicates that de Lairesse means small-scale genre scenes and portraits.
17 Petrus Francius compared speech and body language when he wrote that, 'like pronunciation, all gesturing should be stately and distinguished (*staatelyk en deftig*) without any addition that is either actor-like or affected'. This claim echoes Samuel van Hoogstraten's celebrated expression that painting should look *as if it is painted*. *Inleyding to de hooge schole der schilderkonst, anders de zichtbare werelt*, Rotterdam, 1678, 76. For a substantial discussion of rhetorical gesticulation in the Netherlands, see Herman Roodenberg, *The Eloquence of the Body: Perspectives on Gesture in the Dutch Republic*, Zwolle, 2004, and Jan Bremmer and Herman Roodenberg, eds, *The Cultural History of Gesture: From Antiquity to the Present Day*, Cambridge, 1991.
18 Peter de Bolla, 'The culture of visuality', in *The Education of the Eye: Painting, Landscape, and Architecture in Eighteenth-Century Britain*, Stanford, CA, 2003, 14–71.
19 Joanna Woodall, 'Sovereign bodies: the reality of status in seventeenth-century Dutch portraiture', in Joanna Woodall, ed., *Portraiture: Facing the Subject*, Manchester, 1997, 75–100.
20 As Woodall points out, Rembrandt's work, in particular his portrait of Jan Six, is among the most prominent representations of such an interiorized conception of identity.
21 Woodall, 'Sovereign bodies', 92.
22 Woodall, 'Sovereign bodies', 92. See also, J. L. Price, *Culture and Society in the Dutch Republic during the Seventeenth Century*, London, 1974.
23 Nancy, 'The look of the portrait', 222.
24 In her essay on 'Giving an account of oneself', Judith Butler discusses the irreducibility of exposing this body (one does not have another) in relation to the difference between giving an account of oneself and of giving an account for another. Judith Butler, 'Giving an account of oneself', *Diacritics*, 31:4, winter 2001, 25–6. See also Judith Butler, *Giving an Account of Oneself*, New York, 2005.
25 Previously thought to be a portrait of the Haarlem-based art lover and shell collector Jan Govertsen, it has recently been revealed as a picture of van der Aar. This section is informed by Sam Segal, *A Prosperous Past: The Sumptuous Still Life in the Netherlands 1600–1700*, The Hague, 1988, 77–92.
26 Sam Segal, *A Prosperous Past*, 77.
27 Philibert van Borsselen, *Strande, oft Ghedichte van de schelpen...*, Haarlem, 1614, 42–3. Quoted in English in Sam Segal, *A Prosperous Past*, 78.
28 Van Borsselen, *Strandt*, 8; Segal, *Prosperous Past*, 79.
29 René Descartes, *Discourse on Method and Meditations on First Philosophy*, trans. Donald Cress, Indianapolis, IN, 1999, 3.
30 For a discussion of the relationship between dualism and portraiture, see Woodall's 'Introduction', in *Portraiture*, 1–28.
31 Butler, 'Giving an account', 25–6.

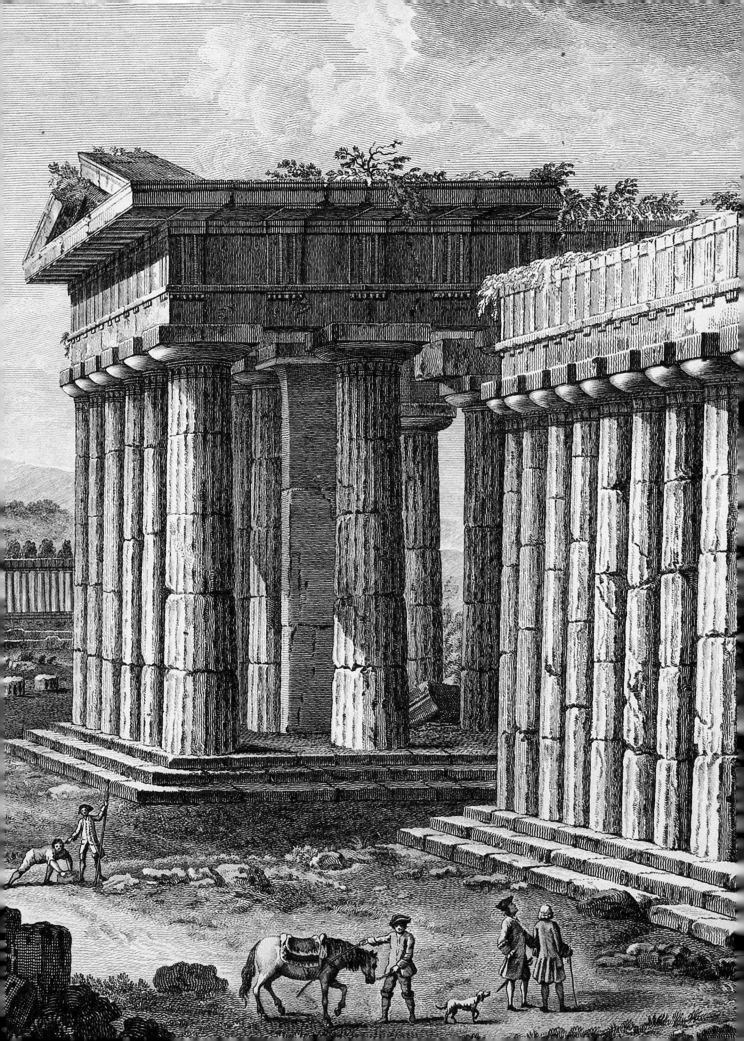

Chapter 10
Staging Ruins:
Paestum and Theatricality
Sigrid de Jong

In the notes for one of his academy lectures, the British architect John Soane (1753–1837) compared the experience of seeing and walking through a building with that of watching a theatre performance:

> The front of a building is like the prologue of a play, it prepares us for what we are to expect. If the outside promises more than we find in the inside, we are disappointed. The plot opens itself in the first act and is carried on through the remainder, through all the mazes of character, convenience of arrangement, elegance and propriety of ornaments, and lastly produces a complete whole in distribution, decoration and construction.[1]

What becomes clear in Soane's thoughts on architecture is that for a building to perform, or to express its character, it needs certain specific elements. In the notes to his lecture quoted here, the impression a building makes on us is indispensably linked to the presence and the movements of the observer, to the stage settings of the architecture, and to the plot through which the spectator experiences it. Soane makes explicit that in architecture there are three elements of utmost importance: the spectator, the screenplay and the stage. And in linking theatre to architecture, he singles out the temporal experience of those two arts, and the impact architecture and theatre can have on the beholder.

The relationship between architecture and theatre, so apparent in Soane's ideas, seems a compelling one. However, despite the publication of a number of studies on the topic, there are few concrete and precise definitions of this relationship.[2] This chapter proposes to make the connection between architecture and theatre more explicit by examining a case where building and theatre are connected very clearly. The Greek temples in Paestum in the south of Italy form an exceptional case because they bring together spectators, screenplays and a stage.[3] These three elements are also exceptionally well documented in numerous publications, drawings and manuscripts.

But there is a more important reason why Paestum is interesting to study in this context: it posed problems to architects. Reading the testimonies of travellers, it is evident that the temples formed something of a conundrum to them. James Adam, for instance, thought that the temples 'don't merit half the time and trouble they have cost me. They are of an early, an inelegant and unenriched Doric, that afford no detail and scarcely produce two good views. So much for Pesto.'[4] John Soane described them as 'exceedingly rude' with no 'elegance and taste'.[5] Charles Dupaty wondered how

Detail from 'A View of the Three Temples taken from the East' [from the south], plate II from Thomas Major, *The Ruins of Paestum otherwise Posidonia* (plate 3).

Theatricality in Early Modern Art and Architecture *Edited by Caroline van Eck and Stijn Bussels* © 2011 Association of Art Historians.

1 'A North View of the City of Paestum taken from under the Gate' [view from the southeast], plate III from Thomas Major, *The Ruins of Paestum otherwise Posidonia*. London: T. Major (printed by James Dixwell), 1768. Photo: © Leiden University, Plano 42 C1.

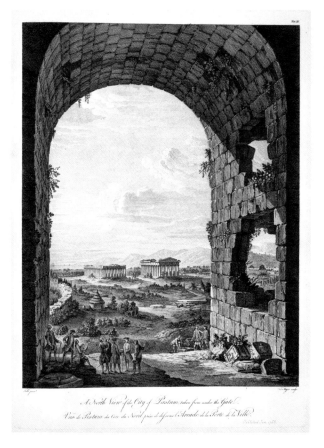

A North View of the City of Paestum taken from under the Gate.
Vue de Paestum du Coté du Nord prise de dessous l'Arcade de la Porte de la Ville.

the Greeks could have built 'columns of so vile a material, of so rough a work, of such a heavy mass, and of so monstrous a form?'[6] Antoine-Laurent-Thomas Vaudoyer thought the architecture 'very heavy and very ponderous, the columns short, very dense, with big capitals, no base'.[7] Goethe wrote about 'these crowded masses of stumpy conical columns', which were 'offensive and even terrifying'.[8] The architecture of the temples was completely uncanonical. With its rough forms and porous material, partly overgrown and surrounded by peasants and cattle, it was very different from the classical architecture that travellers were familiar with through publications and visits to Roman sites. When they finally reached the temples after a dangerous and complicated journey, travellers found they could not take in these monuments in a single view. The three temples were situated in a valley between the mountains and the sea, and could only be observed by walking around and through them.

Because of the peculiarity of Paestum, architects struggled in their accounts to define what they had seen and to represent their experiences in drawings and texts. One solution was to take refuge in a positive portrayal of the site, for despite these negative reactions to the architecture, many travellers hastened to say that they did appreciate the setting of the temples. In fact, that was exactly what made the most intense impression on them. The architect Richard Payne Knight (1751–1824) preferred to keep a distance to appreciate the temples instead of approaching them:

> When one examines the Parts near, they appear rude, massive and heavy; but seen at a proper distance, the general effect is grand, simple and even elegant. The rudeness appears then an artful negligence, and the heaviness a just and noble Stability.[9]

There was also another solution. How could architects express their experiences in words and images in order to make others understand what they saw there? My argument is that by using strategies of representation that had been developed in the theatre or can be associated with it, architects and other travellers presented peculiar Paestum in an accessible way to the eighteenth-century public. In this way in fact they made it less curious, bizarre, and threatening. This strategy had an impact on the monuments and their representations, as Goethe stated in his *Italian Journey*:

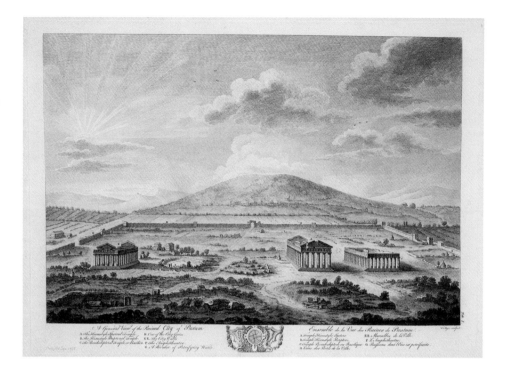

Reproductions give a false impression; architectural designs make them
look more elegant and drawings in perspective more ponderous than they
really are. It is only by walking through them and round them that one can
attune one's life to theirs and experience the emotional effect which the
architect intended.[10]

By taking different viewpoints to observe and experience a building spectators come
to understand it. And as in the theatre, the representation of these experiences takes
into account the way it is viewed. As Roland Barthes expressed it: 'The theatre is
precisely that practice which calculates the place of things as they are observed.'[11]

The Sequence of Experience: Acting and Directing

Often the accounts of eighteenth-century travellers read like a screenplay, with
different stage settings for every part of the experience. The sequence followed in the
descriptions of different travellers is often very similar. The accounts are chronologies
of experience, shaped by eighteenth-century culture, their sequences draw on
eighteenth-century theatre, a storehouse for representational strategies, but were
also formed by the information that was available on the site. Preparing their voyage
beforehand, travellers already had an image of Paestum in their minds, engendered by
the publications, engravings and paintings that were available. In these publications
the sequence of the Paestum experience was created.

The Italian court painter Antonio Joli (1700–77) played a key role in this
dissemination of the image of Paestum among eighteenth-century audiences.[12]
Not only did Joli produce eleven different paintings of Paestum that were widely seen
in Europe; they were also the basis for the majority of the publications on the site that
appeared in this period. Joli was trained as a *vedute* painter, he also worked in the studios
of Paolo Giovanni Panini and Galli Bibiena, and he designed stage sets for theatres. At
the time he painted Paestum he was court painter to Charles of Bourbon in Naples. His
paintings show the *vedute* influence, but most of all his theatrical background. The series

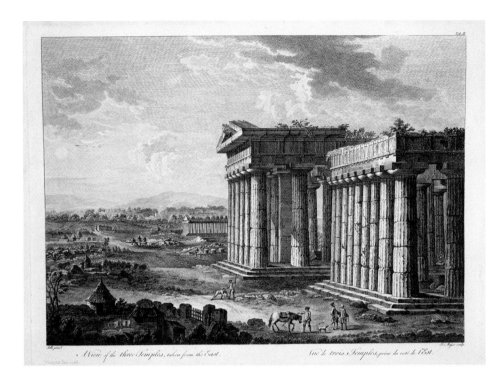

shows an interesting sequence of four different scenes: firstly an opening view through the east gate onto the three temples – in which the third temple is nicely placed in the little opening in the gate wall; secondly, a nearer view, seen from the south-east, of the three temples with the mountains in the background; thirdly a still nearer view from the south along the facades of the three temples, and finally a view of the interior of the Neptune temple. These paintings, and the engravings that were based on them,

3 'A View of the Three Temples taken from the East' [from the south], plate II from Thomas Major, *The Ruins of Paestum otherwise Posidonia*. London: T. Major (printed by James Dixwell), 1768. Photo: © Leiden University, Plano 42 C1.

took eighteenth-century readers by the hand and led them through the several stages of observation through which Paestum could be best experienced.

Eight monographs were published on the temples between 1764 and 1799, and in five of them the paintings of Joli were used to make the engravings.[13] In the other three monographs the engravers often used the same viewpoints as Joli.[14] The engravings made after his paintings were also sold separately, and in this way shaped the image of Paestum to an even larger extent.[15] Thomas Major's (1714–99) publication *The Ruins of Paestum* (1768), for instance, used three pictures from Joli as opening views (*plates 1–3*). In this publication Joli's perspective views were combined with measured drawings of plans, elevations, sections and details. Sir James Gray (c. 1708–73), envoy extraordinary and plenipotentiary in Naples from 1753 until 1764, commissioned two paintings of Paestum by Joli, and served as a cultural agent in the dissemination of the views through his contacts in Italy, France and England.[16] He was present when Joli drew his views, as Major, who obtained the Paestum views through Gray, wrote in the footnotes of his plates.[17] Institutions in Italy like the Académie de France in Rome where foreign artists and architects met and debated provided a fertile soil for the distribution of such publications and plates.[18]

The different perspective views followed the path that was taken by the traveller when he approached the temples: first they offered an overview of the three buildings, then they examined them further from the outside, and finally they entered the temples. In fact, after a long, adventurous, and often dangerous voyage, there were conventionally a few moments when travellers stopped to observe the site. These scenes represent the precise points where they paused to analyse what it was that they saw and what they experienced. In this way the visual representations of these pauses or scenes are simultaneously illustrations of their experiences, and a guide to travellers for observing the site.

In one of his Royal Academy Lectures, John Soane spoke of the importance of pausing when looking properly at architecture. He compared Blenheim Palace to Paestum:

there is a constant variety of outline [in Blenheim] that pleases from whatever point it is viewed (as are viewed ancient temples), whether at a distance wherein the great masses only are made out, or at a nearer approach when the prominent features are distinguished, or still nearer where the general details are distinguished. Here the eye reposes to enjoy the whole picture … In this respect the interest is kept up as in the ancient temples, but this would not be the case if variety of outline and continuity of character were confined to one front only. To keep up the first impression there must be the same character observed in every part externally and internally. This is seen in the great temple [of Neptune] at Paestum. Its interior is of the same character as the exterior.[19]

The advantage of Paestum as opposed to other ancient sites, those in Rome for instance, was that it provided the opportunity for the traveller's eye to contemplate a scene and then to come to rest again at another point, constantly taking another viewpoint, and in this way becoming more interesting to the beholder. Every different view, from afar to nearby, offered a different scene and generated diverse feelings and associations in the viewer's mind. We find a similar sequence of perspective views, representing these moments of repose in Robert Wood's *The Ruins of Palmyra* (1753), which, as Nicolas Savage describes, 're-enacts the drama of first setting eyes on, and then exploring in detail, the huge expanse of the marble ruins of the deserted city'.[20] In the middle of the eighteenth century the publication of topographical views of ancient sites, representing the monuments *in situ*, became an indispensable element in volumes on archaeological travels, and the readers of such volumes were not unfamiliar with the way Paestum was represented. Stuart and Revett, Wood, Le Roy, and Adam all tried to do the same thing in their books: to let the readers retrace their experience.[21] But in the case of Paestum readers were more likely than in the case of many other monuments to go there themselves and actually undergo these same experiences. Readers could not travel to Palmyra after reading Wood's *Ruins*, or to Athens after reading Stuart's *Antiquities*, as easily as they could travel to Paestum after reading Major and other monographs. Once arrived there they could put theory into practice, performing for themselves what they had read about before. The number of people who travelled there, and who had the opportunity to read the volumes and be influenced in their travels, the quantity of publications, and in consequence, the availability of testimonies tracing the detail of reactions to the site is incomparable to any other site. Architects went

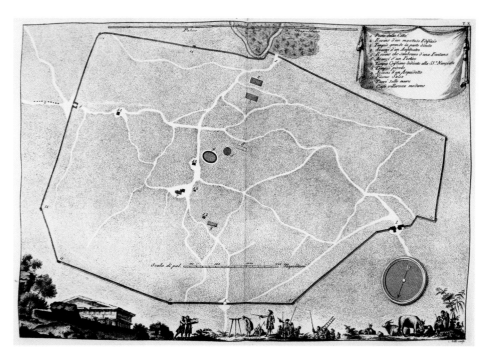

4 'Plan of the site of Paestum', plate **X** from Paolo Antonio Paoli, *Paesti, quod Posidoniam dixere, rudera*. Rome: in typographio Paleariniano, 1784. Photo: © cliché Bibliothèque de l'Institut national d'histoire de l'art (collections Jacques Doucet).

to the temples with the publications in their hands, comparing the monuments to what they had read and seen, as Paolo Paoli pictured them doing in his *Rovine della città di Pesto* (1784)[22] (plate 4).

It was like reading a screenplay and viewing the stage sets before becoming the protagonist in the play. In these different representations of Paestum, the travellers are both directors staging the ruins in images, spectators in viewing these images and the site itself, and actors in experiencing their own voyage.

Architecture as Scenographic Experience

The experience of architecture, and the different feelings it arouses when approaching a building, walking around it and entering it, is a new, and very conspicuous theme in eighteenth-century publications by architects. The French architect Julien-David Le Roy (1724–1803) wrote an interesting passage on this. In his *Ruines des plus beaux monuments de la Grèce* (1758 and 1770) he used more than three pages to describe the experience of observing colonnades, using Claude Perrault's colonnade on the east front of the Louvre (1672) as an example. Le Roy recounted the diverse stages of his approach to the colonnade, 'first from afar, then on approaching, then walking alongside or under it, whether in bright sunlight or on a clouded day'.[23] In this way each scene offered new emotions to the spectator.

In Le Roy's text the role of the spectator as director and actor becomes clear: he himself creates the spectacle he is to view, or he phases his viewing experience as a playwright would build his plot. Le Roy also advises his readers how to observe the colonnade:

> Run your eye along the full extent of the colonnade ... while walking the
> length of the row of houses opposite; stand back to take in the whole;
> then come close enough to discern the richness of its soffit, its niches, its
> medallions; catch the moment when the Sun's rays add the most striking
> effects by picking out certain parts while plunging others in shadow: how
> many enchanting views are supplied by the magnificence of the back wall
> of this colonnade combined in a thousand different ways with the pleasing
> outline of the columns in front of it and with the fall of the light![24]

Le Roy's directions on how we should observe a building recall Aristotle's ideas on plot, vividness and fictionalization in the *Poetics*. The essence of the plot according to Aristotle is its selectiveness. Similarly, Le Roy lets the sun select the architectural elements which have the most vivid effect on the beholder.[25] This brings to mind another theme in Aristotle's *Poetics*, the important role of *enargeia* in making an impression on the viewer.[26] The Greek *enargeia* derived from *argès*, or shining light, and originally meant clearness, distinctness or vividness, putting the spotlight on something. Vivid representation, whether by the use of metaphor in speech, or by the use of colour and light in the visual arts, was one of the main instruments to impress and thereby move the public.[27] Taken together, this combination of selectiveness and highlighting allows us to make explicit the sense in which Le Roy's account is a fictionalization of the experience of looking at the Louvre colonnade. It becomes a narrative, unfolding in time, in which Le Roy asks the reader to walk along the colonnade in a sequence of scenes. He directs and positions the gaze of the beholder, selects what is to be seen, and lets the sun function as a spotlight to single out conspicuous details.

As we come closer, our view alters. The mass of the building as a whole escapes us, but we are compensated by our closeness to the columns; as we change position, we create changes of view that are more striking, more rapid, and more varied. But if we enter beneath the colonnade itself, an entirely new spectacle offers itself to our eyes: every step adds change and variety to the relation between the positions of the columns and the scene outside the colonnade, whether this be a landscape, or the picturesque disposition of the houses of a city, or the magnificence of an interior.[28]

The way in which Le Roy describes his observations anticipates the treatise *Le Génie de l'Architecture ou l'analogie de cet art avec nos sensations* (1780) by the French architect Nicolas Le Camus de Mézières (1721–c. 1793), who offered a theory to account for the ways in which experiencing architecture can arouse different emotions. In this study Le Camus de Mézières used theatre as an analogy for architecture. He considered the experience of buildings as akin to the dramatic structure of a play, in which for instance walking through a sequence of spaces in a house was an experience similar to that of viewing a succession of stage sets during a theatrical performance:

Each room must have its own particular character. The analogy, the relation of proportions, decides our sensations; each room makes us want the next; and this engages our minds and holds them in suspense. It is a satisfaction in itself.[29]

Le Camus de Mézières speaks in his introduction about the relation between architecture and stage decorations, which are a perfect example of what he called the 'threefold magic' of painting, sculpture and architecture, 'which addresses almost all the affections and sensations known to us'. Then, in the part entitled 'The Genius of Architecture', he makes the link between the characteristic qualities of well-designed architecture and the effects of the theatre:

The grand ensemble alone can draw and hold the attention; it alone can engage both the soul and the eye. The first glimpse must hold us spellbound; the details, the masses of the decoration, the profiles, the play of light, all conduce to this same end. Large divisions, purity of profiles, a play of light that is neither too bright nor too sombre, grand openings, and great harmony will proclaim the grandeur and magnificence to come.[30]

In drawing a comparison between the expressiveness of architecture and the evocation of emotion in theatre by changes in scenery, Le Camus de Mézières emphasizes the importance of the beholder and the different stages of his experience.

The Landscape as Scenery
In Le Camus de Mézières' emphasis on the first impression when viewing a play or a building, we can find the same elements that travellers to Paestum mentioned. For instance, when Richard Payne Knight describes the temples in his travel diary he says:

The first appearance of them is exceedingly striking – the three temples, which are tolerably well preserved, rise one beyond the other in the midst of a rich and beautiful vale, surrounded by romantic Hills, covered with flowering Shrubs and Herbs.[31] The importance of this first scene, and the first impression of the ruins situated in the scenery of the southern Italian landscape, is re-enacted in the accounts of many visitors to the site. The French architect Antoine-Laurent-Thomas Vaudoyer (1756–1846) also appreciated the visual effect from a distance and deliberately chose a viewpoint from afar to observe this scene:

> This town is situated half a mile from the seaside, and at the foot of a chain of beautiful mountains. What gives a very beautiful viewpoint when one goes back enough to enjoy a glance over the three monuments, there is nothing like climbing on the top of the tower by the seaside, facing the grand temple.[32]

This scene seen from afar, so well captured in Joli's paintings, reappeared in publications on the site. One of the printmakers who made engravings after Joli's paintings was Filippo Morghen (1730–1807). He published the opening scene in his *Vedute della città di Paestum*, and copied three other engravings in the same work from Joli's images as well. Working at the Neapolitan court of Charles of Bourbon, Morghen was responsible for many publications on archaeological sites in the Kingdom of the Two Sicilies, meant to disseminate images of the Kingdom. Two years later Thomas Major, who never went to Paestum but bought numerous drawings from architects like Jacques-Germain Soufflot (1713–80) and from Italian artists and used them for his engravings, also published an engraved version of Joli's opening scene.[33] The French architect Gabriel-Pierre-Marie Dumont (1720–90) who, in 1750, was with Soufflot the first foreign architect to visit the site after its rediscovery, published the same view in 1769.

The second scene that confronted visitors during their Paestum experience was captured by Dominique Vivant Denon (1747–1825), who viewed the temples in 1778: 'We entered through the north [gate], and caught sight of the three large temples, arranged side by side, which divide slightly diagonally the whole width of the city.'[34] The temples that flanked each other were a popular viewpoint, also first captured by Joli. And the same view was again copied by, for example, Morghen, Major and Jean Barbault (1718–62).[35]

It is noteworthy that the same sequence that the images follow in these publications appears in the written representations of travels to Paestum. For instance Charles Dupaty (1744–88), a French lawyer who published *Lettres sur l'Italie* in 1788, unfolds the dramatic succession of scenes before our eyes in this way:

> I proceed across desert fields, along a frightful road, far from all human traces, at the foot of rugged mountains, on shores where there is nothing but the sea; and suddenly I behold a temple, then a second, then a third: I make my way through grass and weeds, I mount on the socle of a column, or on the ruins of a pediment: a cloud of ravens take their flight; cows low in the bottom of a sanctuary; the adder, basking between the column and the weeds, hisses and makes his escape; a young shepherd, however, carelessly leaning on an ancient cornice, stands serenading with his reedy pipe the vast silence of this desert.[36]

The way in which Dupaty poetically described the different scenes of his experience makes him partly a spectator, especially when from a pediment he perceives the animals and the shepherd among the ruins; but he also becomes a participant in the experience he directs. By walking through the deserted landscape, enclosed by mountains and sea, generating the sight of the three temples, one after another, and anxiously continuing to observe the ruins, he effectively creates his own sequence of experience. The French architect Claude Mathieu Delagardette (1762–1805) looked at the setting of the temples as if it were a stage set as well, and wrote in his monograph on Paestum:

> And to tell the truth what an impressive scene for an artist observer it is to see on the sea shore, an immense and arid space, enclosed by walls, covered by columns and majestic monuments, where under a beautiful sky that no cloud darkens, reigns the most absolute silence; having no other inhabitants around him except his travel companions, some peasants busy grazing their buffaloes, or stones and snakes.[37]

In his introduction to the monograph *Ruines de Pæstum*, he presented the next scene:

> Deeply moved, I was in a sort of delirium, in the prospect of the extraordinary scene that took place in front of me. But looking at each of the monuments in particular, I believed I perceived the sublime genius that had presided over the creation of these masterpieces, and the profound knowledge that executed them.[38]

In this way he paused twice to observe the scene before his eyes: the setting of the temples in the Italian landscape, and the temples themselves. But although Delagardette speaks in the introduction in a poetic way about his Paestum experiences, these lyrical accounts of experience are not continued in the rest of his publication. This is merely an analysis of the architecture, aiming to prove that he is the first to examine and measure the temples in a thorough way. His second plate shows the temples from afar, a reminder of the way Joli pictured them. However, there is an important difference. With Delagardette people are no longer pictured among the ruins. He depicts the ruins alone in the landscape, or as part of an architectural analysis of the temples, with facade, section, plan and details. That marks the moment when Paestum is canonized and becomes part of the norm of classical architecture. The specificity of the place, and the experience, is reduced to pictures of Paestum's baseless Doric order.

In Delagardette's drawings we cannot find anything of the 'deeply moved' feelings he described in his introduction. He remains rather distant. The monuments are not personal anymore, as they are with Piranesi, as we will see shortly, but become objective and like any other ancient monument. The theatricality that was used to present the temples to the novice eighteenth-century reader was not necessary anymore, the baseless Doric order had become part of a vocabulary familiar to everyone. But the abstraction in a canonization of Paestum had moved away from the Paestum that we saw in the descriptions of Dupaty and Goethe and that we will see in Piranesi's etchings.

The Ruins as a Stage

Paolo Antonio Paoli (1720-1790) alludes to the next scene after the perspective view from a distance and the view of the ruins closer by, in his monograph on

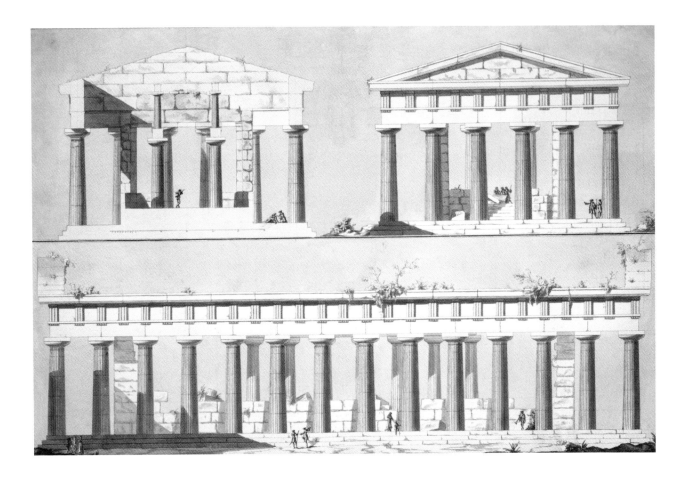

Paestum. This is the view of the temples individually and being entered.[39]
Paoli presents the temples on the same page with a plan of the site, several visitors
hurrying with ladders to reach the monuments and measure them, and others
comparing the temples with publications (*plate* 4). In this attempt to stage the
gaze of the architectural connoisseur by picturing people measuring the ruins
and reviewing the temples *in situ* while comparing them to their representations
in plates, Paoli reinforced his argument, in the accompanying text, that careful
examination would prove that the temples were actually Etruscan, and thus
Italian and not Greek in origin. But beyond that, because Paestum was strange and
unfamiliar it was necessary to place figures among the ruins so that eighteenth-
century readers or visitors were able to identify with people that looked just like
them, dressed like them, busy measuring the temples. In this way the readers could
assume the role of the tourist and connoisseur, and the temples were made a subject
fit for eighteenth-century discourse.

Vincenzo Brenna (1747-1820), an Italian architect who was hired to draw
the temples in 1768 by Charles Townley, the British connoisseur and one of the
founders of the British Museum, pictured this scene as well, showing the temples
as if they were a stage set.[40] Brenna's drawings are an interesting combination of
the familiar perspective views with the grand-tourists as actors, and an architectural
presentation (*plate* 5). The gesturing figures in the drawings are reminiscent of the
typical characters in engravings by Piranesi. But when Piranesi actually pictured
Paestum he did it in a radically different way. Piranesi made some strikingly
impressive drawings, fifteen of which were bought by Soane.[41] In twenty *vedute*
he presented his vision of the site. While most publications – such as those by

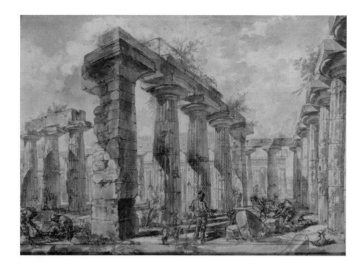

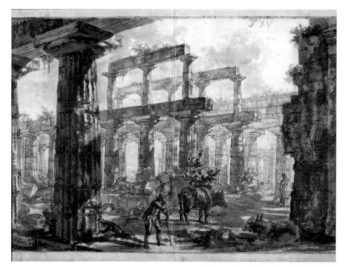

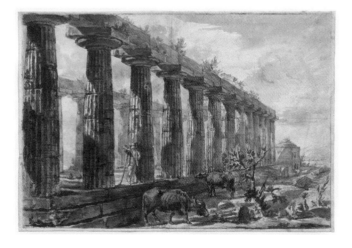

Dumont, Morghen, Longfield and Major (see *plate* 3 for example) – try to bring the monuments to the reader by depicting them like Roman architecture without entasis and surrounded with either historical figures or contemporary travellers, Piranesi is the only one to picture them realistically, with their entasis and their porous limestone overgrown with vegetation, and surrounded by local people and animals (*plate* 6). And while in all the publications the figures among the ruins had been either fictional characters with an historical touch to them or travellers busy measuring, analysing, and discussing the temples, only Piranesi depicts just the local people, farmers and cattle strolling around the ruins. He alone represents the actual situation, without any historical reference. In doing so he probably wanted to emphasize the Italian origin of the temples as well, a source of debate in the second half of the eighteenth century. But he also pictures the decline of ruins. He eliminated the eighteenth-century conventions, and robbed them of their usefulness for contemporary architectural design, because it no longer offers the information needed for design (*plate* 7).

All the monographs on Paestum mentioned above have the identical structure of an opening scene with a bird's eye view or a perspective of the three temples in the landscape with mountains in the background. Readers are then taken to the next scene where they approach the temples, walk around them, and enter them to take a closer look. The spectator can identify easily with the travellers depicted. This is not the case in the etchings by Piranesi, who drew local people living and working amongst the ruins. In some drawings he almost seems to give more attention to the cattle than the buildings. The temples seem to become a mere backdrop to the simple life of farmers who happen to be living around some structures in stone (*plate* 8). It is here that we start to comprehend how these ruins functioned for many centuries. They were simply part of familiar surroundings and nobody paid any real attention to them. Only when architects became interested in rediscovering classical architecture and its ancient origins, did the ruins begin to be explored. Piranesi's etchings eventually make explicit what the eighteenth-century visitors actually knew but did not express before: Greek architecture had very little to do with the Renaissance version of classical architecture, and as such could not serve as a timeless model of design.[42]

9 Plates I to **XX** of G.
B. Piranesi, *Différentes
Vues [...] de Pesto*, Rome,
1778. (Plates are to be
read horizontally over
two pages).© Collection
University Library Ghent
BHSL.RES.ACC.024064/15.

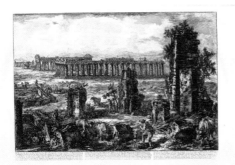
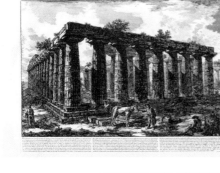
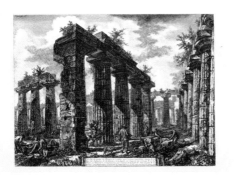
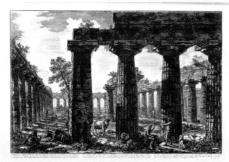
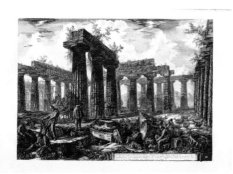
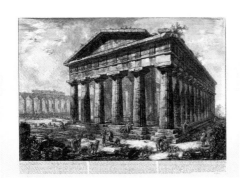
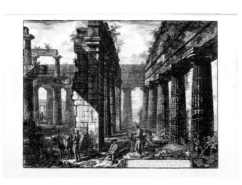
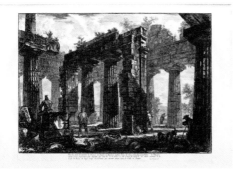
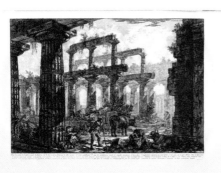
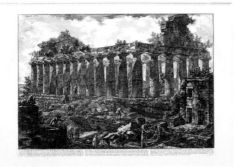

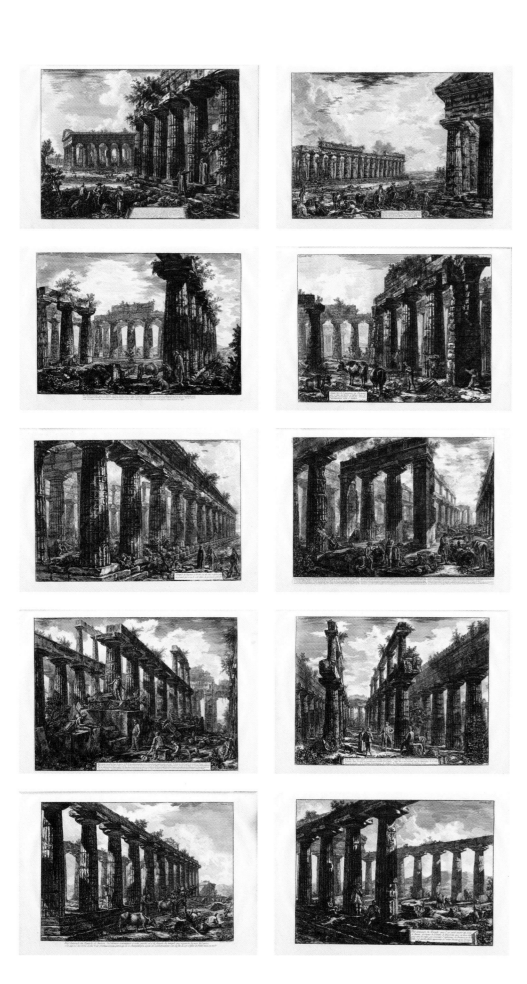

Theatricality as Means of Plotting an Architectural Experience

The plot of the experience of Paestum is twofold, or rather has two different scenarios and these extremes define the position of Paestum. Travellers to the site had to deal with the strangeness of the architecture they saw. In order to make sense of the temples they represented their often contradictory experiences in images or texts using theatrical features. Sequences of experiences available in representations of the temples guided them, the landscape surrounding the temples functioned as scenery and the ruins provided a stage.

On this stage an experience in three steps unfolded, and these three steps clearly connect architecture to theatre. First, the building itself can provide a certain experience by the conscious use of certain elements. It stages the gaze of the beholder, as Soane stated in one of his academy lectures, because it endows a building with character. In this way, organizing the spectator's perception of the building, the architecture functions as a stage. Second, the experience of such a building can follow the intentions of the architect, but through selection the viewer can also recreate the building as a sequence of emotions or scenes. Le Roy's account of seeing the Louvre colonnade, and Knight's and Vaudoyer's accounts of Paestum illustrate this. Third, the representation of this experience can have three different results. It can follow a sequence (as it did with Joli, Major, Morghen and Dupaty) by selecting views and presenting the different stages of experiencing architecture. It can express the wandering eye rather than a clear sequence (as in Goethe's written and Piranesi's visual account) and in that way create another, more personal, experience. But the representation can, finally, also ignore the experience by transforming it into an abstraction, conceived by the measuring architect in search of an order, and considered in relation to its applicability to contemporary architecture, as Delagardette showed.

In all these outcomes spectators play their part; their role may even be said to define the outcome. In the publication by Delagardette the spectator is a measuring architect, in Joli's paintings he is an erudite connoisseur, whereas in Piranesi's publication the spectator is endowed with a mood. Knowledge of architecture is not important in this experience. But these different representations of an architectural experience, and the different stages, from architecture to experience to representation of an experience, show the active role of the spectator as well, and this tells us something more about the relationship between architecture and theatre in general. In viewing architecture, the spectator is not merely an observer or a witness. In architecture, unlike the other arts, one can step in and become an actor as well. When eighteenth-century architects saw the paintings and engravings of Paestum and read the publications about the site, their experience did not end. Unlike viewing a painting or a sculpture, viewing a representation of architecture could be enhanced by the experience of actually approaching and entering the building. They could travel to Italy and when they did so, in a way they entered the engraving or painting. They could compare their own experience *in situ* to earlier experiences they had seen depicted, as Paoli showed. When looking at the engravings of Paestum and experiencing the effect of the offered identification with one of the characters depicted, one can imagine that the urge to live the exploration of the site oneself was forceful. As Denis Diderot (1713–84) put it: 'The performance had been so true that on many occasions, forgetting that I was a spectator, and an ignored spectator for that matter, I had been on the verge of coming out of hiding to add a real character to the scene.'[43] In commenting upon one of Hubert Robert's paintings of ruins in the Salon of 1767 he wrote, 'I would

never have been able to restrain myself from dreaming under that vault, from sitting between those columns, from entering your painting'.[44] The invisible fourth wall that Diderot described, marking the boundary between fiction and reality, that eighteenth-century viewers experienced when they looked at the engravings in their armchair, was smashed to pieces when they entered the site themselves and became actors in their own play, experiencing the architecture instead of being mere spectators.

Finally, in living the experience, another crucial analogy between architecture and theatre comes to the fore: that of temporality. Just as in watching a play, the narrative structure of visiting the ruins was created by a temporal experience of successive scenes. Although Joli and Piranesi did not present the same sequence of scenes, both offered a narrative framework to bring Paestum to the eighteenth-century reader, and showed the temporary experience of visiting the site. Moreover, Piranesi revealed something else as well. In viewing the sequence Piranesi presented in his etchings, it becomes clear that to him the experience of wandering around and in the temples was important (*plate 9*). Here the reader wanders through a forest of columns, continually encountering yet another perspective influenced by the rays of the sun. But Piranesi also presents the vulnerability and decay of architecture, and as such the element of time is expressed in his drawings. By emphasizing the decline and fall of ruins he also illustrated the temporary nature of all architecture. He demonstrated that Paestum could not serve as a timeless model for design. This was the complete opposite of Delagardette's vision of Paestum and his quest for architectural elements useful to the architects of his day. Not only did Delagardette close his eyes to the temporality of the buildings and the visitor's experience of them, in his abstraction he also ignored the specificity of Paestum. In his account the role of the spectator is diminished, whereas in the visualization of Piranesi the spectator is essential. He is drawn into the engraving and comes to realize eventually that in a sense architectural knowledge does not help us to understand Paestum. The experience at the site is vital.

Notes

1 David Watkin, *Sir John Soane: Enlightenment Thought and The Royal Academy Lectures*, Cambridge and New York, 1996, 188. Manuscript in Sir John Soane's Museum Library, London: Ms Lecture V: AL Soane Case 156.

2 Most publications on theatre and architecture concentrate on buildings, for instance by Daniel Rabreau, 'The theatre-monument: a century of "French" typology, 1750–1850', *Zodiac*, 2, September 1989, 44–69; Daniel Rabreau, *Le Théâtre de l'Odéon*, Paris, 2007; *Victor Louis et le théâtre*, Paris, 1982; Briant Hamor Lee, *European Post-Baroque Neoclassical Theatre Architecture*, Lewiston, NY, 1996; Louise Pelletier's *Architecture in Words: Theatre, Language and the Sensuous Space of Architecture*, London, 2006, is the interesting exception.

3 Because of the traditional focus of architectural history on design and buildings, the travels of architects to Paestum have often been studied only from the viewpoint of subsequent applications of the baseless Doric order in architecture. In this way the diversity of experiences at the site and their subsequent implications have been overlooked. E.g. Joselita Raspi Serra, *La Fortuna di Paestum e la Memoria Moderna del Dorico*, Florence, 1986; Joselita Raspi Serra, *Paestum and the Doric Revival 1750–1830*, Florence, 1986; John Mordaunt Crook, *The Greek Revival: Neo-Classical Attitudes in British Architecture 1760–1870*, London, 1972; Robin Middleton and David Watkin, *Neo-Classical and 19th Century Architecture*, London, 1980; Joseph Rykwert, *The First Moderns: The Architects of the Eighteenth Century*, Cambridge, MA, 1980.

4 James Adam in a letter written on 21 November 1761, cited in John Fleming, *Robert Adam and his circle in Edinburgh & Rome*, London, 1962, 293.

5 John Soane, Sketchbook, entitled 'Italian Sketches/J. Soane/1779', Sir John Soane's Museum London, Vol. 39, 32–4.

6 'Comment donc des Sybarites on-ils imaginé et mis debout des colonnes d'un nombre si prodigieux, d'une matière si vile, d'un travail si brut, d'une masse si lourde et d'une forme si monotone?' Charles Dupaty, *Lettres sur l'Italie en 1785*, Paris, 1788, 196.

7 'd'un caractère très lourd et très pesant; les colonnes sont courtes, très serrées, de gros chapiteaux, pas de base'. Antoine Laurent Thomas Vaudoyer, travel diary entitled 'Voyage de Rome à Paestum', 1787, 123 (Private collection, Paris).

8 'diese stumpfen, kegelförmigen, enggedrängten Säulenmassen lästig, ja furchtbar erscheinen.' Johann Wolfgang von Goethe, *Italienische Reise* (1787), München, 1988, 205; English translation W. H. Auden and E. Mayer, *Italian Journey*, London, 1970, 218.

9 Richard Payne Knight in his travel diary, published in Claudia Stumpf, ed., *Richard Payne Knight: Expedition into Sicily*, London, 1986, 15. Manuscript in Goethe-Schiller Archiv, Weimar.

10 'Denn im architektonischen Aufriß erscheinen sie eleganter, in perspektivischer Darstellung plumper, als sie sind, nur wenn man sich um sie her, durch sie durch bewegt, teilt man ihnen das eigentliche Leben mit; man fühlt es wieder aus ihnen heraus, welches der Baumeister beabsichtigte, ja hineinschuf.' Goethe, *Italienische Reise*, 206.

11 Roland Barthes, 'Diderot, Brecht, Eisenstein', in Stephen Heath, ed., *Image, Music, Text*, New York, 1977, 69: 'The theatre is precisely that practice which calculates the place of things *as they are observed*: if I set the spectacle here, the spectator will see this; if I put it elsewhere, he will not, and I can avail myself of this masking effect and play on the illusion it provides. The stage is the line which stands across the path of the optic pencil, tracing at once the point at which it is brought to a stop and, as it were, the threshold of its ramification. Thus is founded – against music

(against the text) – *representation*.'

12 For Joli see: Ralph Toledano, *Antonio Joli. Modena 1700–1777 Napoli*, Turin, 2006. See also: Mario Manzelli, *Antonio Joli. Opera pittorica*, Venice, 2000; Roberto Middione, *Antonio Joli*, Soncino, 1995. The entire Paestum series by Joli is published in Toledano, *Antonio Joli*, 390–401.

13 Gabriel-Pierre-Martin Dumont, *Suites de Plans (...) de Pesto*, Paris, 1764; Filippo Morghen, *Sei vedute delle rovine di Pesto*, Naples, 1765; [John Longfield], *The Ruins of Poestum or Posidonia*, 1767; Thomas Major, *The Ruins of Paestum*, Naples, 1768; Gabriel-Pierre-Martin Dumont, *Les vues (...) de Poestum*, Paris, 1769. For other travel accounts Joli's paintings were used as well, for example in Joseph Jérôme de Lalande, *Voyage d'un Français en Italie*, Paris, 1769; Jean Barbault, *Receuil de divers monuments (...)*, Rome, 1770.

14 Giovanni Battista Piranesi, *Différentes vues de quelques restes de trois grands édifices qui subsistent encore dans le milieu de l'ancienne ville de Pesto*, Rome, 1778; Paulantonio Paoli, *Rovine della città di Pesto detta ancora Posidonia*, Rome, 1784; Claude-Mathieu Delagardette, *Les Ruines de Paestum ou Posidonia*, Paris, 1799.

15 Eleven pictures by Joli (see Toledano, *Antonio Joli*, 390–401): (1) Perspective view three temples from the southeast (3 variants) (private collection), 390–3; (2) Bird's eye view perspective three temples from the west (2 variants) (Norton Simon Art Foundation Pasadena California and private collection), 394–5; (3) Perspective facades seen from the south (private collection, former Gray collection), 396; (4) Perspective view through the gate from the east (2 variants) (private collection, one former Gray collection), 398–9; (5) Perspective Neptune temple from the west (private collection), 401; (6) Interior perspective Neptune temple from the southwest (Palazzo Reale Caserta), 400; (7) Interior perspective Neptune temple from the east, 397. Morghen (1765) published 2, 3, 5 and 6; Longfield (1767) 2, 3 and 5; Lalande (1767) 2; Major (1768) 2, 3 and 4; Dumont (1769) 2; Barbault (1770) 2, 3, 5 and 7, and Paoli (1784) 1.

16 Another cultural agent in Naples was Felice Gazzola (1698–1780), officer at the Neapolitan court, one of the first visitors to Paestum, after its rediscovery in 1740. The drawings made on his request at the time by Gian Battista Natali and Gaetano Magri were shown to Soufflot before his visit to Paestum in 1750, and were used in Major's and Paoli's publication. See Paoli, *Rovine*, 4–7; Suzanne Lang, 'The early publications of the temples at Paestum', *Journal of the Warburg and Courtauld Institutes*, 13, 1950, 48–64; Michael McCarthy, 'New light on Thomas Major's "Paestum" and later English drawings of Paestum', in Serra, *Paestum*, 47–50.

17 'This view was taken in Presence of his Excellency Sir James Gray, and engraved from a fine Painting in the Collection of Major General Gray.' Major, *The Ruins*, 43 (referring to plates II and III). For Gray: John Ingamells, *A Dictionary of British and Irish Travellers in Italy 1701–1800*, New Haven and London, 1997, 424. See Toledano, *Antonio Joli*, 396, 398.

18 See for example Janine Barrier, *Les architectes européens à Rome*, Paris, 2005.

19 As quoted in Watkin, *Sir John Soane*, 372–3.

20 Nicolas Savage, 'Shadow, shading and outline in architectural engraving from Fréart to Letarouilly', in Caroline van Eck and Edward Winters, eds, *Dealing with the Visual: Art History, Aesthetics and Visual Culture*, Aldershot and Burlington, VT, 2005, 248.

21 James Stuart and Nicolas Revett, *The Antiquities of Athens*, London, 1762–1816; Robert Wood, *The Ruins of Palmyra*, London, 1753; Robert Wood, *The Ruins of Balbec*, London, 1757; Julien-David Le Roy, *Les Ruines des plus beaux monuments de la Grèce*, Paris, 1758/1770; Robert Adam, *Ruins of the Palace of the Emperor Diocletian at Spalatro*, London, 1764.

22 Paoli, *Rovine*, first plate.

23 Robin Middleton in Julien-David Le Roy, *The Ruins of the Most Beautiful Monuments of Greece*, trans. David Britt, introduction Robin Middleton, Los Angeles, CA, 2004, 103–4.

24 Le Roy, *The Ruins*, 372.

25 Aristotle, *Poetics*, 1450a–1451a: 'the plot, by which I mean the ordering of the particular actions', in D. A. Russell and M. Winterbottom, eds, *Ancient Literary Criticism: The Principal Texts in New Translations*, Oxford, 1972, 97–101.

26 Aristotle, *Poetics*, 1411b24 ff.

27 See on the parallels of looking at a building and watching a play: Caroline van Eck, *Classical Rhetoric and the Visual Arts in Early Modern Europe*, Cambridge, 2007, 127–34.

28 'Lorsque nous nous en approchons, un spectacle different nous affecte; l'ensemble de la masse nous échappe, mais la proximité où nous

sommes des colonnes nous en dédommage; et les changements de lieu, sont plus frappans, plus rapides et plus varies. Mais si le spectateur entre sous le peristyle même, un spectacle tout nouveau s'offre à ses regards, à chaque pas qu'il fait, la situation des colonnes avec les objets qu'il découvre en dehors du peristyle varie, soit que ce qu'il découvre soit un paisage, ou la disposition pitoresque des maisons d'une ville, ou la magnificence d'un intérieur.' Le Roy, *The Ruins*, 372.

29 'Chaque piece doit avoir son caractere particulier. L'analogie, le rapport des proportions decident nos sensations; une piece fait désirer l'autre, cette agitation occupe & tient en suspens les esprits, c'est un genre de jouissance qui satisfait'. Nicolas Le Camus de Mézières, *Le génie de l'architecture, ou L'analogie de cet art avec nos sensations*, Paris, 1780, 45; English translation: *The Genius of Architecture; or, the Analogy of that Art with our Sensations*, trans. David Britt, introduction Robin Middleton, Santa Monica, CA, 1992, 88. See also Pelletier, *Architecture in Words*.

30 'C'est par le grand ensemble qu'on attire & que l'on fixe l'attention; c'est lui seul qui peut intéresser tout à la fois & l'ame & les yeux. Le premier coup d'œil doit nous frapper, il enchaîne" ne nos sens; les détails, les masses de la décoration, les profils, les jours conduisent à ce but. Les grandes parties, la pureté des profils, des jours ni trop vifs ni trop sombres, de beaux percés, les masses bien cadencées, beaucoup d'harmonie annoncent la grandeur & la magnificence.' Le Camus de Mézières, *Le génie de l'architecture*, 64; English: Le Camus de Mézières, *The Genius of Architecture*, 96.

31 Richard Payne Knight, 'Expedition into Sicily', 1777, 2, published in Stumpf, *Richard Payne Knight*, 28.

32 'Cette ville est située à un demi mille du bord de la mer, et adossée à une chaîne de belles montagnes. Ce qui fait un très bel aspect quand on se recule assez pour jouir d'un coup d'œil des trois monuments, rien n'est tel que de monter au haut de la tour sur le bord de la mer, en face le grand Temple.' A.L.T. Vaudoyer, travel diary entitled *Voyage de Rome à Poestum et tout le Royaume de Naples*, 1787 (Private collection Paris), 123.

33 The collection of drawings Major bought is now in the Sir John Soane's Museum in London, together with his publication. Soane obtained the whole set in 1800. Library Sir John Soane's Museum, Vol. 27.

34 'Nous entrâmes par celle du nord, et aperçûmes les trois grands temples rangés en flanc, qui partagent un peu obliquement toute la largeur de la ville.' Dominique Vivant Denon, *Voyage au royaume de Naples*, (1778), Paris, 1997, 288–9.

35 Morghen, *Sei vedute*, plate III; Longfield, *The Ruins*, plate IV ; Major, *The Ruins*, plate II; Barbault, *Recueil*, plate 7.

36 'J'avance à travers des campagnes désertes, dans un chemin affreux, loin de toutes traces humaines, au pied de montagnes décharnées, sur des rivages où la mer est seule; et tout-à-coup, voilà un temple, en voilà deux, en voilà trois: j'approche à travers les herbes, je monte sur le socle d'une colonne ou sur les débris d'un fronton; une nuée de corbeaux prend son vol: des vaches mugissent dans le fond d'un sanctuaire: la couleuvre, entre les colonnes et les ronces, siffle et s'échappe: cependant, un jeune pâtre, appuyé nonchalamment sur une corniche, remplit, des sons d'un chalumeau, le vaste silence de ce désert.' Dupaty, *Lettres sur l'Italie*, 198.

37 'Et à la vérité quelle scène imposante pour un Artiste observateur, que celle de voir sur les rivages de la mer, un espace immense et aride, entouré de murailles, couvert de colonnes et de monuments majestueux, où sous un beau ciel qu'aucun nuage n'obscurcit, regne le silence le plus absolu: n'ayant d'autres habitants autour de lui que ces compagnons de voyage, que quelques rustres occupés à faire paître des buffles, que des pierres et des serpents.' Delagardette, *Les Ruines*, 3.

38 'Vivement ému, j'étais dans une sorte de délire, à l'aspect du tableau extraordinaire qui se déroulait devant moi. Mais portant mes regards sur chacun des monuments en particulier, je crus appercevoir [sic] ce génie sublime qui avait présidé à l'invention de ces chef d'œuvres, et le savoir profond qui avait conduit leur exécution.' Delagardette, *Les Ruines*, 3–4.

39 Paoli, *Rovine*, plate X.

40 The drawings by Brenna are in the collection of the Victoria & Albert Museum, London. For Paestum: VI 1–31, 8478 13–17. For Brenna see: Gerard Vaughan, ' "Vincenzo Brenna Romanus: Architectus et Pictor" Drawing from the Antique in late eighteenth-century Rome', *Apollo*, 144: 416, October 1996, 37–41.

41 Sir John Soane's Museum, London (P 51, 54, 69–72, 74–77, 125,

133, 139–140, 146). Two others ended up in the collection of the Bibliothèque Nationale de France in Paris and of the Rijksmuseum in Amsterdam. Piranesi, *Différentes vues*. Piranesi died during the engraving process and his son finished the work.

42 The publications by Stuart and Revett and by Le Roy on Greek architecture offered a mixture of archaeological account, architectural theory and travelogue of Greece; design instructions based on Greek architecture were not yet an independent category.

43 'La représentation en avait été si vraie, qu'oubliant en plusieurs endroits que j'étais spectateur, et spectateur ignoré, j'avais été sur le point de sortir de ma place, et d'ajouter un personnage réel à la scène.' Denis Diderot, *Oeuvres esthétiques*, ed. Paul Vernière, Paris, 1994, 78.

44 'Je n'aurais jamais pu me défendre d'aller rêver sous cette voûte, de m'asseoir entre ces colonnes, d'entrer dans votre tableau.' Denis Diderot, *Salons*, ed. Michel Delon, Paris, 2008, 364.

Chapter 11
Oprar sempre come in teatro:
The Rome of Alexander VII as the Theatre of Papal Self-Representation

Maarten Delbeke

Between the years 1665 and 1669 the engraver Giambattista Falda, together with Giovanni Giacomo de'Rossi, published three volumes of the *Novo teatro delle fabriche ... [di] Roma* (plate 1).[1] The first two volumes in particular document the building activity of Pope Alexander VII Chigi (1655–67), which is in no small measure responsible for the appearance of Rome to this day. Alexander's interventions are scattered across the entire area of the city, and Falda's engravings provide clear and open views of the streets, *piazze*, churches and *palazzi* that were built, finished, or modified during his reign.

The strategy of collecting the different collections of views or *vedute* under the title *Nuovo teatro* fits the volume into several traditions. From the sixteenth century onwards, books and manuals presented themselves as *teatri*, well-arranged displays of knowledge, objects or actions, and read along those lines, Falda's *Nuovo teatro* presents on orderly overview of all there is to see in Rome. The use of the adjective 'nuovo' recalls the conventional division between *Roma antica* and *Roma moderna*, and Falda's dedications to Mario Chigi, Alexander's brother, stress how the Pope returned the city to its ancient luster. Thus, the 'new theatre' of Alexander's achievements complements a virtual 'teatro antico' of ancient buildings.

The title of Falda and de'Rossi's publication also invites a transfer of meaning. The engraver liberates buildings from their surroundings, enlarges, widens and heightens spaces while stressing their focal points such as altars or obelisks, or combines multiple vanishing points to insert accurate depictions of façades into a vast setting (plate 2).[2] Alexander's Rome itself is built, it seems, as a 'nuovo teatro', consisting of buildings and spaces prone to arranging and displaying people and events to the best effect, an intention illustrated by the frequent use of the word *teatro* in reference to St Peter's Square. Falda's and de'Rossi's ambition to collect and display valuable and noteworthy objects – Alexander's interventions – is reflected in those objects themselves.

The theatricality of Baroque, and particularly Alexander's, Rome has become all but identified with the qualities that Falda has so successfully emphasized in these buildings. But how does this theatricality relate to the way these buildings were intended and understood? Is there a connection between spatial and formal characteristics of architecture that are termed 'theatrical', and the possible meaning of buildings? Richard Krautheimer's classic *The Rome of Alexander VII* of 1985 sees Alexander's preoccupation with architecture and urbanism as a compensation for the 'trauma of Westfalen'. As the papal envoy to the negotiations that would result in the Peace of Westphalia in 1648, Alexander, who was still Fabio Chigi at the time,

experienced at first hand the lesson that the role of the Pope as European arbiter was finished . Consequently, Krautheimer argues, Alexander's Rome would be a chain of *teatri* – public, ritual spaces – that was meant to convince the visitor of the power and greatness of the papacy.[3]

Krautheimer characterizes Alexander's architectural ambitions as a compensation for a real loss of power, and his reading of Alexander's *nuovo teatro* carries with it more than a hint of scepticism about the relation of theatricality to truth and authenticity. But was this suspicion shared by the Baroque papacy and society? There is also good reason to reconsider Krautheimer's assumptions about Alexander's motivations to lose himself in display. Although political circumstances are as intrinsic to Alexander's Rome as to any building, and contemporary sources offer tantalizing glimpses into his careworn psyche, it remains unclear whether Chigi really experienced a debilitating powerlessness, and if so, exactly how this would have translated into his patronage.[4] Despite some blatant setbacks, especially in dealing with France, papal foreign policy under Alexander VII was not a complete disaster and Rome remained Europe's most important diplomatic hub.[5] And although his influence in European matters waned, Alexander VII played a crucial role in the reform of papal institutions which would make his state a model for other budding absolutist administrations.[6] Moreover, our knowledge of Alexander's psyche depends largely on biographical sources produced with the Pope's own involvement and destined to circulate in public. Rather than unmasking a dark reality lurking underneath Alexander's triumphant theatre, such sources form part of it. As this chapter hopes to demonstrate, these texts – in particular the biography drafted by his close friend Sforza Pallavicino – offer an insight into Alexander's own notion of theatricality, where the display of art and architecture stands in a direct and quite unproblematic relation to his *persona*.

Sforza Pallavicino's *Vita di Alessandro VII* came about under close supervision of the pope himself, who provided autobiographical notes and remarks.[7] Probably undertaken not long after Alexander ascended to the papal throne in 1655, the unfinished biography ends in 1659, eight years before Alexander's (and Pallavicino's) death; it was published only in the nineteenth century. The introduction of the work

explicitly states Pallavicino's aims. Our author writes how he, as a Jesuit, devotes his life to God and to educating people by means of his pen.

> Anyone knows how useful it is for Christendom to know that the one who is venerated because of his supreme dignity, can also be venerated for his supreme virtue, and that he who is hierarchically closest to Christ, also follows Him through imitation. Moreover, because from the goodness of the Supreme Priest, almost as of the very influence of the first mover, depends all the well-being of the Church, and because a good and recent example is a more useful master to men than any other, it follows that the life of a pope, revealed to the world, contributes optimally, and for a long period to the highest good of the church, because it will bring forth a long line of good pontiffs.[8]

If Alexander's life is an example worthy of emulation, it is because his deeds shine forth so strongly, and lend themselves well to the kind of detailed description that distinguishes biography from historiography in general. Pallavicino even stresses the parentage of biography to the observation of live phenomena by comparing it to the empirical practices that emerged in his own circles in the 1620s, for instance in the Accademia dei Lincei.

> [O]f unique and marvelous events, everyone wants to know even the most minute circumstances; exactly as of the new phenomena in the heavens every tiny difference is observed, and every subtle movement, and that in the anatomy of the human body not a single nerve or fibre is overlooked.[9]

At the same time, the biography is also meant to serve as an 'intellectual mirror', a *Fürstenspiegel* reflecting the pope's own actions to him. It allows him to live according to the tenets of Seneca, who says that virtue is best maintained by always acting 'as though one were in a theatre', that is, under the close and not always sympathetic scrutiny of one's fellow men.[10]

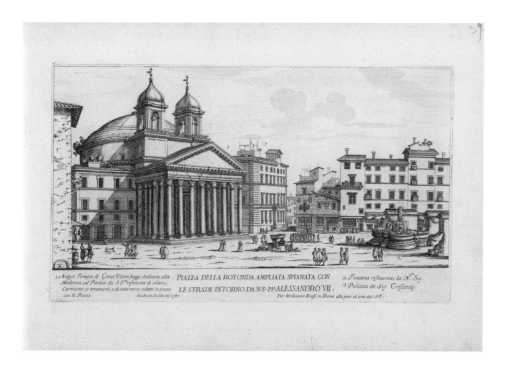

2 'Piazza della Rotonda', plate 3 from Giambattista Falda, *Il nuovo teatro delle fabriche, et edificii, in prospettiva di Roma moderna*, Rome: de'Rossi, 1665–69, vol. 2. Photo: Department of Architecture, Ghent University.

3 Inscription commemorating the refusal by Alexander VII of his honorific statue. Rome: Palazzo dei Conservatori. Photo: Fabio Barry.

With these words, Pallavicino embraces a view of the ruler examined in an important strand of contemporary political historiography, most notably by Virgilio Malvezzi, Pallavicino's uncle and a close friend of Chigi's.[11] In an attempt to marry Christian ethics with the conditions of emerging absolutist rulership, Malvezzi emphasizes a neo-stoic notion of theatricality as the condition proper to the ruler.[12] He should be a worthy *exemplum* and therefore act accordingly, balancing virtue and caution.[13] As I will argue, this theatricality defines the *persona* that Alexander VII attempts to project to the public, and explains why Alexander's Rome can be read as a theatrical space: it is where he performs his life as a ruler, and the city is called upon to bear witness to his virtue and success. In this reading of theatricality, the notion becomes disengaged from the architectural and spatial qualities of buildings, to describe the function of these buildings within a theatrical view of rulership. Whether and how this view relates to the specific qualities of Baroque architecture (if any) is an altogether different question, but the two near contemporary controversies presented here should at least suggest that this relation is more complicated than the requirement to suggest grandeur where actually there is none.

Pope Alexander VII's Refusal of his Capitoline Statue

From May 1656 to March 1657 the city of Rome was in the grasp of the bubonic plague. Even if the city authorities and the papal curia were unable to stop the disease from entering the city, their decisive actions contained the contamination and limited the number of victims.[14] The measures to protect the city and its population, ranging from medical and administrative interventions to implorations for divine assistance, became memorialized in several books and monuments, and the Roman senate vowed to offer the pope a statue in the Palazzo dei Conservatori on the Capitol Hill. Through the gift, Alexander would follow Leo X, Paul III, Gregory XIII, Sixtus V, Urban VIII and Innocent X as a pontiffs whose beneficial acts the Roman Senate rewarded with the erection of a monumental statue in the seat of Roman civic government.[15] Alexander VII, however, refused the statue. In the words of his master of ceremony, Francesco Maria Febei, the pope considered 'the image [that the citizens of Rome] had imprinted in their hearts a sufficient hallmark of their gratitude, without them making another, exterior demonstration of it'.[16] In its stead an inscription was installed in the Palazzo dei Conservatori (*plate* 3) and the pope received a splendid medal, both in honour of his good governance and the modest refusal of the statue.[17]

If Alexander's refusal of a monumental statue seems to contradict the general tendency towards ostentation ascribed to him in historiography,[18] it fits fairly well into his conception of rulership and its relation to theatricality. As becomes evident from Sforza Pallavicino's biography, the episode forms an integral and important part of Alexander's public performance. In fact, the Jesuit writes little on the pope's extensive patronage in art and architecture but devotes a detailed analysis to the unmade statue. He casts the refusal as exactly the kind of act that corresponded to Alexander's theatrical condition, a display of virtue worthy of public commemoration and emulation. A closer examination of Pallavicino's arguments will in fact delineate the field of action available to the prudent theatrical ruler when it comes to patronage

and ostentation, somewhere between the tangible yet vulnerable object and the total abnegation of self-representation.

Pallavicino's account of the episode is an apology, and evinces concerns that Alexander's decision would be seen less as an act of sincere humility than fear. Pallavicino tackles the problem head on, by rehearsing the long and vivid history of iconoclastic violence against the papal statues on the Capitol. He recalls the sorry fate of Paul IV, whose dismembered sculpted head was paraded through the streets of Rome before it was thrown into the Tiber.[19] In Pallavicino's day, the relics of Paul's statue must have served as a grim reminder of the risk a vulnerable effigy posed to one's posthumous fame. Its rump languished for years on the Capitol, until in 1645 it was decided to 'unearth' it and transform it into a likeness of Innocent X, Alexander's predecessor. This project was never executed, and later attempts to restore the statue also proved unsuccessful.[20] Pallavicino also reminds his readers how upon the death of Sixtus V in August 1590 the destruction of his bronze statue (only the second capitoline papal statue erected since Paul IV) was narrowly avoided. This episode induced the Senate to ban its members from proposing to erect a statue to a living pope on the Capitol; in 1605, this ban was extended to include all members of the papal family.[21]

Alexander's refusal, Pallavicino assures his readers, had nothing to do with these memories. The ban of 1590 was lifted under Urban VIII (1623–44), and his statue installed in 1640. Pallavicino continues,

> Alexander, even if he saw similar honours being bestowed upon two immediate predecessors without any ill effect, and even if the benefits for which the city wanted to render him homage were so manifest and important that it excluded any suspicion of adulation, nonetheless disagreed [with the proposal] in a modest and courteous manner … [22]

The citizens were 'more amazed, than satisfied' with Alexander's answer, and asked again if they would be at least allowed to install an inscription that not only would cost nothing to the people of Rome, but would also constitute 'a simple witness to the truth'. Even so Alexander declined.[23]

Pallavicino's otherwise well-informed account leaves out one crucial event. Barely four years after the installation of Urban's statue, it was nearly destroyed when on 29 July 1644, upon the news of Urban's death, angry Romans stormed the Capitol, exhausted as they were by the consequences of the disastrous Castro War. Only a swift intervention of the Colonna and Orsini families saved Urban's likeness. The crowd then turned against the large and very similar plaster effigy still gracing the courtyard of the nearby Collegio Romano, where it had been the centrepiece of the decorations installed there for the centennial of the Jesuit Order in 1640.[24] The Barberini even feared that the mob would attack Bernini's studio, where a *statua* of Urban awaited completion.[25]

Pallavicino must have known about the mob violence against Urban's effigy and the destruction of the plaster statue, and was certainly able to appreciate its importance. In 1644 he taught at the Collegio Romano, and four years earlier he had authored an extensive description of the festive decorations of the Collegio Romano which paid ample attention to the statue.[26] If the mere survival of Urban's capitoline statue allowed Pallavicino to argue that Alexander's two immediate predecessors were spared the infamy of having their likeness destroyed, his suppression of the related episodes in the *Vita* strongly suggests that he sought to allay suspicions about Alexander's motivations in refusing the statue.[27]

Out of the same concern, Pallavicino proceeds to examine these motivations in minute detail. If our Jesuit is loath to address anxieties inspired by iconoclasm, he delights in weighing the possible pitfalls of modesty, to conclude that Alexander's decision is, in fact, an act of political prudence. Alexander, Pallavicino argues, wished to 'liberate' the Roman people of the 'pension' to offer each pontiff a statue, regardless of what the pope had done for them. Conversely, he endeavoured to prevent subsequent popes from automatically expecting such a statue, since the habit of the gift would turn its absence into a matter of dishonour. Such practices, Pallavicino continues, would foment adulation and vanity, a menace to the sincerity and modesty required for good government.[28]

With this detailed examination, Pallavicino clears the path to transform Alexander's decision into an act that bears witness to pontifical concern for the benefits of the Roman people and as such even worthier of commemoration than the deeds that occasioned the gift of the statue. That is why, Pallavicino argues in the final section of his justification, Alexander ultimately accepted an inscription commemorating the episode. It would appear to be a double statue, one erected for earlier merit, Alexander's containment of the plague, and the other to the generosity of the refusal, with its important implications for the future.[29] For it is true, Pallavicino concludes, that the only worthy 'simulacro' of esteem is the one shaped by the pens and tongues of the most reputed men, since those are not remunerated with the treasures of power, but of virtue.[30]

Just like the *damnatio memoriae* that so preoccupied Alexander VII and his friend, both the praise of the exquisite virtue of refusing the honour of the statue in favour of the image kept in the citizens' heart and the *paragone* between commemoration by means of the effigy or letters have a long pedigree.[31] In fact, the whole episode strongly reminds one of Plutarch's Life of Cato the Elder.[32] But by claiming the superiority of the text over the statue, Pallavicino also implicitly sets up a subtle comparison between the unmade effigy and the very context of his own justification: like the inscription, his biography of the pope is a 'simulacro' drafted by a reputed writer. This portrait is a far superior mirror image of the sovereign than any 'external' effigy and a much more effective reflection of his thoughts and deeds. As such, it is not only safe from harm when the populace turns against the portrayed ruler, but also guarantees an at once truthful and lively transmission of his deeds and thoughts. By virtue of its microscopic attention to detail, the biography acts as a much better analogue to the pontiff's historical, 'real' presence than the effigy. Only under those conditions will the portrait act as an *exemplum*, a 'living text' adapted to the peculiar theatrical condition of the ruler.[33]

A Controversy over the Papal Residence

The episode of the capitoline statue suggests that Alexander's theatricality, his existence in public, could do without monumental representations. The case is specific, however, in that it concerns an effigy, invoking the twin spectres of iconoclasm and idolatry, and inviting comparison with other forms of representation. With regard to both issues, Pallavicino sees a solution in advancing Alexander's real presence as the guarantee for theatricality. This conception of theatricality imposes specific requirements on the presence of the ruler in the city, which pertain more directly to architecture and urbanism. They are discussed in another episode that called upon Pallavicino's apologetic skills, a controversy regarding the proper papal residence. Alexander VII's favourite residence was the palace on the Quirinal Hill (*plate* 4). He was not the first pope to have spent considerable time at Monte Cavallo,

but he may have considered moving the papal residence permanently from the Vatican.[34] Probably quite early in Alexander's papacy, a number of opinions on the matter were drafted.[35] Pallavicino endeavoured to prove that 'not a single temporal or spiritual prerogative of the Vatican palace' could be used to argue against a 'permanent residence' for the pope at the Quirinal.[36] Another confidant of Alexander's, Lucas Holste or Holstenius,[37] responded to Pallavicino and argued that the pope belonged at the Vatican. Both pamphlets were published together in 1776, when the same issue arose once again.[38] A little under a century later, Holstenius' arguments served to prove that the pope could only rightfully claim the Quirinal as a temporal leader. Because the Italian nation had relieved him of this heavy burden, the palace consequently belongs to the new head of state.[39]

This touches upon the first central point of the original controversy. Pallavicino argues on the basis of the pope's threefold task. He is the head of the Church, bishop of Rome, and king of the Papal State.[40] In order to perform this daunting feat, Pallavicino prescribes qualities for the papal residence that are still very much in line with Paolo Cortesi's remarks on the cardinal's palace.[41] The pontiff's residence must provide optimum accommodation for the court through a central location, easy access, and ample space.[42] In addition, the papal residence must be healthy. As Pallavicino had remarked earlier in his treatise on ethics *Del Bene*, a healthy *principe* can serve the interests of his subjects more hours a day and therefore 'with a clearer head'.[43] Moreover, as Pallavicino well knew, Chigi's poor health while he was Papal Nuncio in Cologne had impeded his thinking and prevented him from performing his religious exercises.[44]

Thus, Pallavicino's argument focuses on the convenience of the palace. Convenience serves the common good, the well-being of Christians, of the subjects of the papal state, and of 'this extraordinary flock' of Rome.[45] Pallavicino recalls that popes have always chosen the most practical residence, and points out how Rome rose from its ashes through the building of fountains, a process of resurrection crowned by the palace Sixtus V built on the Quirinal, which has since become the most logical choice of residence for popes, 'for their own health as well as the convenience of others'.[46]

4 'Palazzo e piazza sul 'Quirinale', plate 13 from Giambattista Falda, *Il nuovo teatro delle fabriche, et edificii, in prospettiva di Roma moderna,* Rome: de' Rossi, 1665–69, vol. 1. Photo: Department of Architecture, Ghent University.

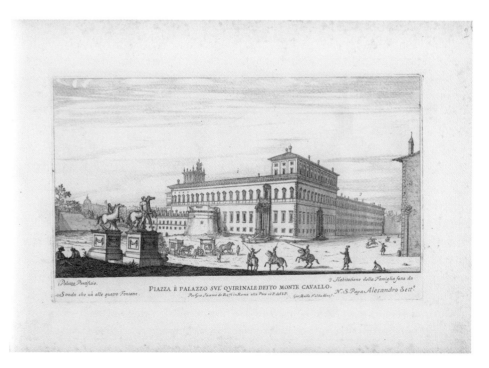

Because Holstenius really only discusses the role of the pope as head of the Universal Church, he gives the papal residence an entirely different significance. He starts by showing the primacy of St Peter's as the papacy's most important church. The pope is the bishop of Rome and the successor of St Peter. This dual role is reflected in the relationship between St John Lateran and St Peter's. The authority of the pope is embodied by St Peter's, because it is based on the succession of Peter and

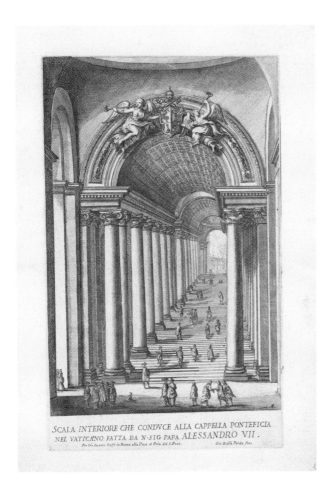

SCALA INTERIORE CHE CONDVCE ALLA CAPPELLA PONTEFICIA
NEL VATICANO FATTA DA N·SIG PAPA ALESSANDRO VII.

5 'Scala interiore che conduce alla cappella pontifica', plate 5 from Giambattista Falda, *Il nuovo teatro delle fabriche, et edificii, in prospettiva di Roma moderna*, Rome: de'Rossi, 1665–69, vol. I. Photo: Department of Architecture, Ghent University.

the body of Peter is tangible proof of that authority.[47] Holstenius asks the reader to imagine the 'holy veneration' that would befall the pope throughout the world if he were to reside in the most famous palace in all Christendom 'as in his own house', next to the first and most important Church in the world and right by the body and seat of Peter.[48]

Holstenius' attention to the adoration of the pontiff relates to the second point of the controversy. A considerable part of Pallavicino's discourse refutes the claim that a long absence of the pope from the Vatican would harm worship at St Peter's. According to Pallavicino the private cult, the visiting of holy places by Romans and pilgrims, is only hindered by the presence of the court. But the ceremonies that really tie the pope to San Pietro, like the *Corpus Domini* procession, will take place with 'greater splendour and conspiciousness', if he travels there in a lustrous cavalcade, instead of descending the 'nearby stairs' from his usual quarters.[49] In this context, Pallavicino refers explicitly to the policy of Sixtus V to spread the papal *cappelle* over different Roman basilicas, in order to promote the dignity of worship in different churches. This spread gave rise to a great number of ceremonial parades per year, which were accommodated by Sixtus' new road system.[50]

According to Holstenius, 'secular spectacles' such as cavalcades never brought anyone closer to faith. The usefulness of the Vatican palace does not lie in the 'appearance of solemn or other ceremonies that take place in this basilica rather than others', nor is it limited to the devotion of Romans or pilgrims. It lies in the 'opinion' and 'respect' that the pontiff gains with kings and all Christians through his devotion to St Peter's.[51] The dignity of the papacy is based on the authority of Peter and on the assumption of apostolic virtues. The adoration of some popes, for example, was greatly enhanced by rumours that they secretly prayed at St Peter's tomb at night, in order to make their decisions under the influence of the Apostolic Spirit.[52] Acquaintances of Holstenius who converted to Catholicism did not do so after attending 'cavalcades and other secular pomp and circumstance', but after witnessing public acts of humility by the pope, such as washing the feet of the poor or going in procession on foot.[53]

Numerous studies have made us familiar with the architectural and urbanistic interventions initiated or supervised by Alexander VII. Many concerned the Vatican and Quirinal Palace, St Peter's and St John Lateran, and others ameliorated roads and *piazze* to accommodate increasing traffic, processions and ceremonies.[54] It is hard to judge whether the *Scritture* had any impact on Alexander's decisions. Pallavicino's dismissal of the connection between the Vatican palace and St Peter's is the most glaring reference to the site of an important new architectural intervention, Gianlorenzo Bernini's *Scala Regia* (plate 5).[55] Yet even here a direct relation between text and building is hard to draw. Marder has argued that Bernini's design served to enhance the effect of processions such as the *Corpus Domini*, and this might indicate that Alexander and his entourage indeed felt that the papal *persona* was better served with a more conspicuous ceremonial connection between palace and church than a tunnel leading to Peter's

6 Foundation Medal of Saint Peter's Square, 1656 (recto). Bronze, diameter 5.6 cm. Brussels: Royal Library of Belgium. Photo: Royal Library of Belgium.

tomb. But it would certainly stretch the *Scritture* too far to argue that the pope needed Pallavicino to convince him to undertake the project. On the other hand, Holstenius' arguments resonate with his own involvement with the colonnade, and especially the iconography of its foundation medal (*plate 6*).[56] Its inscription, *Fundamenta eius in montibus sanctis*, recalls his citation of Cesare Baronio, when the venerated church historian describes the Vatican as the new Capitol with a verse taken from the prophecies of Isaiah 'cujus est domus Domini in vertice montium',[57] or his reference to the dedication of St Peter's as the moment when the church was declared 'tamquam ad Fidei petram & Ecclesiae fundamentum'.[58] But in this case, too, it is far more probable that Alexander VII employed Holstenius' strengths when devising the colonnade and the concomitant symbolism, rather than having the librarian direct pontifical patronage.

If the *Scritture* are read as defending opposing views of how the intrinsic theatricality of Alexander's life translates into architecture, however, it makes sense to relate the *Scala Regia* to Pallavicino's views, even if the intervention enhanced the importance of the Vatican.[59] The dispute between Pallavicino and Holstenius offers two models to interpret the visual presence of the pope in the city, and its relation to his exemplarity. Pallavicino wonders in dismay what kind of education a Christian could possibly get from knowing that the pope chooses to maintain a 'glorious palace' before attending to the well-being of everybody connected with the court.[60] To Holstenius the pope's public humility is the pre-eminent edifying example to all Christians. Thus, the public appearance of the pope is just one of the elements that constitute the essence of the papacy, his reputation as a holy man in the entire Christian community. Holstenius is less interested in the vitality of the city than in places with historical significance for Christianity. To the converted man of letters, Rome is not the embodiment of good governance, but the historical locus that justifies the exercise of papal authority. The true measure of the pope's virtue is his piety with regard to that locus, with at its centre the tomb of Peter. Or as he sums it up: 'if Rome honours Saint Peter's, the world will honour Rome'.[61]

Pallavicino favours the model of the Christian ruler whose public appearance convinces his audience of his exemplary virtue; therein, too, lies the function of ceremonies, processions and the *cavalcata*. The manifestation of virtue is therefore bound to Rome, and also concerns the buildings and other interventions that came into being under the pope's patronage, for they are living witnesses to his preoccupation with the common good, and the decorous worship of God. In the *Vita* of Alexander VII, too, Pallavicino pays much attention to the embodiment of papal virtue by his living presence in the city. Building projects are mentioned as contributions to the common good;[62] Pallavicino describes in detail the many measures taken by Alexander VII to enhance the dignity and splendour of ecclesiastical life and offices in Rome, as an example to Christianity.[63] The pontiff's own ceremonial appearance is discussed, with Pallavicino carefully balancing Alexander's innate humility with the requirements of *decorum*.[64] An important ambassador once said that 'the splendour and the majesty' of the papal mass during Alexander's papacy lends something superhuman and heavenly to the apostolic college and its head.[65]

The Condition of Theatricality

Pallavicino's defence of the Quirinal as an appropriate papal residence dovetails with his justification of Alexander's refusal of the honorific statue. Choosing the Quirinal not only evinces an appropriate concern for the common good but also activates the city centre of Rome as a theatre for the living and superhuman presence of the papal *persona*. This presence is worthy of the biographical record as an *exemplum* for every Christian in general and future pontiffs in particular. As exactly such a record, the capitoline inscription recalling the refused statue not only reminds Romans and popes alike of Alexander's virtue, but also of the peculiar risks that living 'as in a theatre' entails. Alexander's theatre is not a magnificent but vainglorious backdrop to a drama of political decline, but a condition incessantly balancing the need to externalize virtue and to adopt a dignified modesty.

If these considerations only indirectly reflect upon Falda's depictions of buildings in the *Nuovo teatro*, they do pertain directly to De'Rossi's decision to publish a book under that title. The relation of the *Nuovo teatro* to Alexander's theatricality is well expressed in the dedication of a contemporary guidebook to Rome, addressing Flavio Chigi, Alexander's nephew: 'if this booklet contains a compendium of the sacred and profane antiquities of this city, it could not be published under any other patronage than of him who is a compendium of the virtues of his sovereign uncle, the supreme monarch of this city.'[66] The detailed and refined *representation* of Alexander's buildings is like the minute description of his actions in the biography and, as such, a 'new theatre' of papal Rome.

Notes

1 Giambattista Falda, *Il nuovo teatro delle fabriche, et edificii, in prospettiva di Roma moderna*, Rome, 1665–69.

2 Francesca Consagra, *The De Rossi Family Print Publishing Shop: A study in the History of the Print Industry*, 1992; Paul A. Wilson, 'The image of Chigi Rome: G. B. Falda's Il nuovo teatro', *Architectura*, 26, 1996, 33–46.

3 Richard Krautheimer, *Roma di Alessandro VII 1655–1667*, trans. Giuseppe Scattone, Rome, 1987, 140–56, with the citation on 149.

4 Similar questions have been raised in Theodore Rabb, 'Politics and the arts in the age of Christina', in Marie-Luise Rodén, ed., *Politics and Culture in the Age of Christina*, Stockholm, 1997, 9–22.

5 See for instance Renata Ago, 'Sovrano Pontefice e società di corte. Competizioni cerimoniali e politica nella seconda metà del XVII secolo', in Cathérine Brice and Maria Antonietta Visceglia, eds, *Cérémoniel et rituel à Rome (XVI–XIX siècle)*, Rome, 1997, 223–38.

6 Maria Louise Rodén, 'After the Westphalian Peace: the political transformation of the 17th-century papacy', in Rodén, *Politics*, 29–42.

7 Giovanni Incisa della Rochetta, 'Gli appunti autobiografici d'Alessandro VII nell'archivio Chigi', in *Mélanges Eugène Tisserant*, Città del Vaticano, 1964, vol. 1, 439–57.

8 Sforza Pallavicino, *Della vita di Alessandro VII. Libri Cinque. Opera inedita del P. Sforza Pallavicino della Compagnia di Gesù. Accademico della Crusca e poi Cardinale di S. Chiesa*, Prato, 1839–1840, vol. 1, 'Proemio', 21–2: 'Ciascun sa quanto giovi alla edificazione del Cristianesimo il sapersi, che chi è adorato per suprema dignità, sia venerabile per suprema virtù, e che il più prossimo a Cristo nel grado, gli sia vicino ancora nell'imitazione. Oltre a ciò dipendendo dalla bontà del Sommo Sacerdote, quasi dalla propria influenza del primo mobile tutto il ben della Chiesa, ed essendo agli uomini il buon esempio recente il più profittevole d'ogni altro maestro, ne segue, che la vita palesata al mondo d'un Papa ottimo giovi per diuturno tempo a sommo pro della chiesa, cagionando una lunga serie di Papi buoni.'

9 Pallavicino, *Vita*, vol. 1, 372: '... sì perchè intorno a singolari e maravigliosi avvenimenti ciascuno è vago di risaper ancor le minime circostanze; siccome nelle nuove apparenze del cielo curiosamente s'osserva ogni picciola diversità d'aspetto, ed ogni tenuissimo movimento, e nella notomia dell'umano corpo niun nervicciuolo, e niuna fibra si trascura.' On Pallavicino's involvement with the Lincei, and especially his recurrent references to empirical observation in religious and literary contexts, see Eraldo Bellini, 'From Mascardi to Pallavicino: The biographies of Bernini and seventeenth-century Roman culture', in Maarten Delbeke, Evonne Levy and Steven Ostrow, eds, *Bernini's Biographies: Critical Essays*, University Park, PA, 2006, 298–307.

10 Pallavicino, *Vita*, vol. 1, 'Proemio', 22. Similar considerations can be found in Pallavicino's *Arte della Perfezion Cristiana* (1665), in Sforza Pallavicino, *Opere*, Milan, 1834, vol. 2, 737; and *Del Bene* (1644), in *Opere*, vol. 2, 578.

11 See Sylvia Bulletta, *Virgilio Malvezzi e la storiografia classica*, Milan, 1995.

12 On this subject, see for instance Diego Quaglioni, 'Il modello del principe cristiano. Gli ìspecula principumî fra medio evo e prima età moderna', in Vittor Ivo Comparato, ed., *Modelli nella storia del pensiero politico*, Firenze, 1987, vol. 1, 103–22; Chiara Continisio, 'Il principe, il sistema delle virtù e la costruzione di una ìbuona societàî', in Cesare Mozzarelli and Danilo Zardin, eds, *I tempi del Concilio. Religione, cultura e società nell'Europa tridentina*, Rome, 1997, 283–305.

13 As Pallavicino indicates, the reference here is Seneca. As Alexander Roose pointed out to me, Seneca's *De Clementia*, in particular, is a key source for the *Fürstenspiegel*. In Seneca's oeuvre, the exercise of virtue is often associated with theatrical performance; see Ben L. Hijmans Jr, 'Drama in Seneca's stoicism', *Transactions and Proceedings of the American Philological Association*, 97, 1966, 237–51. As Ezio Raimondi has shown, Seneca and stoicism had a formative impact on the Baroque notion of theatricality as the defining characteristic of the human condition; see for instance his 'Il seicento. Un secolo drammatico', in Ivano Dionigi, ed., *Seneca nella conscienza dell'Europa*, Milan, 1999, 181–97. As the quote suggests, Pallavicino knew that Alexander VII was familiar with Seneca's work; see also Incisa della Rochetta, 'Gli appunti autobiografici', 444–5.

14 On the plague of 1656, see Rose Marie San Juan, *Rome: A City out of Print*, Minneapolis MN, and London, 2001, 219–31, with earlier literature.

15 On the capitoline statues, see Kaspar Zollikofer, *Berninis Grabmal für Alexander VII. Fiktion und Repräsentation*, Worms, 1994, 82–93, with earlier literature.

16 The episode is dealt with in detail by Zollikofer, *Bernini's Grabmal*, 95–6, and documents B10–B12, with the quote 119–20.

17 On the medal, see among others Shelley Perlove, 'Bernini's Androclus and the Lion: a papal emblem of Alexandrine Rome', *Zeitschrift für Kunstgeschichte*, 45, 1982, 287–96; Maurizio Fagiolo dell'Arco and Francesco Petrucci, eds, *L'Ariccia del Bernini*, Rome, 1998, nos. 22a, 22b.

18 See, for instance, Krautheimer, *Roma di Alessandro VII*, 16.

19 Pallavicino, *Vita*, vol. 2, 167.

20 Ernst Steinmann, 'Die Statuen der Päpste auf dem Kapitol', in *Miscellanea Francesco Ehrle. Scritti di storia e di paleografia*, Città del Vaticano, 1924, vol. 2, 492–4; Monika Butzek, *Die Kommunalen Repräsentationsstatuen der Päpste des 16. Jarhunderst in Bologna, Perugia und Rom*, Bad Honnef, 1978, 316–18. The head was eventually retrieved.

21 See Zollikofer, *Bernini's Grabmal*, 88–9, with earlier literature.

22 Pallavicino, *Vita*, vol. 2, 167: 'Alessandro ancorchè ritrovasse simiglianti onoranze fatte a due prossimi antecessori senza verun effetto sinistro, ed ancorchè il benefizio per cui la città volea render a lui questa gratitudine fosse così manifesto ed insigne, che assolveva quell'atto da ogni nota di adulazione, tuttavia dissentì con modesta e cortese maniera … .' It should be noted that Pallavicino is careful not to specify the two immediate predecessors.

23 Pallavicino, *Vita*, vol. 2, 167–8.

24 Zollikofer, *Bernini's Grabmal*, 89, with earlier literature. On the decoration of the Collegio Romano, see Maurizio Fagiolo dell'Arco, *La festa barocca*, Rome, 1997, 316–18.

25 Karen Lloyd, 'Bernini and the vacant see', *Burlington Magazine*, 150: 1269, December 2008, 821–4. Lloyd argues convincingly that the *statua* in question was the bust destined for Spoleto. I thank the author for making her manuscript available to me.

26 Sforza Pallavicino, *Relazione scritta ad un'Amico delle feste celebrate nel Collegio Romano della Compagnia di Giesù per l'anno centesimo dopo la fondazione di essa*, Rome, 1640. The text is reprinted in Renato Diez, *Il trionfo della parola. Studio nelle relazioni di feste nella Roma barocca 1623–1667*, Bologna, 1986, 160–84.

27 Zollikofer, *Bernini's Grabmal*, 96. Another witness of the same discussion is Andrea Borboni's *Delle statue* of 1661. As I will argue in my forthcoming book on Sforza Pallavicino's theories of art, Borboni's treatise should be read as a historical and theoretical justification of the refusal.

28 Pallavicino, *Vita*, vol. 2, 168.

29 Notes in Alexander's diary describe the inscription as a substitute for the statue, see Richard Krautheimer and Roger B. S. Jones, 'The diary of Alexander VII: notes on art, artists and buildings', *Römisches Jahrbuch für Kunstgeschichte*, 15, 1975, 199–235, no. 135: 'la memoria della statua recusata'; no. 368: 'Iscrittione … in vece della Statua in Campidoglio'.

30 Pallavicino, *Vita*, vol. 2, 168–9.

31 See, for instance, Peter Seiler, 'Petrarcas kritische Distanz zur skulpturalen Bildniskunst zeiner Zeit', in Renata L. Colella, Meredith J. Gill, Lawrence A. Jenkens and Petra Lamers, eds, *Pratum Romanum, Richard Krautheimer zum 100. Geburtstag*, Wiesbaden, 1987, 299–324. My thanks to Kathleen Christian for this reference.

32 Plutarch, *Lives*, trans. Bernadotte Perrin, Cambridge, MA, 1998, 19.4.

33 The citation is from Balthazar Gracian's *Oraculo manual y arte de prudencia* (1647), as quoted in Timothy Hampton, *Writing from History: The Rhetoric of Exemplarity in Renaissance Literature*, Ithaca, NY, 1990, 11.

34 On Alexander's preoccupation with the Quirinal, see now the synthesis in Antonio Menniti Ippolito, *I papi al Quirinale. Il sovrano pontefice e la ricerca di una residenza*, Rome, 2004, 58–60 and further.

35 Dorothy Metzger Habel, *The Urban Development in the Age of Alexander VII*, Cambridge and New York, 2002, 327, n. 14 mentions two other statements on the matter kept in the Biblioteca Apostolica Vaticana, one of which is discussed in Ippolito, *I papi al Quirinale*, 100–3.

36 *Scritture contrarie del card. Sforza Pallavicino e del chiarissimo monsignor Luca Holstenio sulla questione nata a'tempi di Alessandro VII se al Romano pontefice più convenga di abitare S. Pietro, che in qualsivoglia altro luogo della Città. Ora per la prima volta date in luce con qualche annotazione e consecrate All'Eminentissimo, e Reverendissimo Principe Il Signor Cardinale Gio. Battista Rezzonico Pro-Segretario de'Memoriali Da Francesco Zaccaria*, Rome, 1776, 22. A description of the *Scritture* in Ippolito, *I papi al Quirinale*, 91–100.

37 Holstenius died in 1661, after two years of illness; this dates the *Scritture* between 1655 and 1659. Pallavicino and Holstenius had known each other since the latter's arrival in Rome in 1627; see also Pallavicino, *Vita*, vol. 1, 357. A recent biographical profile by Giovanni Morello, 'Olstenio', in Lorenza Mochi Onori, Sebastian Schütze and Francesco Solinas, eds, *I Barberini*, Rome, 2007, 173–80.

38 Pius VI (1775–99), to whom the edition is dedicated, is the first pope to choose to stay at the Vatican after a long series of predecessors who stayed at the Quirinal 'per comodo della curia e del popolo'.

39 Achile Gennarelli, *Il Quirinale e i palazzi pontificali in Roma. Osservazione storiche e risposta alla nota del Cardinale Giacomo Antonelli*, Rome and Florence, 1870.

40 *Scritture*, 6.

41 See Kathleen Weil-Garris and John F. D'Amico, 'The Renaissance Cardinal's ideal palace: a chapter from Cortesi's *De Cardinalatu*', in Henry A. Millon, ed., *Studies in Italian Art and Architecture, XV through XVIII Centuries*, Rome, 1980, 47–123.

42 *Scritture*, 6.

43 *Scritture*, 7; See also Pallavicino, *Del Bene*, in *Opere*, vol. 2, 549.

44 Pallavicino, *Vita*, vol. 1, 109 and 267.

45 *Scritture*, 8.

46 *Scritture*, 15.

47 *Scritture*, 46.

48 *Scritture*, 59.

49 *Scritture*, 19.

50 *Scritture*, 19. On the *cappelle*, see most recently Sible De Blaauw, 'Immagini di liturgia: Sisto V, la tradizione liturgica dei papi e le antiche basiliche di Roma', *Römisches Jahrbuch der Bibliotheca Hertziana*, 33, 1999/2000, 259–302.

51 *Scritture*, 60.

52 *Scritture*, 60–1. Clement VIII installed a corridor between palace and tomb; see Jack Freiberg, *The Lateran in 1600: Christian Concord in Counter-Reformation Rome*, Cambridge and New York, 1995, 178.

53 *Scritture*, 62.

54 Alexander's most important interventions at the Quirinal consist of the construction of the *Manica Lunga*, of Sant'Andrea al'Quirinale and the decoration of the long gallery, which is now restored; see Stefania Pasti, 'Pietro da Cortona e la Galleria di Alessandro VII al Quirinale', in Marcello Fagiolo and Paolo Portoghesi, eds, *Roma barocca. Bernini, Borromini, Pietro da Cortona*, Milan, 2006, 88–97.

55 See Tod Marder, *Bernini's Scala Regia at the Vatican Palace*, Cambridge and New York, 1997.

56 Daniela Del Pesco, *Colonnato di S. Pietro 'Dei Portici antichi e la loro diversità.' Con un ipotesi di cronologia*, Rome, 1988; Anna Menichella, 'Genesi e sviluppo del processo progettuale della fabbrica dei nuovi portici', in Valentino Martinelli, ed., *Le statue berniniane del colonnato di San Pietro*, Rome, 1987, 14, note 112, links Holstenius' point of view with the iconography of the colonnade.

57 *Scritture*, 39.

58 *Scritture*, 37.

59 Pallavicino's stance is linked to Alexander's urbanistic strategy in Augusto Roca de Amicis, *L'Opera di Borromini in San Giovanni in Laterano*, Rome, 1995, 19–20.

60 *Scritture*, 7.

61 *Scritture*, 64.

62 Pallavicino, *Vita*, vol. 2, 177–84.

63 Pallavicino, *Vita*, vol. 1, 410–13.

64 Pallavicino, *Vita*, vol. 1, 267–8.

65 Pallavicino, *Vita*, vol. 1, 334–5.

66 Fioravante Martinelli, *Roma ricercata nel suo sito*, Rome, 3rd edn, 1658, dedication.

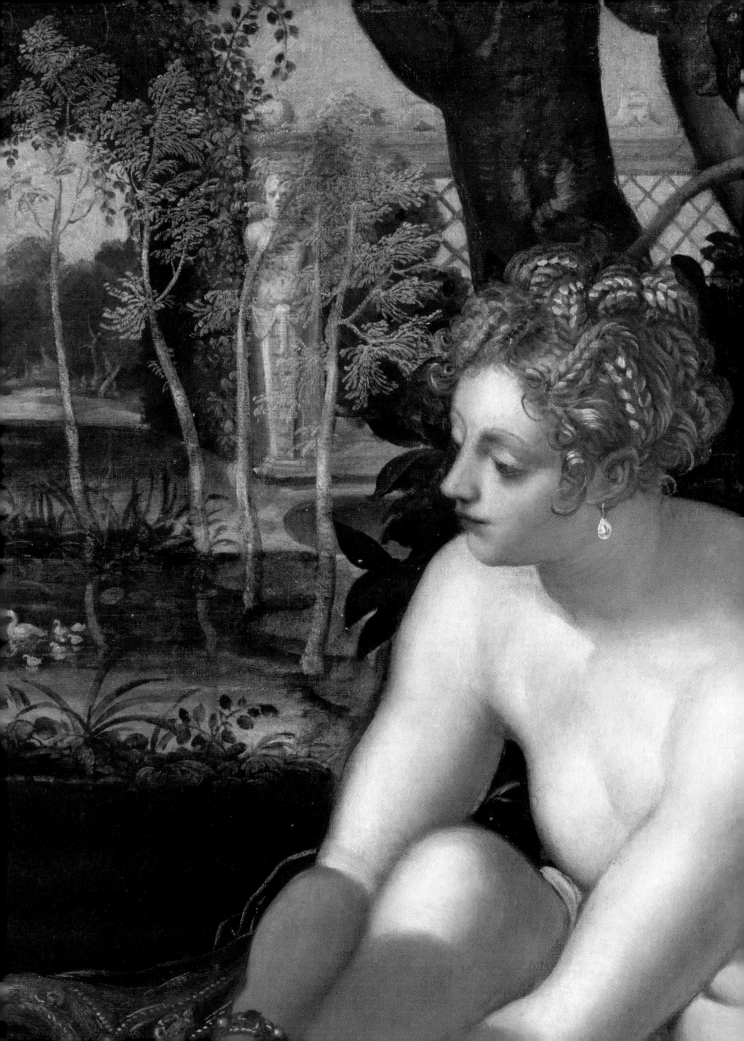

Chapter 12
Ut pictura hortus/ut theatrum hortus: Theatricality and French Picturesque Garden Theory (1771–95)
Bram van Oostveldt

The picturesque vogue in eighteenth-century garden design is primarily understood today in the context of a close relationship at the time between landscape painting and gardening. However, in reality the picturesque had a much wider relevance for the eighteenth-century garden. As garden theorist and historian John Dixon Hunt stated, 'the term picturesque was originally used to refer to material that was suitable for inclusion in a painting or, by extension, material in the actual world that could be conceived of or viewed as if it were already part of a picture.'[1] The use of the picturesque during the eighteenth century not only refers to landscape, but draws even more influentially on history painting, where the depiction of a human action is at stake. Saying that a garden should be like a painting – Ut pictura hortus – means then that the picturesque garden should provide the perfect setting in which human action can be depicted, a viewpoint that ultimately comes to transform the garden into a silent poem. For this reason, the picturesque is still firmly rooted in the Ut pictura poesis-doctrine. Horace Walpole, for instance, famously declared that 'Poetry, Painting, and Gardening, or the science of Landscape, will forever by men of Taste be deemed Three Sisters, or the Three New Graces who dress and adorn nature.'[2]

In discussing Gardening, or 'the Science of Landscape', one should include a fourth sister: theatre. The idea that a garden might provide a perfect setting in which one could represent human action was also closely related to the eighteenth-century understanding of the purpose and nature of stage scenery.[3] Both gardens and stage sets functioned as backcloths in front of which a story or a drama unfolded, and this long before the picturesque became paradigmatic for eighteenth-century gardening. The theatre, theatrical machinery and scenography were considerable influences on gardening theory and practice in the gardens of the Italian Renaissance and Baroque and, subsequently, in the French classical garden. Late sixteenth-century gardens like Francesco de Medici's garden at Pratolino surprised visitors with their theatre automata,[4] while in Baroque and classical gardens like André Le Nôtre's at Versailles or the Grosser Garten at Herrenhausen near Hannover (*plate 1*), open air theatres were substantial elements in garden design. Sometimes even entire gardens, with their spatial structuring along lanes, through porticoes, statues, and tricks of perspective that recall Palladian scenography, functioned as theatre space.[5] During the reign of Maria Theresia, the gardens of Schönbrunn were a favourite setting in which to recite the verses of Pietro Metastasio, which expressed the emotional states the delights of nature could arouse.[6] The intimate relation between garden and theatre is also noticeable in paintings of gardens. Garden historian Marianne Roland Michel, for

Detail from Tintoretto, ***Bathing Susannah***, 1555, **(plate 3).**

Theatricality in Early Modern Art and Architecture *Edited by Caroline van Eck and Stijn Bussels* © 2011 Association of Art Historians.

instance, relates Antoine Watteau's painting *La perspective* to Pierre Crozat's garden in
Montmorency, as well as to the scene of *Les Bohémiens* in the opera *Fragments de M. de Lully*,
performed at the Paris opera in 1702.[7]

In the second half of the eighteenth century this triangular relationship between
poetry, painting, and theatre in the garden continued to exist. In his article 'Théâtre'
for the *Encyclopédie* (1755), Louis de Jaucourt mentioned gardens such as Saint-
Germain en Laye in France or the pastoral landscapes of Roman vineyards as the ideal
scenery for the representation of human action.[8] Nonetheless, French Picturesque
garden theory from the last quarter of the eighteenth century clearly favoured
painterly and even poetical references as apt models for the art of gardening, while
direct references to the theatre became less obvious and posed some particular
problems, which I will discuss in depth later on. One might suggest that the negative
connotations of the theatre for picturesque theory can be seen as symptomatic of the
way that, in French aesthetics after the mid-eighteenth century, the doctrine of the
Sister Arts was challenged by a new search for the phenomenological characteristics
of the individual arts.[9] Nonetheless, I want to suggest another, almost opposed,
way of considering this development. By exploring how references to the theatre
were inscribed, debated and criticized in French picturesque garden theory, my aim
is to show that it is not the theatre itself that posed the problem, but the seemingly
related danger of theatricality. In juxtaposing French picturesque garden theory
with contemporary French theories of the theatre, I will demonstrate how the
theatre itself developed solutions to overcome its own difficulties with theatricality,
solutions which were of considerable importance for picturesque garden theory as
well. In short, far from being expelled from the new gardens, the theatre remained an

important constituent of picturesque garden theory, underlining Walpole's statement that the art of gardening draws all the arts into a community.

Theatrical References

For Louis Carrogis, generally known as Carmontelle, the question of the preference for one art over another was of no importance. This painter, draughtsman, poet, dramatist and theatre designer happily combined all these arts in one of the most theatrical of picturesque gardens in France: the Parc Monceau, designed for the Duke of Chartres between 1773 and 1779.[10] In his accompanying text *Le jardin de Monceau près de Paris* (1779), Carmontelle states that he wanted to create a picturesque garden in which the display of Egyptian pyramids, Roman Temples, Gothick ruins, and Turkish pavilions would make the visitor forget that he was walking through a garden close to Paris. The garden should become a place of illusion, in which one travelled through time and space, just as in the different scenes of an opera: 'let us bring to our gardens the scene changes of the opera. Let us show in reality what the most accomplished painters can offer us in their decorations, at all times and in all places.'[11] Carmontelle also translated his own designs for the Parc Monceau into a new visual spectacle that foreshadowed the diorama and panorama of the early nineteenth century. Between 1783 and 1804 he made eleven very small transparent, moving panoramas (*plate 2*), a medium destined to become a very popular type of spectacle in French aristocratic society during the last two decades of the century. These mini panoramas were mounted in viewing boxes that could be placed on a table and were lit from behind. The movement of the scenes was suggested by scrolling the canvas from one side to the other, while Carmontelle himself accompanied the whole show with a lively commentary.[12]

The idea that a picturesque garden could be conceived of as a painting, which one could enter and move about in, was of great importance to Carmontelle and others. In one of the first theoretical writings advocating the picturesque garden in France, Claude-Henry Watelet's *Essai sur les jardins* (1774), we read that movement makes the quintessential difference between painting and garden. The composition of a painting will always remain the same: it holds complete sovereignty over the beholder regardless of his point of view. On the other hand, the spectators of picturesque scenes in a park 'change their order in changing places'.[13] This capacity for movement led Watelet to state that one should not speak of 'tableaux' in picturesque gardens but of 'theatrical scenes', because 'works of art that are not animated by movement and action, or which do not recall the perceptible idea of it, interest us only for a short time'.[14] And in Thomas

2 Detail of Louis Carrogis de Carmontelle, *Figures Walking in a Parkland*, c. 1783–1800. Watercolour and gouache on translucent paper, 47.3 × 377 cm. Los Angeles: J. Paul Getty Museum. Photo: J. Paul Getty Museum.

Whately's *Observations on Modern Gardening* (1770), which was translated into French in 1771 by François de Paule Latapie, we read that movement animates the garden and makes the scenes of nature look 'like those of a dramatic representation'.[15]

Anti-Theatrical Sentiments

Despite such direct comparisons with the theatre and the frequent use of theatrical terms such as *mouvement, scène, spectacle*, references to the stage in picturesque theory are rather ambivalent. In his *Coup d'oeil sur Beloeil et sur une grande partie des jardins en Europe* (1781– 95),[16] Prince Charles Joseph de Ligne recognized the qualities of the Parc Monceau. But he nevertheless thought that the different scenes in the Parc Monceau were too close to one another, and lacked sufficient plants and trees to separate them, making them appear to merge into one another. According to de Ligne then, Parc Monceau 'is not a real garden' but a catalogue or a 'sort of storehouse ... of mere scenes',[17] which ends by destroying Carmontelle's intended illusion that one is travelling through time and place. A garden, claimed de Ligne, should please our eyes and may even deceive them like a painting, but 'not ... with some sort of theatrical decoration, painted planks, wooden pyramids, and so forth. Such tricks are unworthy, vulgar, and mean.'[18] Is the triangle of painting, poetry and theatre destabilized for de Ligne here? And, if so, what is the problem with the theatre?

According to picturesque garden theory the aesthetic effect of a garden may indeed be deceptive, but the spectator should never be aware of this deceit, something which is too often the case in the theatre. The visitor in the garden should retain the illusion that the garden he sees is not a work of art but a creation of nature, wrote de Ligne,[19] while in Watelet's *Essai sur les jardins* (1774), which I cited above, we read that a garden will only be pleasing when art itself is concealed, because 'art that shows itself destroys the effect of art'.[20] This despised artificiality is not limited to gardens alone, it is a problem that is perceived to haunt all the arts. In the *Dictionnaire des beaux-arts* (1788–91), begun by Watelet and completed after his death by Pierre Charles Lévesque, artificiality was defined in terms of theatricality. In the article 'Théâtral', Lévesque wrote that in a country where there is a strong taste for the performing arts it is likely that other arts, especially painting and sculpture, will be affected by their character and potential. Painters and sculptors will tend, not to study nature, but to copy actors and reproduce their vices in their own practice:

> A false style has been formed in painting, called 'style théâtral'.
> Compositions no longer represent history but theatrical scenes.
> The attitudes, gestures, and expressions of the characters are those of performers; and art has been degraded so much that its works are no more than imperfect imitations of imitations that were by themselves already defective. As the tragic actors were ridiculously removed from nature, the painters, in copying them, remove themselves even further because copyists always exaggerate the vices of their originals.[21]

A more telling example of the rejection of theatricality in the arts is hard to find, but how can this disapproval be explained?

Theatre and Society

Contemporary theorists and historians of theatricality, from Elizabeth Burns in the 1970s, Erika Fischer-Lichte and Helmar Schramm in the 1990s, to Thomas Postlewait and Tracy Davis most recently,[22] may employ different perspectives to study

theatricality, but all begin with the observation that the notion of theatricality operates in very divergent ways and can have very divergent meanings. They also agree that in order to give theatricality its historical and culturally embedded meanings, one is obliged to study it within a broader discursive field and to look closely at the concept's migrations from one context to another.

As Elizabeth Burns states in her groundbreaking study of theatricality, the old topos of *theatrum mundi* in early modern Europe 'referred not only to the stage at it was seen but also to the centuries-old idea of the stage as the paradigm of human life, and of the artificial boundaries placed on feasible behaviour and on the actualities of social existence'.[23] Since the theatre functioned as an extended metaphor, describing social life as role-playing in order to account for the character of our short time on earth, it should not surprise us that this topos persistently recalled the danger of false perspectives. Hence, as Jonas Barish has shown, the frequent subtext of the topos of *theatrum mundi* was anti-theatricality.[24]

The assumption that there was a regime of truth beyond the theatrical organization of society received new and forceful expression in the second half of the eighteenth century. According to Richard Sennett, the practice of social behaviour as role-playing, which was not only rife at the Versailles court, but also notable in the expanding cities of Paris and London, came into conflict with emerging romantic ideas of the uniqueness of the subject and consequent fears of the dissolution of identity.[25] The theatre was now not deployed solely as a metaphor to describe the evils of society. Soon the discussion focused on the theatre itself. In Jean Jacques Rousseau's *Lettres sur les spectacles* (1758) we read that theatre bears an important responsibility for the current deplorable state of society. The theatre auditorium is where one is educated in the actor's abject capacity of selling his own person and his own identity. Rousseau uses the actor as the figure par excellence through which to warn his readers against everything that might fragment the subject.[26] In Rousseau's account only the well-known *retour à la nature* could offer protection against the pernicious threat of multiplying and diversifying identities.[27]

The influence of Rousseau's rejection of theatre and theatricality and ideas of naturalness was central to the formation of theories of sentiment in the Enlightenment and pre-romanticism. This was even more true for French picturesque garden theory. In Clarens, Julie's domain in *La Nouvelle Héloïse* (1761), Rousseau created a spiritual and sentimental landscape that became paradigmatic for French garden theorists and came to function as the basis for the moral justification of many gardens. De Ligne, for example, concluded his *Coup d'œil sur Beloeil* with the statement that a life far from the theatricality of city and court is the only way to live honestly.[28] He even made this moral justification of gardens the central theme of his pastoral *Colette et Lucas*, performed in early august 1779 in the gardens of Beloeil.[29]

Naturalness and Visuality

Both theatricality and its apparent cure, naturalness, occur in a wide range of discourses. As Robert Mauzi has shown, naturalness and virtuousness became more and more intertwined towards the middle of the century when they began to function as synonyms. Very widely acknowledged and only contested from the margins by figures like De Sade, the simplicity and innocence of *l'homme naturel* is opposed to the corruption of *l'homme policé*.[30] The polarity between theatricality and naturalness implies an aesthetic as well as a moral judgment. As early as 1717, Shaftesbury had already in his influential *Characteristicks* rejected theatricality in the arts as the negation of the natural.[31] More than half a century later this same opinion was expressed in the

article 'Naturel', which appeared in the supplements to the *Encyclopédie* written by the Swiss philosopher Johann Georg Sulzer.[32]

> NATURAL, *Fine Arts*, adjective by which one designates artificial objects that are presented to us as if art is not involved and as if they were products of nature itself. A painting that strikes the eye as if it were the object itself; a dramatic action that makes us forget it is only a spectacle; a description, the representation of a character that gives us the same ideas of things as if we had seen them ... all this is called *natural*.[33]

This is a noteworthy argument. By acknowledging that 'natural' was an appropriate adjective to describe 'a dramatic action that makes us forget it is only a spectacle',[34] Sulzer dissociated theatricality from theatre itself.

The search for a theatre without theatricality has been central to French theatre theory since the mid-eighteenth century. Among others, Luigi Riccoboni, his son François Riccoboni, Pierre Rémond de Saint Albine, and Jean Nicolas Servandoni D'Hannetaire all discussed the possibility of a theatre that could be perceived as natural.[35] In an attempt to shift the artificiality of classical theatre, they advised actors to moderate their declamatory style, to speak as if in real life, and to rely more on intimate and natural gesture. However, it was Denis Diderot who, in his *Entretiens sur le Fils naturel* (1757) and *De la poésie dramatique* (1758), gave a new direction to the whole discussion. In his attempt to overcome the theatricality of theatre and to make it more natural, he shifted the focus from the literary and verbal to the visual in what Roland Barthes justly called an aesthetics of the tableau.[36] In his two texts Diderot advocated the introduction of tableau, which he characterized as 'a natural and true arrangement of ... characters on stage, that if faithfully rendered by a painter it would please me in a canvas'.[37] Visualization of this sort functioned as a most effective strategy for making the theatre seem less theatrical. This should not surprise us, since French empiricists during the eighteenth century constantly promoted vision over the other senses.[38] As early as 1719, the abbé Dubos had written that 'sight has more power over the soul than the other senses. ... One could say, metaphorically speaking, that the eye is closer to the soul than the ear.'[39] The experience of truth is here clearly caught up in a discourse of occularcentrism engaged in creating the mythology of 'just looking' as a natural epistemological instrument that gives us direct and unmediated access to truth.[40]

Theatre and Spectator

Although Diderot clearly contributed to the emergent mythology of vision as 'just looking' by his praise of gesture as the visual language of truth,[41] he hesitated to subscribe to it fully.[42] According to Diderot, the naturalness of a representation depends on more than an accurate and realistic *imitatio naturae*. Far more important to Diderot is the question of spectatorship in general and the place of the spectator in particular. It is the beholder who should be invited to forget that he is attending a performance, a position that is reminiscent of Sulzer. This question of spectatorship is solved simply but magnificently in Diderot's fiction of the fourth wall. In *De la poésie dramatique* he advised the actor: 'do not think of the spectator anymore. ... Imagine at the front of the stage a great wall that separates you from the parterre; play as if the curtain will not rise.'[43] By doing so the actor would give the impression that he was not performing a role.

This 'natural' and non-theatrical performance was thus built on a double strategy of forgetting, the effect of which depended on the position of the spectator. With the

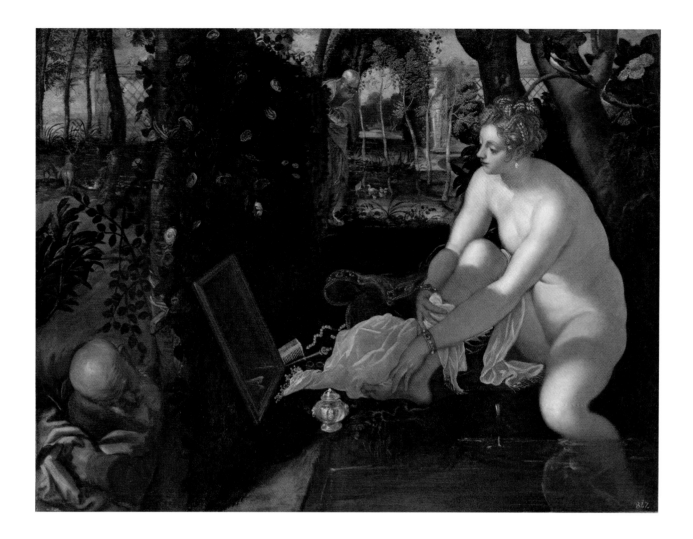

3 Tintoretto, *Bathing Susannah*, 1555. Oil on canvas, 147 × 194 cm. Vienna: Kunsthistorisches Museum. Photo: Kunsthistorisches Museum.

clear distinction between representation and the spectator enforced by the fictional fourth wall, the performer could sustain the illusion that he was not acting a role, and this, in turn, helped to persuade the viewer that he was watching the events themselves and not a play. The unawareness inherent in this type of looking was in this way part of the replacement of an earlier conception of viewing as an active principle with one of vision as unmediated access to the object represented.[44] In this sense, then, theatricality deserves the poignant definition the theatre theorist Maaike Bleeker gives it: 'Theatricality describes a situation in which the address makes the addressee explicitly aware of him or her being addressed. In doing so, it undermines the position of seer as unseen and (the illusion of) vision as unmediated access to what is there to be seen.'[45]

Painting and Spectator

According to Diderot the dramaturgic and theatrical concept of the fourth wall was of great importance for painting as well. In discussing Louis-Jean-François Lagrenée's painting *La chaste Suzanne*, Diderot refers in his *Salon de 1767* to Jacopo Tintoretto's *Bathing Susanna* (1555). In this painting (*plate* 3) Diderot particularly admires the way Tintoretto treated the old men, peering out from behind a flower-covered wall while Susanna is unaware of their act of looking. The nakedness of Susanna is here totally innocent, Diderot wrote, because she is not posing for the two men. According to Diderot, the illusion that the persons depicted are not aware of being the object of

looking is essential for a good painting or a natural performance: 'A scene represented on canvas or on the stage does not presume witnesses.'[46] This organization of the gaze as a form of secrecy is, however, a multilayered strategy. It not only provided the representation with its natural and non-theatrical qualities; it also defined spectatorship as voyeurism. The images of female innocence Diderot discussed in paintings like Tintoretto's *Bathing Susanna*, or the characters of female innocence he created in his own plays like *Le fils naturel* (1757) and *Le père de famille* (1758), were always subject to this voyeuristic gaze that eventually turned them into objects of erotic desire.[47]

The interchangeability of painting and theatre in Diderot's aesthetic theory has been thoroughly studied in Michael Fried's well-known *Absorption and Theatricality* (1980). Fried shows that Diderot's argument for painting and theatre without theatricality was built on the dramatic conception of the tableau. The tableau in Diderot's view was closely linked to the Aristotelian conception of drama as a closed form striving for an internal unity that excludes everything else, that does not tolerate any witnesses.[48] The exclusiveness of Diderot's concept of tableau is reinforced by a specific strategy which Fried calls *absorption*. Characters depicted in a painting or presented on stage must be so absorbed by what they are doing, hearing, thinking or feeling that they seem to forget that they are the object of a beholder's gaze, just like actors in front of the imagined fourth wall.[49] Absorption clearly acts here as a strategy of persuasion that neutralizes the awareness of spectatorship, or at least makes it secretive. But as Bleeker rightly says, it only functions in this way as long as it remains invisible as a strategy. As soon as it reveals itself as a strategy, absorption becomes its opposite, it becomes theatrical.[50] This is precisely what Watelet meant by writing that 'art that shows itself destroys the effect of art'.[51]

Returning to picturesque garden theory and practice, this particular way of dealing with the spectator still poses some problems. The paintings in which, for Diderot, the absorptive strategy was at work are all paintings in which the depiction of a human action is the central theme. Towards the end of the century, however, as John Dixon Hunt argues, picturesque garden theory and practice became increasingly interested in painted landscapes in their own right and not as backcloths for the depiction of human action. French picturesque theory and practice cited the work of Nicolas Poussin, Claude Lorrain or Salvator Rosa, and paid some, relatively novel, attention to seventeenth-century Dutch landscape painters such as Jacob van Ruisdael, Philip Wouwerman or Nicolaes Berchem. But it drew in particular on contemporary painters. The landscapes by Jacques Philippe de Loutherbourg directly influenced de Ligne's picturesque garden theory,[52] while Hubert Robert, after he had become famous for his paintings of imaginative ruins and gardens, was hired as a garden designer in Versailles, Rambouillet, and Méréville. Something of his reputation can be gauged by the fact that, in 1778, Robert was appointed as Designer of the King's Gardens, a position vacant since Le Nôtre's death in 1700.[53]

Since in landscape painting the depiction of human action is not the central theme, Diderot developed for it a totally different view of the relation between beholder and representation. In his accounts of Jacques Philippe de Loutherbourg, Jean Baptiste Le Prince, Hubert Robert or Joseph Vernet the viewer is no longer said to be excluded from the depicted scene, but is now understood as invited to participate, or seduced into doing so.[54] At first sight this may seem completely at odds with all the efforts Diderot makes elsewhere to cure the arts of theatricality by excluding the spectator. But this apparent opposition is in fact better thought of as a paradox. In the case of landscape painting Diderot relinquishes his conception of the dramatic

tableau as a closed form for what Fried calls a 'pastoral'[55] conception of dealing with the beholder. This 'pastoral' strategy solves the problem of theatricality in its own way by inviting the viewer to step into the painting. With the fiction of physically entering a painting, 'the estrangement of the beholder from the objects of his beholding is overcome; the condition of spectatorship is transformed and thereby redeemed'.[56] In fact the illusion is created that the spectator has stopped being a spectator of a work of art. Instead, as Diderot has shown in his famous section on the Vernet paintings in the *Salon de 1767*, the spectator has become a participant that has successfully closed the gap between representation and spectator.[57]

Garden and Spectator

Such redefinitions of spectatorship also solved the problem of theatricality in the French picturesque garden. Unlike theatre and paintings in which the depiction of human action is the central theme, the picturesque garden employed both the dramatic and the pastoral conception of spectatorship to overcome theatricality. The dramatic conception of the tableau was important for the persuasiveness of those scenes representing human action which were presented in the garden. There, the illusion of naturalness was constructed around an economy of vision in which the viewer is denied, or at least in which his attention is not drawn to the act of looking. This device allowed human action to animate the picturesque garden and reinforce its status as a natural and true tableau as fully as its statues, ruins, follies and inscriptions. But all this would have been of little consequence had it not been supported by the secretive gaze Diderot had already advocated in relation to theatre and painting. This is particularly noticeable in de Ligne's description of his own garden at Beloeil. In the 'English' section of the garden he planned to build a Tartar village inhabited by shepherds and milkmaids who would sing and dance in the evening.[58] This spectacle would only have been visible from the French part of the garden, through a number of openings in the espaliered walls. Describing the viewpoint from which his Tartar village was to be observed, de Ligne writes, 'here you can see everything without being seen'. In the garden, just as in the theatre or in a painting, this hidden gaze is a necessary condition to overcome the problem of theatricality and offer instead, 'the continual animation of a spirited tableau'.[59] And like Diderot's, de Ligne's gaze can be called voyeuristic since it tends to make what it falls upon into an object of erotic desire. On the Isle of Flora in the gardens of Beloeil, he erected a pool 'in the Russian manner ... with several steps down so one may bathe in comfort, whereas around it there are curtains that, gracefully spread and draped, should protect young Susannas from the curiosity of indiscreet swains'.[60]

For the tableaux and scenes in the picturesque garden it was clearly not enough that they merely address the eye, they also needed to arouse emotional and even physical sensations in the spectator. In order to transform the garden into an affective, living, picture, movement itself was essential, wrote Abbé Delille.[61] As I pointed out above, Watelet thought that the picturesque garden was better described in terms of 'theatrical scenes' than 'tableaux'.[62] Although he stated that the viewer's interest in the garden would be attracted by scenes in which actors were performing, he was also aware of the threat of theatricality. In too many royal and princely estates, he claimed, the basis of theatrical scenes was a conspicuous vanity that corrupts society.[63] In order to avoid this it was not enough that theatrical performance within the garden was restricted to dancing pantomimes. The real solution to the problem of theatricality is again located in the figure of the spectator. In gardens that are remote from the artificiality of capitals

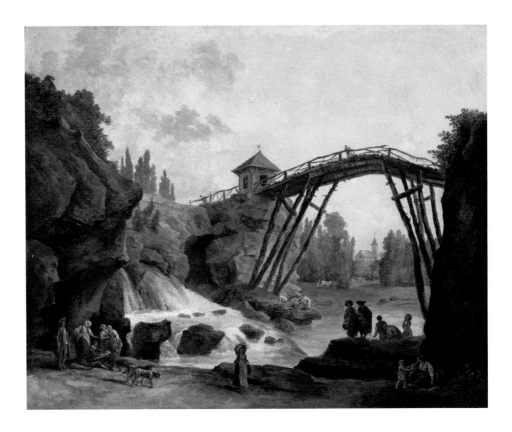

or big cities, theatrical representations pose fewer problems because they attract fewer visitors. In those gardens, wrote Watelet, 'the actors play in a more liberated and natural way, and often better, when they play for a half empty house', implying then that it is easier for the actor to sustain the illusion that he is not playing a role when there are fewer onlookers.[64] This point of view is similar to Diderot's conception of the fourth wall in which he argued that an actor should play as if there were no spectators at all. With Watelet's emphasis on the number of visitors, the onlooker and the object of looking are again caught up in a regime of visuality that neutralizes the act of looking and that contributes to the fiction of natural representation.

Diderot's claim that a painting, like a theatre performance, ought to be conceived independently of a beholder, was not only important for the naturalness of the representation. Neutralizing the act of looking was also an essential condition for involving the spectator in the scene represented and transforming his position from an excluded spectator into that of an involved actor. Discussing Hubert Robert's *Grande galerie éclairée du fond* (now lost), Diderot wrote in his *Salon de 1767* that he was prevented from entering this painting because there were far too many figures. He would have been inclined to step into this painting, he says, only when 'three-quarters of the figures were eliminated', and only those kept 'which add to solitude and to silence'. There are 'too many intruders' to allow the spectator to enter the painting secretly or without attracting attention. Now Diderot satisfies himself by admiring Robert's work, being fully aware of the fact that he is only *looking* at the painting: 'I stop, I look, I admire and I pass by.'[65] If we look at the painting Robert made of the garden of Méréville (*plate* 4) – a garden which he actually designed as well – a similar remark could be made: the number of figures here would also have prevented Diderot from stepping unnoticed into this painting.

The idea that there are too many visitors or intruders is one of the annoyances de Ligne often complained about in his *Coup d'oeil*, and can even be related to his

disapproval of the theatricality of Parc Monceau. The fact that one could see all the different scenes at once in Parc Monceau, not only made it 'a storehouse ... of mere scenes',[66] for de Ligne, it meant that above all one was constantly aware of being the possible object of looking. In his own garden designs, de Ligne always took care that a spectator could not see his scenes or follies all at once, but arranged the design so that they were successively revealed to the visitor in a series of walks, each of which had their specific dramaturgies.[67] This demand for a succession of scenes implied that the visitor must walk through the garden in order to see everything. With the picturesque garden, walking and strolling had themselves become a topic in the art of gardening. Pierre Henri Valenciennes wrote in his *Eléments de perspective pratique à l'usage des peintres* (1800), 'that in France only recently one did not know how to walk. The composition of gardens was totally different from those of today.'[68] Two years later in 1802, the German Karl Gottlob Schelle wrote *Die Spatziergänger oder die Kunst spatzierenzugehen* (The Stroller or the Art of Strolling). By that time, Rebecca Solnit writes in her study on the history of walking, the pedestrian repertoire was already an expressive medium for the visitor's desire to merge with nature, and typically followed a carefully constructed *mise-en-scene* that strictly defined the place of the spectator.[69]

The spectator's place was marked by more than simply the benches, temples, grottoes or other follies that were distributed in the garden. Equally important, but generally overlooked, is the way in which the pathway functioned as a *locus of looking*. Although many picturesque garden theorists gave some attention to paths, only Christian Hirschfeld in his *Théorie de l'art des jardins* (1779–85) provided a true typology.[70] Pathways in the garden had not only formal and affective meanings. Big avenues and straight paths, small curved paths adorned with flowers bushes or trees, for instance, were essential in marking the spectator's place as well. Most of Hirschfeld's attention went to winding or serpentine paths because he judged them apt for circuit walks. 'Secreting them here and there rather then allowing many to burst into sight all at once',[71] makes it possible for serpentine paths to lead the visitor from one scene to another in such a way that 'he does not notice the continuation of the path'.[72] Secreting or at least minimizing the spectator's place is a further strategy through which the spectator is made unaware of his own spectatorship and through which the estrangement between the spectator and the object he beholds is overcome. Walking along pathways that should 'have something of a careless and negligent quality such as nature bestows ... on her own works'[73] encouraged the spectator to overcome the theatricality of the garden in order to become a participant in the grand spectacle of nature.

Conclusion

Picturesque garden theory in the second half of the eighteenth century in France drew first on painterly examples. Painterly models deployed in gardens were considered to be the ideal way to reconcile art and nature or, rather, to naturalize art and to overcome the threat of artificiality. As we have seen, this artificiality was explicitly defined in theatrical terms, suggesting that the theatre was not a feasible model for picturesque gardening. However, theatricality in the second half of the eighteenth century was an extremely complex and extensive problem that was not confined to the theatre itself but haunted the arts and even society itself. Operative in almost every discourse, theatricality and anti-theatricality posed specific questions about spectatorship. How could one see oneself and others without a theatrical frame? How could a work of art – be it a garden, a painting or even a theatrical performance – be seen without the disabling awareness that one is looking? In response, theatricality in eighteenth-

century French picturesque garden theory came to embrace a scopic regime that tried to neutralize visuality by promoting an ideology that vision was 'just looking'.

While picturesque garden theory and practice remained firmly embedded in the doctrine of ut *pictura poesis*, as John Dixon Hunt has argued, this is not only to do with the fact that gardens, paintings and theatre influenced each other and were comparable with each other in style, theme and effect. Belonging to one family 'who', as Horace Walpole said, 'dress and adorn Nature',[74] they also dealt in similar ways with the problem of theatricality. In all three arts, the spectator was a figure who had to be forgotten or at least minimized in order to avoid the danger of a distanced and self-reflexive way of looking that would hinder the unnoticeable transformation of spectator into participant.

Notes

1 John Dixon Hunt, 'Ut pictura poesis: the Garden and the Picturesque in England', in Monique Mosser and Georges Theyssot, eds, *The History of Garden Design: The Western Tradition from the Renaissance to the Present Day*, London and New York, 2000, 231. See also John Dixon Hunt, *The Picturesque Garden in Europe*, London and New York, 2002, 16–20.

2 Horace Walpole cited in Rebecca Solnit, *Wanderlust: A History of Walking*, London and New York, 2001, 89.

3 Dixon Hunt, *Garden Design*, 231–3 and Dixon Hunt, *Picturesque Garden*, 25.

4 For automata theatres and gardens, see L. Zangheri, 'Suggestionie fortunadei teatrini di automi. Pratolino come una Broadway manierista', *Quaderni di Teatro*, 7: 25, 1984, 78–84.

5 For the relation between architecture, theatre and gardens see John Dixon Hunt, *Gardens and the Picturesque: Studies in the History of Landscape Architecture*, Massachussets, 1994; Dieter Hennebo and Erika Schmidt, 'Das Theaterboskett. Zu Bedeutung und Zweckbestimmung des Herrenhäuser Heckentheaters', *Niedersächsisches Jahrbuch für Landesgeschichte*, 50:1, 1978, 213–74.

6 See Paolo Morachiello, 'Schönbrunn: a theatre of fragments', in Mosser and Theyssot, *Garden Design*, 197.

7 Marianne Roland Michel, 'Scenography and perspective in eighteenth-century French gardens', in Mosser and Theyssot, *Garden Design*, 243.

8 Louis de Jaucourt, 'Théâtre', in Jean Le Rond D'Alembert and Denis Diderot, eds, *Encyclopédie, ou dictionnaire raisonné des sciences et des arts*, Lausanne and Bern, 1781, vol. 33, 354.

9 A question that in France can largely be related to the reception of Abbé Dubos' influential *Réflexions critiques sur la poésie et sur la peinture* (1719) by Batteux, Laugier, Diderot, Marmontel and others without a consistent and systematized opinion of the sort promoted in Lessings *Laokoon* (1766), ever emerging. See Ernst Cassirer, *The Philosophy of the Enlightenment*, Boston, MA, 1962, 349–55 and Annie Becq, *Genèse de l'esthétique française moderne 1680–1814*, Paris, 1994, 630–5.

10 On Parc Monceau, see Dixon Hunt, *Picturesque Garden*, 119–22; Dora Wiebenson, *The Picturesque Garden in France*, Princeton, NJ, 1978, 89–99; David Hays, 'Carmontelle's design for the Jardin de Monceau', *Eighteenth Century Studies*, 32, 1999, 447–62.

11 'Transportons nous dans nos jardins les changements de scènes des opéras. Faisons-y voir en réalité ce que les plus habiles peintres pourraient y offrir en décorations, tous les temps et tous les lieux.' Carmontelle, *Le jardin de Monceau, près de Paris*, Paris, 1779, 4.

12 For the moving panoramas of Carmontelle, see Barbara Maria Stafford and Frances Terpak, *Devices of Wonder : From the World in a Box to Images on a Screen*, Los Angeles, CA, 2001, 330–5. Monique Mosser, 'Les promenades du regard: les panoramiques et la theorie des jardins', in Odile Kammerer, ed., *Papiers peints panoramiques*, Paris, 1990, 194–209.

13 Claude-Henri Watelet, *Essai sur les jardins*, Paris, 2004, 23.

14 Watelet, *Essai sur les jardins*, 23–4.

15 Thomas Whately, *Observation on Modern Gardening*, London, 1771, 106. See also Michel Baridon, *Les jardins. Paysagistes-Peintres-Poètes*, Paris, 1998, 850–2 and 863–76.

16 There are three editions of the work, the first dating from 1781, the second from 1786 and the last from 1795. I use the last version, which is the only one that has been translated into English and annotated. Charles Joseph de Ligne, *Coup d'oeil sur Beloeil and a Great Number of European Gardens*, trans. and ed. by Basil Guy, Berkeley and Los Angeles, CA, 1991. An excellent account of de Ligne's life is to be found in Philip Mansel, *Prince of Europe: The Life of Charles Joseph de Ligne*, London, 2003.

17 De Ligne, *Coup d'oeil*, 195–7.

18 De Ligne, *Coup d'oeil*, 121.

19 De Ligne, *Coup d'oeil*, 135.

20 'L'art qui se montre détruit l'effet de l'art.' Watelet, *Essai sur les jardins*, 26.

21 'Il s'est donc formé dans la peinture un style faux, qu'on a nommé style *théâtral*. Les compositions n'ont plus représenté l'histoire, mais des scenes de théâtre. Les attitudes, les gestes, les expressions des personnages, ont été ceux des comédiens, & l'art a été d'autant plus dégradé, que ses ouvrages n'ont plus été que des imitations imparfaites d'imitations elles-mêmes défectueuses. Comme les acteurs tragiques s'étoient ridiculement écartés de la nature, les peintres, en les copiant, s'en écartèrent encore d'avantage, par la raison que les copiistes exagèrent toujours les vices de leurs originaux.' Claude-Henri Watelet, *Dictionnaire des Beaux-arts*, Paris and Genève, 1972, vol. 2, 405.

22 Elizabeth Burns, *Theatricality: A Study of Convention in the Theatre and in Social Life*, London, 1972; Erika Fischer-Lichte, 'Introduction: Theatricality: a key concept in theatre and cultural studies', *Theatre Research International*, 20:2, 1995, 85–9; Helmar Schramm, *Karneval des Denkens. Theatralität im Spiegel philosophischer Texte des 16. und 17. Jahrhunderts*, Berlin, 1996; Thomas Postlewait and Tracy Davis, 'Theatricality: an introduction', in Thomas Postlewait and Tracy Davis, eds, *Theatricality*, Cambridge, 2003, 1–39.

23 Burns, *Theatricality*, 9.

24 Jonas Barish, *The Anti-theatrical Prejudice*, Berkeley, CA, 1985.

25 Richard Sennett, *The Fall of Public Man*, London and Boston, MA, 1974, 35–8.

26 Jean Jacques Rousseau, *Lettre à M. D'Alembert sur son article Genève*, Paris, 1967, 163.

27 For Rousseau's *Lettre* as an expression of his fear of loss of identity caused by the theatre, see Günther Heeg, *Das Phantasma der natürlichen Gestalt. Körper, Sprache und Bild im Theater des 18. Jahrhunderts*, Frankfurt a. Main and Basel, 2000, 13–31.

28 De Ligne, *Coup d'oeil*, 264–7.

29 Charles Joseph de Ligne, *Colette et Lucas, comédie en 1 acte, melée d'ariettes*, s.l., 1781. See Mansel, *Prince of Europe*, 80.

30 Robert Mauzi, *L'idée du bonheur dans la littérature et la pensée farnçaises au XVIII siècle*, Paris, 1994, 145–8. See also Jean Ehrard, *L'idée de Nature en France dans la première moitié du XVIIIe siècle*, Paris, 1994, 742–52.

31 Postlewait and Davis, *Theatricality*, 17. For the influence of Shaftesbury on French aesthetic theory, see Becq, *Genèse de l'esthétique*, 162–73 and Jean-Marc Braem, 'Diderot traducteur de l'Inquiry Concerning Virtue or Merit', *Etudes sur le XVIIIe siècle*, 8, 1981, 7–24.

32 On the rather strange way Sulzer and his *Allgemeine Theorie der schönen Künsten* found their way into the Encyclopédie, see Lawrence Kerslake, 'Johann Georg Sulzer and the supplement to the Encyclopédie', *Studies on Voltaire and the Eighteenth Century*, 148, 1976, 240.

33 'NATUREL, *Beaux arts*, adjectif par lequel on désigne les objets artificiels qui se présentent à nous comme si l'art ne s'en étoit point mêlé, &

qu'ils fussent des productions de la nature. Un tableau qui frappe les yeux, comme si l'on voyoit l'objet même qu'il représente; une action dramatique qui fait oublier que ce n'est qu'un spectacle; une description, la représentation d'un caractère qui nous donnent les mêmes idées des choses que si nous les avions vues ... tout cela s'appelle *naturel*'. Johann Georg Sulzer, 'Naturel, Beaux-arts', Diderot and D'Alembert, *Encyclopédie*, 238.

34 Diderot and D'Alembert, *Encyclopédie*, 238.

35 Luigi Riccoboni, *Pensées sur la déclamation*, Paris, 1738; François Riccoboni, *L'art du théâtre*, Paris, 1750; Pierre Rémond de Saint-Albine, *Le comédien*, Paris, 1748; Jean Nicolas Servandoni D'Hannetaire, *Observation sur l'art du comédien*, Paris and Bruxelles, 1772; Charles Joseph de Ligne, *Lettres à Eugénie sur les spectacles*, Bruxelles, 1774. For a discussion of French 'reformist' theatre theory of the second half of the eighteenth century, see David Trott, *Théâtre du XVIII siècle. Jeux, écritures, regards*, Montpellier, 2000; Bram van Oostveldt, *Tranen om het alledaagse. Het verlangen naar natuurlijkheid en de enscenering van burgerlijke identiteit in drama en theater in de Oostenrijkse Nederlanden*, Ghent, 2005.

36 Roland Barthes, *Image, Music, Text*, New York, 1977, 69–78. See also Pierre Frantz, *L'esthétique du tableau dans le théâtre du XVIIe siècle*, Paris, 1998.

37 'Une disposition de ces personnages sur la scène, si naturelle et si vraie, que, rendue fidèlement par un peintre, elle me plairait sur la toile, est un tableau.' Denis Diderot, 'Entretiens sur le fils naturel', in Denis Diderot, *œuvres Complètes. Esthétique – Théâtre*, ed. Laurent Versini, Paris, 1996, vol. 4, 1136.

38 Peter de Bolla remarks that 'Vision is not only literally a topic of great concern to Enlightenment thought; it also furnishes, via an entire tropological field, some of the grounding figures of conceptualization in general. In this sense one might say that vision figures Enlightenment thought.' Peter de Bolla, 'The visibility of visuality', in Teresa Brennan and Martin Jay, eds, *Vision in Context: Historical and Contemporary Perspectives on Sight*, New York and London, 1996, 65.

39 'La vuë a plus d'empire sur l'ame que les autres sens. ... On peut dire, métaphoriquement parlant, que l'oeil est plus près de l'ame que l'oreille.' Jean-Baptiste Dubos, *Réflexions critiques sur la poésie et sur la peinture*, Genève, 1967, 111.

40 Martin Jay, *Downcast Eyes: The Denigration of Vision in Tentieth-Century French Thought*, Berkeley, CA, London and Los Angeles, CA, 1994, 1–15.

41 See for instance Denis Diderot, 'Lettres sur les sourds et muets', in Diderot, *œuvres Complètes*, vol. 4, 17 and Denis Diderot, 'De la poésie dramatique', in Diderot, *œuvres Complètes*, vol. 4, 1336–44.

42 Jay, *Downcast Eyes*, 98–103.

43 'Soit donc que vous composiez, soit donc que vous jouez ne pensez non plus au spectateur que s'il n'existait pas. Imaginez sur le bord du théâtre un grand mûr qui vous sépare du parterre; jouez comme si la toile ne se levait pas. Denis Diderot, 'De la poésie dramatique', in Diderot, *œuvres Complètes*, vol. 4, 1310.

44 For the difference between vision and visuality, see Hal Foster, 'Preface', in Hal Foster, ed., *Vision and Visuality*, Seattle, WA, 1988, x–xi and Martin Jay, 'Scopic regimes of modernity', in Foster, *Vision and Visuality*, 3–27.

45 Maaike Bleeker, *Visuality in the Theatre: The Locus of Looking*, Amsterdam, 2002, 32.

46 'Une scene représentée sur une toile, ou sur les planches, ne suppose pas de témoins'. Denis Diderot, 'Salon de 1767', in Diderot, *œuvres complètes*, vol. 4, 558.

47 For the mixture of innocence and eroticism in Diderot's ideas on theatricality and painting see Heeg, *Das Phantasma*, 55–64

48 On the exclusivity of the Diderotian tableau see Barthes, *Image, Music, Text*, 69–78.

49 Michael Fried, *Absorption and Theatricality: Painting and Beholder in the Age of Diderot*, Chicago, IL, 1980, 8–11.

50 Bleeker, *Visuality in the Theatre*, 35.

51 Watelet, *Essai sur les jardins*, 26.

52 De Ligne, *Coup d'oeil*, 99.

53 Dixon Hunt, *Picturesque Garden*, 139. See Jean de Cayeux, 'The gardens of Hubert Robert', in Mosser and Georges, *Garden Design*, 340–3.

54 This trope of physically entering a painting is particularly noticeable in the long and famous section in the *Salon de 1767* where Diderot describes a series of walks he pretends he has taken within the paintings of Vernet. Denis Diderot, 'Salon de 1767', in Diderot, *œuvres Complètes*, vol. 4, 595–635.

55 See Fried, *Absorption and Theatricality*, 131–43.

56 Fried, *Absorption and Theatricality*, 131–2.

57 Diderot, *œuvres Complètes*, vol. 4, 594–635.

58 De Ligne, *Coup d'oeil*, 79–80.

59 De Ligne, *Coup d'oeil*, 93 (my emphasis).

60 De Ligne, *Coup d'oeil*, 85.

61 Jacques Delille, *Les jardins*, Paris, 1818, 22.

62 Watelet, *Essai sur les jardins*, 23–4.

63 Watelet, *Essai sur les jardins*, 38.

64 'Les acteurs jouent d'une manière plus libre, lorsque la salle du spectacle n'est qu'à moitié remplie, et n'en sont que plus naturels, et souvent meilleurs.' Watelet, *Essai sur les jardins*, 40.

65 'Ne sentez-vous pas qu'il y a trop de figures ici, qu'il en faut effacer les trois quarts ? Il n'en faut réserver que celles qui ajouteront à la solitude et au silence. ... Je n'aurais jamais pu me défendre d'aller rêver sous cette voûte, de m'asseoir entre ces colonnes, d'entrer dans votre tableau. Mais il y a trop d'importuns ; je m'arrête, je regarde, j'admire et je passe.' Denis Diderot, 'Salon de 1767', in Diderot, *œuvres Complètes*, vol. 4, 701.

66 De Ligne, *Coup d'oeil*, 195.

67 In the English section of his own gardens at Beloeil, he created a small circuit walk which he named 'the tableau of human life'. Through small paths and rills, the visitor is led to several scenes representing the different stages of life from childhood to death. De Ligne, *Coup d'œil*, 81–4.

68 'Il n'y a pas longtemps qu'on s'est aperçu, en France, qu'on ne savait pas se promener. La composition des jardins était toute différente de ce qu'elle est aujourd'hui.' Pierre-Henri Valenciennes, *Eléments de perspective pratique à l'usage des peintres*, Genève, 1973, 347.

69 Solnit, *Wanderlust*, 100–2.

70 Although Hirschfeld was German, his *Theory* appeared simultaneously in German and French. Christian Hirschfeld, *Theory of Garden Art*, trans. and ed. by Linda Parshall, Philadelphia, PA, 2001, 251–4.

71 Hirschfeld, *Theory of Garden Art*, 252–3.

72 Hirschfeld, *Theory of Garden Art*, 355.

73 Hirschfeld, *Theory of Garden Art*, 254.

74 Walpole, cited in Solnit, *Wanderlust*, 89.

Chapter 13
'What do I See?' The Order of Looking in Lessing's *Emilia Galotti*

Kati Röttger

In his much cited study *Absorption and Theatricality: Painting and Beholder in the Age of Diderot* (1980), Michael Fried gives a central place to the terms 'absorption' and 'theatricality' as ways to describe two competing kinds of gaze by the beholder. Whereas the concept of absorption implies the exclusion of the spectator and the autonomy of the world[1] depicted in the painting, according to Fried a theatrical relation emerges as soon as a painting presents itself to the spectator as something to be seen. In this latter case the realm of pictorial representation is expanded and extends outward into the reality of its spectator. Following up a 'renewal of interest in the sister doctrines'[2] of *theatre and painting, forms that traditionally exhibit very close parallels*, Fried bases his distinction on Diderot's theoretical writings on their relationship.[3] Both paintings and stage were conceived from the Renaissance onwards from the point of view of a spectator, and not only when linear perspective was used. Theorists such as Alberti explicitly postulated the inclusion of figures who negotiate the boundaries between beholder and pictorial world.[4] In the course of the eighteenth century the popularity of this tradition waned in favour of a new mode of representation that, as on the stage conceived by Diderot, presented its characters as solely occupied with themselves. Fried reads this presentation of immersed characters or scenes as the response to a 'demand that the artist bring about a paradoxical relationship between painting and beholder – specifically, that he find a way to neutralize and negate the beholder's presence, to establish the fiction that no one is standing before the canvas'.[5]

This paradoxical relation – the imagining of a continuity between reality and the pictorial space through the depiction of figures who ignore the spectator – arises because only the autonomy of scenes can captivate beholders and make them forget their position as beholders. Particularly noteworthy is the way Fried formulates the illusionist principle that marks the interplay between the figure's absorption within the painting and the beholder's absorption in front of the painting as a *dramatic conception*. 'At bottom', Fried notes, this interplay is 'a means to its end', that is, it is conducive to the abolition of the sense that reality and pictorial space are distinct.[6] This hypothesis is worth discussing for two reasons.

Firstly, Fried derives the very concept of 'absorption' to describe the new 'relationship between painting and beholder' directly from the theatre. The same dramatic concept can be found in Diderot's definition of the relation between the viewer and the stage, for which he invented the concept of the 'Fourth Wall' that has since gained wide acceptance: 'whether you are writing or whether you're acting, think no more of the spectator than if he did not exist. Imagine at the edge of the stage

Detail from Heinrich Gottlieb Eckert, *Portrait of Friedrich Ludwig Schröder in the role of Odorado in 'Emilia Galotti'*, c. 1780, (plate 1).

Theatricality in Early Modern Art and Architecture *Edited by Caroline van Eck and Stijn Bussels* © 2011 Association of Art Historians.

a large wall which separates you from the orchestra; act as if the curtain never rose.'[7] Fried's distinction between the concepts of *absorption* and *theatricality* is based on two distinct approaches to theatre. While *absorption* derives from an eighteenth-century concept of a theatre primarily founded on dramatic structure, the notion of theatre inherent in *theatricality* builds on its status as an event that unfolds in front of an audience.

Secondly, these distinct approaches to theatre imply different value systems and thus also distinct criteria for valuing painting. While the term absorption sees the autonomy of the work of art in a positive way, the concept of theatricality commonly carries negative connotations by challenging the *value* of the work of art. Fried states: 'In several essays on recent abstract painting and sculpture I ... argued that much seemingly difficult and advanced but actually ingratiating and mediocre work of those years sought to establish what I called a *theatrical* relation to the beholder, whereas the very best recent work ... was in essence *anti-theatrical*.'[8] From the perspective of theatre studies, Fried's analysis appears to be rooted in a tradition of 'antitheatrical prejudices' going back to Plato.[9]

In the following, I will accordingly use the perspective of theatre studies to shed some light on the paradoxical relation between a work of art and its viewer that Fried applies to painting of the second half of the eighteenth century. Assuming that the term 'theatricality' at root denotes the coherence of structures that constitute theatre, my argument will focus on the structural use of this concept as a model of thought (*Erkenntnismodell*).[10] In order to elucidate this, I will concentrate on the art-theoretical discussion of Emilia's portrait developed by Lessing in his play *Emilia Galotti* (1772). In the play Lessing, who was considered the first and leading expert on Diderot's writings in eighteenth-century Germany, debates the latter's aesthetic programme, particularly the paradox of the viewing situation, as well as his own aesthetic theory about the difference between poetry and painting (*Laocoön*, 1766).[11] The play offers statements about enlightenment theatricality from the perspective of theatre studies that may be considered an amendment to Fried's analysis. The concept of theatricality developed in this chapter refers to a network of relations between knowing, seeing, and theatre that reflects corresponding historical conditions of representation. The aesthetic self-understanding of enlightenment theatre, especially in relation to the function of the so-called Fourth Wall, might be regarded as the aesthetic precondition of what Fried calls 'the paradoxical relationship between [absorptive] painting and beholder'. A scrutiny of the relation between image, language, and body through an interrogation of the appropriateness of the media used on stage will clarify this paradoxical relationship. By media in this context I mean the aesthetic means of representation I am calling image, language, and the actors' bodies. I base this notion especially on the idea of the interrelation between media that constitute the theatrical event by the distribution of the sensible (Ranciére) and the transmission of meaning.

Theatricality as a Search Criterion, or, the Paradox of the Fourth Wall

As an important scholar of theatricality, Helmar Schramm provides one of the most prominent contributions to the definition of the concept of theatricality and its epistemological usefulness in his book *Karneval des Denkens: Theatralität im Spiegel philosophischer Texte des 16. und 17. Jahrhunderts* (1996). Schramm defines theatricality as an historically transformative structure that consists of three key elements: aisthesis (perception), kinesis (movement), and semiosis (language). As a dynamic field of interrelation these elements form an 'architectural triangle' that can be projected like an epistemological map onto historically conditioned modes of representation.

Theatricality thus denotes a specific mode of perception and also becomes, simultaneously, a central figure of representation and an analytic model of crises of representation that can be traced back to changes in the material basis of linguistic behaviour, cultures of perception, and modes of thinking. Schramm's motivation for his desire to establish theatricality as an element of interdisciplinary discourse is a philosophical interest in transferring the heuristic energies of the theatrical model into a 'performance of thought'.[12]

In Schramm's model, enlightenment theatre and its obsession with the search for a truthful representation of reality, is given a key role. None other than Diderot states frankly that this search ultimately seeks conformity with a *fictional* model of reality: 'What, then, is truth for stage purposes? It is the conformity of action, speech, facial expression, voice, movement, and gestures [of the character portrayed by an actor] with an ideal model imagined by the author.'[13] This idea of conformity with a fictional ('ideal') model of reality attempts to mask the nature of theatricality by avoiding any reference to the fact that the audience attends a theatre performance. Nonetheless, an examination of Diderot's definition of the Fourth Wall will support the hypothesis that this mode of representation is completely infused with theatricality.

Diderot seems to introduce the Fourth Wall as a warrant for an illusionist technique on stage that is as natural as possible and that can only be called ideal if it dispenses with the spectator completely. Fried's notion of absorption is deduced from this assumption. But in the study *Der Blick durch die Wand. Zur Geschichte des Theaterzuschauers und des Visuellen bei Diderot und Lessing*,[14] Johannes Friedrich Lehmann vehemently rejects any such position. Contrary to what theatre historical research has often assumed,[15] Lehmann clarifies in a plausible and enlightening argument how Diderot does not primarily address the natural truth of the actor and of gesticulation but rather its observation, and moreover the *observation of the observer*:[16] 'One should not interpret the Fourth Wall as a means of creating illusion or as the enlightenment's propagation of the *vrai de nature* but rather *as a means of producing relationships of observation* ... and simultaneously reveal[ing] its effects to be artificial.'[17] Lehmann offers the most convincing evidence for this hypothesis in a discussion of Diderot's novel *Les Bijoux indiscrets* (1748). Lehmann writes:[18]

> The idea of confronting theatre with an unobserved observer appears for the first time – in the shape of the Fourth Wall – in the *Bijoux Indiscrets*. Here, a stranger appears as spectator who – watching the stage from a hidden place in a special box – thinks that he is a surreptitious witness of the events in the sultan's palace. ...The spectator is to take fiction for reality, which, in turn, is used to gauge the fiction's perfection. ...With this awareness of being a spectator every aesthetic illusion reaches its limit. And the Fourth Wall is no attempt to abolish this limit but *a means to create a relation between the viewer and the stage* that allows a specific aesthetic experience by way of this limit.[19]

This specific aesthetic experience raises not only the question of the 'how' of representation[20] and its specific means, but also, as Diderot states in his letters on the deaf-and-dumb and on the blind, the question of the difference between the senses with which we perceive. This leads Lehmann to the conclusion that Diderot interrelates the senses' modes of perception by separating the perceptive organs (eye and ear) on the one hand, and putting them under mutual supervision on the other. As far as perception in theatre goes, this means that, according to Diderot, the illusionist theatrical stage presents the relation between the gaze of the observer and

1 **Heinrich Gottlieb Eckert,**
Portrait of Friedrich Ludwig
Schröder in the role of Odorado
in 'Emilia Galotti', c. 1780.
Engraving, 153 × 93 cm.
Cologne: Theatermuseum
Schloss Wahn. Photo:
Universität zu Köln.

the body of the actor – that is, between observation and representation – by means of the Fourth Wall, and simultaneously questions it.[21] Far from being absorptive, this type of stage must be considered highly theatrical.

Fundamentally, theatricality appeals to the subject to approach the world and its objects from another, 'different' perspective.[22] In this light, the concept functions also as a discursive element since it does not represent disguise or deception but rather negotiates the relationship between truth and deceit, between reality and fiction. Theatricality inserts a gap between beholder and beheld that pervades their relationship with alterity, thus regulating and deregulating relations of perception: either by referring to the very status of beholder by opening up another perspective, an outsider's perspective, or by referring to the status of the beheld that 'breaks out of the frame' when it is considered to be theatrical. The pivotal point is the relationship of truth and illusion within the economy of epistemic objects, for theatricality suspends the fundamental constituents of the belief in perception, the 'deep-seated set of mute "opinions" implicated in our lives'.[23] These constituents are inseparably connected to what we believe we see when we see the world, to *how* we see the world, and in which media we see the world. By raising the question 'what is this *we*, what *seeing* is, and what *thing* our *world* is'[24] and how they are mediated, the discursive element of theatricality operates on epistemological, phenomenological, *and* medium-specific levels at the edge of this belief.

Ultimately this question also concerns world-views (*Weltbilder*). In a way, theatricality separates world-views by transgressing and thus making perceivable the boundaries (by framing them, for example, or by demonstrating their constructedness) that reveal them as world-views, in order to expose them to evaluation or devaluation.[25] Theatricality thus represents a *threshold* of knowledge and intuition in Kant's sense, for theatricality regulates the doubt of sense-deception: by either dissolving it or reinforcing it, depending on the discursive (or even ideological) formations within which the structural concept operates. Theatricality functions at the core of the difference between reality and fiction, and thus acts as an impetus to the theory of representation. Theatre attains such a prominent role as the primary medium of vision in the eighteenth century – a paradigmatic status that Fried recognizes – because it represents the ambiguity of the world that is implanted into this thought and transforms it into aesthetic discourse. It appears as mediator between the imagination (as a mental 'performance') and the actual performance that unfolds in time and space. Theatre institutionalizes the deceit of perception as a necessary illusion in order to rehearse and reinforce our belief in what we perceive. Theatre thus embodies a central, precarious, concern of the enlightenment. It calls on eyewitnesses to bring forth (human) 'nature' as a 'truth of nature' in a congruence of imagination and representation by means of an 'imitation' of an ideal model existing in the

imagination. Consequently, and as an extension of Johannes Friedrich Lehmann's argument, the Fourth Wall represents what turns out to be the core problem of the 'theatricality of the enlightenment': a mimetic paradox[26] that describes the chiasmus between belief in perception and doubt about perception, between fiction and truth, reality and illusion, a chiasmus, because these terms can also be related in reversal.

The Portrayed Body as an Object of Exchange and Deception in Lessing's *Emilia Galotti* [27]

In his domestic tragedy *Emilia Galotti*, Lessing presents an aesthetic programme for the theatre of his time that examines, within their exemplary interaction on stage, the distinction between poetry and painting (word and image) he had offered in his *Laocoön* (1766). The following will demonstrate how Lessing negotiates in *Emilia* the different ways the media image, word, and body make Emilia appear on stage. The underlying question of the appropriateness of these media for the true representation of a character includes a theory of vision that appeals to a theatrical perspective. The starting point for the explication of this hypothesis is the well-known art-theoretical discussion that the portrait of the citizen's daughter Emilia sparks between her aristocratic seducer, Prince Gonzaga, and his painter Conti.

'If she is not worthy of what I plan to do for her?'[28] reads the inscription underneath the picture of the actor Friedrich Ludwig Schröder in the role of Emilia's father Odoardo (*plate 1*). No statement could summarize better the precarious relationship between verbal and visual representation that *Emilia Galotti* negotiates in the account it gives of their intersection within the portrait. For the play addresses not only the problem of presence or absence of bodies (that is, characters) in various media of representation, it also raises the issue of the value of each respective body. Indeed, within the medium of the image or, more precisely, of the portrait, the representation of the actor Schröder refers to the fictional character of Odoardo embodied in the medium of the actor, whose words in turn invoke the image of the absent Emilia. The issue of value that appears within this medial interweaving of image, body, and word, and the resulting means of representation, is an issue of the authenticity of the represented 'objects' as original and replica. Emilia thus becomes the invisible centre of the discussion. In order to achieve this effect, Lessing brings the media of the sayable and the seeable into constant competition (collision) in order to fight for the appropriateness to represent her character. This competition of media makes it possible to use the scale of (successful) illusion or similitude to gauge the (exchange-)value of the 'object' in the alternation of media in which it appears.[29]

Lessing introduces this motif directly in the play's exposition in the first act. Emilia does not appear 'corporeally' but as an arbitrary sign: 'Emilia? – An Emilia?', asks the Prince, who works his way through a pile of petitions. Instantly, this first oral reference to the character proves to be a mistake. Though it is the 'right' name, it refers to the 'wrong' person: 'But an Emilia Bruneschi – not Galotti. Not Emilia Galotti!' The arbitrary nature of the following scene further reinforces the apparent arbitrariness of the sign: 'What does she want, this Emilia Bruneschi? (*He reads*) She asks for much, very much. – But her name is Emilia. Granted!'[30]

Even though it denotes the 'wrong' Emilia, the arbitrary sign invokes thoughts of the 'right' Emilia – and thus the Prince's desire to see her. In competition with the mental image of Emilia that the name evokes in the Prince, the next scene introduces the pictorial representation of the character. Conti, the painter, offers the Prince a portrait of Emilia. The first reaction of the Prince indicates the images' striking similitude: 'What do I see? Your work, Conti? Or the work of my imagination? –

Emilia Galotti!' And soon after: 'By God! As if stolen from a mirror!'[31] Gradually the nature of the exchange object becomes apparent: it is the initially undefined internal or mental image of Emilia which in the course of the play undergoes various stages of materialization (naturalization) within the competing media of making-visible (painting and theatre; portrait and actor's body) until in the end, and following the argument of *Laocoön*, the imagination separates the mental image from the visible surface and the image transforms into a new 'incorporeality'.[32] In the 'arena' of the theatre the play thus presents the indistinguishable nature of image and reality as a struggle about illusion and deception between the arts. At the same time this struggle is a central aspect of the dramatic conflict of the tragedy: dramaturgical motif is confusion and *Emilia* the object. Thus, Lessing offers a statement that takes a clear stance, particularly in respect to Diderot's writings. What does this mean?

Lessing's Answer to Diderot

Lessing was well acquainted with Diderot's writings, having published *The Theatre of Monsieur Diderot* in 1760. In *Laocoön*, Lessing critically analyses semiotic issues that Diderot had raised in his *Lettre sur les sourds et les muets* (1751). He was therefore familiar with Diderot's discussion of the 'how' of representation, its specific means, and its perception through the various senses, as well as Diderot's discussion of the relationship between the audience's gaze and the actor's body, between observation and representation. In *Emilia Galotti*, Lessing follows up the idea of an economy of appropriate signs by scrutinizing exchange (*Tausch*) and illusion (*Täuschung*) in the staging of transitions between body, image, and word. Emilia's (fictional and performative) body appears in alternating forms (severally, text, the actor, portrait, projection screen, stage), and Lessing employs the exchange between the media of Emilia's image and body to examine the question of representational media by pitting them against each other. In other words: Lessing directs our gaze onto the media of representation in order to make the paradoxical visibility of the actor's body explicit in relation to the illusive imitation of nature within theatre's *stage-of-perception* and – thus answering Diderot – in order to propose a solution. The key to this process is the portrait[33] that triggers the conflict about original and replica, about the reality and fiction of Emilia (and as an object of struggle for her possession by the father, the prince and her husband-to-be) in the play.

The Stage of the Portrait

In its function as a stage, the portrait serves as a gauge for the symbolic value of 'Emilia' based on the *media of her representation*. Lessing thus stages her character as the location of an aesthetic debate:[34] In the very first portrait scene Lessing opens up a Diderot-like perspective on the female body by comparing its representation on the basis of 'artistic judgement'. It is noteworthy that this comparison uses a second portrait depicting the Countess Orsina, an aristocrat and a schemer who is the former mistress of the Prince, as a reference. While the Prince only detects illusion instead of similitude in the portrait of Countess Orsina ('her picture in any case is not herself'[35]), in the portrait of Emilia he discovers the 'masterwork of nature' that matches the art-theoretical ideal of his time. This ideal, however, only appears to the 'dismembering gaze', which results from 'the process of amalgamating the most beautiful parts of miscellaneous models into a completely new, ideal whole'.[36] Essential here is the epistemic theatrical gaze that Lessing places on the very media that render the female body visible: the media of pictorial images and of the theatre. Hans Belting's analysis of the historic constitution of the concept of the

body in the image cultures of modernity and the enlightenment further illuminates this correlation.[37] On the basis of the problematic of similitude, Belting argues for a difference between the Court representations of a proper body-sign and the bourgeois representation of a body-image. While the sign in heraldic abstraction appears on the escutcheon, the image emerges in the portrait. Belting's formulation of a media-historical interrelation between both forms of representation is especially enlightening in our context:

> In this context it is important to introduce a distinction that is commonly forgotten in heraldry, namely the distinction between the crest itself and the escutcheon that is its transporting medium. The same distinction applies to the portrait and the portrait plate as an object in its own right. In the case of the crest, the so-called écus or escutcheons were a privilege of the liege and person of rank while the crests were early on adapted by the bourgeoisie. The image (crest) carrier not only represents a body (in the case of the crest, however, a social body) but also possesses as an object itself a physical body: a carrier of a function for the ritual of representation. The medium of an independent carrier is constitutive for this distinction. Let us compare in this context the escutcheon and the plate, which incidentally have the same historical name (*Schild* or *tableau*).[38]

Of course, what may seem a too stark contrast must be recognized as the product of a gradual development, which, as Belting points out elsewhere, emerges in the process of the 'formation of painting'[39] after 1440. Naturally, the new bourgeoisie did not invent the portrait, but it certainly re-defined its status. Only in the form of an autonomous picture did it fulfil its purpose of representing a person. 'In the case of the citizen, the similitude with the portrayed person thereby replaced the emblem of status and dominion that belonged to the gentry.'[40]

In short: there is a strong divergence of opinion regarding the medium representing the body. The escutcheon or *tableau* – that is, the wooden panel or the wooden board as the material medium of representation – goes back to the title of the sovereign, for 'the image became law based on the panel's function as a gift or trade object of the sovereigns or as an element of a genealogical line'.[41] The related concept of 'representation' 'connoted more the *right for representation* than the *accomplishment of representation* that our modern perspective isolates as "similitude"'.[42] The play contains various references that further indicate that Lessing must have been aware of this background: On the one hand, Lessing explicates the theoretical proposal of an aesthetics of representation in the eighteenth century with an incident (the Roman-republican subject of Virginia whom her father killed with a poniard) the sources of which date back to the fourteenth century (Collucio Sallutati), and the time and location of which he transfers to Renaissance Italy. And, on the other hand, Lessing chose to refer to the painting as a *Schilderei* (depiction) at the very moment that it is *thematized* as an object of possession: 'Conti: ... The first [*Schilderei*], the one for which she sat, went to her absent father.'[43] In all other instances the play always uses the terms portrait or image. However, the extent of Lessing's vehement statement for the programme of a national theatre and *against* the conventions of court theatre implicit in the critique of the Prince's claim of ownership of the portrait panel becomes clear only when one considers the following:

As soon as it moved away from the profile of a heraldic-rigid figure, the plate introduced the metaphor of the windowpane to overcome the flat surface of the medium and direct our gaze into space. By turning into frontality, the portrait moved away from the crest as it had to define a real concept of the body, which also effectively transformed the very concept of the image.[44]

The connection between the portrait panel and the stage is particularly conspicuous in the Prince's different treatment of the two portrait panels. While he demands the servant to 'order a frame' for the discredited, deceiving image of Orsina so that it 'be placed in the gallery'[45] – and thus reveal the opaque, visible viewing area within the framework of the sovereign culture of intrigues that Orsina represents to a crucial extent within the play – the audience initially sees only the *empty space* behind the portrait representing Emilia until Conti turns it round to show the portrait to the Prince. This procedure is repeated after the conversation with Conti: before his adviser Marinelli enters, the Prince turns the image to face the wall.[46]
The visible area is now relinquished in order to open up a theoretical perspective on the image through a debate about the degree of illusion and similitude in the imitation. Lessing breaks with the illusionist practice of painting and theatre and opens the gaze to their nature as media by focusing the audience's gaze on the back of the painting, the *medium of the empty space*. He thus makes it possible to *recognize* the media-specific conditions of visible phenomena in the illusionist process of painting and theatre. At this point the concept of an intermediality of theatre takes effect, a concept that makes perceivable the medial modalities that allow the visible and audible, image and speech to appear. The very media that make perceivable thereby become themselves visible and *distinguishable*. This, in turn, is the precondition for resolving the danger of indistinguishability, the mistakeability that is already present in Emilia's name, into a difference: image and body will separate. The staging of the gaze into the empty space of the portrait panel could not be realized more explicitly. It draws attention to the *medium* of the image in its objectivity and materiality. Simultaneously, it points to the empty space of the theatrical stage for it does not simply direct the gaze through a window in the Fourth Wall but refers to empty space as its precondition. The resulting frontality of the audience's gaze is analogous to the concept of the empty space of *mental imagination*. It refers the visibility of the image to the beholder's *powers of imagination*. Thus Lessing resolves his call for an *intellectuality of the image*[47] that he had formulated in his *Laocoön*. However, the precondition for this intellectuality is not an absorption into the image but rather a theatrical relation towards it. This relation, in turn, concerns not only an awareness of the spectator of his or her own status as observer; above all it concerns an awareness of the appropriateness of those media in which the image appears.

(Translated by Götz Dapp)

Notes

1 Michael Fried, *Absorption and Theatricality: Painting and Beholder in the Age of Diderot*, Chicago, 1980, 5: 'The paintings ... treated the beholder as if he were not there'.
2 Fried, *Absorption*, 108.
3 Denis Diderot, 'The Paradox on Acting', in Lester G. Crocker, ed, *Diderot's Selected Writings*, trans. Derek Coltman, New York, 1966, 318–29. Fried furthermore refers to Diderot's 1758 treatise 'De la poésie dramatique' and his 'Essais sur la peinture' (Fried, *Absorption*, 108).
4 Frank Büttner, 'Der Betrachter im Schein des Bildes. Positionen der Wirkungsästhetik im 18. Jahrhundert', in *Mehr Licht. Europa um 1770. Die Bildende Kunst der Aufklärung*. Katalog des Städelschen Kunstinstituts und Städtische Galerie, Frankfurt am Main, 2000, 341–50.
5 Fried, *Absorption*, 108.
6 Fried, *Absorption*, 108.
7 Denis Diderot, 'Von der dramatischen Dichtkunst', in Gotthold Ephraim Lessing, *Das Theater des Herrn Diderot*, Stuttgart, 1986, 283–404, 340.
8 Fried, *Absorption*, 5.
9 Jonas Barish, *The Antitheatrical Prejudice*, Berkeley, Los Angeles, 1981.
10 Helmar Schramm, *Karneval des Denkens. Theatralität im Siegel philosophischer Texte des 16. Und 17. Jahrhunderts*, Berlin, 1996.
11 Gotthold Ephraim Lessing, *Laocoön: An Essay on the Limits of Painting and Poetry*, trans. Eward Allen McCormick, New York, 1962. *Emilia Galotti* was written between 1768 and 1772, very shortly after the publication of *Laocoön* in 1766.
12 'Schauspiel des Denkens', Schramm, *Karneval*, 36.
13 Diderot, 'The Paradox on Acting', 324.
14 Johannes Friedrich Lehmann, *Der Blick durch die Wand. Zur Geschichte des Theaterzuschauers und des Visuellen bei Diderot und Lessing*, Freiburg i. Br., 2000.
15 Herbert Dieckmann, *Studien zur europäischen Aufklärung*, München, 1974, 284.
16 Lehmann supports this hypothesis with various situations of double observation that Diderot creates both theoretical as well as dramatically. Compare in this context the 'Letter on the Blind' [French: 'Lettre sur les aveugles'], Crocker, *Diderot's Selected Writings*, 14–30 and 'Letter on the Deaf and Dumb' [French: 'Lettre sur les sourds et les muets'], Crocker, *Diderot's Selected Writings*, 31–9.
17 Lehmann, *Blick durch die Wand*, 86.
18 French 1748. Compare the German translation: Denis Diderot, 'Aus den "Geschwätzigen Kleinodien"', in Denis Diderot, *Ästhetische Schriften*, 1968, 6–16.
19 Lehmann, *Blick durch die Wand*, 89.
20 Lehmann, *Blick durch die Wand*, 102.
21 For further information about how this relation is discussed in Diderot's plays see Lehmann, *Blick durch die Wand*, 88–110.
22 Elizabeth Burns, *Theatricality: A Study of Convention in the Theatre and in Social Life*, London, 1972, 11, 13: 'The theatrical quality of life taken for granted by nearly everyone, seems to be experienced most concretely by those who feel themselves on the margin of events ... Theatricality is not therefore a mode of behaviour or expression., but attaches to any kind of behaviour perceived and interpreted by others and described (mentally or explicitly) in theatrical terms.'
23 Maurice Merleau-Ponty, *The Visible and the Invisible. Followed by working notes*, ed. Claude Lefort, trans. Alphonso Lingis, Evanston, IL, 1968, 3.
24 Merleau-Ponty, *Visible and Invisible*, 3.
25 Compare for example Schramm, *Karneval*, 191: 'The vigorous attempt in the seventeenth century to teach human nature methodologically with reference to the universe ... is suspended ... in a highly ambivalent relationship towards theatrical implications of thinking and agency. While the critical observer strongly criticizes any display of pretense, deception, role play, and masquerades in others, he naturally picks up on refined techniques of self-presentation himself, i.e. the secret staging of events, as long as it benefits his own appearance.' Trans. GD.
26 With this concept I refer to Wesley Trimpi, *Muses of One Mind*, Princeton, NJ, 1983, 97, 98. Trimpi explains that this paradox is the result of a dilemma between knowledge and representation that has pervaded aesthetics since Plato: 'It is helpful to formulate the dilemma as a distinction between the excellence of the object to be represented and the accuracy with which the mind may know the object.'
27 Translator's note: The author builds on the strong etymological connection between the German *Tausch* (exchange) and *Täuschung*

(illusion or deception) to emphasize the same connection in the process of mediation.
28 Gotthold Ephraim Lessing, *Emilia Galotti*, trans. Anna Johanna Gode von Aesch, New York, 1959, V, 6, 99.
29 The very name of the 'object' points in this direction. Etymologically, Emilia derives from *aemulatio*, a concept that Foucault defines as one of four categories of thinking in similitude. Michel Foucault, *The Order of Things*, London and New York, 1989, 21–2.
30 Lessing, *Emilia Galotti*, I, 1, 1.
31 Lessing, *Emilia Galotti*, I, 4, 6–7.
32 Lessing, *Laocoön*, 40.
33 *Emilia Galotti* is considered to be the first play in which the status of a portrait is negotiated on stage. For more information about this aspect of the play see Georg-Michael Schulz, 'Conti und seine Kollegen. Über Maler und Malerei in einigen Dramen Lessings, Klingers, Schillers and anderer', in *Literatur in der Gesellschaft. Festschrift für Theo Buck zum 60. Geburtstag*. Frank-Rutger Hausmann, Ludwig Jäger, Bernd Witte, eds, Tübingen, 1990, 75–86.
34 Compare Fried's discussion of Diderot's view about the portrait in Fried, *Absorptions*, 109–25, and especially the following remark: 'But what I find arresting are those cases in which a portraitist was praised for devising a composition in which his sitter or sitters appeared to be engaged in a characteristic activity and thus were rendered proof against the consciousness of being beheld that compromised the genre' (111).
35 Lessing, *Emilia Galotti*, I, 3, 3.
36 Sigrid Schade and Silke Wenk, 'Inszenierungen des Sehens. Kunst, Geschichte und Geschlechterdifferenz', in Hadumod Bussmann and Renate Hof, eds, *Genus. Zur Geschlechterdifferenz in den Kulturwissenschaften*, Stuttgart, 1995, 340–407, 374.
37 Hans Belting, 'Wappen und Porträt. Zwei Medien des Körpers', in Hans Belting, *Bild-Anthropologie. Entwürfe für eine Bildwissenschaft*, München, 2001, 115–42.
38 Belting, 'Wappen und Porträt', 120f. This and all following citations of Belting trans. GD.
39 Hans Belting and Christiane Kruse, *Die Erfindung des Gemäldes. Das erste Jahrhundert niederländischer Malerei*, München, 1994, 36.
40 Belting and Kruse, *Erfindung des Gemäldes*, 40.
41 Belting, 'Wappen und Porträt', 122.
42 Belting, 'Wappen und Porträt', 122.
43 Lessing, *Emilia Galotti*, I, 4, 8. See also Belting and Kruse, *Erfindung des Gemäldes*, 41: 'Painting as "Schilderei" (schilderije) considered itself to be the art of painting pictures, that is, picture plates, that resembled the escutcheons in use and as a portrait also substituted a person.'
44 Belting, 'Wappen und Porträt', 126.
45 Lessing, *Emilia Galotti*, I, 4, 9.
46 Lessing, *Emilia Galotti*, I, 5, 10.
47 Translator's note: Lessing uses the term *Geistigkeit des Bildes*, which McCormick renders as 'incorporeality' (*Laocoön*, 40). This translation, however, falls short of emphasizing the mental involvement of the beholder that is essential in the present context, which is why I have chosen the term 'intellectuality' although I realize that this usage is highly unusual in English.

Index